*Pre-Raphaelite Art in
Its European Context*

Pre-Raphaelite Art in Its European Context

Edited by
SUSAN P. CASTERAS AND ALICIA CRAIG FAXON

Madison ● Teaneck
Fairleigh Dickinson University Press
London: Associated University Presses

Associated University Presses
440 Forsgate Drive
Cranbury, NJ 08512

Associated University Presses
25 Sicilian Avenue
London WC1A 2QH, England

Associated University Presses
P.O. Box 338, Port Credit
Mississauga, Ontario
Canada L5G 4L8

The paper used in this publication meets the requirements of the American National Standard for Permanence of Paper for Printed Library Materials Z39.48-1984.

Library of Congress Cataloging-in-Publication Data

Pre-Raphaelite art in its European context / edited by Susan P. Casteras and Alicia Craig Faxon.
 p. cm.
 Includes bibliographical references and index.
 ISBN 0-8386-3539-3 (alk. paper)
 1. Pre-Raphaelitism—England. 2. Art, English. 3. Art, Modern—19th century—England. 4. Pre-Raphaelitism—England—Influence. 5. Art, European—Influence. I. Casteras, Susan P. II. Faxon, Alicia Craig.
N6767.5.P7P72 1995
709'.42'09034—dc20 92-55114
 CIP

For John Paul Schnapper-Casteras, his mother's special muse, and also the family of Alicia Craig Faxon, for their support and understanding

Contents

Preface

One of the phenomena of the modernist para-digm of art history was the virtual omission of significant areas of art production: the Modernist paradigm excluded from its narrative those areas of art production that did not fit into its narrow scope. Whole eras and schools were thus dismissed because they did not mirror the Hegelian march toward abstract art postulated by Alfred Barr and echoed by many other upholders of the Modernist creed. In a post-Modern period, it is therefore appropriate to reevaluate a number of such excisions in light of their own legitimate contributions to art history and to the theory and practices of their own era.

Similarly, certain aspects of European art, notably of French art, were valorized and separated from the European milieu, as if totally divorced from British as well as Continental art. This practice has skewed and falsified our perspective of both French art and other contemporaneous works of art in Europe in the nineteenth century. The aim of this volume is to attempt some partial redress—namely, to see Pre-Raphaelite art in a different nineteenth-century context and to reunite it with the art of its era, in terms of not only its impact on European art but also the Continental influences and interrelationships engendered among various artists. In the essays that follow, we thus propose a revisionist view of Pre-Raphaelite art—a view that does not treat such art as a separate entity or as an exotic offshoot of British culture. This argument is, in fact, more fully expanded in Alicia Craig Faxon's introductory essay, which offers some new grounds and questions for scholars in the field to consider.

This book is organized into four parts: "Pre-Raphaelite Influences on European Art and Taste," "European Influences on Pre-Raphaelite Art," "European Connections with Pre-Raphaelitism: People, Places, and Forces," and "Continuations of the Pre-Raphaelite Tradition." In the first part, European Symbolism is a common thread weaving through each essay. Susan P. Casteras begins by demonstrating the major influence of Pre-Raphaelite art and iconography on the European Symbolist movement, particularly on the artists who contributed to the Rose + Croix salons. Sarah Phelps Smith, on the other hand, focuses on Venetian prototypes for the art of Dante Gabriel Rossetti and links these prototypes with Rossetti's subsequent influence on Continental Symbolism. Colleen Denney enlarges the examination of Pre-Raphaelite art seen abroad by showing how Sir Coutts Lindsay's radical Grosvenor Gallery—along with his methods of selection, installation, and publicity—brought fame on the Continent to Edward Burne-Jones and "second-generation" Pre-Raphaelites and inspired Symbolist and other artists. Barbara Watts extends the range of these investigations by commenting not only on the decisive role that Pre-Raphaelite aesthetics exerted in the late–nineteenth-century establishment of Botticelli's reputation but also on the intercontinental rivalry that developed for the acquisition of the manuscript of Botticelli's illustrations to Dante's *Divina Commedia*.

Part 2 commences with Liana Cheney's tracing of Burne-Jones's indebtedness to Italian Mannerist sources and then shifts to Norman Kleeblatt's investigation of Early Italian inspiration for some of Simeon Solomon's paintings with Hebraic subjects. The final essay in this delving into European connections with Pre-Raphaelitism is Linda Julian's evaluation of the role of Icelandic sagas in the formation of William Morris's socialist aesthetics.

The third part explores more diverse—and larger—issues, encompassing specific individuals as well as national, spiritual, and cultural forces. Helene Roberts initiates the reader into the complexities of Victorian religion and Roman Catholicism, by not only focusing on Cardinal Wiseman's influence on James Collinson but also considering the generally adverse reception of pre-Raphaelite art that con-

9

tained sacred subjects. Julia Ionides moves beyond Rome to Greece and, utilizing unique and unpublished family resources, chronicles the important position of several Greek families in London and shows how, as patrons and friends, these families encouraged Pre-Raphaelite artists and other Victorian painters, too. Alice H. R. H. Beckwith shifts the location and discussion to French Impressionism, invoking Ruskinian credos as well as French criticism of Pre-Raphaelite art, while concentrating on Lucien Pissarro's Eragny Press and its interconnections with the art of William Morris in particular.

The final section suggests some new directions in the continuation of the Pre-Raphaelite tradition. Pre-Raphaelite art and aesthetics intersected with the commercial world, for example; Laurel Bradley uses John Everett Millais's *Bubbles* as a yardstock of commercial commodity to measure the practices of artistic advertisement in England and also posits some parallels to the fate of "high" art on the Continent. Gail Weinberg ends with an assessment of the imprint of Pre-Raphaelite works on Aubrey Beardsley and their mutual indebtedness to European sources.

The material included in these essays incorporates much new insight and information in the field of nineteenth-century art and presents fresh opportunities and perspectives for interpretation and insight. Many of these areas have not been previously investigated, and a number of previously overlooked interconnections between the Pre-Raphaelites and the Continent are clearly forged. Most of the more eminent artists in the Pre-Raphaelite circle—Dante Gabriel Rossetti, John Everett Millais, William Holman Hunt, Edward Burne-Jones, and William Morris— receive due attention; but some more minor figures, like James Collinson, are also included in the analyses.

As might be imagined, this book was shaped by the editors' selection process and by the kinds of essays that the editors received. Certainly, there are numerous other directions that remain to be explored, whether in the realm of Pre-Raphaelite absorption of—or effect on—European decorative arts, poetry and literature, book illustration, costume and theatre design, photography, or other areas. The editors also would have liked to offer some emphasis on Pre-Raphaelite women artists such as Elizabeth Siddal, Marie Spartali Stillman, Joanna Brett, Evelyn Pickering DeMorgan, or Lucy Madox Brown; but, unfortunately, no work of this nature was submitted for this project. After compiling this volume, the editors are more convinced than ever of the need to continue to pursue these rich interconnections and others and hope that these essays will help point the way toward some new approaches and untrodden paths.

The editors would like to thank the contributors for their patience and diligence. In addition, we are very grateful to the numerous museums and collectors who have permitted the reproduction of materials in their collections. Funding for research from the National Endowment for the Humanities was also very useful. We also thank the Frederick W. Hilles Publications Fund of Yale University for its support of this work. Thanks are due as well to Barry Friedman, Ltd., of New York; to Bonnie Grad; to the University of Texas at Austin; to the Yale Center for British Art; to Page Stevens Knox for her copy-editing labors, and to Richard Caspole. On a personal note, this book is dedicated to John Paul Schnapper-Casteras, his mother's special muse, and also to the family of Alicia Craig Faxon, for their continuing support and understanding throughout the many labors and stages of making this volume a reality.

SUSAN P. CASTERAS
ALICIA CRAIG FAXON

Introduction:
A New View of Pre-Raphaelitism

ALICIA CRAIG FAXON

RECENT DEVELOPMENTS IN THE STUDY OF ART HIS-tory in a post-Modern era suggest that a number of areas should be considered for the possibility of a new methodology and a more inclusive structure. Such a consideration includes a revisionist view of the place of Pre-Raphaelite art in nineteenth-century European art history and a critique of the selectivity and artificiality of a Modernist bias that exalts one form of art to the detriment of others and that excises whole areas of art from the so-called canon of correct art. That Pre-Raphaelite art is a relative terra incognita results from excluding a vital school of art from what is studied in most graduate schools of art history and from what is considered proper to write about in art journals. Because of the artificial distinctions made in the study of art history, the strong links between Pre-Raphaelite and Continental art—and the influence of Pre-Raphaelite art abroad—have not been more widely recognized. What Linda Nochlin in her recent book *The Politics of Vision* refers to as "the politics of art history itself"[1] often operates to define what areas may be studied, not according to their own merits, but according to how they fit into the thesis of the determining group, such as for-malism, Marxism, or structuralism—or as Walter Benjamin put it so succinctly, "History has . . . been written by the victors."[2]

Instead of presenting the Pre-Raphaelite Brother-hood and their followers as an isolated English phe-nomenon, we propose viewing these artists and their works within the tradition of European nineteenth-century art, in general, and French art, in particular. In this context, we are suggesting that the separation of Pre-Raphaelite art from European art is an arbi-trary one created by modern art historians. As art-ists, the Pre-Raphaelites used many of the same sources as the French artists—many of the same types of subjects drawn from literature, religious tra-dition, and contemporary life—and were affected by new sources of art patronage and new modes of exhibition.

We are accustomed to seeing the French as the first in all art innovations, but according to Robert Rosenblum, the members of the Pre-Raphaelite Brotherhood were the first group consciously to de-clare themselves avant-garde artists.[3] They had a literary manifesto in which they denounced aca-demic taste and technique, and they opposed the greatest artistic idol of the day—Raphael—preferring, instead, the art that came before him. In 1857, they organized their own group exhibition in Fitzroy Square, a full seventeen years before the first Impressionist (or Independent, as Degas would have it) Exhibition of 1874. Several members of the group—such as Hunt, Millais, Rossetti, and Brown—painted outdoors (or *en plein air*) before the Impressionists did, as exemplified in the 1850s by such works as Brown's *The Pretty Baa-Lambs* (1859, Birmingham City Museum & Art Galleries, En-gland), Hunt's *Hireling Shepherd* (1851, Manchester City Art Galleries, England) and Millais's *Ophelia* (1851–52, Tate Gallery, London).

Who were these daring upstarts? They comprised two main groups: the Pre-Raphaelite Brotherhood, formed in 1848, and a second group, formed around Dante Gabriel Rossetti in the 1850s, whose main artists were William Morris (1834–1896) and Edward Coley Burne-Jones (1833–1898). The Pre-Raphaelite Brotherhood consisted of seven in num-ber: William Holman Hunt (1827–1910), John Ever-ett Millais (1829–1896), Dante Gabriel Rossetti (1828–1882) and his younger brother William

Michael Rossetti (1829–1919), James Collinson (1825–1881), Thomas Woolner (1825–1892), and Frederick G. Stephens (1828–1907). The second Pre-Raphaelite movement consisted of young artists recruited by Dante Gabriel Rossetti in 1857 in a project to paint Arthurian frescoes on the walls of the Oxford Debating Union.

According to Holman Hunt, in his *Contemporary Review* article of 1887 and in his book *Pre-Raphaelitism and the Pre-Raphaelite Brotherhood* (first published in 1905), the term "Pre-Raphaelite" was given to John Everett Millais and himself as students at the Royal Academy Schools when they said that they preferred paintings made before the time of Raphael and criticized Raphael's late work, *The Transfiguration* (1517, Vatican Museum, Rome), a painting adulated by their fellow students. "So you are Pre-Raphaelite admirers, are you?" they were asked, and they laughingly agreed that they were.[4] Rather than detailing again the history of the Brotherhood and its second manifestation in the works of Morris, Burne-Jones, and other followers, let us examine some of the similarities of their concerns to the work of their European nineteenth-century counterparts. In some cases, European works preceded the English; in other instances, the Pre-Raphaelites were first in the field. The main question is not proof of priority but rather the examination of areas of similarity and of mutual cultural interests and affinities.

Although we do not usually think of the Pre-Raphaelites as being socially concerned or as exposing social evils, the young Pre-Raphaelite Brotherhood was very active in this area, either overtly in such works as Hunt's *The Awakening Conscience* (1853–54, Tate Gallery, London, fig. 1) or under the cover of literary reference as in Millais's *The Woodman's Daughter* (1851, Guildhall Art Gallery, London), which was painted after a poem by Coventry Patmore condemning the inequalities of the English class system. Hunt's *The Awakening Conscience* pictures a kept woman in a flat in St. John's Wood (which Hunt conscientiously reproduced, renting a flat in which to paint the picture), hearing a song of her childhood and, recalling her past innocence, forming a resolve to leave her lover and start a new life. The painting refers specifically to a very common situation which existed in mid–nineteenth-century England, especially in London, where prostitution was rampant and of increasing concern to both social reformers and law-enforcement officers. In referring to nineteenth-century social realism, we automatically think of Gustave Courbet (1819–1877) and

of such works as *The Stonebreakers* (1849; destroyed in Dresden, Germany, in 1945), which expose the backbreaking toil of an underclass; but we tend to forget such paintings as Dante Gabriel Rossetti's *Found* (1853–82, Delaware Art Museum, Wilmington, fig. 2), which condemns not only the social ostracism of "the fallen woman" but also the society that, through its unjust wage structure, made it impossible to live without recourse to prostitution.

We tend not to realize, also, that the Pre-Raphaelites traveled on the Continent and knew both its contemporary art and artists. Henri Fantin-Latour (1836–1904), for example, introduced Dante Gabriel Rossetti to Édouard Manet (1832–1883) in 1864; and Alastair Grieve suggests that Rossetti's use of a black figure in *The Beloved* (1865–66, Tate Gallery, London) may have derived from Rossetti's view of Manet's *Olympia* (1863, Musée d'Orsay, Paris), which was in the studio at that time.[5] Fantin-La Tour had wanted both Rossetti and Manet to sit for his painting, *Hommage à Delacroix* (1864, Musée d'Orsay, Paris), but Rossetti was unable to come at that time and, therefore, he did not appear in the painting. James McNeill Whistler (1834–1903) was probably influential in introducing Dante Gabriel Rossetti to both Fantin-Latour and Manet and also in asking that Rossetti be included in the group homage to Delacroix. Both Manet and Dante Gabriel Rossetti were admirers of Delacroix's paintings, and Rossetti's presence in France in November 1864 was principally to see the Delacroix Memorial Exhibition at the Société Nationale des Beaux Arts. Although Rossetti disliked Manet's painting style, he offered to submit Manet's paintings to the Royal Academy Art Exhibition in the spring of 1865; but, unfortunately, they were not hung in the final installation due to lack of space.[6]

Although often stylistically very different, both Pre-Raphaelite and Continental artists shared many similar tastes in subject matter. The Pre-Raphaelites, for example, have often been condemned for their unrealistic and literary imagery, as if these areas were of interest to them alone rather than to artists on both sides of the channel. Religious art was a category still of interest to nineteenth-century artists and patrons. It is not always realized that the members of the Pre-Raphaelite Brotherhood started as painters of religious works, and it was when these religious images were mercilessly criticized for not fitting in with contemporary ideas of religious decorum—and when Pre-Raphaelite art was even confused with so-called Romanist tendencies—that the Brotherhood left this area for contem-

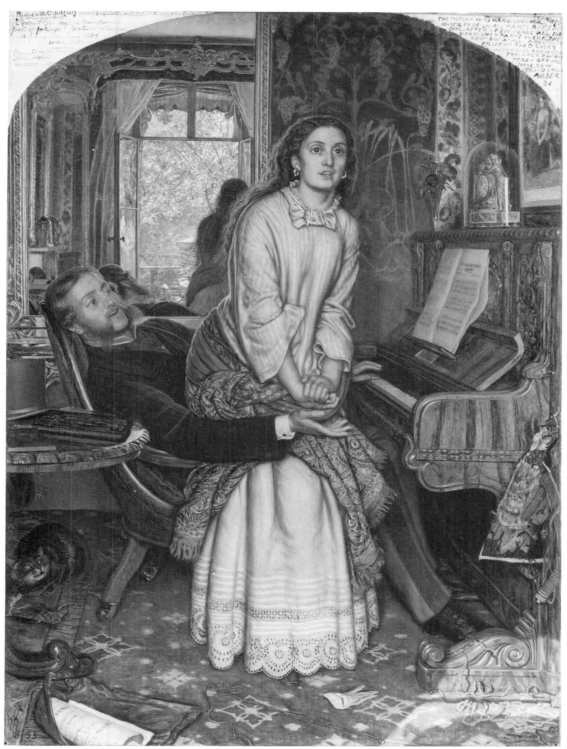

Fig. 1. William Holman Hunt. *The Awakening Conscience,*
1853–54. Oil on canvas. 30″ × 22″. Courtesy of the Tate Gal-
lery, London.

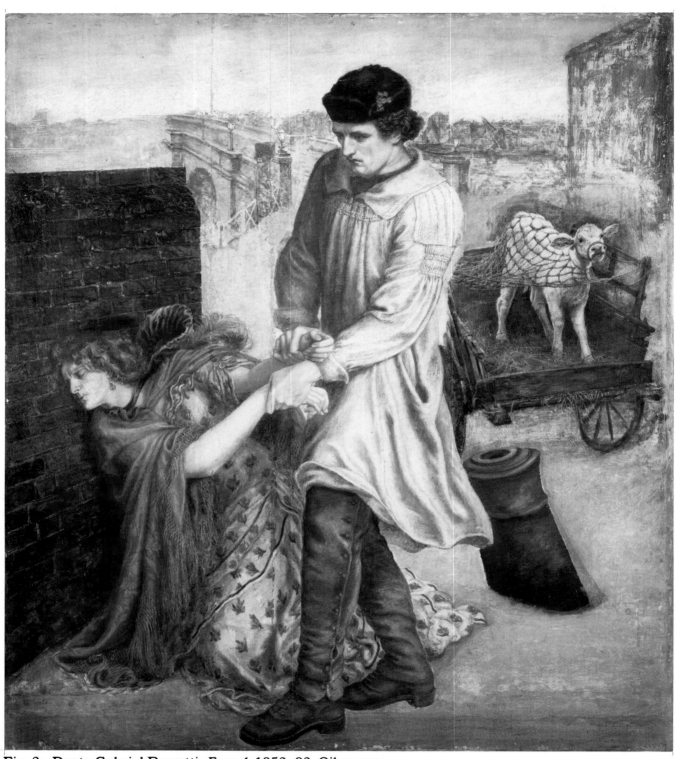

Fig. 2. Dante Gabriel Rossetti. *Found*. 1853–82. Oil on canvas. 36″ × 31½″. Courtesy of the Delaware Art Museum, Samuel and Mary R. Bancroft Memorial Collection.

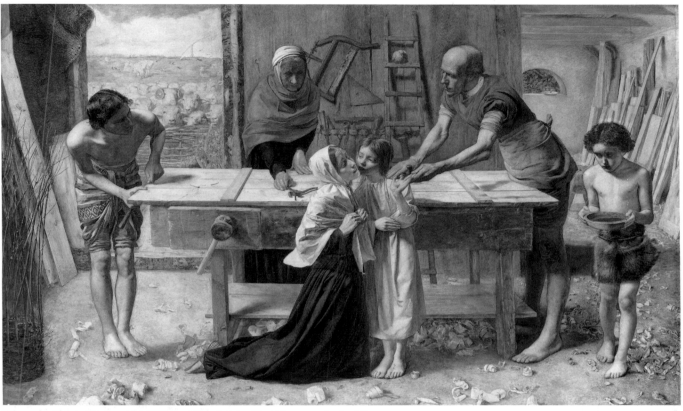

Fig. 3. John Everett Millais. *Christ in the Carpenter's Shop*
(Christ in the House of His Parents). 1850. Oil on canvas.
34″ × 55″. Courtesy of the Tate Gallery, London.

porary and literary references. Dante Gabriel Rossetti's first exhibited work was *The Girlhood of Mary Virgin* (1848–49, Tate Gallery, London), and Millais's *Christ in the Carpenter's Shop* (ca. 1850, Tate Gallery, London, fig. 3), which was derided for its undignified portrayal of the Holy Family in a workingman's shop, was shown in 1850 at the Royal Academy. Hunt's *A Converted British Family Sheltering a Christianary Missionary from the Persecution of the Druids* (1849–50, Ashmolean Museum, Oxford) was criticized also. What is of interest is that these painters' representations of religious scenes were presented unconventionally, in new interpretations. This unconventionality is evident in Dante Gabriel Rossetti's *Ecce Ancilla Domini* or *The Annunciation* (ca. 1850, Tate Gallery, London) in which he has shown Mary as a shrinking young girl in a simple Palestinian bedroom, and an angel without the customary wings. Both Hunt's *The Light of the World* (1851–54, Keble College Chapel, Oxford) and Manet's *Dead Christ with Angels* (1864, Metropolitan Museum of Art, New York, fig. 4) presented unconventional views of Christ—Manet's possibly under the influence of Ernst Renan's *La Vie de Jesus,*

published in 1863, which showed Christ as a human being and not as a divinity. An unidealized human Christ was the subject of Millais's *Christ in the Carpenter's Shop* and, later, of Manet's *Christ Mocked* (1865, Art Institute of Chicago); both artists were bitterly criticized for this unconventional view. For his nonidealized types in *Christ in the Carpenter's Shop,* for example, Millais was pilloried in *Punch* in a review entitled "Pathological Exhibition at the Royal Academy (Noticed by Our Surgical Advisor)," which concluded, "It will be a pity if this gentleman does not turn his abilities—which, in a mechanical way are great—to the illustration of COOPER'S Surgical Dictionary and leave the testament alone."[7] A writer in the London *Times* of 9 May 1850, accused Millais of "a marked indifference to everything we are accustomed to see and to admire. . . . His picture . . . is . . . revolting, . . . the meanest details of a carpenter's shop, with no conceivable omission of misery, of dirt, and even disease, all finished with the same loathsome minuteness . . . ;" while in *The Illustrated London News,* 4 May 1850, in "Town Talk and Table Talk," signed A.B.R., a writer castigated the Pre-Raphaelite Brotherhood who devoted "their energies

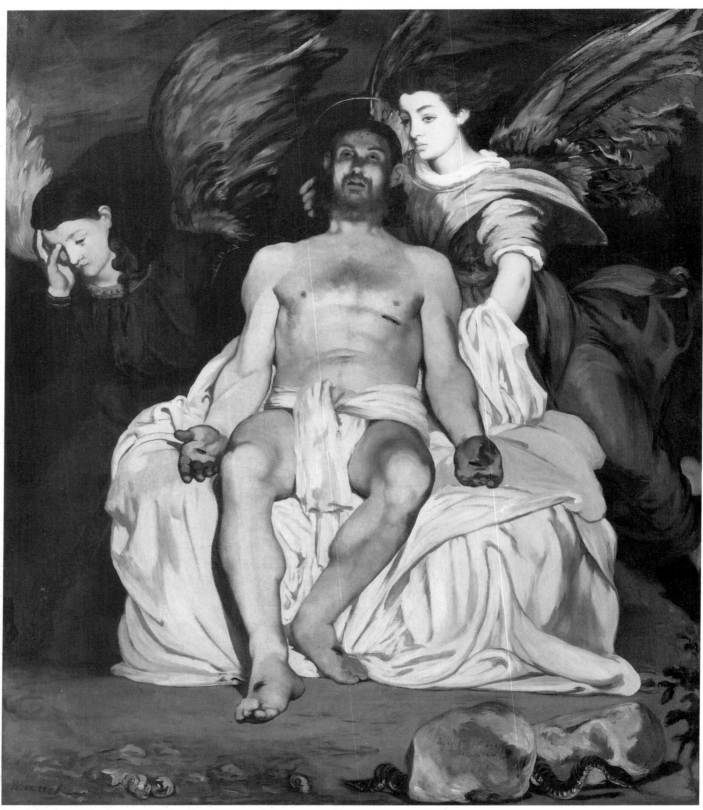

Fig. 4. Édouard Manet. *The Dead Christ with Angels*. 1864. Oil on canvas. 70⅝″ × 59″. Courtesy of the Metropolitan Museum of Art, H. O. Havemeyer Collection.

to saints, squeezed out perfectly flat—as though the gentlemen had been martyred by being passed under a Baker's Patent ironing machine; their appearance being further improved by their limbs being struck akimbo, so as to produce a most interesting series of angles and finely developed elbows."[8] In his journal *Household Words,* Charles Dickens railed against Millais's painting, saying, "Whatever it is possible to express ugliness of feature, limb and attitude, you have it expressed. Such men as the carpenters might be undressed in any hospital where dirty drunkards, in a high state of varicose veins are received. Their very toes have walked out of Saint Giles's."[9]

For the same refusal to idealize religious figures, Manet was also castigated. Théophile Gautier wrote of *The Dead Christ with Angels* (fig. 4), "The angels . . . have nothing celestial about them and the artist hasn't tried to raise them above a vulgar level";[10] and in 1865 in *La Presse,* Paul de St. Victor inveighed against Manet's *Jesus Mocked by the Soldiers:* "The crowd, as at the morgue, press together in front of the gamy *Olympia* and the horrible *Ecce Homo* of M. Manet. Art, having sunk so low, does not even deserve reprimand."[11] In the *Moniteur* of 24 June 1865, in words very similar to the criticism of the Pre-Raphaelites, Gautier wrote of *Jesus Mocked by the Soldiers,* "The artist seems to have taken pleasure in bringing together ignoble, low, and humble types."[12] (In passing, it is interesting to note that many of Manet's sources were the same as those of the Pre-Raphaelites. He shared with Millais a great admiration and emulation of Velásquez; and with Dante Gabriel Rossetti, he shared an homage to the Venetians, especially Giorgione, Titian, Tintoretto, and Veronese.) Recent scholarship suggests that several of Manet's paintings—such as his *Philosopher* (1865–67, Art Institute of Chicago) and his *Ragpicker* (1869, Norton Simon Museum, Pasadena), possibly derived from Baudelaire's "The Wine of Ragpickers" from *Les Fleurs du Mal,* as well as precedents in Velásquez's sages—rather than having no connection with literature, were inspired by specific literary sources.[13]

In an era when the formal artistic components of a painting were considered the only important standards, Pre-Raphaelite art was dismissed as being too literary or too symbolic. However, recent research has revealed an interest in literature and symbolism in a number of Continental paintings hitherto regarded as relatively subjectless and as self-referential only. Without delving into esoteric meanings, however, it is quite obvious that many of the same references to literature apply on both sides of the channel.

There was, for example, a great revival of interest in the works of Dante Alighieri, especially under the impetus of the Romantic movement, which saw many of the episodes of *The Divine Comedy* as fit subjects for the depiction of terror and sublimity. Dante Gabriel Rossetti—who as a poet had translated Dante's poems as well as Dante's autobiography *La Vita Nuova*—depicted episodes from Dante's works in his art, as in *The Salutation of Beatrice* (1849–50, Fogg Art Museum, Harvard). This interest was not unique to Dante Gabriel Rossetti: The first work of Eugène Delacroix (1798–1863), shown at the Salon of 1822, was *The Barque of Dante* (1822, Louvre, Paris), or *Virgil and Dante in Hell,* which depicts Virgil and Dante's emotion-filled journey on the River Styx to the Inferno. Delacroix was a great admirer of Dante and used him as an inspiration for his paintings. Delacroix's journal has fourteen references to the immortal Italian, such as an entry for 7 May 1824, "Concentrate deeply when you are painting and think only of Dante. In his works lie what I have always felt in myself."[14] While painting *The Barque of Dante,* Delacroix had a friend read aloud passages from Dante that "electrified" him to produce the best head in the work.[15]

Dante Gabriel Rossetti showed another episode from *La Vita Nuova,* namely, *Dante Drawing an Angel on the Anniversary of Beatrice's Death* (1853, Ashmolean Museum, Oxford); and even so neoclassic a painter as Jean-Auguste-Dominique Ingres (1790–1867) fell prey to the romantic story of *Paolo and Francesca* (ca. 1819, Musée Condé, Chantilly) from canto 5, lines 123–33 of Dante's *Inferno.* Both of these paintings are narrative, Romantic representations of literary episodes, done in fairly similar ways even though we do not usually associate these two artists. An unacknowledged source for Dantean images on both sides of the channel was the work of John Flaxman (1755–1826). Flaxman did a series of line drawings of Dante's *Divine Comedy,* commissioned by Thomas Hope and engraved by Thomas Piroli. These were published in Rome in 1793 and were available throughout Europe in a number of editions. Both Ingres's *Paolo and Francesca* (of which he made six similar versions) and Delacroix's watercolor of the same name (1824–25, Collection of Dr. Peter Nathan, Zurich) show by the poses and placement of the figures that they were derived from the Flaxman engraving of the subject.[16] Flaxman also served as a source for renditions of Paolo and Francesca by Ary Scheffer (1854, Hamburg, Kunsthalle);

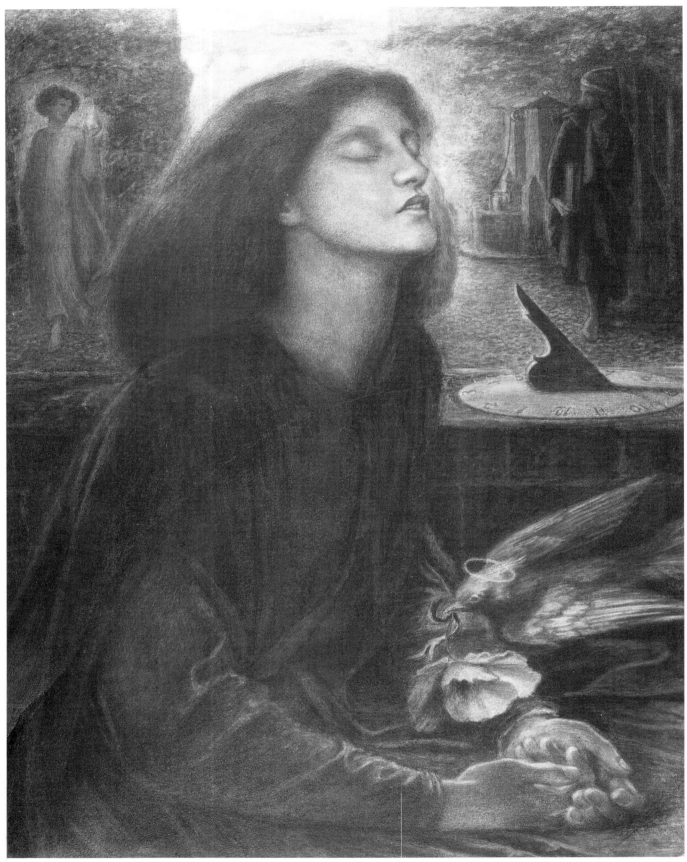

Fig. 5. Dante Gabriel Rossetti. *Beata Beatrix*. 1871. Watercolor on paper. 27¾″ × 21½″. Courtesy of the Fogg Art Museum, Harvard University, Cambridge, Massachusetts, Bequest of Grenville L. Winthrop.

for *Francesca da Rimini* (1837, National Gallery of Scotland, Edinburgh) by William Dyce (1806–1864); and for *Paolo and Francesca da Rimini* (1855, Tate Gallery, London) by Dante Gabriel Rossetti possibly through the intermediary painting by Dyce.

Another example of Dantean subject matter is Dante Gabriel Rossetti's *Beata Beatrix* (1871, Tate Gallery, London, fig. 5, seen here in its Fogg Art Museum version of 1871), which commemorated Beatrice's death from *La Vita Nuova* and the death of Rossetti's wife, Elizabeth Siddal, in 1862; the painting became an icon of the Symbolist movement. Although not in the same medium, the sculptor Jean-Baptiste Carpeaux (1825–1875) represented an episode for canto 33 of *Divine Comedy* in *Ugolino and His Sons* (1865–67, Metropolitan Museum of Art, New York); and Rodin's *Gates of Hell* (1887–1917, Musée Rodin, Paris), which were based on Dante's description of the gate to Hell in the *Inferno*. One rather amusing testimony to Dante's popularity with

English and French artists is Millais's and Delacroix's wearing Dantean garb to costume balls—although, fortunately, not the same ball.

Shakespeare was also a great favorite on both sides of the channel. Hunt's *Two Gentlemen of Verona (Valentine Rescuing Sylvia from Proteus)* (1850–51, Birmingham, City Museum and Art Gallery, England) finds a parallel interest in Delacroix's *Hamlet and Horatio in the Graveyard* (1839, Louvre, Paris), although the action is not as lively in Delacroix's work. Millais's *Ophelia* (1851–52, Tate Gallery, London) as well as several of Dante Gabriel Rossetti's drawings and watercolors that take their subject from *Hamlet* show an English interpretation of Shakespeare's drama. Perhaps it is stretching the point of literary reference a bit, but even Ingres's *Jupiter and Thetis* (1811, Montauban) is based on the literary prototype of an episode from Homer's *Iliad*.

The model for Millais's *Ophelia* was Elizabeth Siddal (1829–1862)—who became the model, pupil, fi-

Fig. 6. Elizabeth Eleanor Siddal. *The Lady of Shalott.* 1853. Pen, black ink, sepia ink, and pencil. 6½″ × 8¾″. Courtesy of Jeremy Maas Collection.

ancée, and, finally, wife of Dante Gabriel Rossetti in 1860. Siddal was a great devotee of the contemporary poet Alfred Tennyson, and she created one of the earliest representations of his poem *The Lady of Shalott* (1853, Jeremy Maas Collection, London, fig. 6). At approximately the same time, Delacroix was also drawing from a poem by a contemporary whom he admired, *Bride of Abydos* by Lord Byron (1856, Kimbell Art Museum, Fort Worth, Texas). Delacroix took the subjects for a number of his most important paintings from literary works by Byron: *The Death of Sardanapalus* (1828, Louvre, Paris), *The Prisoner of Chillon* (1835, Louvre, Paris), *Mazeppa* (1828, whereabouts unknown) (which also inspired Théodore Géricault, Horace Vernet, Louis Boulanger, Théodore Chassériau, and many other French artists), *Marino Faliero* (1826, Wallace Collection, London), *The Shipwreck of Don Juan,* (1841, Louvre, Paris), several versions of *The Giaur and the Pasha,* and several versions of *The Bride of Abydos.* Delacroix's *Massacres at Chios* (1824, Louvre, Paris) and *Greece Expiring on the Ruins of Missolonghi* (1827, Musée des Beaux Arts, Bordeaux) were also tributes to Byron's participation and death in the Greek War of Independence. Byron's poem *Manfred* inspired paintings by John Martin, Ford Madox Brown, and Thomas Cole—paintings spectacularly Romantic in their settings in the Alps. Another English literary source for Delacroix was Sir Walter Scott, from whose works Delacroix was inspired to paint the *Murder of the Bishop of Liége* (1829, Louvre, Paris) from Scott's novel *Quentin Durward* and *The Abduction of Rebecca* (1846, Metropolitan Museum of Art, New York) from Scott's *Ivanhoe.*

Contemporary poetry was also the inspiration for Hunt's *The Lady of Shalott,* inspired by Tennyson's poem. The large painting purchased by The Wadsworth Athenaeum, in Hartford, illustrates the theme of Lady of Shalott that Hunt worked on from the 1850s until 1905—a work extraordinarily rich in color, compositional complexity, and symbolic intent. Tennyson's poems evoked important works by Millais, Dante Gabriel Rossetti, and Burne-Jones; and Hunt, Millais, and Dante Gabriel Rossetti chose themes from Keats for their early paintings.

Another area in which both Continental and English artists were involved was the re-creation of the Middle Ages, an era consciously adopted by the Romantics as an alternative to neoclassical themes and ancient mythology. However, there are significant differences between the handling of this medieval theme by the Pre-Raphaelite Brotherhood, on the one hand, and the approach of most French artists

on the other—French artists such as Delacroix, for whom medievalism came secondhand, interpreted through a contemporary literary treatment, as exemplified in his *The Abduction of Rebecca* (1846, Metropolitan Museum of Art, New York), which was taken from Scott's *Ivanhoe* (published in 1819). The members of the Pre-Raphaelite Brotherhood strove for authenticity in their representations of medieval themes. This is evident in Millais's *Mariana* (1851, Makins Collection), whose subject is taken from Tennyson's poem, but whose details follow genuine medieval artifacts, such as the stained-glass window that Millais copied from the windows in Merton College chapel, which date from 1288 to 1328. For authentic details, Dante Gabriel Rossetti used manuscripts available to him in the British Museum; compositional devices such as the costumes in his *St. Catherine* (1857, Tate Gallery, London) are based on "The Dance of Mirth," folio 14v, of the *Roman de la Rose,* Harley MS. 4425 from ca. 1500. Rossetti's illustration of *The Lady of Shalott* for the Moxon *Tennyson* of 1857 took its composition from the oldest source on the subject that he could find in the British Museum, namely, a *Lancelot du Lac* of 1316 (Add. MSS 10294, fol. 65, fig. 7). Rossetti and Siddal worked together on a painted jewelry casket for Jane Morris (before 1862, Kelmscott Manor), and it has recently been discovered that the source for this casket also came from a medieval manuscript in the British Museum, namely, Christine de Pisan's "Two Lovers in A Garden" (Harley MS. 4431, fol. 376)[17] from the early fifteenth century, a very Post-Modern type of appropriation indeed.

Although not always associated with the Pre-Raphaelites, there was a great interest in landscape—as Allen Staley's excellent book, *The Pre-Raphaelite Landscape* (1973) amply testifies—many paintings being done *en plein air.* Pre-Raphaelite technique tended to be too microscopically rendered, with an often fanatic truth to nature; but lyricism is not lacking in works like Hunt's *The Haunted Manor* (1849, Tate Gallery, London)—which shows the same interest in specific topographical features as Courbet's later *A Brook et Les Puits Noirs* (ca. 1870, Fogg Art Museum, Harvard)—as well as other Continental landscape paintings. Millais was interested in landscape all of his life and was as attached to the Scottish countryside, shown in *Lingering Autumn* (1890, Lady Lever Art Gallery, Port Sunlight), as Cézanne was to Provence, exhibited in such works as *Mont Sainte Victoire with Aqueduct* (1885, Metropolitan Museum of Art, New York), although one may not usually think of these artists' contemporane-

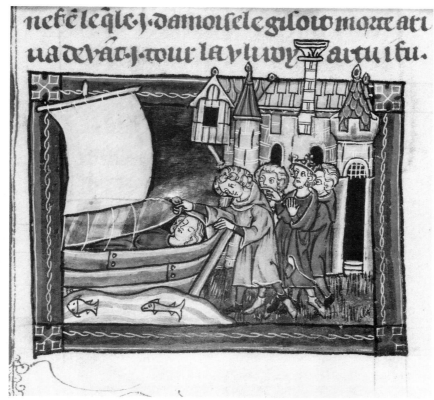

Fig. 7. *Lancelot du Lac*. Add. MSS 10294, fol. 65v. 1316. Manuscript illumination. 2″ × 2⅝″. Courtesy of the British Library, London.

ity or like interests. Pre-Raphaelite landscape painters such as John Everett Millais, Holman Hunt, Ford Madox Brown, John Brett, George Price Boyce, Joanna Boyce, Thomas Seddon, William Bell Scott, and John William Inchbold tended to pay scrupulous attention to exact details in the scene chosen, taking seriously the Ruskin dictum to reproduce nature, "rejecting nothing, selecting nothing and scorning nothing."[18] Some painters even took their subjects directly from Ruskin—painters like John Brett, whose *Glacier of Rosenlaui* (1856, Tate Gallery, London) and *Val d'Aosta* (1858, Collection of Sir Frank Cooper, Bt. England) were powerful and compelling works. This minute exteriority was, certainly, very different from the approach of most French landscapists, especially Cézanne, who re-created rather than copied the scene before him; but landscape was a passionate concern for pre-Raphaelite—as well as Continental—artists.

In the nineteenth century, in both England and France, there was a tendency to romanticize the work of artists of the past. An interesting example of this mode can be found in Dante Gabriel Rossetti's *Giotto Sketching Dante* (ca. 1852–59, Fogg Art Museum, Harvard), which is well matched by Ingres's

Raphael and La Fornarina (1814, Fogg Art Museum, Harvard) although Ingres's is incomparably more romantic. Dante Gabriel Rossetti also did drawings entitled *Fra Angelico Painting* (ca. 1853, Birmingham City Art Gallery, England) and *Giorgione Painting* (ca. 1853, Birmingham City Art Gallery, England) and portrayed in watercolors an imaginary medieval painter, *Fra Pace* (1856, Lord and Lady Freyberg Collection, see Smith, fig. 2) at work. Dante Gabriel Rossetti wrote to his brother William on 16 February 1873, "Condivi tells us that he heard Michelangelo, when quite old, say that he regretted nothing more than that, when he visited Vittoria Colonna on her deathbed, he did not kiss her face but only her hand. This interview would make a noble picture, and I think I ought to paint it as a companion subject to my *Dante's Dream*. I suppose the omnivorous French School must have nobbled it somewhere, but don't remember to have seen it done."[19]

Dante Gabriel Rossetti never got to this subject, but Delacroix had anticipated him on a Michelangelo subject in his oil painting *Michelangelo in His Studio* (1850, Musée Fabre, Montpellier) and had also written an article on Michelangelo in 1830. In both of these studies by Delacroix, the artist is depicted as

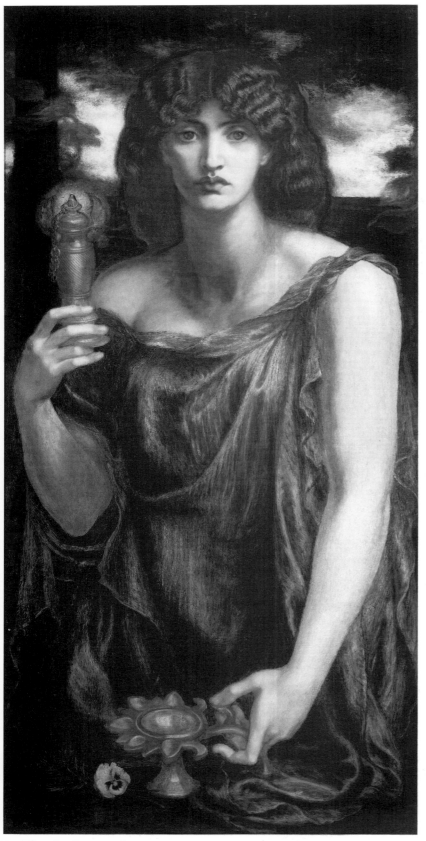

Fig. 8. Dante Gabriel Rossetti. *Mnemosyne*. 1881. Oil on canvas. 49¾″ × 24″. Courtesy of the Delaware Art Museum, Samuel and Mary R. Bancroft Memorial Collection.

a lonely, brooding character, separated from others by divine gifts, much as Delacroix's portrait of his musician friend *Frédéric Chopin* (1838, Louvre, Paris) shows the musician as a tormented genius.

One of the earliest glorifications of the artist was Angelica Kauffman's *Death of Leonardo in the Arms of Francis I* (1778), now lost. Another early artist personified as a hero appeared in Ingres's *Aretino in Tintoretto's Studio* (1815, private collection, Belgium). Later, contemporary artists in their studios became subjects, as in Géricault's *Artist in His Studio* (1818–19, Louvre, Paris) and Vernet's *The Artist's Studio* (ca. 1820, private collection). Even the childhood of great artists was imagined, as in William Dyce's *Titian's First Essay in Color* (1856–57, Aberdeen Art Gallery, Scotland),[20] thus testifying to the Romantic attraction of Continental and Pre-Raphaelite practitioners to the artist as hero.

Another development in both England and France, especially in the second half of the nineteenth century, was the movement of Symbolism in literature and art. In this area there are some very suggestive similarities, which may be coincidental but which present both formal and iconographical correspondences. This can be seen in such works as Dante Gabriel Rossetti's *Bocca Baciata* (1859, Museum of Fine Arts, Boston), echoed in Paul Gauguin's iconic *La Belle Anglaise* (ca. 1889, Musée d'Orsay, Paris). Two works of exactly the same date, *The Days of Creation* (1876, Fogg Art Museum, Harvard), by Edward Burne-Jones, and *The Apparition* (1876, Fogg Art Museum, Harvard), by Gustave Moreau (1821–98), present worlds of fantasy and mysticism. In both artists, there was a similar morbid strain as well as an interest in the femme fatale, as can be seen in Burne-Jones's *The Depths of the Sea* (1887, Fogg Art Museum, Harvard) and Moreau's *The Young Man and Death* (1856, Fogg Art Museum, Harvard). Another similarity—and even heritage—of the Pre-Raphaelites may be found in Rossetti's iconic women looking out at the viewer, as in *Mnemosyne* (1881, Delaware Art Museum, Wilmington, fig. 8), which found counterparts on the Continent in such works of Odilon Redon (1840–1916) as *Silence* (ca. 1911, Museum of Modern Art, New York).

As Susan Casteras chronicles in her essay, one of the influential admirers of Pre-Raphaelite art and literature was Joséphin Péladan (1859–1918), art critic and originator of the five Rose + Croix Salons of 1892–97. Born in Lyons in 1859, the son of the editor of a religious and literary periodical, Joséphin Péladan came to Paris in 1882 to pursue a career as

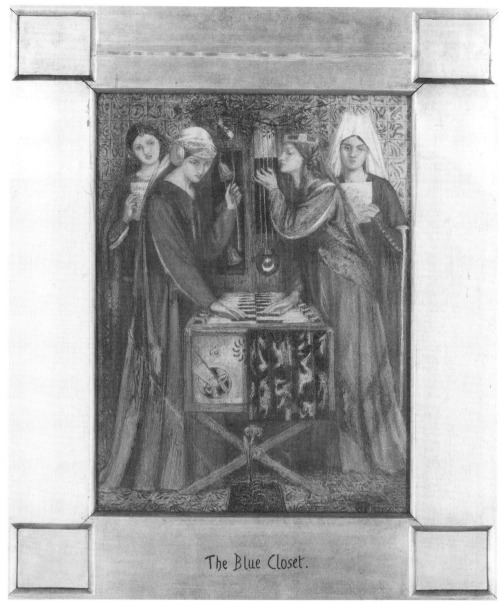

The Blue Closet.

Fig. 9. Dante Gabriel Rossetti. *The Blue Closet.* 1856–57. Watercolor on paper. 13½″ × 9¾″. Courtesy of the Tate Gallery, London.

art critic and author, both of which careers he fulfilled. Like the Pre-Raphaelites, he was a supporter of the art of the Italian Primitives—or painters before Raphael—admiring both their faith and their naïveté as did the English Pre-Raphaelites. In regard to literature, he was drawn to Dante; and therefore, it is not surprising that in May 1887 he wrote five letters to William Rossetti, Dante Gabriel Rossetti's brother, and, after Dante Gabriel's death in 1882, became executor of his estate and copyright holder of his literary rights. Péladan requested permission to publish a French translation of Dante Gabriel Rossetti's sonnet sequence entitled *The House*

of Life, for which he wished to write an introduction. The poems were translated both literally and literarily by Mme Clémence Couve and published as *La Maison de vie* in Paris in 1887. This translation, with Péladan's introduction on the Neoplatonic essence of the Dante-Beatrice relationship, supplied "a growing vogue for things English" in France.[21]

When Péladan launched his "esthetic renaissance" in the first Rose + Croix Salon at Durand-Ruel's gallery on 10 March 1892 (for which 22,600 visiting cards were left),[22] he planned to invite Burne-Jones, Watts, and five other English Pre-Raphaelites to exhibit their works; but none actually participated in

the salons. A number of their imitators in France and Belgium, however—such as Fernand Khnopff, Paul Delville, Carloz Schwabe, and others—exhibited in the Rose + Croix Salons and perpetuated the ideal of late Pre-Raphaelitism in the realms of myth, legend, allegory, and the dream.

One area in which Pre-Raphaelitism was immensely influential was the decorative arts. A motive force came from William Morris's desire for medieval-like furnishings for his new home and his discovery that it was impossible to find what he wanted on the market. This led to the formation, in April 1861, of Morris, Marshall, Faulkner, and Company—usually known as Morris and Company—which included the artists Dante Gabriel Rossetti, Burne-Jones, and Ford Madox Brown, who lent their skills to the designing of furniture, stained glass, tapestry, wallpaper, and other furnishings which decisively changed the taste of the late nineteenth century. A brief suggestion of this influence can be seen in the densely patterned interior of Rossetti's *The Blue Closet* (1856–57, Tate Gallery, London, fig. 9), which found actuality in the wallpaper and fabric designs of William Morris. It may be somewhat fanciful, but it would seem that the repeated designs of Morris's wallpaper and fabrics influenced painting as well, as in the painting by G. Lacombe (1868–1916) entitled *Effect of Waves* (ca. 1894, Musée des Beaux Arts, Rouen), where the froth of the spent wave repeats a brocade-like pattern. Other areas in which Morris and Company was particularly influential were stained-glass decoration and the reformed type in Morris's Kelmscott Press (founded in 1892, for which Burne-Jones did many illustrations, the most famous being for the Kelmscott *Chaucer* of 1896).

The influence of Pre-Raphaelitism as a movement has yet to be definitively charted, in part because it was pervasive in the last decades of the nineteenth century and in the early twentieth century. The cult of the femme fatale was particularly popular. This cult had many sources, but one of the sources was surely Rossetti's beautiful and enigmatic women, as in his *Astarte Syriaca* (1875–77, Manchester City Art Gallery, England), which can be seen echoed in such popular images as Alphonse Mucha's poster advertising Sarah Bernhardt entitled *La Dame aux Camélias* (1898, Museum of Fine Arts, Boston, fig. 10). Dante Gabriel Rossetti's *Lady Lilith* (1868, Delaware Art Museum, Wilmington, fig. 11) in some manifestation seems to have been the inspiration for Louis Rhead's poster for *Prang's Easter Publications* (Museum of Fine Arts, Boston, fig. 12), Paul Berthon's 1900 *L'Hermitage Revue Illustré* adver-

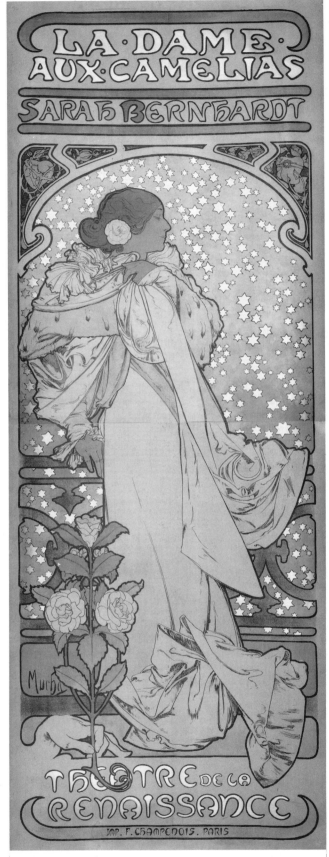

Fig. 10. Alphonse Mucha. *La Dame aux camelias/Sarah Bernhardt.* 1896. Color lithograph poster. 80″ × 29½″. Courtesy of the Museum of Fine Arts, Boston, Gift of Charles Sumner Bird.

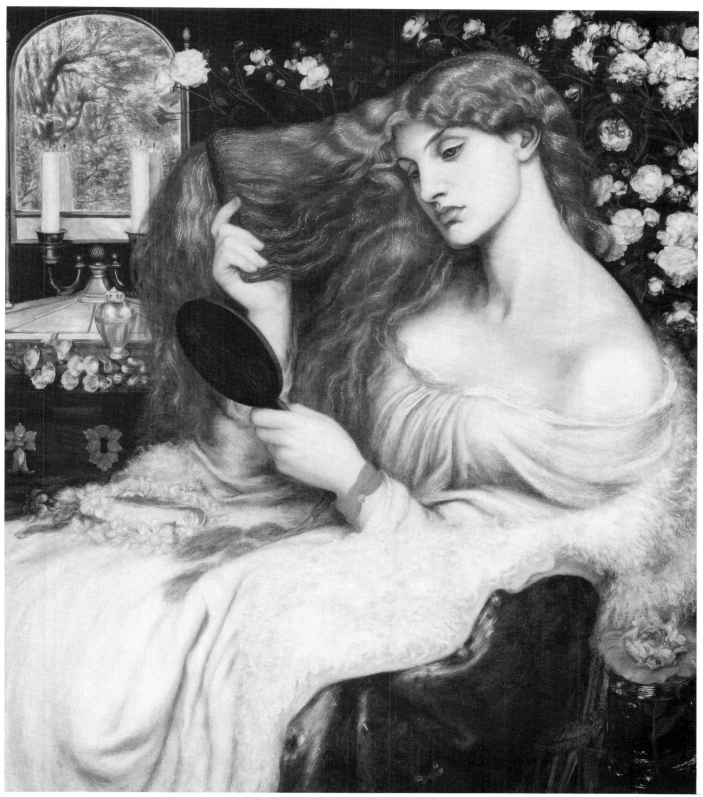

Fig. 11. Dante Gabriel Rossetti. *Lady Lilith*. 1868. Oil on canvas. 38½″ × 33½″. Courtesy of the Delaware Art Museum, Samuel and Mary R. Bancroft Memorial Collection.

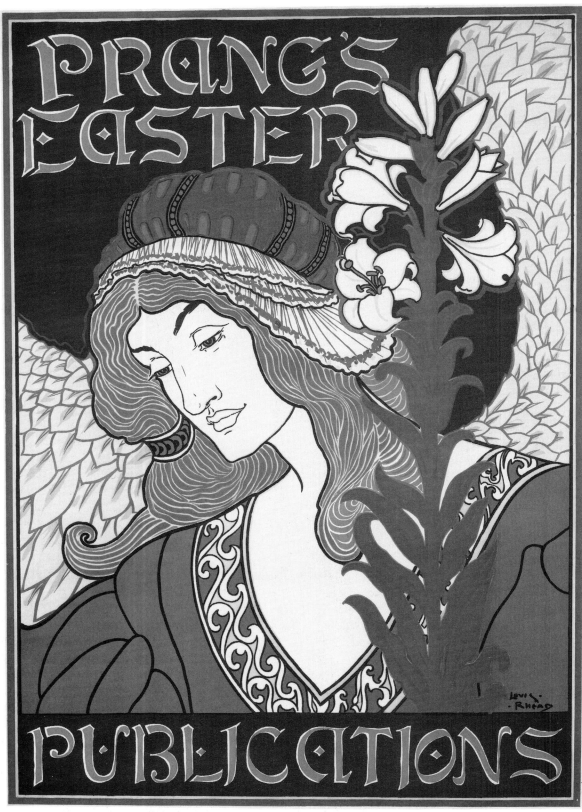

Fig. 12. Louis Rhead. *Prang's Easter Publications*. Lithographic poster. 24″×17″. Courtesy of the Museum of Fine Arts, Boston, Gift of Louis Prang and Company.

tisement, Alphonse Mucha's *Job Cigarette Poster* (1898), and even a toothpaste advertisement by Will Bradley (1868–1902)! The repeated patterned images and the peacock feathers, beloved of Pre-Raphaelitism, can be seen in such popular manifestations as Will Bradley's peacock-embellished Art Nouveau posters.

Many Pre-Raphaelite paintings—especially those of Millais, Hunt, Brown, and, later, Burne-Jones—were seen in the Universal Expositions in Paris in 1855, 1867, 1878, 1889, and 1900. Burne-Jones's paintings were exhibited in the Champs-de-Mars salons throughout the 1890s, while a good portion of Dante Gabriel Rossetti's oeuvre could have been seen by crossing the channel to London in the massive retrospective exhibitions of his work in 1883. Reproductions of Pre-Raphaelite paintings in copper and wood engraving were augmented since the 1870s by the new technology of photography, and such firms as Adolphe Braun of Dornach, Haenfstangl of Munich, C. Dietrich of Brussels—as well as such English firms as the Autotype Company, Frederick Hollyer, and W. A. Mansell—sold photographs of old and contemporary masters. By the 1890s, photographic reproductions of the works of Burne-Jones, Dante Gabriel Rossetti, Hunt, Millais, Watts, Brown, and Simeon Solomon were readily available for purchase from catalogs issued by these photographic companies.

The reach of Pre-Raphaelite imagery to Scandinavia seems extremely unlikely, and yet, Edvard Munch's *The Kiss* (1892, Oslo Kommunes Kunstsamlinger, Sweden) has as its suggested source Rossetti's *The Kiss of Paolo and Francesca* (1855, Tate Gallery, London),[23] which Munch could have seen either in an exhibition of photographs of Dante Gabriel Rossetti's and of Burne-Jones's work shown in Brussels in 1891–92 at the Cercle de l'Art et de la Presse or in illustrations in books and articles on Pre-Raphaelite art in periodicals.

The nineteenth-century area that I have not referred to is Impressionism, because both in appearance and technique Impressionism is so different from Pre-Raphaelite art. In a review of an exhibition, Prosper Mérimée pointed out, "The *exact* imitation of nature, this is the key-note of these innovators. . . . [They] came to protest against academic practices, against theatrical poses, subjects taken from mythology and the imitation of antique statues. They want to take nature as it is. . . . All the artifices that were formerly studied and admired in the masters are repudiated. . . . 'We must,' they say, 'be accurate or perish in the attempt.' Everything

that the eye sees, the hand must reproduce truly, nature can do no wrong, neither can the artist who copies it faithfully. . . . Many of these young artists work out of doors to avoid artificial shadows, they say."[24]

This sounds like a standard criticism of Impressionism, but it was actually published in the *Revue des Deux Mondes* of 15 October 1857, as a result of Mérimée's seeing Pre-Raphaelite paintings in the 1857 Manchester Exhibition. It is also interesting that English writers considered the progressive, new movements of the nineteenth century to be Pre-Raphaelitism and Impressionism—as in the case of W. P. Frith's writing negatively in *Magazine of Art* (1888), under the title "Crazes in Art";[25] but in the case of other writers, such as Bernhard Sickert's "The Pre-Raphaelite and Impressionist Heresies" in the *Burlington Magazine* (1905),[26] there was recognition of both Pre-Raphaelitism and Impressionism as important and interesting avant-garde statements.

Although the outward appearance of Pre-Raphaelite art is very different from Impressionism, both groups employed new techniques, the Impressionists' using complementary colors and optically based effects and the Pre-Raphaelites also espousing complementary hues but brightening their canvases still further by painting on a wet white ground, partially in imitation of early fresco painting. As Mérimée pointed out in an 1857 essay, the Pre-Raphaelites as well as the Impressionists disavowed stilted poses and an academic hierarchy of values in order to faithfully paint what they saw. Both groups painted outdoors—although the minute botanical accuracy of such artists as Hunt and Millais took much longer than the sketchy approximations of the Impressionists—and both were interested in exact effects of light. The two groups saw themselves as avant-garde in opposing the values and techniques of the Royal Academy and the École des Beaux Arts, Paris. As a result, both groups were greatly criticized and held unofficial exhibitions to show their work. Both schools influenced the painting of their day and had many imitators after they became successes. The Pre-Raphaelites dissolved after associating from 1848 to 1857, and the Impressionists after associating from 1874 to 1886.

We have ranged far in our look at Pre-Raphaelite art as a part of European art in general rather than as a specialized English phenomenon. The suggestions for parallels could be duplicated many times over—or improved upon—but they serve the purpose of providing concrete examples of similar concerns, types, and ideas that unite the Pre-

Raphaelites with artists on the Continent. That the Pre-Raphaelites were part of the European artistic continuum—and that they also made influential contributions to movements on the Continent—is the subject of the present volume, *Pre-Raphaelite Art in Its European Context.*

In this book, the essayists will be tracing Pre-Raphaelite artists' use of European artistic and religious traditions, connections of the group and individual artists to the Continent, common themes on both sides of the channel, and Pre-Raphaelite influence abroad, especially in the development of Symbolism and the Rose + Croix Salons. New documentary and artistic material—as well as conceptual reorientation—will be presented, showing the strong links of Pre-Raphaelites to their artistic colleagues on the Continent and the mutuality of many of their concerns and sources. In many ways, Pre-Raphaelitism was a strong and unique movement in art—and will always be seen as such; but in many unrecognized instances, Pre-Raphaelitism was also an international phenomenon that helped to shape such opposite ideals as truth to nature and the imagery of dreams, legends, and fantasy.

It is interesting to observe that Pre-Raphaelite art had its strongest influence abroad after the movement itself in England had ebbed, but there was interest in Pre-Raphaelite art on the Continent since 1855, with several Pre-Raphaelite artists contributing to the 1855 Universal Exposition in Paris. Starting in the 1850s, Continental art critics such as Prosper Mérimée and Fernand Khnopff reviewed a number of Pre-Raphaelite exhibitions in England; and reviews of the annual French Salons were printed in English art journals. The advent of photography as a medium for more accurately reproducing art was used both to disseminate artists' works and to present representations of these works in English and Continental journals. Although many prejudices remained on both sides of the channel, new possibilities for understanding and appreciating English ideals and artistic manifestations especially operated in the 1890s to make Pre-Raphaelite art internationally known and valued. This book contributes to a larger context for understanding Pre-Raphaelite artistic activity and adds a number of new perspectives to our view of the movement.

NOTES

1. Linda Nochlin, *The Politics of Vision: Essays on Nineteenth-Century Art and Society* (New York: Harper & Row, 1989), xiv.

2. Gary Smith, ed., *Benjamin* (Chicago: University of Chicago Press, 1989), 255.

3. Robert Rosenblum, "British Painting vs. Paris," *Partisan Review* 24 (Winter 1957): 95–100.

4. William Holman Hunt, *Pre-Raphaelism and the Pre-Raphaelite Brotherhood* 2 vols. (London: Macmillan, 1905), 1:100–101.

5. Tate Gallery, *The Pre-Raphaelites* (London, 1984), 211.

6. Robin Spencer, "Manet, Rossetti, London and Derby Day," *Burlington Magazine* 133 (April 1991): 228–29, 234.

7. "Pathological Exhibition at the Royal Academy (Noticed by Our Surgical Advisor)" *Punch* 18 (June 1850): 198.

8. S. N. Ghose, *Dante Gabriel Rossetti and Contemporary Criticism,* Folcroft Library Editions (1929; reprint, Folcroft, Penn.: Folcroft Press, 1970), 34.

9. Charles Dickens, "Old Lamps for New," *Household Words* 1 (June 1850): 266.

10. Quoted in George Hamilton, *Manet and His Critics* (New Haven: Yale University Press, 1969), 57.

11. Quoted in Étienne Moreau Nelaton, *Manet raconté par lui-même* 2 vols. (Paris: Laurens, 1:1926), 69.

12. Hamilton, *Manet and His Critics,* 74.

13. Françoise Cachin, *Manet, 1832–1883* (New York: Metropolitan Museum of Art, 1983): 234.

14. *The Journal of Eugène Delacroix,* edited by Hubert Wellington and translated by Lucy Norton (Ithaca: Cornell University Press, 1980), 38.

15. Lee Johnson, *Eugène Delacroix (1798–1863): Paintings, Drawings and Prints from North American Collections* (New York: Metropolitan Museum of Art, 1991), 13.

16. Sarah Symmons, "Flaxman and the Continent," in *John Flaxman, R.A.,* ed. David Bindman (London: Thames & Hudson, 1979), 160–62.

17. Joanna Banham and Jennifer Harris, eds., *William Morris and the Middle Ages* (Manchester, England: Manchester University Press, 1984), 120–21.

18. *Complete Works of John Ruskin,* ed. E. T. Cook and Alexander Wedderburn, 39 vols. (London: George Allen, 1903–12), 3:623–24.

19. *Letters of Dante Gabriel Rossetti,* ed. Oswald Doughty and John Robert Wahl, 4 vols. (Oxford: Clarendon Press, 1967), 3:1136–37).

20. For further information, see Francis Haskell, "The Old Masters in Nineteenth-Century French Painting," *Arts Quarterly* 34 (Fall 1962): 55–85.

21. Robert Pincus-Witten, *Occult Symbolism in France: Joséphin Peladan and the Salons de la Rose + Croix* (New York: Garland Publishing, Inc., 1976), 64.

22. Ibid., 104.

23. Munch Museum, *Edvard Munch, Liebe, Angst, Tod* (Munch Museum, Oslo, 1980), 427.

24. Prosper Mérimée, "Les Beaux-Arts en Angleterre," in *Études Anglo-Americaines* (Paris: Honoré Champion, 1930), 161, 168. Translation is mine.

25. William Powell Frith, "Crazes in Art: Pre-Raphaelism and Impressionism," *The Magazine of Art* 2 (1888): 187–91.

26. Bernhard Sickert, "The Pre-Raphaelite and Impressionist Heresies," *Burlington Magazine* 7 (1905): 97–102.

*Pre-Raphaelite Art in
Its European Context*

Part I
Pre-Raphaelite Influences on European Art and Taste

The Pre-Raphaelite Legacy to Symbolism: Continental Response And Impact on Artists in the Rosicrucian Circle

SUSAN P. CASTERAS

PRE-RAPHAELITE ART, INITIALLY ARRIVING ON THE CONtinent partly in the intellectual wake of John Ruskin's theories, sustained a sizable impact abroad, eliciting more than three decades of critical response, debate, and interpretation by European artists.[1] From the mid-1850s through the 1890s, the reactions of French critics ranged widely, fluctuating between scathing derision to warm acceptance of Pre-Raphaelite paintings and ideals.[2] One of the figures whose remarks spanned much of this period was Ernest Chesneau, who in 1864 wrote *L'art et les artistes modernes en France et en Angleterre*. He is also significant because, like Robert de la Sizeranne and other critics, he actually saw in France many of the expositions and exhibitions in which Pre-Raphaelite works appeared. Over the years, his opinions also underwent some modifications, but his 1864 book enunciated what was to become a standard early criticism of Pre-Raphaelite (allegedly excessive) detail (coupled with a lament that the Pre-Raphaelite Brotherhood seemed unaware of modern French art), nonetheless interfacing this criticism with an appreciation of the group's strong moral sentiment and earnest approach to nature. Beginning in the 1860s (roughly 1864–83), Chesneau corresponded with John Ruskin, whose high esteem for Pre-Raphaelitism the Frenchman absorbed to some degree. During the many years of their letter-writing exchange, Chesneau complimented his English friend's famous writings *The Two Paths* and *Pre-Raphaelitism*, among other books; and Chesneau even tried to persuade Ruskin to allow him to translate the latter's works into French. Ruskin reciprocated this admiration, citing Chesneau's opinions in his terminal lectures at Oxford on the art of England and expressing his faith in Chesneau's judgment at various times in print.[3] Although Ruskin's writings were not translated by Chesneau, the latter's book *The English School of Painting* (with a prefatory endorsement written by Ruskin) was published in 1885 and permitted English readers to judge for themselves this Frenchman's assessment of their native art, including Pre-Raphaelitism. In his text, Chesneau expressed both criticism and approbation, bemoaning the alleged harshness and "barbarity" of Pre-Raphaelite colors, while applauding its "hatred of forms, appearances, and pretences, and . . . noble, passionate love of truth."[4] He also reminded readers that the first Gallic exposure abroad to this radical art had occurred at the Universal Exposition of 1855, which staged the first French exhibition of several paintings by members of the Pre-Raphaelite Brotherhood. For example, Eugène Delacroix himself attended this exhibition and wrote approvingly of a few works, singling out John Everett Millais's *Order of Release, 1746* (1853, Tate Gallery, London, fig. 1) for its exquisitely "truthful understanding . . . so singular in its observation and, above all, in its sentiment."[5] Similarly, the critic for *Athenaeum Français* concurred with Delacroix's high esteem for this work, reiterating how "an astonishing impress of truth" not only "attains the force of the dramatic without seeming to search for it" but also contributes to a paradoxical ideal beauty conveyed by the figures' "truthfulness of expression."[6] Théophile Gautier also mentioned the debut of the Pre-Raphaelites in *L'Artiste*, admitting that he knew virtually nothing of their art but nevertheless stating his belief that they generally displayed unprecedented merit allied to a "most baroque eccentricity."[7] Like other Frenchmen, he, too, was perplexed by the unidealized ultrarealism attempted by Millais and Hunt. Yet, he realized

Fig. 1. John Everett Millais. *The Order of Release, 1746.* 1852–53. Oil on canvas. 40½″ × 29″. Tate Gallery, London.

ages, central to Symbolist preferences for female protagonists floating in a literal or metaphoric state of repose, suspended in a twilight zone of inner vision and sensuality.[11]

Microscopic attention to detail in William Holman Hunt's paintings was simultaneously applauded and castigated as well. Although basically bewildered by Hunt's *The Light of the World* (1851–54, Keble College, Chapel, Oxford), Gautier discerned in Christ's expression "an unctuous melancholy, a sadness full of pity" that was compelling. To Gautier and his fellow critics François Aubert, Paul Mantz, and Henri Viel-Castel, French art had never gone as far as Hunt's works, which preserved "the pious simplicity of Memling, the color of Van Eyck, and the thoroughgoing realism of Holbein."[12] But although innovative, this painting and Hunt's *Claudio and Isabella* (1850, Tate Gallery, London)—and, especially, Hunt's *Our English Coast (Strayed Sheep)* (1852, Tate Gallery, London)—all reinforced French perceptions of Pre-Raphaelitism primarily as a supremely odd phenomenon, original but bizarre. For Gautier, *Strayed Sheep* and its blue shadows (which had amazed Delacroix too) promulgated a particularly disconcerting paradox of realism; since its blades of grass and trees received equal emphasis by the artist, "the painting which seems the most false is precisely the most true."[13]

As has been pointed out, most French critics who saw the 1855 exposition, in general, reacted rather negatively.[14] Théophile Thoré, Charles Blanc, and others deemed the Pre-Raphaelites too photographic, too grossly materialistic, and too brutally raw in their use of color and excessive detail. Chesneau generally seemed quite correct in later maintaining that "whether owing to its novelty, or the surprise it occasioned, or . . . its real merit, most certain it is that the English, until then little thought of and almost unknown abroad, obtained in France a great success" in 1855.[15]

In the late 1850s and 1860s, Gallic reactions to the Brotherhood remained mixed, at times hostile. In 1857, for example, disapproval resurfaced in Prosper Mérimée's comments (subsequently cited by Chesneau) on the great Manchester Art Treasures exhibition and specifically, on Hunt's *Awakening Conscience* (1853–54, Tate Gallery, London, see Faxon, fig. 1) in the *Revue des deux mondes.*[16] Two years later, a *Gazette des Beaux-Arts* London correspondent condescendingly remarked that the Pre-Raphaelite Brotherhood was instilled with "a false notion of art."[17] Tepid, erratic, sometimes biting evaluations of Pre-Raphaelitism as a mostly aberrant

how idiosyncratic Millais's *Order of Release* (to him both "marvelous and repugnant") was in contrast with the mainstream of contemporary art; and he praised the painting's deliberate, if naïve, sincerity, communicated "with the soul and eyes of an artist of the fifteenth century."[8] Millais's *The Return of the Dove to the Ark* (1851, Ashmolean Museum, Oxford) similarly puzzled yet impressed him as a mystical tableau filled with indefatigable detail, while an *Athenaeum Français* reviewer hailed the Van Eyckian scrupulousness and "portrait" of the hay but disliked the severe silhouette effect of the figural group.[9] The last work by Millais displayed in this exposition, *Ophelia* (1851–52, Tate Gallery, London, see Beckwith, fig. 1) provoked a similar lack of consensus. *Ophelia* appealed to Gautier because of its prodigious details inviting closer inspection, but the painting put off some who disparaged the alleged lack of pictorial unity sustained by the virtual botanical effects.[10] Ironically, *Ophelia* proved to be the most iconic and haunting of all Pre-Raphaelite im-

curiosity still prevailed in the 1860s, when Hunt, Millais, and Arthur Hughes sent paintings to another Universal Exposition in 1867. Millais's *Eve of St. Agnes* (1863, Collection of Queen Elizabeth the Queen Mother) drew forth both positive and negative reviews in England and France and later enjoyed the status of becoming somewhat of a cult sensation—in time, arguably, the most renowned Pre-Raphaelite image in France.[18] The poet Arthur Rimbaud praised *The Eve of Saint Agnes* when he saw it in London in 1872–73 (when Paul Verlaine also saw it), and Joris-Karl Huysmans referred to it in his famous 1884 "decadent" novel, *À Rebours (Against the Grain)*.[19] This appeal to Symbolist poets is understandable, given that the subject is, as one French author noted, a dream akin to Edgar Allen Poe's poems—wherein a transfixed and beautiful female somnambulist waits in the eerie moonlight for her beloved to materialize.[20]

By the late 1860s, Chesneau in *Rival Nations of Art*, Philippe Burty in *Gazette des Beaux-Arts*, and others increasingly shifted their focus to a specific member of the Brotherhood, Dante Gabriel Rossetti, whose own brand of Pre-Raphaelitism was less hallucinatory, in terms of hard-edged detail, and much more personal and emotionalized. Rossetti's work was not publicly exhibited in France; but some critics evidently saw his work in England in private collections or read his poetry and, undoubtedly, seized upon him—in part, because of the appeal of his poems.[21] Rossetti's poetry even elicited comparisons with Baudelaire's *Les Fleurs du Mal*—all the more interesting a parallel because Baudelaire himself admired Pre-Raphaelite art.[22] Other developments were witnessed in the 1870s, too, with the next significant exposure of Pre-Raphaelite art made possible at the 1878 Exposition Universelle. Millais and George Frederick Watts (who was often identified with the Pre-Raphaelite circle by Continental critics) sent several works to the exposition, but it was undeniably Edward Burne-Jones whom the French elevated as a singular and major "discovery." Rossetti might have fared well had he participated in this event (indeed, he rarely exhibited even in England); but, instead, his friend Burne-Jones benefited from French appreciation of the feminine beauty, myth, ambiguous meanings, and decorative qualities in his art. Of the three pictures that he submitted, *Merlin and Vivien*, now entitled *The Beguiling of Merlin* (1873–77, Lady Lever Art Gallery, Port Sunlight, see Denney, fig. 2) garnered him the most attention from Edmund Duranty and other critics.[23] In his review, Duranty dubbed Burne-Jones as the leader of

what he termed the "new" Pre-Raphaelites in this position; and to this promising category, Duranty added Watts, Spencer Stanhope, Marie Spartali Stillman, and John Melhuish Strudwick. His enthusiasm was echoed by Charles Blanc, who had seen the 1867 Universal Exposition and was moved to exclaim eleven years later, "To my sense the most astonishing painting we can see from London is Burne-Jones's *Merlin and Vivien*. There is a quintessence of the ideal and a sublime poetry that touches me to the very core."[24]

In the 1880s, the ascendancy of Pre-Raphaelitism solidified, concomitant with the rise of the reputations in France of Burne-Jones and Rossetti; and both became the most publicly venerated British artists and forerunners of Symbolism.[25] In 1882, e.g., Georges Petit included three Millais portraits and, the next year, several works by Watts in his Paris gallery of the same name. Count Robert de Montesquieu—soon to be immortalized in *À Rebours*—visited this exhibition and in 1884 traveled to London and saw Pre-Raphaelite paintings. Also in attendance at the Petit Gallery was Huysmans himself, who canonized a painting by Watts in his renowned novel, thus forging an immediate and indelible connection between the so-called second generation Pre-Raphaelites and the literary Symbolists. The year 1884 also marked a notable increase in favorable press abroad about the Pre-Raphaelites. Even before Jean Moréas issued his manifesto of Symbolism in *Le Figaro* in 1886, analogies were being drawn by French critics between the Pre-Raphaelite Brotherhood and artists such as Gustave Moreau, whose *Salome* (1877, Louvre, Paris) inspired Huysman's often-quoted passage about female seduction and monstrous beauty.[26] Paul Duranty had already noted a link between the aesthetic, ideal, and poetic spirit of Burne-Jones and "the complications of the imagination of Gustave Moreau," responding in part to works by Burne-Jones that were on view at the radical Grosvenor Gallery in London.[27] Moreau knew Burne-Jones's address and owned a reproduction of his *Days of Creation* (1876, Fogg Art Museum, Harvard); and, as has been pointed out, both men shared a nostalgic preference for literary or legendary themes evoking a mystical golden age.[28] Each also excelled at portraying rather inert figures in a rarefied, cryptic realm that was highly decorative as well as almost magically enchanted—qualities evident, for example, in a comparison of Moreau's *St. Elizabeth of Hungary or the Miracle of the Roses* (1879, Barry Friedman Ltd., New York, fig. 2) with Burne-Jones's *King Cophetua*

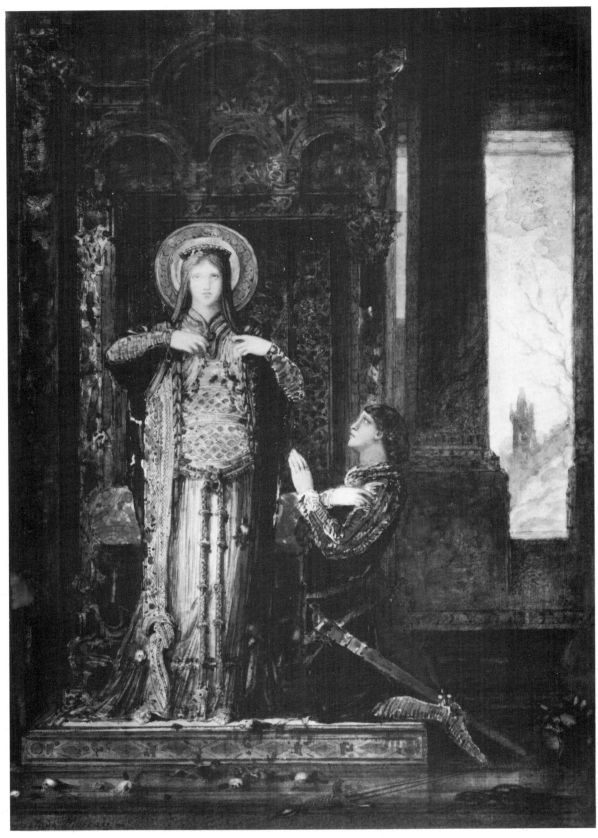

Fig. 2. Gustave Moreau, *St. Elizabeth of Hungary or the Miracle of the Rose.* 1879. Watercolor, heightened with gilt. 10½″ × 7½″. Courtesy of Barrry Friedman, Ltd., New York.

and the Beggar Maid (1884, Tate Gallery, London, see fig. 4).[29] Other visual affinities exist, for example, between Moreau's watercolor Sappho (ca. 1884, Victoria and Albert Museum, London) and Burne-Jones's Psyche and Pan (1869–74, Fogg Art Museum, Harvard) or his Rock of Doom (1886–87, Staatsgallerie, Stuttgart). To Wilfred Meynell, writing in 1887 in The Modern School of Art, the two artists shared "a peculiar melancholy" and sense of fantasy, along with a deep appreciation of Renaissance art and quattrocento ideals.[30] Moreover, in the 1880s Burne-Jones, like Moreau and Rossetti, enjoyed some approval and tribute from French poets: for example, in 1887, Jean Lorraine published a work called "Printemps mystique" which was inspired by Burne-Jones's art.[31.]

The decade of the 1880s also witnessed the rise of the occult figure Joséphin Péladan, a salon reviewer and writer who had praised Moreau as well as the Pre-Raphaelite Brotherhood and who produced his own literary periodical prior to establishing a modern aesthetic Rosicrucian society for artists in 1891. By the mid-1880s, the adulation of Rossetti (who died in 1882) seemed to reach new heights. Both Chesneau's book and Édouard Rod's two articles in Gazette des Beaux-Arts (which was frequently supportive of English art) were turning points in 1887, especially in the overt homage that they paid to Rossetti's paintings. Chesneau, who had written to Rossetti that he was working on a book entitled History of the Pre-Raphaelite School in England (apparently never published), claimed that Rossetti had sent him a list of his works just prior to his death. Among the pictures heralded by Chesneau, Rod, and many others were Beata Beatrix (1864, Tate Gallery, London, see Faxon, fig. 5) and Sibylla Palmifera (1866–70, Lady Lever Art Gallery, Port Sunlight), the former typically interpreted as both a portrait of a Dantean heroine and as a memorial to Rossetti's deceased wife Elizabeth Siddal. The rapt state of spiritual transfiguration had obvious appeal to Symbolists, and one author reckoned that at least five hundred people had reproductions on their walls of this work (and of Burne-Jones's St. Cecilia and Moreau's Salome).[32] Fernand Khnopff even compared Beata Beatrix with Edgar Allan Poe's "Oval Portrait," a poem about an object that embodied a magical correspondence between a painted image and its real-life sitter.[33] Also popular were Rossetti's Lady Lilith (1868, Delaware Art Museum, Wilmington, see Faxon, fig. 11) and La Ghirlandata (1873, Guildhall Art Gallery, London), the latter often praised by reviewers for its emotive musicality and arrested

motion reminiscent of Moreau's paintings. Rod asserted that these works all generated a visionary quality, and his description seemed prophetic of other Symbolist works influenced by Pre-Raphaelite example: "These figures have an immobility, a silence, a pose almost suspended, a slow hesitation in their rare movements, which make them resemble something like sleepwalkers."[34]

In 1891, Péladan issued a doctrine to accompany the secret society or mystic order of the Rose + Croix that he founded. This rather rhapsodical document, widely circulated in Paris, included articles of faith proclaiming the group as a consecrated brotherhood of sorts à la Pre-Raphaelite. Rather like its Pre-Raphaelite progenitor, members were to be referred to by the abbreviated initials "artistes R + C."[35] Like their British counterpart, they too denounced official art; revolted against prosaic history painting, banal genre themes, and anecdotalism; and tried to reform current taste towards a more intellectual, idéaliste bent. Péladan went so far as to proclaim his intention to "go to London to invite Burne-Jones, Watts, and five other Pre-Raphaelites," but this affiliation and meeting never materialized.[36] Burne-Jones declined because he was preoccupied with getting King Cophetua and the Beggar Maid ready for the 1889 Exposition Universelle, where the painting earned accolades from Khnopff as well as the award by the French government of the coveted cross of the Légion d'Honneur. Burne-Jones might also have been persuaded by others (possibly even Puvis de Chavannes) to shun the Rose + Croix in favor of more official exhibition opportunities.[37] He certainly told Watts that he deemed Péladan's Roscrucian creed to be a "disgracefully silly manifesto."[38] Despite the nonparticipation of the Pre-Raphaelite Brotherhood, the first Rosicrucian salon (which ended in 1896) nonetheless took place in March 1892 at Durand-Ruel's gallery and was attended by more than twenty thousand visitors. In early 1892, a writer for the Magazine of Art took note of the self-styled "Rosy + Cross" phenomenon, comparing it with the English group (and also chastizing it for being childishly secretive): "As the Brotherhood was a protest against the inanities, conventions, and the generalisations of the day, and braved ridicule in carrying out its tenets of 'sincerity,' so the new Rosicrucians exist to proclaim by the work of their hand against the triumph of brushwork and the excess of realism. To them, technique or excellence of execution is no longer paramount; Religious Fervour and the 'Beautiful' are what they care for."[39] Indeed, Sâr (or Chief) Péladan himself placed the love of ideal beauty, the

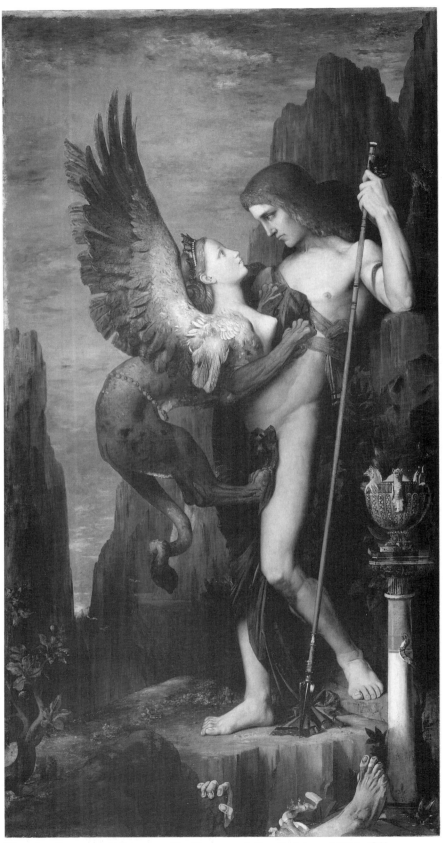

Fig. 3. Gustave Moreau. *Oedipus and the Sphinx*. 1864. Oil on canvas. 81¼″ × 41¼″. Museum of Art, New York. Bequest of William H. Herriman, 1921.

"ruin of realism," and the search for the soulful and spiritual in art among the society's signal goals, repeating at least in part some of the aesthetic signal goals communicated by Burne-Jones's canvases.

In his 1894 edict *L'art idéaliste et mystique*, Péladan enunciated what amounted to almost a worship of Dantean themes, thereby aligning his interests with some of Rossetti's subjects. In addition, like other critics, Péladan believed that sublime affinities existed between the intense imagery of Burne-Jones and Moreau, who had seen the 1855 exhibition and the Galerie Anglaise in 1867. To Péladan, e.g., the prepossessing cabalistic character of the sphinx was one of the most perfect Symbolist emblems of androgyny and enigma. Not surprisingly, this creature appeared, for example, in Moreau's salon entry *Oedipus and the Sphinx* (Metropolitan Museum of Art, New York, fig. 3), (described by one critic as having been painted by a Pre-Raphaelite sympathizer) as well as in Rossetti's drawing entitled *The Question* (1865, Birmingham City Museums and Art Gallery, England). This motif, in fact, became increasingly epidemic in Symbolist vocabulary. Fernand Khnopff's celebrated *Art, the Caress or the Sphinx* (1896, Royaux Musées des Beaux-Arts de Belgique, Brussels), for example, seen in London the next year, was clearly indebted to Burne-Jones's facial types. The subtle "correspondences" among the art of Khnopff, Rossetti, and Burne-Jones had actually been suggested by Walter Shaw Sparrow in an 1890 *Magazine of Art* article that cited *Caress or the Sphinx* as proof not only of Khnopff's empathy with Péladan's occultism but also of his pictorial distillation of Rossetti's art as well.[40]

Following the establishment of the Rose + Croix salons in 1892, a noteworthy essay by Robert de la Sizeranne (who, like Chesneau, had personally seen a lot of Pre-Raphaelite art at earlier exhibitions) appeared that year in *Le Correspondant*. A frequent visitor (like Khnopff) to Burne-Jones's private home (the Grange), Sizeranne was clearly an advocate of Pre-Raphaelism and maintained that reproductions of Burne-Jones's pictures were commonly "in the possession of most Parisian amateurs and writers."[41] Sizeranne also wrote at some length about the kindred traits of the Pre-Raphaelites and the Rosicrucians, emphasizing both groups' common goal of revitalizing art with serious subjects and of trying to discover eternal symbols behind everyday—even fleeting or intangible—appearances.[42] Like other French critics, he, too, thought that Puvis de Chavannes (who disavowed association with the Rose + Croix) best deserved the sobriquet of the "French Burne-Jones."[43] While subtle, a latent affinity is perhaps evident in a comparison of works such as Puvis's *The Poet's Complaint* (1870–80, Louvre, Paris) or his *Pastoral Poetry* (1896, private collection) with Burne-Jones's *Annunciation* (1879, Lady Lever Art Gallery), in which elongated, mannered, dreamy figures are immersed in a beautiful, hieratic world. In reality, Puvis admired Burne-Jones's *King Cophetua and the Beggar Maid;* and the two men corresponded, although they never seem to have met. Like Moreau, Puvis had also seen the 1855 and 1867 displays of English art; perhaps at the former occasion Millais's *Return of the Dove to the Ark* influenced Puvis's own 1871 version of a young female with a symbolic bird, *The Carrier Pigeon* (1871, private collection).

Ultimately, however, in his 1892 article and in his 1895 book *English Contemporary Painting 1844–1894*, Sizeranne queried whether the members of the Rose + Croix could ever exercise as powerful a role in French art as their colleagues had in England, mainly because the Pre-Raphaelite had engendered a revolution in both content and technique. Nor did the Symbolist group seem to him to have the same fervid moralizing force: they were more an offshoot of a literary movement.[44] As a result, Sizeranne lamented that "our Rose + Croix want to be Pre-Raphaelites; they will only be aesthetes."[45]

Sizeranne, too, ranked Rossetti, Burne-Jones, and Watts as the preeminent disseminators of a new art; and, like Rod and Chesneau, Sizeranne concurred with the general critical opinion that Burne-Jones was the reigning English genius, particularly as exhibited in works such as *Love Among the Ruins* (1870–71, Wightwick Manor Collection, Wolverhampton), shown at the 1878 Universal Exposition, and *Laus Veneris* (1873–75, Laing Art Gallery, Newcastle upon Tyne). But it was Burne-Jones's *Merlin and Vivien (The Beguiling of Merlin)*[46] (often exhibited in London as well as abroad) that was the star, a painting that spawned such visual progeny as Khnopff's *Vivien* (1896, private collection), which conflates a Rossettian femme fatale with flame-colored hair with the writhing torso and malevolent energy of Burne-Jones's canvas (which Khnopff saw in 1878).

Burne-Jones's *King Cophetua* (1884, Tate Gallery, London, fig. 4) arguably exerted an even greater influence at the 1889 Universal Exposition. Khnopff, for whom Burne-Jones's work hovered on "the threshold of the Absolute," wrote in *The Magazine of Art* (1898) that he personally contemplated this canvas for hours, "enwrapped in an atmosphere

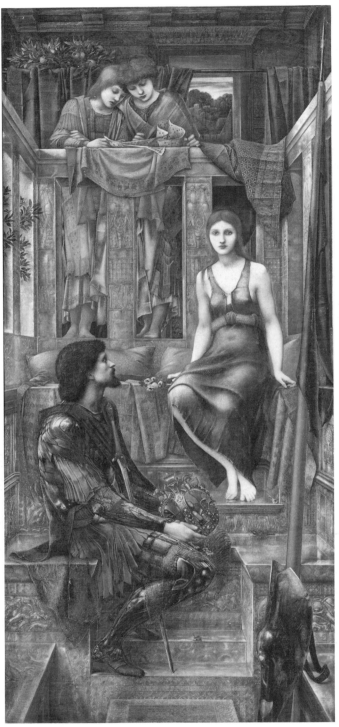

Fig. 4. Edward Burne-Jones. *King Cophetua and the Beggar Maid*. 1884. Oil on canvas. 115½″ × 53½″. Tate Gallery, London.

of dream . . . carried away to an intoxicating level of the soul."[47] Khnopff's comment about Burne-Jones's motionless figures isolated in self-absorbed reveries was an apt assessment of much of his own art of this period, too. Similarly, Burne-Jones's *Perseus* series (1868–88, Southampton Art Gallery, England, and Staatsgallerie, Stuttgart, Germany) caused aesthetes to swoon, stimulating a two-part exegesis from Paul Leprieur in the *Gazette des Beaux-Arts* (1892–93). The *Briar Rose* series (1870–90, Faringdon Collection Trust, Buscot Park) triggered a kindred reaction, with the Vicomte de Vogue among those smitten by the enchanted, esoteric atmosphere that Burne-Jones had created. Much as the *Perseus* series opened French artists' eyes, so, too, did the *Briar Rose* panel depicting the slumbering princess, which moved the viscount to write, "I shall never forget the deep impression made on men, not only by the work itself, but by the attitude of the public who crowded to see it . . . waiting till the picture had delivered its message, and then carefully carrying away its revelation." This series served a metonymic purpose as well, for it seemed to the viscount that Burne-Jones himself had "slept in the depths of some enchanted places, preserving through his slumbers all the exquisite and primitive refinement of the Tuscan painters."[48]

Numerous participants in the Rosicrucian salons, which lasted from 1892–97, were also clearly inspired by the Pre-Raphaelite Brotherhood, in general, and by Burne-Jones and Rossetti, in particular. An extensive study of those who exhibited at the Rosicrucian salons would undoubtedly yield many examples, but a few salient ones are sufficient to cite here. Among the artists who experimented with Pre-Raphaelite style and motifs was Edmond Aman-Jean, who worked with Puvis de Chavannes and was invited to join the Rose + Croix in 1892–93. His poster for one of the salons utilized the Rossettian subject of Dante's Beatrice; Aman-Jean was familiar with Rossetti's work and was known to have admired Burne-Jones, too. A writer for *The Magazine of Art* pronounced Aman-Jean "an apostle of the modern diaphonous movement," adding that "it is clear that the English Pre-Raphaelite school has influenced him."[49] Aman-Jean's *Beneath the Flowers* (1897, Bibliothèque Nationale, Paris), for example, a lithograph with a close-up format of an alluring but listless woman interacting with flowers and the spectator, echoes Rossetti's *Fair Rosamund* (1861, National Museum of Wales, Cardiff) and sundry other "bower pictures."[50] Other seemingly inert, withdrawn, mysterious women isolated amid flowers recur in Aman-Jean's *Seated, Pensive Woman* (private collection), which evokes comparison with Rossetti's drawing of *Reverie* (1868, private collection) or his *La Pia de'Tolomei* (1868–80, University of Kansas Museum of Art, Lawrence, fig. 5). The luxuriant tresses, sym-

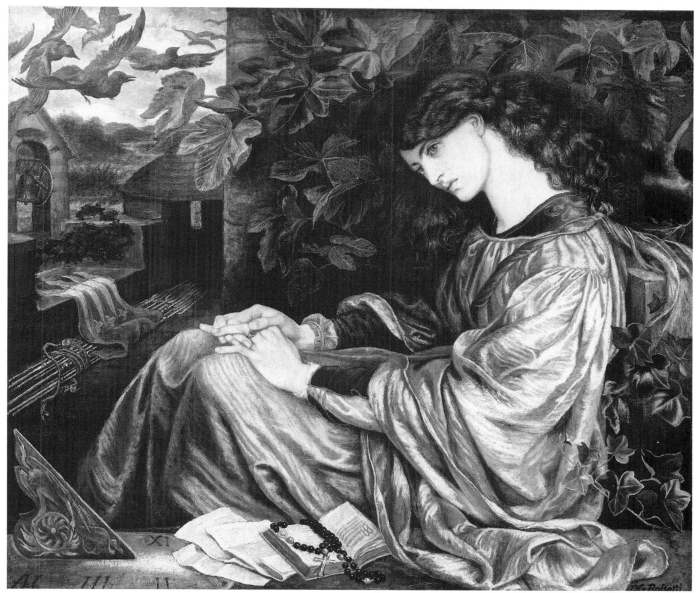

Fig. 5. Dante Gabriel Rossetti. *La Pia de'Tolomei*.
1868–70. Oil on canvas. 41½″ × 47½″. Spencer Museum of
Art, University of Kansas.

bolic blossoms, and even the close-up frontality and
shallow niche characteristic of many bower paintings
by Rossetti were also recast in other Symbolist works
such as Khnopff's *Study of a Woman* (1890–92, Col-
lection of Mme. de Jardin). The latter might, in turn,
be compared to Rossetti's portrait of Jane Morris in
Aurea Catena (ca. 1868, Fogg Art Museum, Har-
vard), in which a dark-haired female, in a somewhat
convoluted pose, similarly beckons from a confined
space. Additional signs of Khnopff's indebtedness to
Rossettian types are evident in Khnopff's *Necklace
of Medallions* (1899, private collection), which, like
Rossetti's *Regina Cordium* (1866, Glasgow Art Gal-

lery and Museum), features a staring, phlegmatic
female holding emblematic blossoms. Ultimately,
Khnopff focused more and more on the face of the
female, flattening and abstracting elements of the
figure, flowers, and niche to a point of compressed
intimacy and confrontation conveyed succinctly as
well even in *Mihi* (ca. 1892, fig. 6), one of his book-
plates.

Another Rosicrucian devotee, German-born Car-
loz Schwabe, produced a propagandistic poster (ca.
1892, private collection, fig. 7) for the Rose + Croix
opening that seems decidedly Pre-Raphaelite in
spirit:[51] the drawing style and overall composition

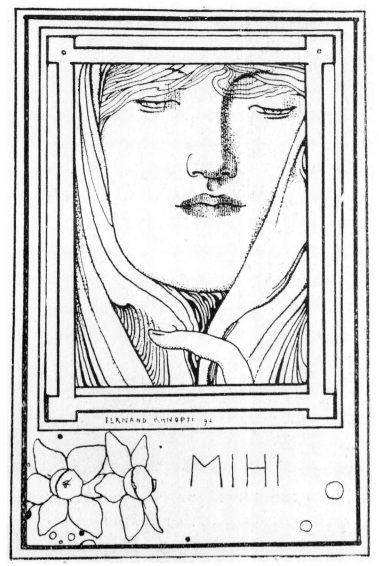

Fig. 6. Fernand Khnopff. *Mihi*. ca. 1892. Bookplate. 2″ × 3¼″. Photography courtesy of the Yale Center for British Art.

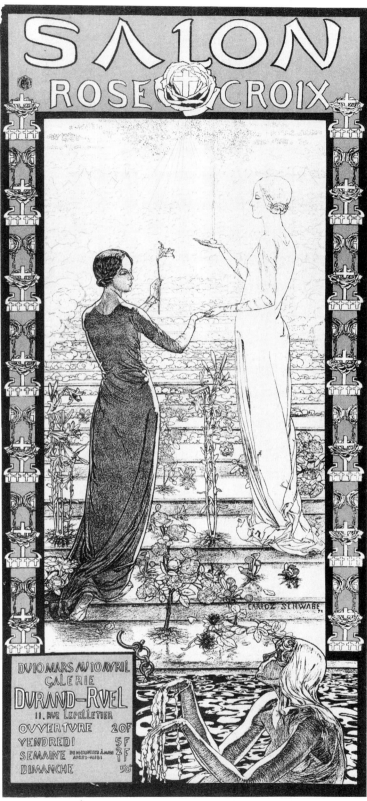

Fig. 7. Carloz Schwabe. Poster for *Opening of the Rose + Croix Salon*. ca. 1892. 7½″ × 14″. Private collection.

appear inspired, for example, by Millais's *Garden Scene* (1849, private collection), Schwabe having retained the female-plus-floral-environment formula while exchanging Millais's border of innocent daisies for one appropriately consisting of roses and crosses. Even Schwabe's later works, such as his pastel *Silence Intérieur* (1908, Barry Friedman, Ltd., New York), are imbued with the introspective ambiguity and isolation of Pre-Raphaelite examples by Burne-Jones and Rossetti. Armand Point, who emerged as a French Pre-Raphaelite after a trip to Italy in 1894 and who later established a William Morris–like decorative-arts workshop, also produced delicate drawings indebted to Pre-Raphaelitism. *The Eternal Chimera* (ca. 1895, private collection), like Burne-

Jones's 1863 illustration for "Summer Snow" in *Good Words* that year, immures a female protagonist in a kind of *hortus conclusus*, or garden of feminine virtue. Similarly, his drawing *St. Cécile* (1896, Barry Friedman, Ltd., New York, fig. 8) recalls the exquisite lassitude, expressionlessness, and suspended motion of works like Arthur Hughes's drawing *My Beautiful Lady* (date unknown, Huntington Art Gallery, San Marino). Moreover, like Burne-Jones, Point was fascinated by Renaissance art, especially works by Leonardo to Botticelli, and this Italianate influence subtly permeates his draughtsmanship.

Another artist who might be mentioned is Edgar Maxence, one of Moreau's pupils who briefly joined in the Rose + Croix venture by exhibiting with the Rose-Croix in 1895–97. Although subsequently better known for his biblical subjects, Maxence's oil on panel entitled *In the Orchard* (1900, location unknown) is yet another work that can be valorized within the largely Rossettian context of intimate (even voyeuristic) glimpses of pensive women amid flowers: the immersion of Maxence's female subject among tree branches compositionally as well as psychologically allies his subject with works like Rossetti's *Hanging the Mistletoe* (1860–61, location unknown) or *The Day Dream (Monna Primavera)* (1880, Victoria and Albert Museum, London); yet Maxence's female—with her Burne-Jonesian, even Mona Lisa–like, expression—presents a daring anomaly, for she holds a lit cigarette in one hand as she poses against a foliate backdrop. Nonetheless, with this kind of female icon, both Pre-Raphaelite and Symbolist artists seemed increasingly vulnerable to criticism. Even in its heyday (in various media, especially posters), this image of a fragile, reflective woman juxtaposed with flowers was ridiculed. In England, *Punch* lampooned the female aesthete; and in the popular French press, her counterpart in the 1890s was also a target—exacerbated, in part, by Octave Mirbeau's 1895 article in *Le Journal* mocking English and French Pre-Raphaelites: "See in this precious flower the symbol of an entire aesthetic. Ah! their princesses with lanky bodies and faces like poisonous flowers—who pass on cloud-like stairs to banks of silly moons."[52]

Other compelling juxtapositions of Rosicrucian works with Pre-Raphaelite prototypes exist, and additional interconnections merit an entire book. But in this essay, a final examination of the most persuasive affirmation of the impact of the Pre-Raphaelite Brotherhood on Symbolist art can be gauged in the art of Khnopff, who exhibited with the Rose + Croix and with other avant-garde associations.[53] By 1890,

Fig. 8. Armand Point. *Saint Cecilia*. 1896. Pencil on charcoal, heightened with white on paper. 73″ × 27⅜″. Courtesy of Barry Friedman, Ltd., New York.

Khnopff's art was brought to the attention of English readers by Walter Shaw Sparrow, who discerned the correspondences between this artist's work and that of Rossetti and Burne-Jones. *The Belgian News* also noticed that Khnopff seems to have "followed in the paths trodden by Burne-Jones and Ford Madox Brown," pointing out how he had been inspired particularly by Burne-Jones's decorative effects.[54] Indeed, Khnopff was a devoted Anglophile whose works were frequently shown in London; and in 1894, he commenced his term as a prolific correspondent for *The Studio*. He also sporadically contributed to other periodicals and owned an extensive private library of English art books. More importantly, Khnopff personally befriended the most celebrated artists of the period—Sir Edward Burne-Jones, Ford Madox Brown, George Frederick Watts, and Val Prinsep, as well as Lord Frederic Leighton and Lawrence Alma-Tadema. Even more persuasively, throughout Khnopff's oeuvre there is continual evidence of his adaptation of the Pre-Raphaelite ideal female, a subject that bordered on near-obsession in his case, as it had—for other reasons—in Rossetti's.[55]

Khnopff's clearest visual debts were to Rossetti as well as to Burne-Jones, whose home he frequented

and with whom he occasionally exchanged drawings.[56] For example, in 1890, Burne-Jones inscribed to Khnopff a drawing of a head of a female; while in ca. 1896, Khnopff gave Burne-Jones a study of a woman (the latter had a prominent place in Khnopff's studio, near the portrait of his beloved sister Marguerite). Khnopff was inspired by Burne-Jones's androgynous facial type—squarish forehead, fixed gaze, somewhat masculinized features—and by the softly descriptive style in which he rendered visages. This blurred sexuality and the sfumato effects in eyes, mouths, and faces are reflected in Khnopff's own handling in works like *Étude de Femme* (ca. 1887, Barry Friedman, Ltd., New York) and *Ygraine à la Porte* (1898, Barry Friedman Ltd., New York), to name only two examples. In addition, Khnopff's English-titled *Memories (The Lawn Tennis Party)* (1889, Royaux Musées des Beaux-Arts de Belgique, Brussels, fig. 9) partly derives from a Burne-Jonesian aesthetic: each figure in this human chain is curiously isolated, a variation on one model—namely, the artist's sister. Perhaps, as has been suggested, *Memories* was intended as a horizontal homage to Burne-Jones's vertical *Golden Stairs* (1880, Tate Gallery, London).[57] In fact, Khnopff's own description of *The*

Fig. 9. Fernand Khnopff. *Memories (The Lawn Tennis Party)*. 1889. Pastel. 50″ × 78¾″. Royaux Musées des Beaux-Arts de Belgique, Brussels.

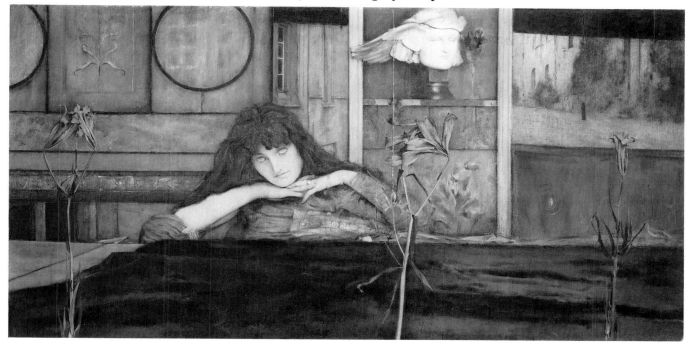

Fig. 10. Fernand Khnopff. *I Lock My Door Upon Myself.* 1891. Oil on canvas. 28¾″ × 54¼″. Neue Pinakothek, Munich.

Golden Stairs as "an array of our most tender and precious memories in the progress of life" also applies to his own pursuit of ambiguity in art and reinforces the common efforts of Khnopff and Burne-Jones to render "memories of the astral life . . . mirages from the dream-life."[58] The format and mood of *Golden Stairs* are also reminiscent of Rossetti's provocative depictions of soulful multiples in works like his chalk version of *Rose Triplex* (1867, Tate Gallery, London) or his *The Bower Meadow* (1850–72, Manchester City Art Gallery, England). As in *The Golden Stairs*, the static movement and lyrical insularity of *Memories*—what Shaw Sparrow called "a hush, an hour of dreaminess" generated by the females—may also owe something to Burne-Jones's *The Mill* (1870, Victoria and Albert Museum, London), with its friezelike order, allegorical underpinnings, and timeless aura.

While Khnopff may have assimilated a Whistlerian influence as well, his *Silence* (1890, Royaux Musées des Beaux-Arts de Belgique, Brussels) not only evokes Whistler's *Symphony in White, No. 1: The White Girl* (1862–82, Freer Art Gallery, Washington, D.C.)—itself steeped in the Rossettian tradition—but also Rossetti's elongated, inscrutable, motionless figures in *Maids of Elfen-Mere* (pen and ink drawing, 1855, Yale Center for British Art). On the other hand, works by Khnopff such as *Britomart* (1892,

private collection) seem to adapt the tall and narrow format, bewitched hair, and slightly closed eyes prefigured in Rossetti's *Damsel of the San Grael* (1857, Tate Gallery, London) and to mingle these elements with a Burne-Jonesian look evident in *St. George* (H.R.H. Princess Ludwig of Hesse and the Rhine) and other images.

Khnopff's *I Lock My Door upon Myself* (1891, Neue Pinakothek, Munich, fig. 10) was criticized by some reviewers for being too Pre-Raphaelite when shown at Les XX in Brussels in 1892 (when Ford Madox Brown also exhibited with this group).[59] The English title was derived from lines in the poem "Who shall deliver me?" by Christina Rossetti, but the figure type—a solitary, brooding beauty with partly lowered eyes and an alienating, willful persona—is one made famous by her brother. The painting was exhibited at the Rose + Croix in 1893, and its enervated protagonist was hailed as "La Lady." The woman's semilowered eyelids, massive hair, withdrawn mood, and hermetic interior all drew upon Rossettian prototypes—e.g., *Pandora* (1879 version, Fogg Art Museum, Harvard), in which Jane Morris's crane neck, beetle brow, and crinkly hair are idealized. Both Khnopff and Rossetti selected as models women who complied with their preconceived notions of feminine pulchritude—Khnopff choosing his sister, Rossetti his paramour.[60] As if to

add a reference to Burne-Jones, Khnopff placed in the background of his composition a crystalline orb akin to one in *The Days of Creation* (Fogg Art Museum) series; while the two-dimensional clutter of objects behind Khnopff's strangely inaccessible female belongs with Rossetti's endless procession of hermetic woman-in-a-niche pictures with their indolent, almost drugged, occupants.

Curiously, the same Christina Rossetti poem inspired Khnopff's *Who Shall Deliver Me?* (1891, Nourhan Manoukian Collection, Paris), which, in turn, has a striking kinship with Rossetti's fallen-woman picture entitled *Found* (1853, Delaware Art Museum, Wilmington, see Faxon fig. 2), well-known in the mid-nineteenth century despite its unfinished state. A red-haired protagonist, urban backdrop with a brick wall, and gutter are common elements, although Khnopff's creature is confrontational, seemingly light years apart from the averted glance and posture of shame borne by Rossetti's bedraggled streetwalker. Both also wear wilted flowers—Khnopff's in her hair, Rossetti's on her dress—as an emblem of defloration. Yet Khnopff's creature is more seer than harlot, her eyes—like her curious brooch—projecting an infinite void, inviting viewers to stare into a crystal ball portending future events and omens.

A final example synthesizing Rossettian and other Pre-Raphaelite visual sources is suggested by Khnopff's spellbinding *Head of a Woman* (ca. 1899, private collection), which can be compared with myriad wild-haired—yet oddly aloof—Rossettian stunners. Khnopff's recycling of this kind of haunting, hypnotic figure was noted by Shaw Sparrow as capturing the elusive "heart of womankind—fascinating us at a distance, repelling us on drawing closer, tempting us half-cruelly, half spiritually"[61] Moreover, related permutations appeared in other Rosicrucian works. Jean Delville, who knew Khnopff, was a disciple of Péladan who exhibited at the Rose + Croix in 1892–95. In establishing the Salon d'Art Idéaliste in 1896, Delville openly stated that "in its analogies with the Rose + Croix in Paris and with the Pre-Raphaelite movement in London, this new group attempts to continue the great tradition of idealist art from the ancient masters to contemporary ones."[62] In his *Portrait of Mme Stuart Merrill* (1892, private collection), for example, Delville alludes to Millais's *Bridesmaid* (1851, Fitzwilliam Museum, Cambridge, England) with its eerie frontal pose, magic net of tresses, and open-eyed trance of otherworldliness. Partial inspiration derives as well from the figure in Rossetti's *Beata Beatrix*, universally

adored in Symbolist circles and translated by Delville into a Rossettian mass of hair that functions as a near-parody of electrical force—with a magnetic field of hair, upturned eyes, and mystic triangle all heightening the intensity of the figure's state of psychological stupor and ecstasy. Another spiritual offspring is *Eve* (1896, Michel Perinet Collection, Paris), by Lucien Lévy-Dhurmer, who admired the Pre-Raphaelites and was invited by Péladan to join the Rosicrucians. The siren with entwining locks pictured in *Eve* also reforges the dense foliate background typical of Rossettian icons and retains a smolderingly enigmatic female protagonist.

Not surprisingly, even more malevolent Symbolist manifestations of the femme fatale proliferated—seen frontally and even more transmogrified into a horrifying and deadly incarnation. The omniscient, serenely emotionless temptress surfaced in Khnopff's drawing *The Blood of the Medus* (ca. 1895, Bibliothèque Royale Albert Ier, Brussels), which echoes the Pre-Raphaelite archetype of Rossetti's killer-women, perpetuated as well in Frederick Sandys's *Medusa* (ca. 1875, Victoria and Albert Museum, London), with her stony demeanor, riveting—literally red-eyed—stare, and sinuous hair-cum-snakes.

The Symbolist phenomenon was by no means exclusive to France and Belgium. Ferdinand Hodler from Austria exhibited in Paris in the 1890s and produced paintings like *The Dream* (ca. 1897–1903, private collection), whose serpentine, red-headed woman rapt with blossoms evokes such Pre-Raphaelite predecessors as Rossetti's *Blessed Damozel* (ca. 1875–78, Fogg Art Museum, Harvard). However, the difference in style and tone is obvious, as is the shift in the lower predella which incorporates a languid, nude male who reserves the pose of his Rossettian counterpart while dreaming of a rendezvous with the beloved. Kneeling amid flowers, Hodler's "blessed damozel" embodies the ideal state of dreams for the hallucinating male and, presumably, for the artist as well.

Gustave Klimt—at one point a contributor, like Hodler, to the Vienna Secession (at which Khnopff exhibited as well)—also assimilated both Rossettian and Burne-Jonesian pictorial legacies. Klimt's *Salome* (1909, Galleria d'Arte Moderne, Venice) qualifies partly as a more sinister variation of Rossetti's sexy but soulful women in *The Blue Bower* (1865, Barber Institute of Fine Arts, University of Birmingham, England) and elsewhere. Yet, while Rossetti's embowered beings often seem restrained by walls or barriers in their niches, Klimt's creatures are cap-

tives, literally locked into the surface of the painting, which becomes a gilded tabernacle enshrining both art and life. The resulting claustrophobic backdrop of pattern and ornament also recurs in Klimt's *Kiss* (ca. 1909, Musée d'Art Moderne, Strasbourg). In some respects a descendant of Rossetti's densely packed, almost spaceless, scenes of amorousness, as in *The Wedding of St. George and Princess Sabra* (1857, Tate Gallery, London), Klimt's work nonetheless escalates the tone and stylized composition into a mosaiclike effect. Burne-Jones's pictures also seem to have haunted Klimt, as reflected in Klimt's *Sea Serpents* (1904–7, private collection), which in its vertical format reinterprets the underwater fantasy and threat of feminine seduction communicated by Burne-Jones's *The Depths of the Sea* (1887, Fogg Art Museum, Harvard).

While numerous additional examples by other nineteenth-century artists abound, it is sufficient to conclude by noting that the works by these artists were ironically created at a time when the prestige of Pre-Raphaelitism began to decline to some degree, caused partly by the censure of detractors like Mirbeau and others who in the late 1890s castigated the group and their imagery. One writer, Léon Balzagette, described this demise in his *New Spirit in Artistic, Social, and Religious Life* (1898), complaining that the failure of Pre-Raphaelitism in France could ultimately be ascribed to the malady projected by a glut of female imagery, an allegedly unhealthy penchant for fleshly lips, and a morbid mysticism that proved oppressive, almost nightmarish.[63] As if a harbinger of the death of this influence, Khnopff's *Iris* (1894, Barry Friedman, Ltd., New York, fig. 11) expands the Symbolist interpretation of Millais's *Ophelia* as a beautiful, drowned victim; and Khnopff's painting might be seen as a counterpoint framing the differences between Pre-Raphaelite and Symbolist approaches to the subject. With her closed eyes and long hair, Iris floats in a watery grave in a transcendent state of consciousness, presumably wavering on the edge of a *symboliste* sphere. Gautier's responses to *Ophelia* many years earlier seem oddly relevant for *Iris*, too, for he described this rather erotic vignette as transpiring near a suggestively slippery shore, generating an insular mood and place where "one can only abandon oneself to the stream that calls with its gentle murmur."[64] In his 1888 book on aesthetic decadence, Péladan had maintained that a woman was the most perfect form to convey the palpably real through the paradox of dreams. Indeed, the imagery in his Rosicrucian salons endorsed this belief and almost universally enthroned the female as a seer or even a priestess—an ethereal symbol of the very triumph of dream and mystery over materialism, over the everyday in both life and art, and over the realistic style itself. From a heritage of Pre-Raphaelite icons, the equally esoteric Rosicru-

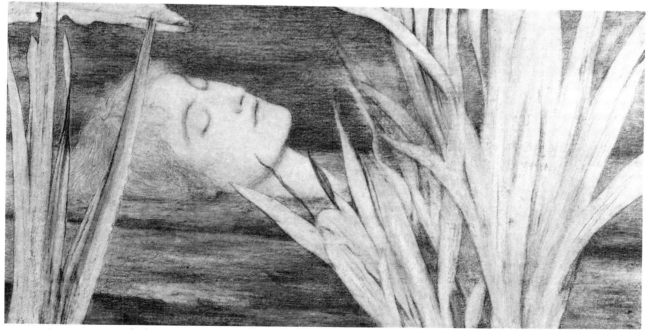

Fig. 11. Fernand Khnopff. *Iris*. 1894. Pencil on tracing paper, laid down and varnished. 4¼″ × 8¼″. Courtesy of Barry Friedman, Ltd., New York.

cians pushed concrete detail to new limits, aspiring to another level of reality and extending the languorous nostalgia of Burne-Jones and Rossetti into a different key of poetic allegory and resonant sensuousness. Rosicrucian images parted company with the chaffing restrictions of morality and storytelling typically inherent in early Pre-Raphaelitism and moved beyond the visible to aim for the transient and unseen, whether emotional, erotic, spiritual, or aesthetic.

In creating their own paradigmatic icons, both Pre-Raphaelite and Symbolist artists evolved rather disturbing—even chilling—notions of the cult of the beautiful. Even more than their predecessors, Symbolist women were simultaneously personified as visionary, overpowering, inscrutable quasidivinities of the canvas as well as enervated, languid, and tantalizing sexual beings. Reigning from their beautifully artificial, escapist realism, it is small wonder that they unnerved Shaw Sparrow, who nonetheless basically approved of the Symbolists' aversion to "the vivisection of naturalism" and search for answers to "the immense algebra" inherent in the problematic "higher" orders of art and representation.[65] Yet, ultimately Sparrow queried whether such an art of anti-reality—peopled almost exclusively by occult sages rather than common laborers (who were disparaged by Péladan as an unworthy subject)—had perhaps gone too far in Khnopff's oeuvre (and presumably in other contemporary artists' output, too). Accordingly, Sparrow urged fin-de-siècle painters not merely to indulge in Symbolist dreams but to "remember our 'strikes' and the life in every alley and street, and the exhaustless source of artistic inspiration that exists in all our individual centres, from the colliery, the shipyards, and the slate-quarry, to the foundry, the forge, and the furnace . . . the art of the religion of daily toil."[66]

NOTES

1. A contemporary overview, "French Criticism on British Art", that dealt with more traditional artists from Reynolds to Elmore (and also included some Pre-Raphaelites) appeared in a series of articles from August through November of 1855 in *The Art-Journal* and was followed by another article in March of the next year. A modern perspective on this phenomenon is provided in Howard D. Rodee, "France and England: Some Mid-Victorian Views of One Another's Painting," *Gazette des Beaux Arts*, 6th ser., 91 (January 1978): 39–48.

2. A useful analysis of part of this period that also includes mention of Pre-Raphaelitism is by Mary Ball Howkins, *The Victorian Example: French Critical Response to Mid-Victorian Paintings in Paris, 1850–1870* (Ph.D. diss., Columbia University, 1985).

3. In his preface to Ernest Chesneau's *The English School of Painting*, trans. Lucy N. Etherington (London: Cassell & Co., Ltd., 1885), e.g., Ruskin described his concurrence with Chesneau's critical judgment "respecting all pieces of art with which we have been alike acquainted" and said his confidence in the Frenchman's "power of analysing the characters of English art least known in France is sufficiently proved by my having commissioned him to write a life of Turner, prefaced by a history of previous landscape" (ix).

4. Ibid., 195.

5. See the entry dated June 17, 1855, in *The Journal of Eugène Delacroix*, trans. Walter Pach (New York: Crown Publishers, 1948), 460.

6. Quoted in "French Criticism on British Art," *Art Journal* 17 (1855): 251.

7. Théophile Gautier, *Les Beaux-Arts en Europe 1855* (Paris: Michel Lévy Frères, 1855, 8.

8. Ibid., 34.

9. For additional reactions, see Comte Henri de Viel-Castel, "Exposition universelle des beaux-arts. Peinture. École anglaise," pts. 1–3, *L'athénaeum français* 4 (June–August 1855): passim.

10. Gautier, *Beaux Arts*, 38.

11. Numerous nineteenth and twentieth century authors, both French and English, have pointed out the appeal of *Ophelia* and of the general link between Pre-Raphaelitism and Symbolism. One of the best articles dealing with this interconnection is by Jacques Lethève, "La Connaissance des peintres pré-raphaélites anglais en France (1855–1900), *Gazette des Beaux-Arts*, 6th ser., 53 (May–June 1959): 315–28. For other modern references to this interconnection, see John Christian, introduction, in *Symbolists and Decadents* (New York: St. Martin's Press, 1978); see also Michael Kotzin, "Pre-Raphaelitism, Ruskinism, and French Symbolism," *Art Journal* 25 (Summer 1966): 347–50.

12. Gautier, *Beaux Arts*, 3.

13. Ibid., 43.

14. Besides the earlier seminal articles already cited, the best current source of information on French reactions in 1855 is Howkins, *Victorian Example*, 110–63.

15. Chesneau, *English School of Painting*, 167.

16. See Prosper Mérimée, "Les Beaux-arts en Angleterr," *Révue des deux mondes* 11 (October 15, 1857).

17. Quoted in Lethève, "La Connaissance des peintres pré-raphaélites anglais en France," 317.

18. This elevated stature for the painting is suggested in Theodore Reff, "Degas's *Tableau de Genre*," *Art Bulletin* 54 (September 1972), 332–37.

19. See Lethève, "La Connaissance des peintres pré-raphaélites anglais en France,", 320–21.

20. Marius Chaumelin, *L'Art contemporaine* (Paris, 1873), 66.

21. See, for example, Olivier Georges Destrées, *Les Pré-raphaélites. Notes sur l'art décoratif et de la peinture en Angleterre* (Paris, n.d.). Other French literary critics who commented on Rossetti's poems include Émile Blémont, Gabriel Sarrazin, and Gabriel Mourey.

22. For comments on Hunt's ardor and Millais's poetic qualities, see Charles-Pierre Baudelaire, "Salon de 1859," *Révue française* 17 (June 10, 1859): 258. One of his compatriots who pointed out a link between Baudelaire's work and Pre-Raphaelite art was Philippe Burty, who frequently reported on Royal Academy shows in the *Gazette des Beaux Arts* in the mid to late 1860s.

23. See, e.g., Edmund Duranty, "Exposition universelle: Les écoles étrangères de peintures," *Gazette des Beaux-Arts* 2d ser. 20 (September 1878): 298–320, passim.

24. Charles Blanc, *Les Beaux-Arts à l'exposition de 1878* (Paris: Rénouard, 1878), 335.

25. For example, Chesneau, in *English School of Painting*, ranked Burne-Jones as "the greatest member of the English contemporary school" (230).

26. On the parallels between Moreau and Pre-Raphaelite art, see Robin Ironside, "Gustave Moreau and Burne-Jones," *Apollo*, 101 (March 1975), 173–82.

27. Paul Duranty, "Expositions de la Royal Academy et de la Grosvenor Gallery," *Gazette des Beaux Arts* 2d ser., 20 (July 1, 1878), 372–73.

28. Julius Kaplan, *The Art of Gustave Moreau: Theory, Style, and Content* (Ph.D. diss., Columbia University, 1982), 81.

29. Additional comparisons between these two artists can be found in Virginia Mae Allen, *The Femme Fatale: A Study of the Early Development of the Concept in mid-19th Century Poetry and Painting* (Ph.D. diss., Boston University, 1979), 278–85.

30. Wilfrid Meynell, *The Modern School of Art* 4 (London: Cassell & Co., 1887): 199.

31. Lethève, "La Connaissance des peintres pré-raphaélites anglais en France," 322.

32. Camille Mauclair, *L'Art en silence* (Paris: Société d'Éditions Littéraires et Artistiques, 1901): 173.

33. Fernand Khnopff, "Les Oeuvres d'art inspirées par Dante," *Le Flambeau* 4 (1921): 358. See also Ronald W. Johnson, "Dante Rossetti's *Beata Beatrix* and the New Life," *Art Bulletin* 57 (December 1975): 548–58.

34. Édouard Rod, "Les Pré-raphaélites anglais," *Gazette des Beaux Arts* 36 pt. 2, (November 1887): 405.

35. Quoted in Robert Pincus-Witten, *Occult Symbolism in France. Joséphin Péladan and the Salons de la Rose + Croix.* (Ph.D. diss., University of Chicago, 1976), 119.

36. Quoted in ibid., 92.

37. This point is made in Martin Harrison and Bill Waters, *Burne-Jones* (New York: G. P. Putnam & Sons, 1973), 174.

38. Quoted in Penelope Fitzgerald, *Edward Burne-Jones, A Biography* (London: Michael Joseph, 1975), 221.

39. See "The Chronicle of Art," *The Magazine of Art* 15 (1892): xiii.

40. Walter Shaw Sparrow, "Fernand Khnopff," *The Magazine of Art* 14 (1890): 40.

41. Robert de la Sizeranne, "In Memoriam. Sir Edward Burne-Jones: A Tribute from France," *Magazine of Art* 22 (1898); 520.

42. Robert de la Sizeranne, "Rose + Croix, Pré-Raphaélites et esthetes," *Le Correspondant* 40 (March 1892): 1127–40.

43. Quoted in Pincus-Witten, *Occult Symbolism in France*, 119.

44. Sizeranne may have been influenced in this appraisal of their literary contributions by Ruskin, whom he admired greatly and whom Sizeranne featured in his essay "Ruskin and the Religion of Beauty," which was translated by the Countess of Galloway in an 1899 London publication.

45. Sizeranne, "Rose + Croix," 1140.

46. See Sizeranne, *Tribute from France,"* 513–28.

47. Fernand Khnopff, "A Memorial Tribute to Burne-Jones," *The Magazine of Art* 22 (1898): 522.

48. Quoted in Sizeranne, "A Tribute from France," 519.

49. "Exhibitions," *The Magazine of Art* 16 (1893): xxi.

50. Sizeranne seems correct in suggesting that the symbolic use of flowers typical of many Rosicrucian artists reveals an indebtedness to the Ruskinian love of botanical detail.

51. An insightful analysis of this poster is found in Marla Hand, "Carloz Schwabe's Poster for the Salon de la Rose + Croix: A Herald of the Ideal in Art," *Art Journal* 44 (Spring 1984): 40–4.

52. Quoted in Lethève, "La Connaissance des peintres pré-raphaélites anglais en France," 323–24.

53. Besides the excellent treatise *The Symbolist Art of Fernand Khnopff* (Ann Arbor: UMI Research Press, 1982) by Jeffrey Howe, another source that refers to Khnopff's link with Pre-Raphaelitism is Barry Friedman, *Fernand Khnopff and the Belgian Avant-Garde* (New York: Barry Friedman Gallery, 1984).

54. An 8 April 1893 review by M. Broadley was quoted in Walter Shaw Sparrow, "English Art and Fernand Khnopff," *The Studio* 2 (1894): 207.

55. In his art, Rossetti was often preoccupied with the faces of women whom he loved—Elizabeth Siddal, Jane Burden Morris, and others—while Khnopff frequently used his sister Marguerite as a model for his female subjects.

56. A critic who noted the connection between Khnopff and Burne-Jones and who wrote after seeing Burne-Jones's work was D. S. MacColl, "The New Gallery," *The Spectator* 68 (April 30, 1892): 608.

57. Howe, *Symbolist Art*, 119–20.

58. Fernand Khnopff, "A Tribute from Belgium," *The Magazine of Art* (1898): 525.

59. Burne-Jones also had an opportunity to contribute to Les XX, another avant-garde Belgian art association; he had been invited in 1888 but chose not to participate. In 1889, however, he did send *King Cophetua and the Beggar Maid* to La Libre Esthétique, another avant-garde society abroad. The Pre-Raphaelite circle was represented when Brown contributed to Les XX in virtually the last year before the society disbanded; and in 1895, both Hunt and Watts exhibited their respective portraits of Rossetti at La Libre Esthétique. For additional details, see Bruce Laughton, "The British and American Contributors to Les XX, 1884–1893," *Apollo* 86 (November 1967): 375.

60. Howe (*Symbolist Art*, 123–24) suggests that Khnopff's creation of a private yet public cult image of his sister raises the possibility of an incestuous relationship between the two. It is interestingly coincidental that more than once Khnopff chose to illustrate the works of Rossetti's sister Christina.

61. Sparrow, "Fernand Khnopff," 43.

62. Quoted in "Symbolist Paintings, Drawings, and Watercolors," *Christie's London Auction Catalogue* (December 1989), entry 1153.

63. Léon Balzagette, *L'Esprit nouveau dans la vie artistique, sociale et réligieuse* (Paris, 1898).

64. Gautier, *Beaux Arts*, 38.

65. Sparrow, "Fernand Khnopff," 42.

66. Walter Shaw Sparrow, "English Art and M. Fernand Khnopff," *The Studio* (1894): 203.

From Allegory to Symbol: Rossetti's Renaissance Roots and His Influence on Continental Symbolism

SARAH PHELPS SMITH

Of THE ORIGINAL PRE-RAPHAELITE BROTHERS, DANTE Gabriel Rossetti was the most well read and the best versed in the history of art and Western culture. He was also the most influential, despite the fact that his works were rarely exhibited in his lifetime. Not only did Rossetti have a following among English painters, most notably Edward Burne-Jones, but his works helped to generate many of the recurring themes of the European Symbolist painters of the 1890s.

The Symbolists, in fact, claimed Rossetti as one of their own. They admired the decorative aspects of his paintings and frames, which reflected their own assertions that art should be decorative. They found many of Rossetti's recurring subjects or themes sympathetic, such as Reflection, the kiss as union of two souls, or the presence of music or symbolic flowers in a painting. But primarily the Symbolists were affected by Rossetti's use of the symbol itself. He absorbed Renaissance attitudes toward symbolic objects but transformed traditional Western symbolism through his own poetic ideals, so that a straightforward $x = y$ symbol was transmuted to an extended metaphor, where one image could elicit a whole series of associations. This suggestive, rather than explicit, use of symbolic images, based on a traditional pool of symbols from Western art and literature and expanded by a use of the Victorian "Language of Flowers,"[1] gave Rossetti's enigmatic subjects their appeal.

It was not the early Pre-Raphaelite style based on Ruskin's cry for so-called truth to nature that found a following in the later nineteenth century. Rather, it was Rossetti's later paintings—those of women and flowers—that dominated his work after 1859, inspiring the second generation of Pre-Raphaelites (Burne-Jones, Whistler, and Watts)[2] and, in fact, defining the

term Pre-Raphaelitism as understood by Europeans in the 1880s, 1890s, and well into this century.

Holman Hunt, in his history of Pre-Raphaelitism,[3] complained that popular opinion proclaimed Rossetti the founder of the school. Hunt had always maintained a meticulous truth in rendering detail, but Rossetti never considered this to be a top priority. Popular criticism rightly identified the founder of the so-called Pre-Raphaelite style but had a very different understanding of the style from Hunt's.

Of the original Pre-Raphaelite Brothers,[4] Rossetti was the least interested in a direct representation of physical reality. In their early pictures, Hunt and Millais painted every detail with scrupulous realism and often worked together in the open air to paint landscape backgrounds. Their sharply focused realism reflects a nineteenth-century interest in scientific accuracy, giving their paintings a very different aspect from their early Renaissance (pre-Raphael) models. Rossetti, Hunt, and Millais agreed primarily in their rejection of the current academic styles that favored not observed nature, but worn-out compositional patterns and chiaroscuro effects borrowed from the old masters of the sixteenth and seventeenth centuries.

Rossetti's two Pre-Raphaelite oil paintings, *The Girlhood of Mary Virgin* (1848–49, Tate Gallery, London, fig. 1) and *Ecce Ancilla Domini* (ca. 1850, Tate Gallery, London, see Roberts, fig. 3) reflect the inspiration of fourteenth- and fifteenth-century (pre-Raphaelite) Italian art by concentrating on formal qualities and content rather than on a direct photographic rendering of nature. *The Girlhood of Mary Virgin* was Rossetti's first exhibited painting; the figures and details are painted from nature and are, correspondingly, naturalistic. His models, like those

of Millais, are family members painted as individuals rather than as idealized types. However, his background is a formalized interior and not a plein-air landscape. The details of the interior—the curtain, lattices, balustrade, and embroidery frame—divide the picture surface into smaller rectangles that give a decorative flatness to the scene. His limited color scheme of red, blue, gold, and green adds to the formality of the picture. The choice of colors reflects Rossetti's Renaissance prototypes—Italian artists as well as northern-European painters like Memling and Van Eyck—whose works influenced Rossetti at this stage in his career.[5]

Even more important than Rossetti's use of the Early Italian masters' formal devices of pattern and color was his understanding and adoption of the kind of symbolism used in Renaissance painting. In the paintings of Memling and Van Eyck, ordinary natural objects within the setting carry a meaning beyond themselves. For example, a made bed, a pitcher and ewer, and a lily in a pot in an Annunciation scene symbolized the Virgin's purity and would have been recognized as symbols in their own time. Although Rossetti admired the northern Renaissance painters' ability to make the symbolism "inherent in the fact,"[6] he perhaps doubted the background knowledge of his nineteenth-century viewers and, therefore, wrote the names of virtues on the stack of books, whose colors symbolically correspond to the titles—for example, hope = green.[7] To go with this painting (fixed to the frame), he also wrote two sonnets, one of which explains his symbols outright:

These are the symbols. On that cloth of red
 I' the centre is the Tripoint: perfect each,
 Except the second of its points, to teach
That Christ is not yet born. The books—whose head
Is golden Charity, as Paul hath said—
 Those virtues are wherein the soul is rich:
 Therefore on them the lily standeth, which
Is Innocence, being interpreted.

The seven-thorn'd briar and the palm seven-leaved
 Are her great sorrow and her great reward.[8]

In addition to the lily, palm, and briar in the sonnet, other plants pictured in the painting are symbolic. The rose without thorns is, like the lily, a favorite Renaissance symbol of the Virgin Mary; the bindweed on the trellis stands for her humility.[9] St. Joachim trains a grapevine—symbol of Christ—which has not yet borne fruit and, thus, can be further interpreted as the yet unborn Christ. The haloes on the figures—and on the dove, which represents the Holy Spirit—are the only visual indication that this

Fig. 1. Dante Gabriel Rossetti. *The Girlhood of Mary Virgin.* 1848–49. Oil on canvas. 32¾" × 25¾". Courtesy of the Tate Gallery, London.

is more than a natural domestic scene. More significant than any of these symbolic details is Rossetti's intention that the painting itself be "a symbol of female excellence."[10] This use of the woman as symbol of an idea foreshadows Rossetti's later paintings.

Hunt and Millais adopted Rossetti's use of symbolic pictorial details (particularly flowers) in their religious subjects of the early 1850s. In *Christ in the House of His Parents* (1850, Tate Gallery, London, see Faxon, fig. 3) in addition to other iconographic novelties, Millais depicted a cactus-flower as an emblem of "bravery and endurance,"[11] which refers to the Crucifixion—as does the main event of the scene, the young Christ having cut his hand with a nail. A study for this painting includes a window box in which Millais planted marigolds and nasturtiums, flowers that represented grief in the so-called language of flowers.[12]

Hunt's *Hireling Shepherd* (1851, Manchester City Art Galleries, England), is an allegory of the pastor who is inattentive to the needs of his parish flock and is caught up instead in a pursuit of abstract theology.[13] The shepherd dallies with a country lass—showing her a symbolic death's-head moth—while his sheep wander off, eating green apples. The two prominent wild flowers in the foreground are a geranium, whose meaning is "folly and stupidity,"[14] and elecampane, the symbol of "woe and tears."[15] The flowers are a comment on the shepherd's behavior and the consequences of his neglect.

Hunt and Millais invented new religious-narrative scenes inspired partly by Tractarian sermons of the time.[16] Rossetti, on the other hand, drew on traditional Renaissance subjects in *Girlhood* and, later, in *Ecce Ancilla Domini* (an Annunciation). At this stage in his career, he also wrote poems about the Renaissance painters that reflected his veneration for their work and, in particular, for their use of symbolism. He admired painters whose symbols were inexplicable or open to more than one interpretation, for he saw that a sense of mystery was thus infused into a picture. In his sonnet for Leonardo da Vinci's *Our Lady of the Rocks* (1483, Louvre, Paris, and ca. 1506–8, National Gallery, London), Rossetti asked if the landscape had hidden meaning:

> Mother, is this the darkness of the end,
> The Shadow of Death? and is that outer sea
> Infinite imminent Eternity?[17]

Rossetti's sonnets for paintings by Mantegna and Memling[18] are also concerned with the mysteries of their meanings; and it is not surprising that one of the greatest iconographical puzzles of the Renaissance, Botticelli's *Primavera* (1478, Uffizi Gallery, Florence), was also the subject of a sonnet:

> . . . What mystery here is read
> Of homage or of hope? But how command
> Dead Springs to answer? And how question here
> These mummers of that wind-withered New-Year?[19]

These sonnets show that Rossetti's fascination was as much with the suggestion of symbolic meaning as with explicit symbols.

Rossetti's poem "St. Luke the Evangelist" (1847) and his story "Hand and Soul" (1850) demonstrate his struggle to define *symbolism* and to go beyond images with a single symbolic meaning to subjects imbued with an indefinite, suggestive mystery. He rejected as *allegory* overly obvious symbolism with a didactic purpose, and he rejected as *talisman* an intrusive symbolic detail:

> Give honour unto Luke Evangelist;
> For he it was (the aged legends say)
> Who first taught Art to fold her hands and pray.
> Scarcely at once she dared to rend the mist
> Of devious symbols: but soon having wist
> How sky-breadth and field-silence and this day
> Are symbols also in some deeper way,
> She looked through these to God and was God's priest.
> And if, past noon, her toil began to irk,
> And she sought talismans, and turned in vain
> To soulless self-reflections of man's skill,—
> Yet now, in this the twilight, she might still
> Kneel in the latter grass to pray again,
> Ere the night cometh and she may not work.[20]

In other words, the beauty of nature in painting should lead to a recognition of God or high ideals and should not be a skillful rendering of an image for its own sake so that the virtuosity of the artist eclipses the content. He rejected art that might be true to nature but that lacked an ideational or symbolic significance.

Didactic allegory is also an enemy to Art, as Rossetti explained in his story "Hand and Soul."[21] Whereas "Art" is personified as a "she" in the Saint Luke sonnet, in "Hand and Soul" a beautiful woman is used as a symbol for the artist's soul. The protagonist of this story is Chiaro dell'Erma, an imaginary painter whose name means "clarity of Hermes," referring to the Greek messenger of the gods who brought communications from heaven to earth. Chiaro experiences a sort of crisis in his career when he realizes that what he had thought was faith was really nothing more than a worship of beauty. He changes his subjects to those with a didactic, moral purpose and represents in complicated allegory such subjects as Peace, abandoning his instinct for depicting the beautiful. Then, one day, a beautiful woman (whom he recognizes as his own soul) appears to him and points out that his new style is folly and that he should paint what is in his heart, not what is in his mind. It is significant that here, again, a beautiful woman represents an idea—this time, the Soul. As in the Saint Luke sonnet, Rossetti is making a double plea: that symbols should be used as a natural part of a depiction of Beauty (not forced into a subject to make a point) and that the artist's ideas should be conveyed principally through a representation of the beautiful.

During the 1850s, Rossetti painted almost entirely watercolors that were illustrations of literature, such as *Morte d'Arthur*, Dante's *Divine Comedy* and *La Vita Nuova*, Shakespeare's works, and the Bible. Although almost every picture that Rossetti painted

Fig. 2. Dante Gabriel Rossetti. *Fra Pace*. 1856. Watercolor.
13¾″ × 12¾″. Photograph courtesy of Sotheby's, collection of
Lord and Lady Freyberg.

contains at least one beautiful woman, most of these watercolor compositions had other figures. (In choosing literature familiar to most people, Rossetti drew on a common experience of Western culture.) These pictures were intended to be primarily narrative, but Rossetti continued his use of traditional Christian symbols (especially flowers and plants). The apple of temptation appears in several pictures of Guinevere (the adulterous wife of King Arthur) or *behind* Sir Galahad, who overcomes all temptations to reach the chapel of the Holy Grail. Lilies, roses, and jasmine—flowers associated with the Virgin Mary—appear with Dante's Beatrice to show love and purity.[22]

The symbolic details are usually unobtrusive, as in the watercolor of *Fra Pace* (1856, Collection of Lord and Lady Freyburg, England, fig. 2), showing a monk illuminating a manuscript. It is a tribute to Durer's engraving of Saint Jerome in his study; and

like the famous print, the painting is full of everyday objects that also have a symbolic purpose. There are details in the room to represent each of the five senses—paints for sight, a pomegranate for taste, a lute for hearing, a rosebush for smell, and a boy tickling a cat for touch. It is not, however, necessary to interpret these symbolic details to understand that the subject is similar to the Saint Luke sonnet: the artist, on his knees, is serving God by rendering the beauties of the (sensuous) world around him. God's blessing on this endeavor is represented by the ray of light that falls on the monk from the right. This watercolor was important to Rossetti's following. Rossetti was working on it when Edward Burne-Jones made his first visit to the older artist's studio and decided to abandon a clerical career to become a painter.[23] William Morris was the first to own the painting.

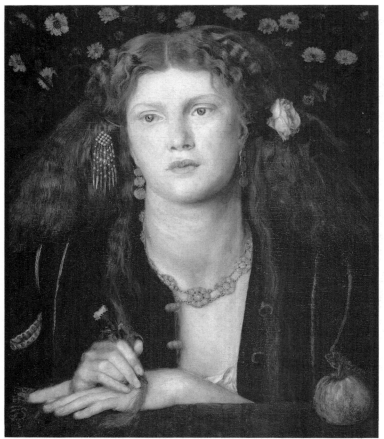

Fig. 3. Dante Gabriel Rossetti. *Bocca Baciata*. 1859. Oil on panel. 13¼″ × 12″. Courtesy of the Boston Museum of Fine Arts, gift of James Lawrence.

Rossetti's oil painting *Bocca Baciata* (1859, Museum of Fine Arts, Boston, fig. 3) marked a turning point in his style. William Bell Scott, Rossetti's friend and fellow painter/poet said of Rossetti, "From now on he would paint beauty only: women and flowers were the only subjects worth imitating."[24] Although Rossetti still painted some multifigured compositions, the bulk of his work consisted of the half- or three-quarter pictures of women, often with floral backgrounds. These paintings established the style for which he became known and that proved to be influential in the later years of the century.

As the subject matter changed, so did Rossetti's sources. Rather than quattrocento painters, Rossetti looked to post-Raphael painters for inspiration—particularly the Venetian artists Titian and Veronese. Of *Bocca Baciata*, Rossetti wrote that it had "a rather Venetian aspect."[25] One possible reason for this change in style was due to John Ruskin, the critic who had been Rossetti's close friend during the mid-1850s, and Rossetti's major source of income. Not only did Ruskin buy Rossetti's works, but he recommended them to friends, who also became patrons. In the summer of 1858, on a holiday in Italy, Ruskin experienced an "unconversion" from his Protestant Christianity, brought on by a comparison between a bad sermon and a painting by Veronese.[26] In the next year or so, Ruskin's letters show an aversion to medieval and early Renaissance awkwardness and an admiration for the cinquecento Venetians.[27] Rossetti often resented Ruskin's patronizing corrections; and it is unlikely that he altered his style just to please his critic, friend, and patron. But it is quite possible that Ruskin's enthusiasm inspired Rossetti to try a Venetian type of painting; and pleased with the results, Rossetti followed the new path that he had created for himself in his painting.

Since Rossetti never went to Italy, he was unable to see many Venetian paintings in the original (except in the Louvre, the National Gallery, and in English private collections such as Ruskin's). By the 1850s, however, photographs of paintings were readily available; and Rossetti had his own extensive collection of autotypes of famous paintings, "chiefly of the pictures of the early Florentine and Venetian schools."[28]

Rossetti adopted stylistic and technical aspects from the painting of the Venetians as he found thematic inspiration in their pictures of women. The most obvious change in Rossetti's technique was his increasing preference for large oil paintings rather than the small watercolors that had preoccupied him in the 1850s. From Titian, in particular, Rossetti borrowed a sumptuous use of color that lent a decorative aspect to his compositions; and his selection of particular color schemes for his pictures recalled his early Pre-Raphaelite oils and the color harmonies of his then-close friend James McNeill Whistler. As time passed, Rossetti abandoned the tiny brushstrokes evident in the 1850s for the broad brushwork of the Venetians, with white highlights visible on the surface of the paintings—another stylistic device that reinforces a painting's decorative rather than illusionistic character.

Rossetti's paintings of women and flowers can be appreciated on two levels—the symbolic as well as the formal—both of which were of importance to the artist. Although these paintings of individual women could be called portraits, none are simply representations of a particular person. The Venetians developed the idea of the so-called fancy portrait, in which a recognizable woman is painted as a classical figure like Flora or Venus or as a character from literature like the one pictured in Giorgione's *Laura* (1506, Kunsthistorisches Museum, Vienna, fig. 4).

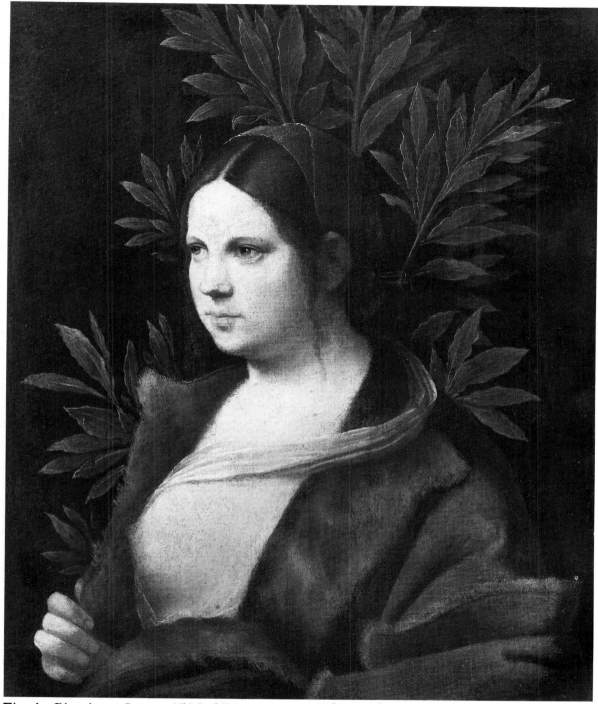

Fig. 4. Giorgione. *Laura*. 1506. Oil on canvas. 16⅜" × 14⅜".
Courtesy of the Kunsthistorisches Museum, Vienna.

Ironically, the fancy portrait was also popular in eighteenth-century England. (Rossetti's bête noire Sir Joshua Reynolds painted Mrs. Siddons, for example, as *Tragic Muse* [1784, Henry E. Huntington Library and Art Gallery, San Marino].)

Some of Rossetti's "beauties" (as he called them) were given personalities from the Bible and other works of literature. *La Donna della Finestra* (1879, Fogg Art Museum, Harvard) and *Beata Beatrix* (ca. 1864, Tate Gallery, London, see Faxon, fig. 5) were taken from Dante's *La Vita Nuova*, which Rossetti had translated in 1849. Other paintings—like *Bocca Baciata*, *Mona Vanna* (1866, Tate Gallery, London) and *La Bella Mano* (1875, Delaware Art Museum, Wilmington)—were given Italian names that hint at symbolic meaning or literary connections.

These titles—and sometimes an accompanying sonnet—help to identify most of these women as personifications of some virtue or idea. Even a painting of a character from literature, such as *La Donna della Finestra*, should be seen as more than a mere illustration. Rossetti's brother and biographer, William Michael Rossetti, wrote of this work:

> [Rossetti] contemplated the Donna as a real woman; but neither was her human reality intended to be regarded as the essence of the pictorial presentment—rather her personal reality subserving the purpose of poetic suggestion—an emotion embodied in human form—a passion of which beautiful flesh-and-blood constituted the vesture. Humanly she is the Lady at the Window; mentally she is the Lady of Pity. This interpretation of soul and body—this sense of an equal and indefeasible reality of the thing symbolized, and of the form which conveys the symbol—this externalism and internalism—are constantly to be understood as the key-note of Rossetti's aim and performance in art.[29]

The essential content of most of Rossetti's paintings of women and flowers is the representation of a beautiful woman as something beyond herself—such as Beauty, Art, or Pity. The flowers and other objects added to the background serve as symbolic attributes.

The idea of the Woman as allegorical figure was not a new one. From medieval times the theological and cardinal virtues were represented as women (or men). Rossetti's stylistic sources, Titian and Veronese, also painted women as the Virtues or as Divine and Earthly Love.[30] In the nineteenth century, Delacroix painted such allegorical women in *Liberty Leading the People* (1830, Louvre, Paris) or *Greece on the Ruins at Missolonghi* (1821, Musée des Beaux-Arts, Bordeaux). The Victorian public was familiar with John Tenniel's political cartoons (in *Punch*) that personified Britannia or Hope as women.

One of Rossetti's primary sources for these fancy portraits is a sixteenth-century Italian *Iconologia*, by Cesare Ripa, which Rossetti had in his library.[31] The *Iconologia* is a kind of dictionary that suggests how ideas, virtues, and even places (such as the provinces of Italy) can be represented by a human figure with attributes such as dress, posture, and accompanying plants, animals, or other objects that symbolize the idea that they personify. Rather than taking his subject matter wholesale from Ripa's book, Rossetti borrowed the format of a woman personifying an idea with the help of floral and other attributes.

The only direct reference to Ripa's text is connected with Rossetti's drawing *Silence* (1870, Brooklyn Museum of Art, fig. 5). This drawing was autotyped for publication in 1878 with a label which was to read: "Silence holds in one hand a branch of peach, the symbol used by the ancients; its fruit being held to resemble the human heart and its leaf the human tongue. With the other hand she draws together the veil enclosing the shrine in which she sits."[32] The first part of this text is a direct translation from one of Ripa's descriptions of Silence.[33]

The personification of an idea is more obvious in some of Rossetti's paintings than in others. For example, the sonnets for his *Lady Lilith* (1868, Delaware Art Museum, Wilmington, see Faxon, fig. 11) and *Sibylla Palmifera* (1866–70, Lady Lever Art Gallery, Port Sunlight) were entitled "Body's Beauty" and "Soul's Beauty," providing the key to the interpretation of these paintings.[34] Other paintings are rather difficult to interpret as personifications but may be deciphered in the light of Ripa's text.

Veronica Veronese (1872, Delaware Art Museum, Wilmington, fig. 6), for example, was ostensibly painted as a subject from literature, *The Letters of Girolamo Ridolfi*.[35] A quotation on the frame describes the moment portrayed:

> Suddenly leaning forward, the Lady Veronica rapidly wrote the first notes on the virgin page. Then she took the bow of the violin to make her dream reality; but before commencing to play the instrument hanging from her hand, she remained quiet a few moments, listening to the inspiring bird, while her left hand strayed over the strings searching for the supreme melody, still elusive. It was the marriage of the voices of nature and the soul—the dawn of a mystic creation.[36]

The quotation shows that the subject of the picture is artistic creation—the transformation of nature into art—the same theme that interested Rossetti in his *Fra Pace*, his sonnet on Saint Luke, and his story "Hand and Soul" discussed above.

Ripa's representation of Arte is a seated woman robed in green with a flame rising out of her head.[37] To make the symbolism "inherent in the fact," Rossetti replaced the flame with an iris—a flower that represents a flame.[38] Although the flower is part of the damask pattern on the drapery behind the woman, it is carefully positioned above the model's head and highlighted to make it stand out without being too obtrusive. Ripa said that the flame was "the symbol of Intellect," and that "through the flame of art, raw materials are softened, shaped or hardened, and so transformed into the products of the mind." According to Ripa, green is used as the color of hope that "spurs the artist on and of youth and freshness (art conquers the passage of time and keeps everything fresh and young, particularly the inven-

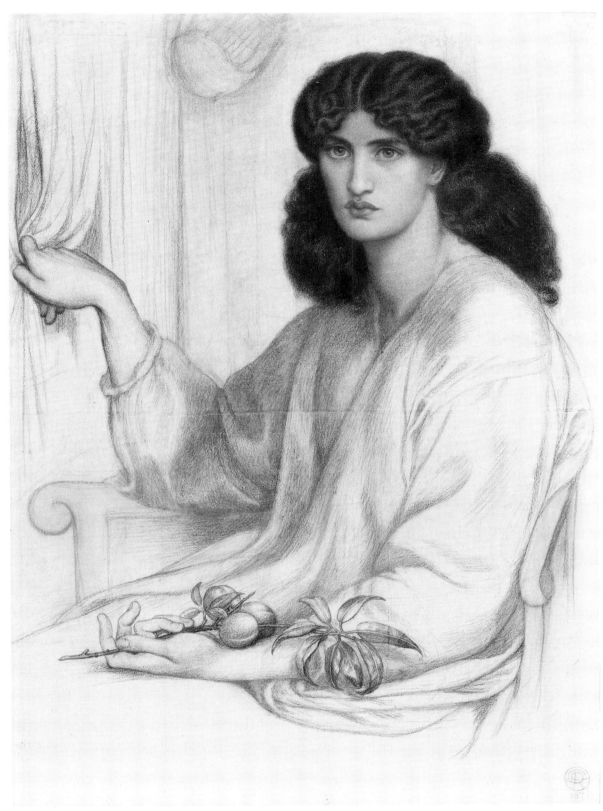

Fig. 5. Dante Gabriel Rossetti. *Silence*. 1870. Black and red chalk. 41¼″ × 31½″. Courtesy of the Brooklyn Art Museum, gift of Luke Vincent Lockwood.

tiveness of the mind)." Although Ripa's woman holds the tools of pictorial art in her hand—which "are used to produce works imitating nature"[39]—the Veronica holds a violin (this is perhaps because Frederick Leyland, the intended patron, was an amateur violinist; Leyland bought several of Rossetti's pictures showing women playing musical instruments). Rossetti also rejected some of Ripa's other symbolic attributes—such as a vulture, maps, or a grapevine—and replaced them with his own symbols. The bird, a traditional emblem of the soul[40] (also here representing Nature), inspires the woman with its song while it is temporarily free from its prison. The cage of the bird is adorned with a sprig of camomile, symbolizing "energy in adversity" in the language of flowers,[41] and is applicable to the bird that sings despite its captive state. The flowers on the desk also carry symbolic weight. The primroses are a symbol of youth[42] and reflect Ripa's mention of "youth and freshness in the invention of the mind." The presence of jonquils is explained by their generic name, *narcissus* which recalls the Greek myth of the youth Narcissus, who fell in love with his own reflection in a pool and was turned into a flower.[43] The use of the narcissus to represent reflection is emphasized by the way in which Rossetti painted the reflections of the flowers in the shiny finish of the desk. The subject of the painting is the reflection of nature in art. Rossetti said of the title: "I mean to call the violin picture Veronica Veronese which sounds like the name of a musical genius";[44] but this conceals the symbolism of the name *Veronica*, which means "true image" and was given to the saint who on Calvary used her veil to wipe Christ's face, whose image was left imprinted on the veil.

Rossetti used his own combination of traditional symbols—rather than Ripa's—partly for color. Rossetti said that he planned to make the picture *Veronica Veronese* "chiefly a study of varied greens."[45] The yellow and green bird and flowers fit into the color scheme and are objects that could be seen as appropriate to a music room. The *Veronese* in the title refers to the Venetian artist who inspired Rossetti's color scheme and handling of paint, which were as important to Rossetti as the meaning of the picture.

Veronica Veronese demonstrates the eclectic and complicated attitude that Rossetti took in choosing his symbolic details. It is hardly surprising if the full content of the painting was not grasped by either the Victorian public or the European Symbolists. The main idea of the picture is explained by the quotation on the frame; therefore, the content is not lost without a full understanding of the accessories. Many of Rossetti's other paintings of women and flowers can be traced to Ripa's allegories. *La Bella Mano* derives from Ripa's allegorical notions of Innocence and Chastity, for example, and *The Day Dream* (1880, Victoria and Albert Museum, London) from Ripa's allegorical notion of Reflection.[46]

Whereas Ripa explained each symbolic detail in his allegories, Rossetti preferred not to talk or write about the meanings of his symbols. Rossetti's father had devoted much of his life to an interpretation of Dante's works, in which he found a network of symbolism that ostensibly pointed to a Masonic conspiracy. Perhaps this almost paranoid search for symbolic meanings led the son to remark sarcastically that Beatrice represented "the two-penny post"[47] and gave him a lifelong aversion to telling what his symbols meant. Rossetti wanted his picture to tell its own story (at times with the aid of a title or sonnet) but without an *explication de texte*. The occasional translation of the meaning of a detail was usually for a patron. (In writing to the buyer of his *Proserpine* [1877, private collection], he remarked that "the ivy may be taken as a symbol of clinging memory."[48]) Rossetti asserted, "If the subject of a picture cannot tell its own story, but has to be explained, that picture is a failure."[49] Rossetti's brother commented: "my brother painted very few things, at any stage of his career, as mere representations of reality, unimbued by some inventive or ideal meaning. It was into his work . . . not into his utterances—that he infused the higher and deeper elements of his spirit."[50] Rossetti believed that explaining his symbols was "allegorizing" rather than symbolizing poetically whereby an object (such as a flower) should suggest a meaning or a multitude of associations depending on the viewer's background and understanding. William Michael Rossetti understood his brother's distinction between symbolism and allegory and, on another occasion, wrote that his brother "was as much indisposed to shuffle concrete things into allegory as he was prone to invest with symbolic detail or suggestion things which are in themselves simply physical and substantial."[51]

In his mature work, Rossetti adopted a sensuous realism from the Venetian painters and the model for the symbolic woman from Cesare Ripa. While adopting Ripa's pattern of the woman with symbolic attributes, Rossetti held fast to the northern Renaissance practice of including only those symbols—principally flowers—that could be a logical part of his scene. It is ironic that a so-called Pre-Raphaelite should rely on sources in the post-Raphael sixteenth century.

Rarely does the title of one of Rossetti's paintings

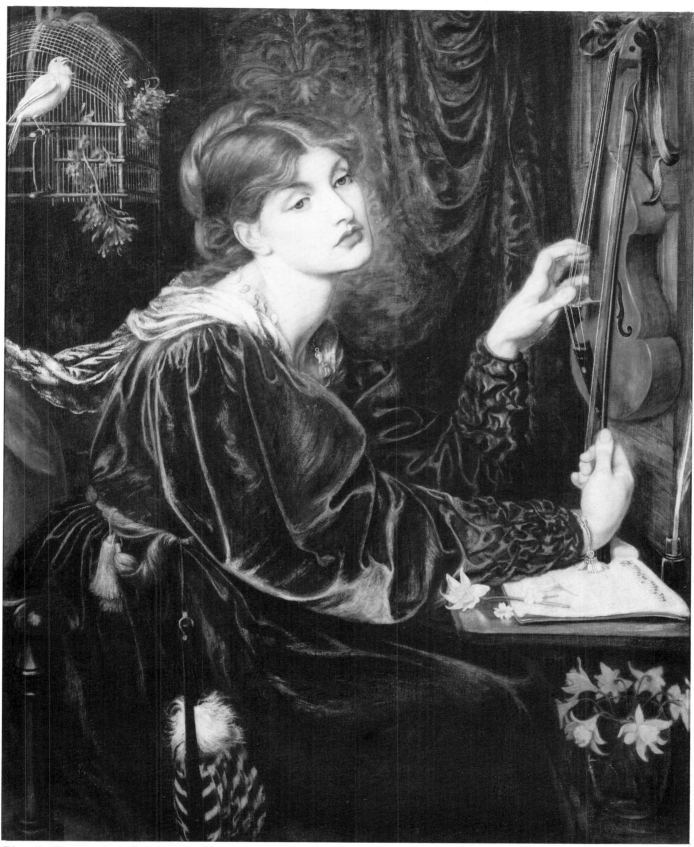

Fig. 6. Dante Gabriel Rossetti. *Veronica Veronese*. 1872.
Oil on canvas. 43″×35″. Courtesy of the Delaware Art Museum, Samuel and Mary R. Bancroft Memorial, 1935.

of women simply identify the personification. A notable exception is *Mnemosyne* (1881, Delaware Art Museum, Wilmington, see Faxon fig. 8) painted from Jane Morris, Rossetti's inspiration in his later years.[52] Again, it shows not only Rossetti's admiration for the Renaissance allegory but also his ability to use traditional symbols with a personal meaning. The subject is clearly Memory. On the frame are inscribed two lines:

> Thou fill'st from the winged chalice of the soul
> Thy lamp, O Memory, fire-winged to its goal.[53]

More appropriate, perhaps, is the couplet entitled "Memory" in the "Fragments" section of Rossetti's complete poems:

> Is Memory most of miseries miserable,
> Or the one flower of ease in bitterest hell?[54]

Beside the symbolic chalice and lamp, Rossetti placed a pansy and a branch of yew, which are not mentioned in the first couplet. The yew stands for "sorrow"[55] and the pansy for "thoughts,"[56] the medium of Memory. In England, the pansy was often called "heartsease"—and, thus, fits the "one flower of ease" perfectly.

The symbolic significance of this flower became apparent when the painting was cleaned in 1976 and another pansy became visible at the neckline of the figure's dress. In Rossetti's mind, the pansy was associated with Jane Morris and appears in other portraits of her, notably a version of *Water Willow* (1871, Birmingham City Museum and Art Gallery, England) and Rossetti's design for a personal letterhead for Morris. The intricacy of the symbolism is not meant for the viewer but only for the painter and possibly (here) the model. The viewer's understanding of the painting was clearly not a concern to Rossetti.

In addition to the individual symbolic roles that Rossetti's women play, it should be remembered that—as in his story "Hand and Soul"—these women are reflections of the artist's soul. As in *Veronica Veronese*, the figures represent the creative process, or Art itself; each picture embodies some aspect of Beauty that the artist conceives within himself. That most women also portray Love or some aspect of Love, is not inconsistent with their roles as Art or the Creative Impulse. Rossetti believed that woman's love contains a certain creative power. She can use it for evil purposes, to thrall her lovers, as does *Lilith* or Helen of Troy—subjects of both paintings and poems—or to comfort, bless, and inspire, as does *Silbylla Palmifera*, Beatrice, or the *La Donna della Finestra*. In the sonnet "Genius in Beauty," Rossetti credits the woman with creating her own beauty:

> Beauty like hers is genius . . . [57]

The delicate balance presented in these paintings between the identifiable symbol (such as a lily that had a long history of representing "purity" in Western art) and the personal or simply suggestive symbol (an unusual flower given a prominent place in a painting and lending itself to *some* symbolic interpretation) was one of the elements of Pre-Raphaelite (i.e., Rossetti's) art that fascinated the Symbolists.

Unlike Pre-Raphaelitism, Symbolism was an international movement. Although French, Belgian, Dutch, and Italian Symbolists painted in many different and diverse styles, the movement was characterized by similarities in thematic interests and an interest in art as decoration. These two aspects of art, form and meaning, seem to separate like oil and water in fin-de-siècle art; and yet form and meaning both held a fascination for the Symbolists, as well as for Rossetti, whose interest in literary, allegorical, and symbolic subjects coexisted with his decorative color schemes and with his work in the decorative arts, which included book illustrations, designs for his own frames, stained glass, and furniture for the firm of his friend and disciple William Morris.

Rossetti died in 1882 at the relatively young age of fifty-three. He rarely exhibited in his lifetime[58] and until recently there has been little emphasis to determine how well known his works were on the Continent. An article of 1955, for example, documents the knowledge of the Pre-Raphaelites as a group in Paris.[59] Rossetti is worth considering separately because of his importance to his English followers and the absence of actual exhibited paintings in France as well as in England.

The earliest knowledge that the French had of Rossetti was through personal contacts. Whistler and Fantin-Latour were friends of Rossetti and moved in English artistic circles as well as French. The poet Swinburne, a close friend who shared Rossetti's house in Cheyne Walk in the early 1860s, subsequently met and regularly corresponded with Stéphane Mallarmé, the principal Symbolist poet. Rossetti's exposure on the Continent increased in the late 1870s and early 1880s due to sources one step removed from his painting. One source was his poetry, which was translated into French and published in periodicals and, then, book form. Since many of the same themes and symbols appear in his painting and poetry (especially his sonnets for his own paintings), his ideas about women, beauty and art were

available to Symbolist writers and painters. The Symbolists were fascinated by the relationships (or what the French called *correspondances*) between different arts, such as music and painting—or between poetry and painting, as with Rossetti's sonnets for his pictures.

Another of these secondary sources was the exhibition of paintings by Rossetti's followers, especially Edward Burne-Jones, who had a *succès fou* in Paris in 1878 with his *Love Among the Ruins* (1870–71, Wightwick Manor Collection, Wolverhampton) and who was asked repeatedly to contribute to exhibitions on the Continent thereafter. Of the painters who were called Pre-Raphaelites by the French, as Susan Casteras reveals in her essay, Burne-Jones was the most influential and the closest in style and content to his mentor, Rossetti. He had already admired Rossetti's works when, as an Oxford student in 1856, he met the artist and was convinced to become a painter, too. The younger artist's early work is derived directly from Rossetti's medieval-like watercolors of the 1850s. From the beginning, Burne-Jones's art was also notable for its depiction of women in narratives or subjects that portray ideas about love and beauty.

In the 1860s and after, Burne-Jones painted more multifigured compositions than single women with flowers; but some paintings reflect Rossetti's compositions. For example, Burne-Jones's portrait of his mistress Maria Zambaco is a personal statement with symbolic flowers used in a Rossettian way (1870, Clemens-sels Museum, Neuss, Germany, see Cheney, fig. 11). In this painting, Cupid draws aside a curtain to reveal the love of the artist—his mistress who holds the white dittany flower, a symbol of passion, and a picture of the artist's painting *Chant d'Amour* (1865 version, Museum of Fine Arts, Boston).[60] Oftentimes Burne-Jones would cast female figures as Hope, the Seasons, or other straightforward allegorical ideas with floral attributes.

Whistler exhibited with the French Academy, and though never considered a Pre-Raphaelite, his paintings of girls in white in the 1860s show a parallel interest with Rossetti's in portraying beautiful women with flowers and suggested meaning. Whistler's *Symphony in White, No. 1* (1862, National Gallery, Washington, D.C.) (completed in the year that he met Rossetti) shows his redheaded model Jo Heffernan dressed in white and holding a drooping lily, representing lost innocence—an idea that is further supported by the symbolic flowers on the floor.[61] George Watts was never as close to Rossetti as these other painters were, although Watts knew Rossetti;

nevertheless, the French also considered Watts to be a Pre-Raphaelite. Many of his paintings, such as *Hope* (1885, Tate Gallery, London) or *Love and Death* (1875, Bristol City Art Gallery, England) are outright allegories, but he used as many male personifications as female.

Although French critics of the 1860s and early 1870s thought that Pre-Raphaelitism was an insignificant, odd, provincial school of art, they had changed their thinking by the 1880s. The Symbolist poet Verlaine wrote a poem about Rossetti's painting *Mona Rosa* (1862, location unknown); and in 1887–89, the Symbolist composer Debussy, in his "La Demoiselle Élue," paid a tribute to Rossetti's painting and poem *The Blessed Damozel*. The paintings themselves—though not exhibited at the Academy during Rossetti's lifetime or included in the Expositions Universelles—had been written about occasionally in French publications.[62] They became more visible after Rossetti's death in 1882.

In 1883, there were two major retrospective exhibitions of Rossetti's paintings in London, one at the Royal Academy and one at Burlington House. Reviews of these exhibitions appeared in both English and French magazines, illustrated with some of his pictures. Most of his major paintings were in the hands of a few loyal patrons; and as these patrons died, the paintings passed through the hands of Christie's auction house, where they were visible to the public in England.

During Rossetti's life, he had his paintings and finished drawings photographed before they left his studio. In 1878, two of his drawings of Jane Morris (one of them the Ripa-influenced *Silence*) were photographed for publication. An exhibition of Hollyer's photographs of paintings by Rossetti and Burne-Jones took place in Belgium in 1891. By that year, the Pre-Raphaelites (Rossetti and his followers) were well known in France. In the previous decade, the Belgians were also discovering the Pre-Raphaelites. Fernand Khnopff knew Burne-Jones and was also familiar with Rossetti's work (probably in the 1880s through photographs, and certainly after his acquaintance with Burne-Jones).

Khnopff's work shows a more complete understanding of Rossetti than that of any other Symbolist, although many Symbolists show influence in one or another aspect of their work. Khnopff's painting of *I Lock My Door Upon Myself* (1891, Neue Pinakothek, Munich, see Casteras, fig. 10)[63] best illustrates his understanding and use of Rossetti's type of symbolism. The title comes from a poem by one of Rossetti's sisters, Christina Rossetti, and refers to the

artist's (poet or painter's) self-imposed isolation from the world. Rossetti himself echoed this idea in a poem fragment published with his *Complete Works* (which Khnopff could also have known):

> I shut myself in with my soul,
> And the shapes come eddying forth.[64]

Khnopff's painting shows an interior inhabited by a redheaded woman of a type similar to Rossetti's beauties, surrounded by symbolic objects that have been interpreted by art historians only with a great deal of research and historical perspective. Along with a poppy placed by a statue of Hypnos (both representing Sleep),[65] there are three branches of daylilies in the foreground, making this composition, like so many of Rossetti's, a woman-and-flowers picture. Despite the fact that the complex symbolism was probably not obvious to the then-contemporary viewer, the essence of the subject—the enclosure of the artistic soul in its own world—was probably made clear enough by the painting's title. The soul in *I Lock My Door*—as in Rossetti's poem "Hand and Soul"—is symbolized by a beautiful woman. Other paintings by Khnopff also represent women with symbolic flowers (for example, *Les Feuilles de Pervenches* [1893, location unknown]) or women as personifications (*Solitude* [1891, private collection] or *Silence*, [1890, Musées Royaux des Beaux-Arts de Belgique, Brussels).[66]

Although it is rare for a Symbolist artist to have as much of a debt to Rossetti as did Khnopff, many of the Symbolists' recurring themes had been prefigured in Rossetti's paintings. For example, the kiss that Rossetti used in his illustration for Tennyson's Saint Cecilia (1857), his *Paolo and Francesca da Rimini* (1855, Tate Gallery, London), his *Rose Garden* (1861, Boston, Museum of Fine Arts, Boston), his *King Réné's Honeymoon* (1864, private collection), and his poem "Willowwood," among other works,[67] finds Symbolist counterparts entitled *The Kiss* in works by August Rodin (1898, Musée Rodin, Paris), Edvard Munch (1892, Munch Museum, Oslo), Khnopff (1883, Illustration in *La Jeune Belgique*) and Gustave Klimt (1895, Staadt Museum, Vienna).

Rossetti's elevation of the female portrait to an icon was an important source of inspiration to the Symbolists. In addition to (a) the enigmatic, symbolic women inspired by Ripa, (b) the literary figures such as Guinevere and Beatrice, and (c) goddesses such as the one depicted in *Astarte Syriaca* (1877, Manchester City Art Gallery, England), Rossetti's femmes fatales from myth and legend were proto-

types of Woman as portrayed by the Symbolists. A long list could be compiled of Symbolist allegorical women alone, which would include, for example, Lévy-Dhurmer's *Silence* (1895, private collection), Von Stuck's *Sin* (1893, Neue Pinakothek, Munich) and his *Innocence* (1889, private collection).

A final aspect of Rossetti's art that had a surprising effect on fin-de-siècle art was his interest in the decorative uses of form and color. Although his influence was mainly disseminated through the works of his followers, Rossetti was more concerned with art as decoration than were most artists of the 1860s and 1870s.

Maurice Denis in his 1891 essay "Definition du neo-traditionisme," which served as a sort of manifesto for the French Symbolists, wrote that "a picture before it is a war horse, a naked woman, or some anecdote, is essentially a flat surface covered with colors arranged in a certain order."[68] Rossetti showed his interest in the formal qualities of his paintings by (a) his specific color schemes for his works, (b) his interest in the design of his own frames, and (c) a tendency to flatten or dematerialize his subjects with decorative use of line, with decorative flat backgrounds, or with sonnets written on the picture plane.

Rossetti's use of flowers as his favorite counterpart to women was another important contribution to the art of the 1890s. The Victorian public (and Europeans on the Continent as well) were aware of the symbolic language of flowers that Rossetti used in order to make his flowers meaningful as well as decorative. Art Nouveau could be called the decorative branch of Symbolism; and flowers and plants, along with beautiful women, became the primary subject matter. Although the flowers seem to be primarily decorative—especially to twentieth-century eyes—a writer of the 1880s showed that the nineteenth-century viewer would see the flowers as symbolic: "[One] may surely suppose Purity, Beauty, and Constancy: are they not adequately expressed to the mind's eye . . . in the lily, the peacock, and the sunflower?"[69]

The posters of women and flowers by Alphonse Mucha perhaps show best the transformation of Rossetti's women and flowers into Art Nouveau. Mucha was a painter as well as a graphic artist who was intimate with Symbolist artists and writers. His famous posters show his fascination with the feminine face and hair as decoration. Often his allegorical subjects emphasize the decorative rather than symbolic use of flowers—at times, forced into almost geometric patterns, as in his *Reverie* (1896, Narodni Galerie, Prague, fig. 8). In Mucha's works, both women

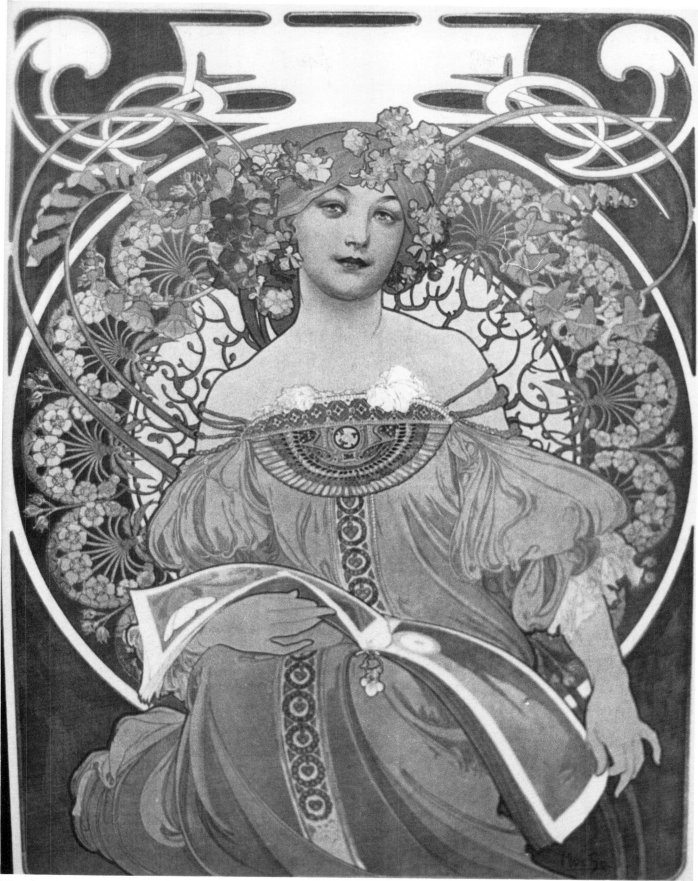

Fig. 7. Alphonse Mucha. *Reverie*. 1896. Color lithograph.
25⅜″ × 18⅞″. Narodni Galerie, Prague.

and flowers became primarily decorative; but just as women would not be totally free from associations of love and beauty, Mucha's flowers were not completely free from the tradition of poetic meaning built up in the nineteenth century.

By 1896, the German art historian Richard Muther, in writing a history of modern painting, summed up opinion in the 1890s. He gave the English credit for taking the lead in creating a new "school of Idealism"[70] in painting. He saw Rossetti as "the centre of a new circle of artists":

> Their art is a kind of Italian Renaissance upon English soil. The romantic chord which vibrates in old English poetry is united to the grace and purity of Italian taste, the classical lucidity of the Pagan mythology with Catholic mysticism, and the most modern riot of emotion with the demure vesture of the primitive Florentines. Through this mixture of heterogeneous elements English New Idealism is probably the most remarkable form of art.[71]

Rossetti's contribution to Symbolism was to absorb and use the vocabulary of allegorical symbols from Western art and literature and, then, to lose the key, so to speak, leaving each image to generate its own symbolic weight—suggesting, without stating, a meaning beyond itself.

NOTES

1. The so-called language of flowers was a system of flower symbolism popular on the Continent as well as in England in the nineteenth century. The flower symbolism came from a combination of folklore, Christian iconography, Greek myth, Persian and other sources. There were scores of editions of books with the title *Language of Flowers* or similar titles. It is not known for certain which editions Rossetti used. He may well have known one of the best compendia of these books, namely, John Ingram's *Flora Symbolica* (London: Frederick Warne, 1868).

2. Whistler and Watts would never have considered themselves to be Pre-Raphaelites.

3. William Holman Hunt, *Pre-Raphaelitism and the Pre-Raphaelite Brotherhood* 2 vols. (London: Macmillan, 1905–6).

4. I limit my discussion to the only three painters of importance among the original seven Pre-Raphaelites: William Holman Hunt, J. E. Millais, and Dante Gabriel Rossetti.

5. Rossetti saw and admired works by these painters on his trip to Belgium and France with Holman Hunt in 1849.

6. *The Letters of Dante Gabriel Rossetti*, ed. Oswald Doughty and John Wahl, 4 vols. (Oxford: Oxford University Press, 1967), I:276.

7. Color symbolism is explained in Anna B. Jameson, *Sacred and Legendary Art* (London: Longmans, Green & Co., 1848), a book that Rossetti owned.

8. *The Collected Works of Dante Gabriel Rossetti* ed. William M. Rossetti, 2 vols. (London: Ellis & Elvey, 1890), I:353.

9. Ingram, *Flora Symbolica*, 355.

10. Quoted in Alastair Grieve, *The Art of Dante Gabriel Rossetti: the Pre-Raphaelite Period 1848–1850* (Norfolk: Real World Publications, 1973), 8.

11. Sarah C. Mayo, *Fables of Flora* (Lowell: J. Merrill, 1844), 115. This book was based on English sources.

12. Ingram, *Flora Symbolica*, 359. Nasturtiums usually meant "patriotism"; but Ruskin, for one, thought they meant "grief." See John Ruskin, *Notes on Some Principal Pictures of the Sir John Millais Exhibition at the Grosvenor Gallery* (London, 1886), 6.

13. Mary Bennett, *Catalogue of the William Holman Hunt Exhibition* (London: Victoria and Albert Museum, 1969), no. 22.

14. *The Language of Flowers* (London: Saunders & Otley, 1835), 295.

15. *Language of Flowers*, 297.

16. Alastair Grieve, "The Pre-Raphaelite Brotherhood and the Anglican High Church," *Burlington Magazine* 117 (May 1969): 294–95.

17. *Collected Works of Rossetti* 1:344.

18. Ibid., 1:346, 348–49.

19. Ibid., 1:352.

20. Ibid., 1:214.

21. William Michael Rossetti, ed. *Germ: A Facsimile Reprint* (London: Stock, 1901), 23.

22. Mirella Levi D'Ancona, *The Garden of the Renaissance* (Florence: Leo S. Olschki, 1977), 194, 210, 332–36.

23. Georgiana Burne-Jones, *Memorials of Edward Burne-Jones*, 2 vols. (London: Macmillan, 1904), 1:129–30.

24. *Autobiographical Notes on the Life of William Bell Scott*, ed. William Minto, 2 vols. (New York: Harper Bros., 1892), 1:315.

25. Quoted in Virginia Surtees, *The Paintings, and Drawings of Dante Gabriel Rossetti 1828–1882: A Catalogue Raisonné*, 2 vols. (Oxford: Clarendon Press, 1971), 1:69.

26. *Complete Works of John Ruskin*, ed. Edward T. Cook and Alexander Wedderburn, 39 vols. (London: George Allen, 1903–12), 29:88–90.

27. For example, see the letter quoted in Mary Watts, *George Frederick Watts*, 3 vols. (London: 1912), 1:173.

28. Thomas Hall Caine, *Recollections of Rossetti* (London: Cassell, 1928), 232.

29. William Michael Rossetti, *Dante Gabriel Rossetti as Designer and Writer* (London: Cassell, 1889), 108.

30. See, for example, Titian's *Sacred and Profane Love*, Borghese Gallery, Rome; see also Veronese's allegorical *Abundance, Fortitude* and *Envy* (1540, Villa Barbaro, Maser) or his *Dialectic* or *Industry* (1577, Pallazo Ducale, Venice).

31. See William Michael Rossetti, unpublished list of D. G. Rossetti's books (Vancouver: Library of the University of British Columbia, 1866). Rossetti may also have used Filippo Pistrucci's *Iconologia* (Milano, 1819–21), which itself was largely based on Ripa. See Alicia Craig Faxon, *Dante Gabriel Rossetti* (New York: Abbeville Press, 1989), 193, n. 26.

32. *Dante Gabriel Rossetti and Jane Morris: Their Correspondence*, ed. John Bryson and Janet Troxell (Oxford: Clarendon Press, 1976), 71.

33. Cesare Ripa, *Iconologia* (1611 reprint, New York: Garland Publishing, Inc., 1976), 482.

34. See Sarah P. Smith, "Dante Gabriel Rossetti's *Lady Lilith* and the Language of Flowers," *Arts Magazine* 53 (February 1979): 142–45.

35. This book does not exist. The quotation was possibly written by Swinburne. See Surtees, *Paintings and Drawings of Rossetti*, 1:128.

36. Translated from the French by Rowland Elzea in *Wilmington Society of the Fine Arts Samuel and Mary R. Bancroft English Pre-Raphaelite Collection* (Wilmington, Del.: Wilmington Society of the Fine Arts, 1962), 13.

37. Cesare Ripa, *Iconologia* (1603; reprint, Hildesheim, N.Y.: George Olms, 1970), 27–28.

38. Anne Pratt and Thomas Miller, *Flowers in Language: Associations and Tales* (London: Simpkin, Marshall, Hamilton, Kent & Co., n.d.), 23.

39. This quotation and quotations above are from Ripa, *Iconologia*, 1603 ed., 27–28.

40. M. Didron, *Christian Iconography*, trans. E. J. Millington, 2 vols. (London: Henry G. Bohn, 1851), 2:173.

41. Ingram, *Flora Symbolica*, 356.

42. Ibid., 360.

43. Ovid, *Metamorphoses*, trans. Mary M.. Inness (Baltimore: Penguin Books, 1955), 83–87.

44. *The Rossetti-Leyland Letters*, ed. Francis L. Fennell, Jr. (Athens: Ohio University Press, 1978), 33.

45. *Rossetti-Leyland Letters*, 29.

46. Ripa, *Iconologia*, 1603 ed., 66–67, 186, 235.

47. Oswald Doughty, *A Victorian Romantic: Dante Gabriel Rossetti* (London: Oxford University Press, 1960), 46.

48. Quoted in William Sharp, *Dante Gabriel Rossetti: A Record and a Study* (London: Macmillan, 1882), 236.

49. Quoted by Johnston Forbes-Robertson, *Times* (London), 11 May 1928.

50. Quoted in Sharp, *Rossetti*, 91.

51. Quoted in Doughty, *Victorian Romantic*, 477.

52. The relationship between Dante Rossetti and Jane Morris is recounted in Doughty, *Victorian Romantic*; and their correspondence can be found in *Dante Gabriel Rossetti and Jane Morris: Their Correspondence*, ed. Bryson and Troxell (Oxford: Clarendon Press, 1976).

53. *Collected Works of Rossetti*, 1:362.

54. *Collected Works of Rossetti*, 1:371.

55. Ingram, *Flora Symbolica*, 362.

56. Ibid., 259.

57. *Collected Works of Rossetti*, 1:185.

58. Because of the initial negative criticism of the Pre-Raphaelites, Rossetti exhibited very few pictures after 1849–50. A few watercolors appeared with other Pre-Raphaelite works in 1857–59 in provincial exhibitions. He never sent works to the Royal Academy.

59. Jacques Lethève, "La Connaissance des peintres pré-raphaélistes anglais en France (1855–1900)," *Gazette des Beaux Arts*, 6th ser. 53 (May–June 1959); 316–28.

60. See Penelope Fitzgerald, *Edward Burne-Jones: A Biography* (London: Michael Joseph, 1975), 130.

61. See Ron Johnson, "Whistler's Musical Modes: Symbolist Symphonies," *Arts Magazine* 55 (May 1981): 165–66.

62. See the *Gazette des Beaux Arts* of 1859, 1865, and 1869; see also Ernest Chesneau, *The English School of Painting*, trans. Lucy N. Etherington (London: Cassell & Co., Ltd., 1885).

63. For two interpretations of this painting, see Leslie Morrissey, "Isolation and the Imagination: Fernand Khnopff's 'I Lock My Door upon Myself,'" *Arts Magazine* 53 (December 1978): 94–97, and Sarah Burns, "A Symbolist Soulscape: Fernand Khnopff's 'I Lock My Door upon Myself,'" *Arts Magazine* 55 (January 1981): 80–88.

64. *Collected Works of Rossetti*: 1:379.

65. Morrissey, "Khnopff's 'I Lock My Door,'" 95.

66. All are illustrated in Jeffrey W. Howe, *Symbolist Art of Fernand Khnopff* (Ann Arbor: UMI Research Press, 1982), nos. 21, 30, 40. Howe thinks that Khnopff may also have used Ripa as a source for symbols (102).

67. *Collected Works of Rossetti*:

> While fast together, alive from the abyss,
> Clung the soul-wrung implacable close kiss.
>
> (1:201)

68. Quoted in *From the Classicists to the Impressionists: Art and Architecture in the Nineteenth Century*, ed. Elizabeth G. Holt (Garden City, N.Y.: Doubleday and Co., Inc., 1966), 509.

69. Walter Hamilton, *The Aesthetic Movement in England* (London, 1882), quoted in Stephen Madsen, *Sources of Art Nouveau* (New York: Da Capo Press, Inc., 1975), 234.

70. Some Symbolists referred to themselves as "idéistes."

71. Richard Muther, *The History of Modern Painting*, 4 vols. (London: J. M. Dent and Co., 1907), 3, 157.

The Role of Sir Coutts Lindsay and the Grosvenor Gallery In the Reception of Pre-Raphaelitism on the Continent

COLLEEN DENNEY

THE GROSVENOR GALLERY (1877–90), LOCATED AT 135–137 New Bond Street, London, was the venue for progressive trends in late–nineteenth-century art; and the owner of the gallery initially focused on the encouragement of Edward Burne-Jones, his followers and associates.[1] Burne-Jones achieved widespread popularity in France in 1878 when he exhibited at the Exposition Universelle in Paris; but while most scholars have recognized this fact, no one has explained exactly what events instigated Burne-Jones's success. This essay investigates the role of Sir Coutts Lindsay (1865, National Portrait Gallery, London, fig. 1), owner and proprietor of the Grosvenor Gallery, in bringing the second generation of Pre-Raphaelites to the attention of the British and French public prior to the 1878 Exposition in Paris, through his selection of exhibitors at the gallery, his recasting of exhibition displays, and his methods of publicizing the artists. Overall, it will be seen that the owner's innovative practices and the gallery's elaborate setting were influential in making the artists' reputations both at home and abroad. Thus, the text reveals the Grosvenor Gallery as a site of change by exploring (a) the reason why the works of second-generation Pre-Raphaelites and their associates created such an impetus when they were shown at the Grosvenor and (b) what Lindsay's part was in staging the Pre-Raphaelites' further influence on the Continent.

In 1878, Sir Edward Burne-Jones acquired international notice when three of his paintings were included in the British Fine Arts Section of the Exposition Universelle in Paris: *Merlin and Vivien* (now called *Beguiling of Merlin*) (1873–77, Lady Lever Art Gallery, Port Sunlight, fig. 2), *Love Among the Ruins* (1873, Private Collection), and *Love the Doctor* (date and location unknown).[2] Other artists of Burne-Jones's circle also appeared at this exhibition; John Spencer Stanhope with *Lock* (now called *Our Lady of the Water Gate*) (undated, private collection) and *On the Edge of the River Styx* (now called *Orpheus and Eurydice on the Banks of the River Styx*) (undated, private collection), Marie Spartali Stillman with a watercolor entitled *Fiametta* (date and location unknown), Walter Crane with two watercolors and his large painting *Renaissance of Venus* (1877, Tate Gallery, London), Albert Moore with three figurative paintings, Thomas Armstrong with a figurative painting *Music* (date and location unknown), and George Frederic Watts with ten paintings that included *Love and Death* (1875, Bristol Museums and Art Gallery, England, fig. 3).[3] The emergence of this group of artists at an international exhibition on the Continent was seen as a major discovery, since the majority of them had only begun to show their works on the London art scene a year earlier at the opening of Lindsay's Grosvenor Gallery. Among these artists, Dante Gabriel Rossetti was asked to exhibit at the Grosvenor. But Rossetti had not shown his works in public since 1857–58 (when he exhibited them at the Hogarth Club); and following the Buchanan controversy over his poems, he was reluctant to seek the limelight.[4] Furthermore, he refused to show at the Grosvenor because he felt that the inclusion of certain Royal Academicians negated the gallery's secessionist purpose.[5] Rossetti's former teacher—Ford Madox Brown, who, as senior member of the Pre-Raphaelite circle, suffered from a wounded ego at not being approached first about the new scheme—also decided not to exhibit at the Grosvenor.[6] As a result, all attention was focused on Rossetti and Brown's colleague and follower, Burne-

Fig. 1. Julia Margaret Cameron. *Sir Coutts Lindsay.* ca. 1865. Albumen print. 8″ × 10″. National Portrait Gallery, London, England.

Jones, who was most important in this respect, since—prior to his appearance at the Grosvenor—his work had not been seen in public for seven years.[7]

Unlike Burne-Jones, Moore had received much more public exposure during the early part of his career. He began to show his works at the Royal Academy in 1857, his mature style receiving notice there as early as 1865.[8] Other young artists who were struggling for public notice on the London exhibition scene included John Melhuish Strudwick, Spencer Stanhope, and Spartali Stillman—painters who were associated with Burne-Jones when their works were exhibited together at the Grosvenor. Their works were occasionally accepted for exhibition at the Royal Academy during the 1870s. However, they achieved better representation during these same years at the Dudley Gallery, where their works were accepted for exhibition on a much more regular basis.[9]

Watts, who was a generation older than this

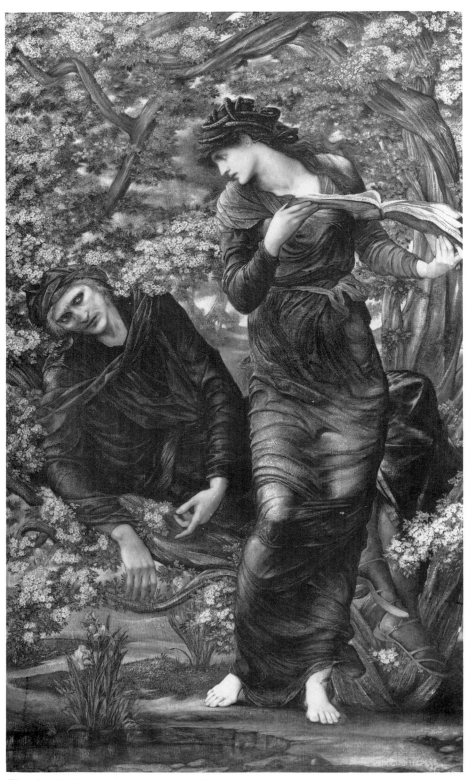

Fig. 2. Edward Burne-Jones. *Beguiling of Merlin*. 1874–77.
Oil on canvas. 73″ × 43¾″. Lady Lever Art Gallery, Port
Sunlight, England.

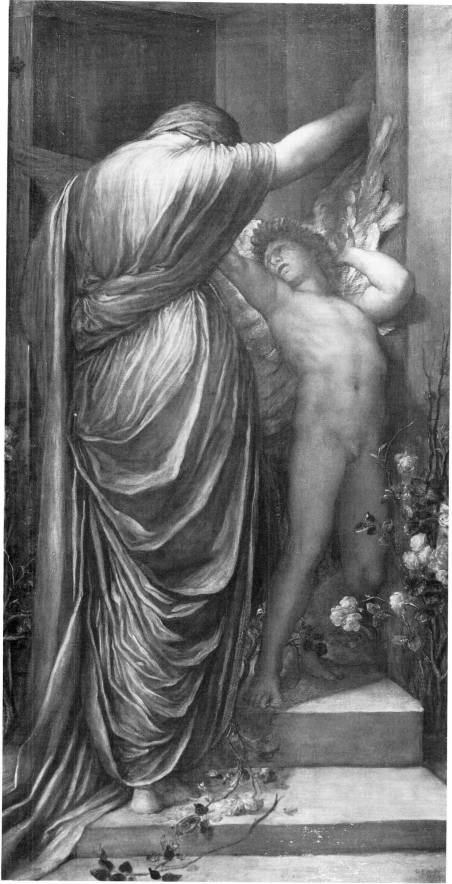

Fig. 3. George Frederic Watts. *Love and Death*. 1875. Oil on canvas. 59½″ × 29½″. Bristol Museum and Art Gallery, England.

younger circle—and actually the teacher of Spencer Stanhope for a period—had begun exhibiting at the Royal Academy in 1837. However, he was not generally popular there and was often badly treated.[10] Like Burne-Jones and Rossetti, he relied primarily on private patronage. Evelyn Pickering, who achieved a Pre-Raphaelite style independent of Burne-Jones and Rossetti, had not finished her schooling until 1875; and the opening exhibition of the Grosvenor signaled her debut, as well as the rediscovery of the talented artists already mentioned.[11]

The collective presence of these painters in the 1878 showing of British art proved influential on Continental artists. The first generation of Pre-Raphaelites (along with Watts) had received attention in France at the 1855 exposition in Paris; but at that time, those artists were criticized for their insularity: for example, Ernest Chesneau believed that the first generation of Pre-Raphaelites did not take advantage of modern movements occurring in France.[12] The true link from the first generation to the second was Rossetti, who exhibited neither in 1855 nor in subsequent expositions in Paris. Burne-Jones was Rossetti's follower; and he responded positively in his own works to Rossetti's treatment of rarified feminine beauty and Rossetti's preoccupation with myth, allegory, and chivalric British history—an approach clearly reflected in Burne-Jones's *Beguiling of Merlin,* a work that was acclaimed by French critics when it was shown in Paris in 1878.[13] In Holman Hunt's retrospective glance at the second generation of Pre-Raphaelites, he understood Burne-Jones's inspiration to be Rossetti himself: in Hunt's eyes, the younger circle, in general, loved "to exaggerate the more 'enfranchised' phase of Rossetti's mind."[14] And Hunt distinguished between the medievalists, of whom he was one, and the *quattrocentists,* whom he saw as "outrageous sentimentalists" who denied forms of masculinity in favor of sickliness and morbidity.[15] Similarly, a critic reviewing the Grosvenor exhibit in 1879 believed that Burne-Jones's *Pygmalion* series (1868–78, Grosvenor version, Birmingham City Museum and Art Gallery) evoked "supersensousness . . . derived from Mr. Dante Rossetti's queer ideal of womankind—with hollow cheeks and square jawbones, necks like swans with the goitre, hair like Topsy's, lips of the same race, 'stung,' therefore swollen, 'with kisses.'"[16] It was this latter school and these very characteristics that would draw attention on the Continent. Rossetti's failure to show his works in public, both on the Continent and in Britain, made Burne-Jones's appearance in both places all the more striking and original. For example, Jacques Lethève, in his article on the French response to these artists in 1878, revealed that the French believed Burne-Jones to be a novelty at the exposition, "especially since they did not know the works of Rossetti."[17] Here was an artist who took Pre-Raphaelitism to new heights, with great attention to decorative treatment, united with a neopagan fascination with the Early Renaissance artist Sandro Botticelli and the classical myths. The responses of the French to this circle of British artists were rather uniform; the French admired these British artists for their deliberate imitation of the Italian Primitives (especially their reinterpretation of Botticelli), the decorative attitude of their figures, and the new type of feminine beauty that they had created.[18] Edmund Duranty perceived Watts's *Love and Death* to be inspired by the younger school—especially by Burne-Jones, Spencer Stanhope, and Crane—in the similar elongation of form in Watts's painting and the mysterious qualities of Watts's figures, writhing with animation. Duranty felt that these younger artists had given Watts new insight, infusing his aged gifts with a young spirit.[19] Duranty's observations are important because he linked Watts with the younger circle of artists, whom he perceived to be a unique school distinguished by the similar expression of their figures and whom he dubbed "the new Pre-Raphaelites," with Burne-Jones as their leader.[20]

Burne-Jones and his circle were given prominent positions at the Paris exposition by virtue of the traditional organization of such events. Oil painting as a medium (along with watercolors) was given pride of place in the fine-art sections: this prominence left little room for the recognition of other media, and oil painting was consistently viewed as the most important art form at such international exhibitions.[21] These fine-art sections were divided equally between host institution and foreign schools. The inclusion of works was determined through a jury system in the home country—a selection of only those works that had been shown in public and had become known; in this case, Lindsay himself was chosen as one of the British jurors by the Prince of Wales, hence he had a direct hand in choosing the British artists who would show in 1878. The result of this 1878 exhibition was reflected in Paul Greenhalgh's statement: "The British artists to appear most consistently in international exhibitions both in Britain and abroad were Sir Edward Burne-Jones, Sir John Everett Millais, William Powell Frith and Sir Laurence Alma-Tadema. All were proclaimed at various times as best British artist . . . and all four exerted enormous influence over their contemporaries. It would

be fair to say also that Burne-Jones had influence on European symbolism between 1880 and 1906."[22] It is hard to imagine the best French artists not benefiting from the art brought to France by the British in 1878 since, as Greenhalgh indicated, dating from this appearance in Paris, Burne-Jones experienced a blossoming of his career on the Continent and began to exert an influence on European Symbolists.

The taste for British art continued in France after Burne-Jones's emergence in 1878, which itself was a direct result of his reappearance in public at the Grosvenor in 1877. This interest in British art was encouraged and enlarged by a number of British and French publications that further disseminated knowledge about the younger generation of Pre-Raphaelites. These writings included Frederick Wedmore's *Studies in English Art,* in which the author praised the same characteristics that so pleased the French in 1878, noting of Burne-Jones in particular that

> in some sense it is to his disadvantage that he has set himself so especially to the art of symbolism, and the realisation of classic or mediaeval story. It has necessarily lost him some admirers; it has made him, to many, more difficult of reception. On old themes, it was asked, what had he to say? But, on the other hand, it is by his resolute adherence to many a theme which weaker and more conventional treatment than his had made appear outworn and henceforth barren that he has shown so conclusively his own inventiveness—one of the great gifts which have prevented him from poorly imitating an elder art while being at the same time no doubt a follower of it.[23]

It is significant, too, that Wedmore used the term *symbolism* to recognize this new artistic departure.

After 1880, the Pre-Raphaelites also received much greater coverage from the French press, which, more often than not, held Burne-Jones up as the example of the school—and one who was responsible for the celebration of a new female type of beauty and who appeared to the young French aesthetes as "a modern Botticelli."[24] That French journals achieved a wide circulation and had an important influence is evidenced in a statement by Elizabeth Gilmore Holt, who wrote that, like the Universal Expositions themselves, "journals and newspapers were yet another vehicle for the popularization and internationalization of the arts. . . . [They] were essential to anyone who wanted to keep abreast of current events in the international world of the fine arts. Europe's most widely read art periodical was the *Gazette des Beaux Arts,* established in 1859 and directed by Charles Blanc."[25] *Gazette des Beaux*

Arts, as I have shown, frequently reported on British artists in its pages; and the journal was certainly, in this way, one of the important means of disseminating information about the work of British artists.

In addition to these publications—and partly as a result of them—exhibition organizations on the Continent were drawn to Burne-Jones and his circle as important artists who experimented with Symbolism. For example, the young Belgian artists who made up Les Vingt (1884–93) invited innovative artists from other countries to exhibit with them—artists who were selected for "their distinction and/or their *avantgardisme,* so that they both attracted public attention to the exhibitions and provided a stimulus for the members."[26] The Germans were also influenced by the younger Pre-Raphaelites—Burne-Jones receiving recognition and honors in Germany in 1893 and 1897; and in 1901, Otto von Schleinitz published his monograph on Burne-Jones. In turn, the young artists of the Jugendstil movement saw him as a spiritual leader.[27] Thus, by 1900, Burne-Jones, Watts, and the younger generation of the Pre-Raphaelites had broken that preconception of the separateness of British art—aided, as I will show, by their mediator, Sir Coutts Lindsay.

What was it that brought about this crucial shift in artistic opinion about British art? I contend that Lindsay's efforts in bringing previously unknown—or only privately recognized—artists before the public marked the starting point of this alteration. In his decision to open a gallery, Lindsay perceived that British art was moving in a new direction that was not being sufficiently represented by the existing institutions. The circle that Lindsay championed at his gallery comprised Burne-Jones and his followers and associates—Pickering, Spencer Stanhope, Strudwick, Moore, and Watts, as well as Whistler.

In the creation of the new exhibition space that would house these misrepresented artists, Lindsay decided that the great need was for an open exhibition invitational policy. He initiated not only new approaches to the arrangement and display of contemporary art but also new approaches to the activities appropriate to an art gallery. Charles Hallé, one of the gallery managers, stated that Lindsay's individual approach to contemporary exhibitions stemmed from Lindsay's examination of the basic criteria that were not met by the Royal Academy: "The fundamental idea was to give pictures during their brief public life a fair chance of being seen at their best."[28] In anticipation of the opening of his first summer exhibition, the *Art Journal* critic stated that Lindsay wanted to provide for artists a space in

which their works could be "fairly and honestly seen and judged."[29] The Royal Academy consistently "skied" unknown or lesser-known artists' works—when they were shown at all—in a very crowded exhibition space. The Dudley Gallery, even though it represented some of these same artists, was a very small exhibition space—only one room—and was run by a jury system, much like that of the Academy.[30] Lindsay, on the other hand, opened his exhibition space to artists without intervention of a jury. In addition, he focused on recognition not only for younger artists who were struggling to make a name for themselves but also for artists who had long been neglected or ill-treated by official institutions; furthermore, he encouraged sales and patrons and published artists' works in important journals.[31] Exhibition reform was brought about by Lindsay's new practices, as was shown in observations about the first exhibition. Agnes Atkinson recognized that "the Grosvenor Gallery is neither a dealer's speculation, the enterprise of a 'limited' company, nor the foundation of a society of artists: in many and important points it differs from each and all of these."[32]

The most important point of departure from previous venues was Lindsay's creation of a gallery that would be suitable for a progressive group, whose members he made the central attraction of his gallery. His key artists were shown together for the first time at the Grosvenor in 1877; their influence was further intensified by their placement in one room—for it was not until the first summer exhibition at the Grosvenor that Burne-Jones reentered the public scene and brought together the ideas of the *quattrocentists* and the philosophies of decorative treatment and two-dimensionality of all of these artists. In the large West Gallery on opposing walls were eight contributions by Burne-Jones—including *Beguiling of Merlin,* a series of six panels framed together as *Days of Creation* (1876, Fogg Art Museum, Harvard), and *Venus's Mirror* (1877, Calouste Gulbenkian Foundation, Lisbon)—and two by Watts, including his *Love and Death;* in between, in individual sections, were Whistler's *Nocturne, Arrangement,* and *Harmony* series, as well as Moore's figure panels. In addition, Strudwick's *Love's Music* (date and location unknown) and Spencer Stanhope's four contributions hung in this same room.[33] In his role as spokesperson for these artists, Lindsay stressed (in an interview with *Art Journal*) that they were "either unable or unwilling to exhibit elsewhere" and emphasized that "there are several thoughtful men in London whose ideas and method of embodying them are strange to us: but I do not think *strangeness,* or even eccentric-

ity of method, a sufficient excuse for ignoring the works of men otherwise notable."[34] In *Art Journal,* for a few months prior to the exhibition, Lindsay advertised that his gallery would be showing the works of certain artists "who for various reasons have during several years kept aloof from the annual exhibitions of the Royal Academy."[35] Furthermore, an *Art Journal* critic, reporting information obtained from Lindsay, pointed out that a new generation of artists was to be shown at the Grosvenor Gallery rather than at the Academy—artists who would put the Grosvenor on an equal footing "with the leading Art Centres of Europe."[36] This statement implied that the Grosvenor artists represented a fresher outlook than that reflected in the art of the Academy, and it also divulged Lindsay's international emphasis. Where the jurors of the Academy sanctioned Victorian "subject-pictures" and the Classic Revival style of Leighton and his circle, Lindsay was not afraid to include pictures that expressed a new spiritual significance (or even "strangeness") that was reflective, not of Victorian mores and insular ideas about art and life, but rather of a wider knowledge of artistic trends that represented a new path. For example, one of his managers, Joseph Comyns Carr, observed with hindsight of the Academy:

> At a time when the national interest in matters of art was scarcely recognized, it might, by a liberal interpretation of its duties, have become the acknowledged centre of a coherent system of art administration, but it had chosen instead to allow nearly all that was done by way of progress to be accomplished by independent effort. . . . Holman Hunt, Rossetti, Burne-Jones, Ford Madox Brown, knew nothing at that time of academic honour, and their work, if it was submitted for official judgement, was either coldly received or was treated in a spirit of active hostility.
>
> It was that which gave to the movement which resulted in the establishment of the Grosvenor its importance and significance.[37]

Thus, Lindsay's gallery was the "independent effort," with Burne-Jones as the central focus for a new school of thought in painting.

A survey of the British response reveals that the link of Burne-Jones's circle to both the Aesthetic Movement and to Symbolism was readily apparent; but unlike the response on the Continent, the English criticism was more often than not negative, even though the critics recognized the same characteristics in the works exhibited. The sensuous subjects of this new school of painters were taken, in large part, from the subjects of Aesthetic poetry—and, thus, these painters aligned their works with the theory of the

correlation of the arts. Oscar Wilde, a proselytizer of Aestheticism himself, was one of the first to recognize this association. Writing of the first exhibition, he concluded by stating: "Sir Coutts Lindsay, in showing us great works of art, will be most materially aiding that revival of culture and love of beauty which in great part owes its birth to Mr. Ruskin, and which Mr. Swinburne, and Mr. Pater, and Mr. Symonds, and Mr. Morris, and many others are fostering and keeping alive, each in his own peculiar fashion."[38] Lindsay addressed this aspect of his Grosvenor exhibitors in a lecture delivered at Manchester in 1879. Observing how Burne-Jones had distanced himself from the original group of the Pre-Raphaelites, he stated:

> The public are only now becoming familiar with his works through the exhibitions of the Grosvenor, and I am happy at the opportunity I have been able to afford for such a result. He and certain others . . . are advancing in the same direction. Mr. Watts stands pre-eminent among them and may, I think, be considered their chief, both from his maturer age, the extent of his knowledge, the dignity of his works, and the authority he has among all sections of artists. Painting and poetry are nobly blended in the efforts of these men.[39]

Regarding the European Symbolists, MaryAnne Stevens has observed that "given the need to protect the discreet position of the artist as mediator, the Symbolists viewed the official art of the Salon as commercial and hence debased, and sought to propogate an art which was accessible only to an elite."[40] The Grosvenor Gallery achieved this same end according to Heathcote H. Statham. His criticism stands for numerous other examples of this stance in relation to the position of the gallery, which was itself, in many respects, striving against the commercial ventures of other exhibition arenas:

> It is impossible to overlook the presence of an element of eccentricity, the prominence given to types of painting which form the special *cultus* of small groups of worshippers who offer up a blind admiration, each to their own special high priest. There is far too much at present of this private clique spirit in connection with painting in England. An artist declines public notice, and shows his productions only as a special favour to a special circle, who kiss the hem of his garment and see nothing but perfection in his work: and if we inquire, why this mystery and privacy? we are gravely rebuked, and asked on what principle an artist is bound to make public his work at all?[41]

This exclusiveness was closely associated with the figures of the Aesthetic Movement who made the Grosvenor their home. George du Maurier, for example, in his series of Aesthetic Movement illustrations, included this so-called mutual-admiration society, in which the ladies wear the forlorn faces of Burne-Jones's models and the characters elicit witty quips à la Whistler and Wilde.[42]

In relation to this concept of elitism, many critics were not delighted by the "peculiar" artists whom Lindsay chose to promote, one critic going so far as to declare "if the eccentric and peculiar are to have in future exhibitions . . . the places of honour, the real artistic geniuses . . . would not care to parade their works with these, and the Grosvenor Gallery would become a merely artistic lounge for the worshippers of the Fleshly School of Art."[43] In this passage, the writer's reference to the criticism made of Rossetti and Swinburne as the leaders of that "Fleshly School of Poetry" thus linked the Grosvenor artists with the Aesthetic school of poetry, as Wilde had done on a much pleasanter note.

One of the major criticisms of Burne-Jones and his school of painters concerned their borrowings from the Italian Primitives—an aspect of their works that was praised by Continental writers. Burne-Jones and his followers were believed to owe a debt to the decorative quality of *quattrocento* art as well as to its intense color.[44] Following from this observation, a number of evaluations of their art took on moral overtones: it was said that their works conjured up another world—remote from the Victorian present—that revelled in self-centered pleasures such as intense melancholy, sensuality, and implied amorality—elements also characteristic of their Italian Primitive models, especially Botticelli.

In addition to their central importance to the Aesthetic Movement, Burne-Jones, Watts, and the other second-generation Pre-Raphaelites belonged, to one degree or another, to the larger cultural trends of European Symbolism through their interest in poetic painting and their search for new subjects. Symbolism was a European-wide phenomenon by century's end; and in 1898, the following definition appeared: "Symbolism is the name given by French critics to that revolt against the dryness and photographic exactness of naturalism, which . . . is characterized, at its best, by a . . . somewhat dreamy poetry, and half-naive, half-mystical attempt to interpret the moods of nature through the medium of human sensation."[45] By showing works like Burne-Jones's *Beguiling of Merlin* and Gustave Moreau's *L'Apparition (Salomé)* (1876, Louvre, Paris) in the same exhibition Lindsay was making a statement about these Symbolist cross-current developments between Britain and the Continent; for Burne-Jones (as I have shown), like

Moreau, was an inspirational figure of the proto-Symbolist generation. The appearance of Moreau's painting "demonstrated that the new British style was not an insular phenomenon. Moreau's paintings were as exotic, jewel-like and visionary as Burne-Jones's."[46] Like Burne-Jones and Watts, Moreau and his fellow Frenchman Puvis de Chavannes were searching for a new art of poetic inspiration that would, at the same time, break with traditional iconography. Like Burne-Jones, these French artists explored images of deviant and mystical religion, of death, dreams, and introspection. What further united Burne-Jones and his circle with the French proto-Symbolists was their celebration of formal pictorial means over narrative ends—of the decorated surface over the subject.

Wilde did not represent majority opinion in Britain when he noted that Burne-Jones, especially in the *Beguiling of Merlin,* was "a dreamer in the land of mythology, a seer of fairy visions, a symbolical painter."[47] Wilde was perceptive in calling Burne-Jones a "symbolical painter" because, as was pointed out earlier, the latter became an inspiration to the younger European Symbolists. And it was this esoteric subject matter—which created the Symbolist context for his art—that also linked Burne-Jones with Aestheticism.

The specific response to Watts was more favorable—and closer to the Continental praise that he received. Statham, while he did not like the eccentricities of Burne-Jones, saw Watts as the ultimate artist in the 1877 Grosvenor exhibit—an artist whose works were appealing for their great beauty and intensity.[48] Just as on the Continent Watts's works were noted for some new directions—owing, in part, to the influence of Burne-Jones and his circle—so, likewise, Henry James noted in 1877 in relation to Watts's *Love and Death:* "Though he has made his reputation by his portraits, which constitute his usual work, I believe he has a great longing to deal with 'subjects.' He has indulged it in one of the pictures at the Grosvenor, and the result justifies him."[49] These allegorical narratives multiplied from year to year—an indication that the audience at the Grosvenor (that elite audience) was probably more accepting of such new experiments than were the patrons of the Royal Academy.[50]

The criticism of Burne-Jones, Watts, and their circle reveals that the larger public was bewildered by the failure of these artists to address Victorian societal issues that had been an important feature of the original Pre-Raphaelite group. In summary, the public—reflected in the average Victorian art critic—

Fig. 4. William Thomas Sams. *Intended Facade of the Grosvenor Gallery, New Bond Street.* Engraving. 4″ × 5½″. *The Builder,* 1877. Author's collection.

was appalled by the references to the Italian Primitives and to the Aesthetic poets, as well as by the unhealthy appearance of the figures in general. For example, one critic responded to the Burne-Jones/Watts circle in the following way: "As to the value . . . of this art, and of the poetry which is its companion, we most seriously protest against it (with a reverence for its genius and a tenderness for its beauty) as unmasculine, and—what is worse from a purely artistic standpoint—self-consciously imitative; nay, unintelligently imitative, for this is not classical, this is not mediaeval, feeling and thought; it is fresh strenuous paganism, emasculated by false modern emotionalism."[51] These were the common complaints about this group of artists who looked

back, but not to the respected sources—and, as a result, their works were affected by an emotionalism that lacked proper Victorian sentimentality. This was not the strong, revered honesty of Greek art—like that of the artists of the Academy—but one associated with rarefied taste. This rejection of the typical Victorian narrative-genre scene set Burne-Jones and his generation apart not only from the first-generation Pre-Raphaelites but also from British art, in general—and, in turn (ironically), this is what made it accessible and exciting to a European audience.

Mirroring the character of its key exhibitors, Lindsay's gallery (figs. 4 and 5) challenged and provoked the normative role of London's expositions. The first summer exhibit opened on 1 May 1877 and ran through 31 July 1877.[52] The building's location at 135–137 New Bond Street contributed to its success since Old and New Bond streets were recognized as the center of the fashionable district of London—a concern that is still reflected today in the many famous jewellers, designer-clothing stores, picture galleries, and auction houses that line the street and attract wealthy middle- and upper-class customers.[53] Thus, during the nineteenth century, at the time of the erection of the Grosvenor Gallery, the Bond Street area was a tasteful combination of fashion and commerce—a strategic position for a gallery whose owner wished to encourage the fine arts.

The facade of the Grosvenor, like the interior, was constructed in a neo-Renaissance style—a sign of Lindsay's desire to convey a sense of splendor in order to attract visitors and potential patrons. The facade was completed with Portland stone, shopfronts appearing on either side of a Palladian entrance.[54] Some critics were not enthusiastic about the ornate building that Lindsay erected. A critic for *Athenaeum* found the Grosvenor "sadly out of place among the shopfronts of Bond Street, and in the character of frontispiece to a picture gallery and the restaurant attached"; but even worse for this critic was the Palladian doorway, "as thoroughly 'Pagan' as anything that has excited the wrath of Mr. Ruskin, and is to be regretted on the score of good taste, and as out of keeping with the spirit which called into existence this institution for the encouragement of fine art."[55] This critic had not understood that the exterior was by large measure indicative of many of the works that would be shown—works that catered to an elite sensibility and were themselves "pagan" in both their subject matter and their approach to that subject matter.

The first floor of the gallery contained the exhibition rooms, the largest being the West Gallery (fig.

Fig. 5. *West Gallery, The Grosvenor Gallery of Fine Art, New Bond Street.* Engraving. *Illustrated London News,* 1877. Author's collection.

5), which during the day was flooded with natural light from the skylight directly above, and during the evenings was given over to the artificial light of the gas jets. This diffused system of lighting was used by many venues, including the Royal Academy. What set the Grosvenor apart was its inclusion of a velarium cover (on the outside) that was used to control the amount of light that entered the gallery.[56] This innovation—decorated, like the ceiling, by James McNeill Whistler—pointed to the significance of Whistler's place in the scheme of decoration since Lindsay incorporated an interior design concept that closely paralleled Whistler's aesthetic sensitivities, from the careful coordination of colors to the placement of paintings and the inclusion of tasteful furnishings.[57] The ceiling of the West Gallery was divided into bays painted in a deep blue—each bay

or panel representing a phase of the moon accompanied by gold stars. The frieze—designed by Lindsay himself—consisted of cherubs holding fruits and flowers, which camouflaged an early version of a cooling/heating system devised for the comfort of visitors. The walls of the West Gallery were divided into sections by sixteen Ionic pilasters of richly gilt oak, which had been salvaged from the foyer of the old Italian Opera House in Paris. The walls were covered with crimson silk damask as an attractive background for the paintings, which were tastefully hung between the pilasters. The dado below the pictures was of a deep green velvet. The visitor could enter the East Gallery through either of the two doors shown on the left of the illustration of the West Gallery. The smaller of the two main galleries, the East Gallery measured twenty-eight by sixty feet. Here, too, light was controlled by a velarium from the exterior of the building. During the day, the principal light source of the East Gallery was the skylight, with gas jets employed in the evenings. There were crimson silk hangings, a frieze designed in a delicate arabesque, and pilasters painted in cream and gold. The overall color scheme of the East Gallery was blue and gold. The beauty of the building created quite a sensation, of which one critic complained: "In sumptuousness no exhibition in London can be compared with it; but,—at least until the splendours of the crimson silk damask, the gilding, the green velvet hangings, the gilt furniture, and other accessories are subdued—this unwonted magnificence is disastrous to some of the finest paintings which it was designed to honour."[58] Ironically, the spectacle of the gallery itself—built to impress and to reflect the neo-Renaissance stance of many of its artists—seemed to overpower the works for which it was created. Obviously, this critic, familiar with other exhibition spaces of the period, recognized the uniqueness of the building. Similarly, the critic for *Architect* believed that the Renaissance splendor of the gallery was "intended as a protest against the prevalent scheme of colour and tone of feeling of the day" and recognized the color and style as *'cinquecento,'* and thoroughly Italian."[59] Galleries of the period, prior to Lindsay's experiment with the color scheme of the Grosvenor, were dull by comparison. At the Royal Academy, for example (as at the Paris salons and Universal Expositions) the works were hung so closely together that there was no room between pictures even to see the wall surfaces. In fact, Lindsay's gallery was the first in London where there was some breathing space between pictures and where an artist's works were hung together in one

grouping. Gordon Fyfe has observed that questions of artist as "creator" and of "authorship" did not exist in exhibitions until the advent of the Grosvenor and that this recognition of a singular artistic talent was achieved by the placing of an artist's works together on one wall—a practice that was not carried out at the Academy or in other venues of the period.[60] Thus, the works by Burne-Jones and his circle, as nowhere else, could be studied as a distinct group—not only as a school but as individual artists. For example, in comparing the Grosvenor and the Academy, a *Saturday Review* critic exclaimed: "It is only fair to remember that Sir Coutts Lindsay's gallery has an immense consummate skill for the exhibition of a limited number of pictures, each one of which is seen to advantage, and that very striking works may suffer considerably from being hung on overcrowded walls."[61] Lindsay's policy of hanging paintings did away with the controversial *line* of the Royal Academy and other long-established institutions—the *line* being the area at roughly eye level that was meant to be the most advantageous height to have one's work positioned. The Royal Academy had continuously used congested hanging methods, from its foundation up through (and even after) the formation of the Grosvenor. However, this tradition was even older than the Royal Academy going back at least as far as the early eighteenth century, when such a system was used at the first permanent exhibition arena in Europe open to the public—the French salon. Lindsay was breaking with an exhibition standard that was at least 150 years old; and in so doing, he took a very important step forward in exhibition reform.

Plans of the Grosvenor Gallery illustrate the other novelties that Lindsay incorporated and that set the Grosvenor apart from the average London or Continental gallery: in addition to the careful hanging arrangments, coordinated color schemes, and a system of diffused lighting, there were buffet bars, a billiard room, dining room, smoking room, and an elegant restaurant for refreshment.[62] In fact, Lindsay had brought the history of galleries full circle: by making his space like that of the aristocrat's country home—to which the proud owner invited guests for public visits—Lindsay duplicated in appearance and accommodations the origins of the picture gallery in the private "palace of art," a phrase that was used to describe the gallery early in its career.[63] In his gallery, Lindsay gave great dignity to works of art: they were not crowded together as though they were commodities at an art fair but rather were "arranged for public exhibition as nearly as possible as though

they formed the decoration of the walls of the house he lived in, and could live in with pleasure."[64]

A critic for *British Architect and Northern Engineer* summarized the prevailing view of Lindsay's achievements in exhibition design and scheme:

> No one who has frequented modern exhibitions can have failed to recognize the unfortunate conditions under which serious works of art are often displayed. The uncomfortable crowding, which in its turn involved as a necessity the most inharmonious juxtapositions of discordant styles, is alike painful to the artist and to the public. It spoils the effect both of things serious and things trivial; and so strong has been the feeling of artists and amateurs on this point that here alone Sir Coutts Lindsay's reformed system has received universal approbation and welcome.[65]

Other reasons for the gallery's early success resulted from the role played by Lady Lindsay. She was an extremely entertaining hostess, who held Sunday receptions for artists, patrons, and critics— thus enabling artists to make the necessary social connections for obtaining private patronage. In her hands, the Grosvenor became more than a picture gallery: it was the premiere social setting for the art crowd, the locale where one went to be seen.[66]

In addition to his efforts in design reform among his exhibitors and his inclusion of a new group of artists, Lindsay was also attentive to the advocacy of his artists. He employed two managers, Charles Hallé (an amateur artist) and Joseph Comyns Carr (a journalist), to aid him in his goal. Hallé had been included in the scheme since its inception in 1875; Carr was involved as a press agent for the opening exhibition in 1877 but did not join the staff until 1878.[67] Carr was recruited partly because he had written articles on Burne-Jones and Rossetti over the signature "Ignotus" in the contemporary journals, and he had also been critical of the Royal Academy practices in a series of articles in the press.[68] Asking a journalist—and one who was not afraid to tackle controversial subjects—to join the team was a strategic move. According to Hallé, early in 1877 Carr and other critics—namely, Tom Taylor and George Redford—were asked "to prepare the mind of the great British public for the artistic treat in store for it in the spring."[69] But Carr became the resident press representative for the gallery—his writings functioning as the official public notice of Lindsay's intentions.

Carr became more active as an art critic after he had joined the staff of the Grosvenor, at which time he began writing for *Pall Mall Gazette, Art Journal,* and *Manchester Guardian;* but as early as 1875,

when plans for the Grosvenor were in their nascent stages, he had been appointed English editor of the luxuriously illustrated French periodical *L'Art.*[70] Carr dropped his editorship of *L'Art* after 1883; but during the crucial years 1877–83, one of his main goals for this French journal was the dissemination of information about the artists whom Lindsay supported at his gallery.[71] In a series of articles in *L'Art* during the time period 1877–83, Carr made a conscious effort to advertise the gallery to a French audience. In his first article, Carr stressed that the gallery had been established because the Royal Academy had not furnished a true representation of contemporary art.[72] Writing at the time of the first shows of the Grosvenor, Carr declared the gallery's special mission—namely, to promote British and foreign art in an international arena that signaled a challenge to the national exhibitions of the Royal Academy.

As editor and writer for *L'Art,* Carr was able to reach a Continental audience (his articles were written in French); and through this medium, the activities of the Grosvenor became known to European artists and critics who could study—in its attractive format—engravings of works by Burne-Jones, Watts, and others, well before the 1878 exposition in Paris. Toward this end, he wrote individual articles on key artists at the Grosvenor, especially Burne-Jones and Watts. He promoted the same qualities and characteristics that would soon be echoed in the French responses to these artists: he singled out Burne-Jones for the individual intensity and beauty in his works, and he distinguished Burne-Jones as the best reinterpreter of the Florentines.[73] He explained, moreover, that Burne-Jones's works had not been seen in public and were unknown except by a small circle of initiates, thus tantalizing his audience into thinking that they were privy to something very exclusive. In this small circle, Carr included all of the artists who would soon be showing in Paris: Spencer Stanhope, Strudwick, Armstrong, Crane, and Watts. These notes of praise were accompanied by very detailed illustrations of exquisite quality and long written descriptions of each work.

Other sources for images by these artists were the offices of the English edition of *L'Art,* which, as early as 20 January 1877 (prior to the official opening of the Grosvenor), were located at 135 New Bond Street—that is, probably in one of the shop-front spaces of the Grosvenor Gallery itself. Advertisements for the *L'Art* offices and the contents of specific issues ran in the English journal *Academy,* one of which (fig. 6), in April 1877, disclosed: "A large col-

Fig. 6. Advertisement for *L'Art. The Academy,* 1877. Author's collection.

lection of the Proof Etchings published by *L'Art,* of which printed catalogues may be had on application, is now on view at the *Librairie de l'Art,* 135 New Bond Street."[74] Included in these lists of proof etchings were, among others, works by Watts, Burne-Jones, and Whistler; in fact, all of the artists listed were included in the first Grosvenor summer exhibition.[75]

Lindsay conducted other publication efforts through the French branch of *L'Art.* The illustrated Grosvenor Gallery catalogs, which included drawings of works from the Grosvenor exhibits, were available at all booksellers in England and were available in France at the Paris offices of *L'Art,* beginning in 1878.[76] Through these catalogs, as well through the journals, Lindsay was able to bring British artists to the attention of French artists and to the Continental public in general.

At the time of its first summer exhibition, the Grosvenor Gallery was destined to be a successful venue for the promotion of new trends in British art. Sir Coutts Lindsay, proprietor and director, had provided an elegant environment for the appreciation of fine art; and he had created a built-in system of publication through his own circle of select art critics, thereby assuring favorable coverage in the press, both in England and on the Continent. With the advent of Lindsay's gallery, British art achieved an international focus—one that was apparent in the subsequent careers of Burne-Jones, his associates, and followers.

NOTES

1. A version of this essay was given at the Sixth Annual Colloquim of Interdisciplinary Nineteenth-Century Studies, Yale Center for British Art, April 1991. Research for this study was funded in part by a Basic Research Grant from the University of Wyoming. On the Grosvenor Gallery, see Barrie Bullen, "The Palace of Art: Sir Coutts Lindsay and the Grosvenor Gallery," *Apollo* 102 (1975): 352–57; Michele Archambault, "The Grosvenor Gallery, 1877–1890" (Ph.D. diss., London; Courtauld Institute of Art, 1978); Frances Spalding, *Magnificent Dreams: Burne-Jones and the Late Victorians* (Oxford: Phaidon; New York: Dutton, 1978); and Colleen Denney, "Exhibition Reforms and Systems: The Grosvenor Gallery, 1877–1890" (Ph.D. diss., University of Minnesota, 1990).

2. *Exposition Universelle Internationale de 1878 à Paris. Catalogue Officiel. Tome 1: Groupe I, Oeuvres d'Art* (Paris: Imprimierie Nationale, 1878). Reprinted in Theodore Reff, ed., *World's Fair of 1878* (New York and London: Garland, 1981), No. 121 (in the painting section); the two subsequent paintings were included in the watercolor section, nos. 84–85.

3. Ibid., Spencer Stanhope, nos. 240 and 241; Spartali Stillman, no. 136; Crane watercolors, nos. 240–241, and his painting, no. 57; Moore, nos. 181–183; Armstrong, no. 16; and Watts, nos. 264–272. Watts worked and reworked his images, often producing several versions of one painting. Scholars are still undecided as to which version actually appeared in 1878 (information from Alex Kidson, 1989), but it was probably the same version that was exhibited at the Grosvenor Gallery in 1877 (*The Grosvenor Gallery, New Bond Street, Summer Exhibition* [London: Jas. Wade and Phoenix, 1877], no. 23, p. 21). The Bristol City Museum and Art Gallery owns the earliest version of this painting, which was shown at the Grosvenor in 1877 (information from Bristol City Museum and Art Gallery files, 1991). I would like to thank Francis Greenacre for sharing files with me and for showing me their version of this painting.

4. On Rossetti's decision, see Evelyn Waugh, *Rossetti: His Life and Works* (London: Duckworth, 1928), 203–4.

5. Oswald Doughty and John Wahl, *Letters of Dante Gabriel Rossetti* (Oxford: Clarendon Press, 1967). See vol. 3, no. 1678, 1422–23, 7 April 1876 letter to Ford Madox Brown concerning the scheme, and vol. 4, no. 1767, 1482–83, 26 March 1877 letter to the editor of *The Times* correcting the notion printed there that he was not to show due to ill health. The Royal Academicians who consistently showed at the Grosvenor included Frederic, Lord Leighton, Edward Poynter, and Laurence Alma-Tadema. Press coverage reveals that their works were outshone by the examples of the other artists who were especially promoted by Lindsay. See Denney, 118–59.

6. Charles Hallé, *Notes from a Painter's Life, including the Founding of Two Galleries* (London: John Murray, 1909), 106.

7. He ceased to show his works with the Old Water Colour Society in 1870 over a censorship dispute. French critics had been attracted to Burne-Jones's works at this time. See Philippe Burty, "Exposition de la Royal Academy," *Gazette des Beaux Arts* 2 (series 2) (July 1869): 53–56. Burty viewed Burne-Jones's works at the Old Water Colour Society and in his studio. The single exception to Burne-Jones's lack of public appearance between 1870 and 1877 came in 1873 when he showed two works at the Dudley Gallery, London: *Garden of the Hesperides* and *Love Among the Ruins*.

8. See Richard Green, *Albert Moore and His Contemporaries* (Newcastle-upon-Tyne: Laing Art Gallery, 1972), 9. On Moore's Royal Academy exhibits, see Algernon Graves, *The Royal Academy of Arts*, vol. 5 (London: Henry Graves and George Bell, 1906), 278.

9. On Strudwick, see George Bernard Shaw, "J. M. Strudwick," *Art Journal* 53 (April 1891): 100; on Spencer Stanhope, see A. M. W. Stirling, "Roddam Spencer Stanhope, Pre-Raphaelite Artist," *Nineteenth Century and After* 66 (1909): 321; and on Spartali Stillman, see Ellen C. Clayton, *English Female Artists*, vol. 2 (London: Tinsley Brothers, 1876), 135–37. For the respective Royal Academy exhibits of each artist, see Graves, vol. 7, 292, 234, 214, and 264.

10. See Ronald Chapman, *The Laurel and the Thorn: A Study of G. F. Watts* (London: Faber and Faber, 1955), 17, 83.

11. Walter Shaw Sparrow, "The Art of Evelyn de Morgan," *The Studio* 19 (1900): 221.

12. Ernest Chesneau, *The English School of Painting*, trans. Lucy N. Etherington, 4th ed. (London, Paris, and Melbourne: Cassell and Co., 1891).

13. See, for example, Edmund Duranty, "Exposition Universelle: Les Écoles Étrangéres de Peinture," *Gazette des Beaux Arts*, 2d ser., 18 (September 1878): 298–320.

14. William Holman Hunt, *Pre-Raphaelitism and the Pre-Raphaelite Brotherhood,* 2 vols. (London: Macmillan, 1905), 364–65.

15. Hunt, 365.

16. "Grosvenor Gallery Exhibition," *Illustrated London News* 74 (3 May 1879): 415. On the *Pygmalion* series, see Henry Blackburn, *Grosvenor Notes: Summer Exhibition* (London: Chatto and Windus, 1879), nos. 167–170.

17. Jacques Lethève, "La Connaissance des peintres préraphaelites anglais en France, 1855–1900," *Gazette des Beaux Arts*, 6th ser., 53 (May-June 1959): 318. The first article on Rossetti was posthumous, written by Théodore Duret, "Les Expositions de Londres: Dante Gabriel Rossetti," *Gazette des Beaux Arts* 28 (1883): 4958.

18. Lethéve, 318.

19. Duranty, 310.

20. Ibid. For the responses of Charles Blanc and, later, Paul Duranty to Burne-Jones, see Susan P. Casteras, "The Pre-Raphaelite Legacy to Symbolism: Continental Response and Impact of the Rosicrucian Circle," in this book.

21. For the most recent overview of such exhibitions see Paul Greenhalgh, *Ephemeral Vistas: The Expositions Universelles, Great Exhibitions and World's Fairs, 1851–1939* (Manchester: Manchester University Press, 1988), on which the following discussion is based.

22. Ibid., 213–14. On Lindsay's role, see Virginia Surtees *Coutts Lindsay* (Norwich: Michael Russell, 1993), 149–50.

23. Frederick Wedmore, *Studies in English Art: Second Series* (London: Richard Bentley and Sons, 1880), 210–11. For the responses of Ernest Chesneau and Wilfird Meynell, see Casteras.

24. Lethève, 322–23, where he mentions several journals that were writing about Burne-Jones in this respect, including *Le Journal des Débats, La Revue indépendante*, the *Gazette des Beaux Arts*, and *L'Evénement*. For the history of the European response, see also Martin Harrison and Bill Waters, *Burne-Jones* (New York: G. P. Putnam's, 1973), 173–77 and Dennis Farr, *English Art 1870–1940* (Oxford: Clarendon Press, 1978), 55–57.

25. Elizabeth Gilmore Holt, *The Expanding World of Art, 1874–1902*, vol. I of *Universal Expositions and State-Sponsored Fine Arts Exhibitions*, 2 vols. (New Haven: Yale University Press, 1988), 4.

26. Bruce Laughton, "The British and American Contribution to Les XX, 1884–93," *Apollo* 93 (November 1967): 373. For further discussion of Burne-Jones's involvement with *Les Vingt* and the Rosicrucian, see Casteras.

27. Harrison and Waters, 57.

28. Hallé, 99–117.

29. "The Grosvenor Gallery," *Art Journal* 16 (1877): 244.

30. On the Dudley Gallery there is little information apart from critical responses in the press of the period. See, for example, "The Dudley Gallery," *Art Journal* 9 (1870): 86–88.

31. Lindsay's promotional activities were advertized at the beginning of each Summer Exhibition catalogue. In terms of sales, Lindsay did not act like an ordinary dealer but rather only took a 5 percent commission on anything sold in his gallery. Beginning in 1878, Henry Blackburn produced illustrated guides of the Grosvenor Summer Exhibitions, which included engravings based on drawings by the artists themselves.

32. Agnes D. Atkinson, "The Grosvenor Gallery," *Portfolio* 8 (1877): 97.

33. Other artists who showed at the Grosvenor during these early years included James Tissot, William Blake Richmond, Walter Crane, as well as the academicians Frederic, Lord Leighton, Alma-Tadema, Poynter, among the most outstanding.

34. "The Grosvenor Gallery," *Art Journal,* 244.

35. "Minor Topics," *Art Journal* 16 (1877): 93.

36. Ibid., 159.

37. Joseph Comyns Carr, *Some Eminent Victorians: Personal Recollections in the World of Art and Letters* (London: Duckworth, 1908), 127–30.

38. Oscar Wilde, "The Grosvenor Gallery," *Dublin University Magazine* 90 (July 1877): 126.

39. Sir Coutts Lindsay, "On the Relation of Fine Art to Social Science," *British Architect* 12 (10 October 1879): 1149.

40. MaryAnne Stevens, "Towards a Definition of Symbolism," in John Christian, ed., *The Last Romantics: The Romantic Tradition in British Art, Burne-Jones to Stanley Spencer* (London: Lund Humphries in association with Barbican Art Gallery, 1989), 33–34.

41. H. Heathcote Statham, "The Grosvenor Gallery," *Macmillan's Magazine* 36 (June 1877): 118.

42. See Du Maurier's cartoon, "Mutual Admiration Society," in *Punch* 78 (April 1880).

43. Megilp, "The Grosvenor Gallery and the Royal Academy," *Vanity Fair* 17 (5 May 1877): 281.

44. See Bullen, 355, on which the following discussion is based.

45. R. N. Bain in *Literature* 1 (12 November 1898): 453; cited in *Oxford English Dictionary*, 2d ed., vol. 17, prepared by J. A. Simpson and E. S. C. Weiner (Oxford: Clarendon Press; New York: Oxford University Press, 1989), 453.

46. Spalding, 20. Moreau's watercolor was shown in the East Gallery (*The Grosvenor Gallery, New Bond Street*, 1877, no. 36). Foreign exhibitors at the Grosvenor included Laurence Alma-Tadema, Baron Von Angell, L. Alvarez, G. B. Amendola, Jules Bastien-Lepage, J. E. Boehm,

Henri Chapu, Philippo Colarossi, Giovanni Costa, Baroness Von Cramm, A. De Breanski, Madame de l'Aubiniere, Baron de Lyoncourt, Madame Darmesteter, Eugene Delaplanche, Madame Victoria Dubourg, Henri Fantin-Latour, Countess Feodora von Gleichen, Prince von Hohenlohe-Langenburg, Count Gleichen, N. Gordigiani, E. E. Geflowski, Ferdinand Heilbuth, Hubert von Herkomer, Carl Haag, Alphonse Legros, Rudolph Lehmann, Mrs. Anna Lea Merritt, Miss Clara Montalba, Miss Helen Montalba, Achille Mazzoni, Carlo Pellegrini, Auguste Rodin, Augustus St. Gaudens, James Tissot, and, of course, James McNeill Whistler.

47. Oscar Wilde, 118.

48. Statham, 119.

49. Henry James, "The Picture Season in London," (1877), in John L. Sweeney, ed., *The Painter's Eye: Notes and Essays on the Pictorial Arts by Henry James* (Cambridge: Harvard University Press, 1956), 142.

50. See Archambault, 250.

51. "The Grosvenor Gallery, Second Notice," *Magazine of Art* 1 (1878): 81.

52. *The Grosvenor Gallery, New Bond Street* (1877).

53. See John O'Callaghan, "The Fine Art Society and E. W. Godwin," in *The Fine Art Society Centenary Exhibition* (London: Fine Art Society, 1976), 5. See also H. B. Wheatley, *A Short History of Bond Street Old and New from the Reign of King James II to the Coronation of King George V* (London: Fine Art Society, 1911). I would like to thank Peyton Skipwith for bringing these sources to my attention.

54. "The Grosvenor Gallery," *Illustrated London News* 70 (5 May 1877): 419 and "The Grosvenor Gallery," *The Builder* (28 April 1877): 424.

55. "The Grosvenor Gallery," *The Athenaeum* (5 May 1877): 583.

56. Descriptions of the gallery are given in "The Grosvenor Gallery," *The Builder* (1877), 424; "The Grosvenor Gallery," *Athenaeum* (1877), 583; and Atkinson, 98, on which the following discussion is based.

57. For Whistler's design concepts, see, for example, David Park Curry, "Whistler and Decoration," *Magazine Antiques* 126 (November 1984): 1186–99; and idem, "Total Control: Whistler at an Exhibition," in *James McNeill Whistler: A Reexamination*, vol. 19 of *Studies in the History of Art*, ed. Ruth E. Fine (Washington, D.C.: National Gallery of Art, Center for Advanced Study in the Visual Arts Symposium Papers VI), 67–82.

58. "The Grosvenor Gallery," *Athenaeum* (1877): 583.

59. "The Grosvenor Gallery," *Architect* 17 (1877): 303.

60. Gordon J. Fyfe, "Art Exhibitions and Power during the Nineteenth Century," in *Sociological Review Monograph 32. Power, Action and Belief: A New Sociology of Knowledge* (London, Boston, and Henley: Routledge and Kegan Paul, 1986), 37.

61. "The Picture Galleries, III," *Saturday Review,* 47 (May 1879): 619.

62. These plans have only recently been discovered (see Corporation of London, Greater London Record Office), and they consist of plans of the basement, ground floor, first floor, and a cross-section, dating from 1889. However, press coverage reveals that most of these comforts were in place in 1877. It is often mistakenly thought that Burne-Jones rejected these innovations as an assault on the artistic integrity of the original gallery policies. However, a letter from Burne-Jones to Hallé, dated 3 October 1887, reveals that his objections were caused by much later changes to the gallery, which occurred in 1884 on, when a new business manager was brought in to help Lindsay make ends meet after his wife had left him, taking half the income for the building with her (see "Correspondence with Sir Coutts Lindsay Concerning the Resignation of Messrs. C. E. Hallé and J. Comyns Carr," 1887, held by the Victoria and Albert Museum Library (National Art Library).

63. See, for example, the poem, "The Palace of Art (New Version), Part I," *Punch* 72 (7 July 1877): 305.

64. Hallé, 109–10.

65. "Notes," *The British Architect and Northern Engineer* 7 (6 April 1877): 208.

66. See the account of the gallery given by Louise Jopling, one of the Grosvenor exhibitors, in Louise Jopling, *Twenty Years of My Life 1867–1887* (London: John Lane; New York: Dodd, Mead, and Co., 1925), 74, 115.

67. See Hallé and *Mrs. J. Comyns Carr's Reminiscences,* ed. Eve Adam, 2d ed. (London: Hutchinson, n.d.), 42.

68. Adam, *Reminiscences,* 42. See Ignotus, "Painters of the Day—Mr. E. Burne-Jones," *Globe* (19 May 1873).

69. Hallé, 108. Redford was a licensor of plays at this time in his career. Tom Taylor was the most popular and representative of English playwrights between 1840 and 1880. He also wrote for *Portfolio.*

70. Carr, 146.

71. Adam, 90.

72. J. Comyns Carr, "La 'Grosvenor Gallery' à Londres," *L'Art* 9 (1877): 265.

73. J. Comyns Carr, "La Saison de l'Art à Londres. VI. La 'Grosvenor Gallery,'" *L'Art* 10 (1877): 77–83, on which the following discussion is based.

74. One of the first advertisements to appear was in *The Academy* 2 (20 January 1877): 64. These announcements continued through 1883. In 1878, the address for the offices of *L'Art* in London changed to 134 New Bond Street, Lindsay's private office space (See the advertisement in *The Academy* 4 [January 1878]: 68 and Sir Coutts Lindsay, letter to Anne Lindsay, 4 March 1878, Crawford Papers, National Library of Scotland, Edinburgh).

75. See *The Grosvenor Gallery, New Bond Street* (1877) for a complete list of exhibitors in 1877.

76. See n. 31.

The Pre-Raphaelites and the International Competition for Sandro Botticelli's Dante Drawings Manuscript

BARBARA J. WATTS

LADY EASTLAKE'S ASSERTION IN 1854 THAT "SANDRO Botticelli is worthy to stand in the Florentine genealogy between Giotto and Michelangelo" was unprecedented.[1] In the succeeding decades, her assessment would become an accepted truth, and Botticelli would take a permanent place in the pantheon of Renaissance masters. The story of Botticelli's apotheosis is entwined in the histories of collecting, connoisseurship, taste, aesthetics, and artistic movements in nineteenth-century Britain; and substantial research has been done on the subject. In 1960, Michael Levey mapped out Botticelli's rise from obscurity, from eighteenth-century France to nineteenth-century Britain.[2] Francis Haskell, in his 1976 study of fashion, taste, and collecting in England and France, established the cultural context of Botticelli's rediscovery and showed its place in the history of rediscoveries of art and artists.[3] More recently, Frank Kermode has considered the artist's *fortuna* in relation to nineteenth-century aesthetics and the history of art-historical methodology.[4] In this essay, I will focus on two new aspects of Botticelli's rediscovery, namely, Dante Gabriel Rossetti's appreciation of the artist and the role that Dante Alighieri (1265–1321) played in the assessments of Botticelli by Walter Pater and John Ruskin. Rossetti's enthusiasm for Botticelli preceded that of Pater and Ruskin and may have prompted their interest in him. Rossetti's deep regard for Dante Alighieri, evidenced in his translations of his works and in his many paintings that drew upon Dante's life and poetry, offers another link to Pater and Ruskin, for their assessments of Botticelli were grounded in the Dantean character of his art. For twentieth-century scholars, the importance of Dante for Botticelli is assumed; and monographs from Herbert Horne's (1908) through Ronald Lightbrown's (1976) assert Dante's profound influence on Botticelli.[5] Such was not the case in the 1870s, however; and both Ruskin and Pater were the first to recognize a significant link between the artist and the poet.

Botticelli's rediscovery in the 1870s insured the appreciative reception of his chief Dantean work, a codex of the *Commedia* with full-page illustrations by him, which became widely known in 1882. In the early nineteenth century, eighty-eight of the originally more than one hundred parchment sheets of this fifteenth-century manuscript were bound; and the codex was purchased by Alexander Douglas, the tenth duke of Hamilton.[6] The estimation of MS Hamilton 201 in the nineteenth century and the story of its sale in 1882 by the twelfth duke of Hamilton offer more than an interesting chapter in the history of the manuscript's provenance. MS Hamilton 201 sealed the connection between Dante and Botticelli that Pater and Ruskin had asserted, and the story of its sale in 1882 offers a fascinating account of British nationalism and artistic taste in the late nineteenth century.

As Michael Levey has shown, Botticelli remained relatively unknown in England through the middle of the nineteenth century.[7] However, some astute commentators on art, such as Lady Eastlake, William Michael Rossetti, and Edward Burne-Jones, noticed his paintings, which were increasingly discussed and purchased. Five of Botticelli's works were exhibited at the Manchester Art Treasures Exhibition of 1857.[8] Among these was the *Mystic Nativity* (ca. 1500, National Gallery, London, fig. 1), which was shown again in the exhibition at Leeds in 1868 and at the Royal Academy in 1871.[9] For the most part, however, knowledge of Botticelli's works was sparse

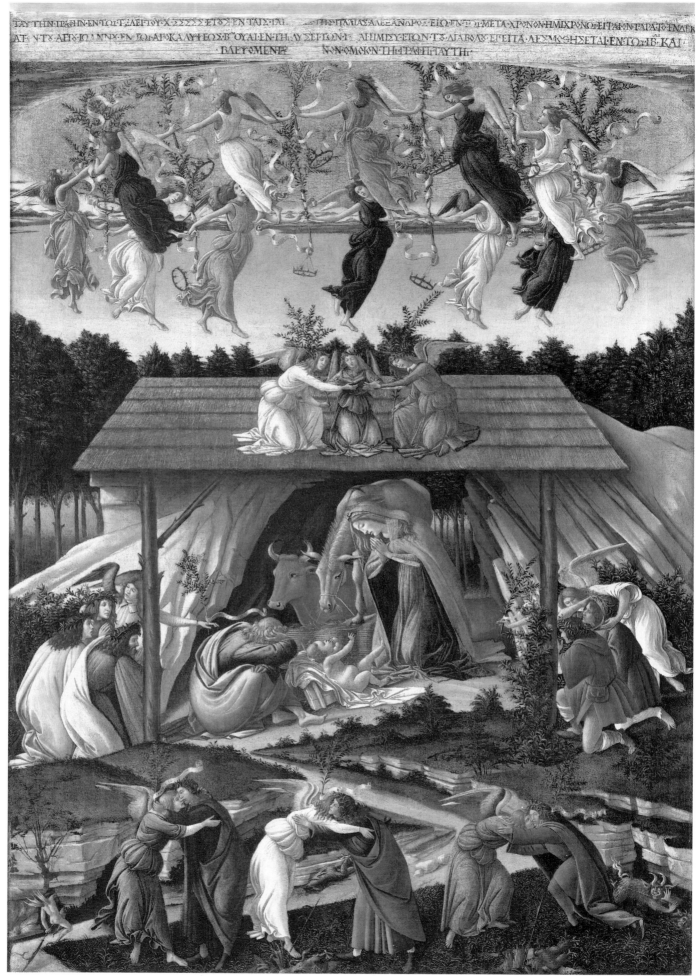

Fig. 1. Sandro Botticelli. *Mystic Nativity*. ca. 1500. Tempera on canvas. 42¾″ × 29½″. Reproduced by courtesy of the Trustees, the National Gallery, London.

Fig. 2. Sandro Botticelli. *Smeralda Brandini*. ca. 1475. Tempera on panel. 26″ × 16¼″. Photograph courtesy of the Board of Trustees of the Victoria and Albert Museum, London.

and flawed with numerous misattributions.[10] The *Primavera* (1478, Uffizi Gallery, Florence) and the *Birth of Venus* (ca. 1484–86 Uffizi Gallery, Florence), today his most celebrated works, were not exhibited publicly until 1815.[11] The *Birth of Venus* did not become widely known in Britain until 1870, when the Arundel Society published a chromolithograph of it.[12]

For most of the century, virtually anything that looked "strange" might be attributed to Botticelli;

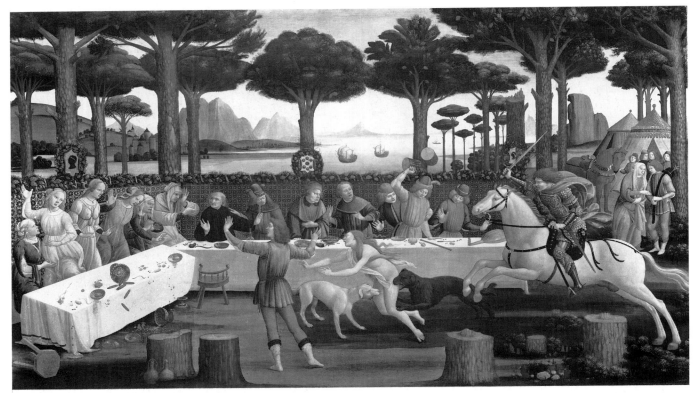

Fig. 3. Sandro Botticelli. *Further Episodes in the Story of Nastagio degli Onesti*. ca. 1483. Tempera on panel. 33″ × 56″. Photography courtesy of Museo del Prado, Madrid.

and his paintings elicited perplexity or distaste as much as pleasure. For example, Lady Mary Calcott in 1827 characterized Botticelli's paintings as "curious" but "interesting."[13] In 1864, Ralph N. Wornum, Keeper of the National Gallery, found Botticelli "capable of expressing beautiful and refined sentiment" but "void in the treatment of his forms." According to Wornum, "His type of female face is, as a rule, coarse, and altogether without beauty."[14] In 1886, the artist William P. Frith saw in Botticelli's works "bad drawing and worse painting, and such a revelling in ugliness."[15]

One of the first Englishmen to appreciate Botticelli was Dante Gabriel Rossetti, whose high opinion would be shared by other members of the Pre-Raphaelite Brotherhood. He first saw works by Botticelli when he visited Paris with Holman Hunt in 1849.[16] In 1860, his brother, William Michael Rossetti visited Florence and was "greatly struck of the Botticelli's—very specially by the *Birth of Venus*." Upon returning to London, William praised them to his brother.[17] By 1867, Dante Gabriel Rossetti's appreciation of the artist led him to purchase a portrait of a woman, now known as *Smeralda Brandini*, that was attributed to Botticelli (ca. 1475, Victoria and

Albert Museum, London, fig. 2).[18] He saw the *Mystic Nativity* when it was exhibited at Leeds in 1868 and, in a letter to William, called it "a most glorious Botticelli."[19] In 1879, Dante Gabriel Rossetti examined the newly restored panels depicting the story of *Nastagio degli Onesti* (ca. 1483, Museo del Prado, Madrid, fig. 3), which Frederick Leyland had bought for £1100; he wrote to Jane Morris that the price was "dirt cheap as they are large and leading works."[20] In the following year, he even wrote a sonnet inspired by Botticelli's *Primavera*.[21] In his memoirs of his brother published in 1895, William Michael Rossetti wrote, "If my brother had not something to do with the vogue which soon afterwards [after 1867] began to attach to that fascinating master, I am under a misapprehension."[22] Dante Gabriel's correspondence, which evidences an ongoing and vocal appreciation of Botticelli, supports his brother's assertion.[23]

It was not until 1870, however, that Botticelli was introduced to the public at large by the young, relatively unknown Walter Pater, whose essay "A Fragment on Sandro Botticelli" appeared in the August issue of the *Fortnightly Review*.[24] This essay subsequently became a chapter in Pater's *Studies in the*

Fig. 4. Sandro Botticelli. *The Temptation of Moses*, detail.
1481–82. Fresco. 137¼″ × 219¾″. Sistine Chapel, The Vati-
can. Photograph courtesy of Monumenti Musei e Gallerie
Pontifici, Vatican City.

History of the Renaissance (1873), which saw four editions before the end of the century. Between 1873 and 1874 reviews of Pater's book appeared in virtually all of Britain's literary journals; these thoroughly discussed his treatment of Botticelli, thus making the artist known even to those who did not read the book.[25]

Shortly after the first publication of Pater's essay, John Ruskin reassessed Botticelli. In the summer of 1872, he looked again at Botticelli's frescoes in the Sistine Chapel and was enchanted by the figure of Zipporah, one of Jethro's daughters in the *Temptation of Moses* (1481–82, Sistine Chapel, Vatican, fig.

PUNCH'S ALMANACK FOR 1881.

NINCOMPOOPIANA.

(*A Test.*)

The Squire. " I BELIEVE IT'S A BOTTICELLI."
Prigsby. " OH, NO! PARDON ME! IT IS *NOT* A BOTTICELLI. BEFORE A BOTTICELLI I AM MUTE!" [*The Squire wishes it was.*

Fig. 5. George Du Maurier, "Nincompoopiana," *Punch* 80, 1881. 3⅜″ × 5⅛″. *Punch's Almanack for 1881* (13 December 1880).

4). That fall, he delivered an Oxford lecture entitled "Sandro Botticelli and the Florentine School of Engraving."[26] Ruskin spent much of 1874 in Italy, at which time, he wrote that Botticelli "couldn't get higher in my mind." Nonetheless, when he saw the *San Barnaba Altarpiece* (ca. 1487, Uffizi Gallery, Florence), he was "more crushed than ever by art," and that December, in his series entitled "The Aesthetic and Mathematic Schools of Art in Florence," he devoted another lecture to the artist. Botticelli, he asserted, was "the greatest Florentine master of engraving," the chief "Delineator," and "pure gold tried in the fire."[27] Most of the works that Ruskin used to exemplify Botticelli's linear genius were engravings that are no longer attributed to him. Nonetheless, Ruskin's lectures established Botticelli's importance for the history of Florentine art. Ruskin's tributes to Botticelli were so frequent and effusive that, in time, Ruskin believed that he alone had brought Botticelli out of obscurity, forgetting Pater's essay that he had read in 1870.[28]

Walter Pater and John Ruskin, in 1870 and 1872 respectively, thus launched Botticelli's nineteenth-century career, which flourished in the following years. The Pre-Raphaelites emulated his works; Marcel Proust modeled Swann's love Odette de Crécy after Jethro's lilting daughter in the Sistine fresco; references to Botticelli, with diverse responses to his female figures, peppered popular novels.[29] Botticelli became so fashionable that *Punch's Almanack for 1881* included a cartoon entitled "Nincompoopiana," which satirized the adulation of Botticelli's paintings by pretentious aesthetes (fig. 5). Botticelli also appeared in a joke about two posturing philistines by George Du Maurier. In this joke, also published in *Punch,* one stylish young man asks another if he likes Botticelli. The man responds that he prefers Chianti, and the other scoffs, "Botticelli isn't a wine you juggins, it's a cheese."[30] So widespread was the fashion for Botticelli that followed Pater and Ruskin's encomia that in 1877 John Addington Symonds wryly observed, "In the last century and the beginning of this, our present preoccupation for Botticelli would have passed for a mild lunacy."[31]

Although both Pater and Ruskin championed Botticelli, their assessments of him were antithetical, each in accord with his own aesthetics and his own beliefs about the purpose of art. To Pater, Botticelli bespoke bittersweet melancholy, the consciousness of man's moral and spiritual frailty, and the hint of death. Conversely, to Ruskin, Botticelli was a pillar of faith, a moral and religious reformer, analogous to Savanarola and Luther.[32] Their assessments had one

thing in common, however: both recognized that Dante offered a key to understanding Botticelli's work. Giorgio Vasari, in his *Le Vite de' più eccellenti architetti, pittori, et scultori Italiani* (1550 and 1568), characterized the artist as overly preoccupied with Dante. After painting in the Sistine Chapel (1481–82), Vasari tells us, Sandro returned to Florence, where he embarked on the study and illustration of the *Commedia:*

> Dove per essere persona sofistica, comentò una parte di Dante: e figurò lo Inferno, e lo mise in Stampa, dietro al quale consumò dimolto tempo; per il che non lavorando fu cagione di infiniti disordini alla vita sua.[33]

> (Being of a sophisticated mind, he commented on a part of Dante, drew the *Inferno* and had it engraved. This consumed so much time that he did no other work, which caused infinite disorders in his life.)

Both Pater and Ruskin, who were Dantephiles, responded to Botticelli's preoccupation with Dante as a revelatory truth.[34] In different ways, each explored the relation between Botticelli's works and those of Dante, from which they developed an interpretation of Botticelli's character and art.

It had long been assumed that the *Inferno* engravings (figs. 6 and 7) to which Vasari referred were the nineteen engravings in the 1481 *Commedia* (the first Florentine printed edition of the poem), and that Botticelli's illustrations had been engraved by Baccio Baldini, who, according to Vasari, lacked all powers of invention and, thus, always used designs supplied by Botticelli.[35] Pater's discussion of Botticelli's works in his 1870 essay begins with these engravings. In coupling the poet and the painter from the start, Pater identified Botticelli's essential artistic character. Botticelli, Pater wrote, "is before all things a poetical painter . . . So he becomes the illustrator of Dante." Botticelli was suited to this task, Pater asserted, because like his contemporaries, Botticelli was a naturalist painter: he observed the world about him and transcribed outward reality. Thus, he could "put the weight of meaning into outward things, light, colour, everyday gesture, which the poetry of the *Divine Comedy* involves."[36] "But this was not enough for him," Pater contended, for Botticelli "is a visionary painter, and in his visionariness he resembles

Fig. 6. Baccio Baldini. *Inferno* 3. After a design by Sandro Botticelli. ca. 1481. Engraving. 3¾″ × 6¾″. Courtesy of Spencer Collection, The New York City Public Library. Astor, Lenox and Tilden Foundations. Photo by Robert D. Rubic NYC.

Fig. 7. Baccio Baldini. *Inferno* 12. After a design by Sandro Botticelli. ca. 1481. Engraving. 3¾″ × 6¾″. The Pierpont Morgan Library, New York. PML.398.

Dante." Pater explicated:

> But the genius of which Botticelli is the type usurps the data before it as the exponent of ideas, moods, and visions of its own; in this interest it plays fast and loose with those data, rejecting some and isolating others, and always combining them anew. To him, as to Dante, the scene, the colour, the outward image or gesture, comes with all its incisive and importunate reality; but awakes in him, moreover, by some subtle law of his own structure, a mood which it awakes in no one else, of which it is the double or repetition, and which it clothes, that all may share it, with visible circumstance.[37]

Pater next discussed an *Assumption of the Virgin* that, according to Vasari, Botticelli made for Matteo Palmieri following a design that his patron had provided.[38] The altarpiece included depiction of the celestial circles and the heavenly host and was evidently so magnificent that it provoked envy. Botticelli's detractors, unable to fault the painting's artistry, alleged that it was heretical and leveled charges against both Sandro and Matteo. Vasari declined to comment on the allegations, stating that it was not for him to say whether they were true or false. Pater, on the other hand, expounded upon the alleged heresy. Matteo Palmieri, he explained, was the reputed author of a heretical treatise, *La Città Divina,* which "represented the human race as an incarnation of those angels who, in the revolt of Lucifer, were neither for Jehovah nor for His enemies."

Pater conjectured that the artist's glories of angels were suspected of embodying Palmieri's "wayward dream." He further asserted that it is likely that Botticelli actually entertained Palmieri's heretical notion; that Botticelli wrote a commentary on Dante and became a disciple of Savonarola suggests his propensity for philosophical speculation. Pater then claimed that "whether true or false," Vasari's account elucidates Botticelli's art: "The story interprets much of the peculiar sentiment with which he infuses his profane and sacred persons, comely, and in a certain sense like angels, but with a sense of displacement or loss about them—the wistfulness of exiles, conscious of a passion and energy greater than any known issue of them explains, which runs through all his varied work with a sentiment of ineffable melancholy."[39]

Pater then returns to Dante, linking Palmieri's heresy of humanity's origins to Dante's *Inferno*. For Dante, angels and humans are endowed with free will, and those who do not use it, who refuse to choose between virtue and vice, are reprehensible. In Dante's *Inferno* (canto 3), those angels who did not take sides in the battle between God and Lucifer have been exiled from Heaven. However, Hell has also found them contemptible; and fearing that the damned would glory over these indecisive souls, it refused to admit them. Thus, the "repulsive choir of angels" remains in Hell's antechamber with the shades of those mortals who likewise could not com-

mit themselves to good or evil. These miserable souls, tinged with the color of sadness, have also been rejected by both Heaven and Hell.[40] Lamenting their "great refusal," they whirl through the nether region following a banner that has no ensignia. Botticelli, according to Pater, is one of these exiles:

> So just what Dante scorns as unworthy alike of heaven and hell, Botticelli accepts, that middle world in which men take no side in great conflicts, and decide no great causes, and make great refusals. He thus sets for himself the limits within which art, undisturbed by any moral ambition, does its most sincere and surest work. His interest is . . . with men and women, in their mixed and uncertain condition, always attractive, clothed sometimes by passion with a character of loveliness and energy, but saddened perpetually by the shadow upon them of the great things from which they shrink. His morality is all sympathy; and it is this sympathy, conveying into his work somewhat more than is usual of the true complexion of humanity, which makes him, visionary as he is, so forceful a realist.[41]

For Pater, Botticelli's "great refusal" is implicit in the images he painted; and it is this that gives his "peevish-looking" Madonnas "their unique expression and charm." His exegesis of the *Madonna of the Magnificat* (ca. 1481, Uffizi Gallery, Florence, fig. 8), with the pen almost dropping from her hand as she writes her words of exaltation—"high cold words" that "have no meaning for her"—is often quoted as an example of his imaginative interpretation. The passage that precedes this, however, in which Pater characterizes all of Botticelli's Madonnas, reveals the Dantean spirit of his response. "For with Botticelli she too, though she holds in her hands the 'Desire of all nations,' is one of those who are neither for Jehovah nor for His enemies; and her choice is on her face."[42] These wistful Madonnas, with their inclined heads and melancholic airs, thus reflect the humanity of those who failed to choose—Botticelli, and the countless numbers in Dante's vestibule to Hell. For Pater, the incisive reality of Dante's *Inferno,* with its compelling compendium of human frailty, awakened in Botticelli a mood that he clothed "with visible circumstance" and shared with us.

Ruskin also saw Botticelli through the lens of Dante but with a much different focus, and his writings offer a full rebuttal of Pater's assertions. Ruskin interpreted Botticelli's work as the fervent visualization of Dante's theology and morality, claiming in 1872 that Botticelli was "the only painter of Italy who thoroughly felt and understood Dante."[43] He saw virtues equivalent to the orthodoxy and earnestness of Dante's poetry in Botticelli's treatment of subject matter and in his style, from the integrity of his line to the honest manner in which he rendered roses. In his 1872 lecture on the artist, Ruskin dismissed the charge of heresy in the Palmieri *Assumption* and chastized Vasari, "our gossiping friend," for mentioning the allegation. Botticelli, he admitted, may have been "hot-headed" and "saucy," but more than that he was "true-hearted," "sweet," and "modest." The theological modifications that brought him into trouble, Ruskin asserted, show that his Sandro thought deeply about church doctrine; the altarpiece was not that of a heretic but that of a young reformer who had "true respect . . . for what was sacred in the church." When contemplating the allegation's veracity, Pater had called upon Dante. Ruskin, therefore, evoked the poet in defense of Botticelli's orthodoxy, stating that Botticelli "knows all that Dante knew of theology, and much more; and he is the only unerring, unfearing, and to this day trustworthy and true preacher of the reformed doctrine of the Church of Christ."[44]

In contrast to Pater, Ruskin envisioned Botticelli's life as a Dantean story of a "great moral choice," transforming Vasari's account of the *Inferno* engravings and the ensuing disorder in Sandro's affairs into a poignant scenario of the altruistic artist. According to Ruskin, when painting in the Sistine Chapel, Botticelli realized that its theological program of the "Eternal Law of God" was too sophisticated for the common man to understand. Later, when reading Dante's lucid account of the consequences of sin in the *Inferno,* Botticelli determined to bring the poet's lessons to the people. Ruskin wrote:

> He reads Dante's vision of Hell created by its [the Mosaic Law's] violation. He knows that the pictures he has painted in Rome cannot be understood by the people; they are exclusively for the best trained scholars in the Church. Dante, on the other hand, can only be read in manuscript; but the people could and would understand *his* lessons, if they were pictured in accessible and enduring form. He throws all his own lauded work aside,—all for which he is most honoured . . . And he sets himself to a servile and despised labour,—his friends mocking him, his resources failing him, infinite "disorder" getting into his affairs—of this world. Never such another thing happened in Italy any more. Botticelli engraved her Pilgrim's Progess for her, putting himself in prison to do it.[45]

In Ruskin's hands, Botticelli's life became a Dantean pilgrimage, and his work a humble union of form and content inspired by Dante's poetry. With fortitude, he endured poverty and ridicule to triumph like a Christian knight, "with such crowning

Fig. 8. Sandro Botticelli. *Madonna of the Magnificat.* ca. 1481. Tempera on panel. Diameter 46½". Uffizi Gallery, Florence. Photograph by author.

blessings as Heaven might grant to him."[46] In short, Botticelli was a moral and artistic exemplum that Ruskin offered to his audience.

In recognizing that Botticelli's interest in Dante played a significant role in his art, both Pater and Ruskin found insights into this complex painter that transcend their errors of fact and fancy, insights that established the foundation for subsequent scholarship. In his seminal monograph on Botticelli (1908), Herbert Horne took Ruskin and Pater to task for the personal biases of their appreciations. Nonetheless, Horne was deeply indebted to them both. He rejected Pater's intimations of Botticelli's heretical reli-

gious views in favor of Ruskin's assertions of his orthodoxy; but Horne accepted Pater's assertion of Dante's pervasive influence on the artist, observing that Botticelli's religious paintings were "deeply coloured by the indelible influence of Dante."[47] Furthermore, Horne's assessment of Botticelli's artistic character as one that was necessarily contradictory— and, therefore, like Dante's *Commedia*—was a direct response to Pater and Ruskin's Dantean approach to Botticelli and their antithetical conclusions about his art and character. More recently, Paul Barolsky has argued that Botticelli's *Primavera* is infused with the spirit of Dante's poetry and has shown that

Purgatoris 28, which describes Earthly Paradise, elucidates the *Primavera's* imagery and mood.[48] As Barolsky has observed, Botticelli's paintings continue to fascinate because, despite the abundance of literary and pictorial sources that inform them, they resist iconographical analysis. Always, an ineffable something transcends categorical exegesis—and in this, Botticelli is Dantean in spirit. The key to Botticelli's paintings may reside not in the religious or philosophical content of Dante's poetry so much as in Dante's approach to his subject and his use of allusion to weave tapestries of significance.

In asserting a bond between Botticelli and Dante, Pater and Ruskin pinpointed a far-reaching and complex aspect of Botticelli's art that is fundamental to this "poetical" painter. Moreover, their appreciative attention to the relation between Dante and Botticelli set the stage for a triumphal entry of the Hamilton codex of Dante's *Commedia,* which, in 1882, would captivate the public's imagination.

In 1882, the year of Dante Gabriel Rossetti's death and about ten years after Pater and Ruskin discovered Botticelli, a folio-size manuscript of the *Commedia* containing eighty-eight parchments with full-page illustrations attributed to Botticelli came to the attention of the British public (Ham. 201; Cim. 33) (figs. 9 and 10).[49] It was one of hundreds of manuscripts in the libraries of the Duke of Hamilton, which, with the entire contents of the Hamilton estate, were to be auctioned at Sotheby's and Christie's. Of all the precious manuscripts in the Duke's collection, MS Hamilton 201 was singled out as the highest in artistic significance. The codex contained nearly ninety designs penned by Ruskin's great delineator and by Pater's poetic visionary, thereby confirming their assessments of Dante's importance for Botticelli. The high estimation accorded the Botticelli Dante reflected the artist's new status as a luminary of the Early-Italian schools, which Pater and Ruskin had brought about.

The Botticelli Dante came to the House of Hamilton through Alexander Hamilton-Douglas (1767–

Fig. 9. Sandro Botticelli. *Purgatorio* 32. ca. 1490. Metalpoint and pen on parchment. 12¾″ × 18½″. MS Hamilton 201 (Cim. 33). Kupferstichkabinett, Staatliche Museen zu Berlin. Photograph courtesy of Staatliche Museen zu Berlin.

Fig. 10. Sandro Botticelli. *Paradiso* 6. ca. 1490. Metal-point and pen on parchment. 12¾" × 8½". MS Hamilton 201 (Cim. 33). Kupferstichkabinett, Staatliche Museen zu Berlin. Photograph courtesy of Staatliche Museen zu Berlin.

1852), Marquis of Douglas and Clydesdale and tenth Duke of Hamilton, a prodigious collector, with an affinity for illuminated manuscripts.[50] He had acquired the codex before succeeding as duke in 1819; for in William Clarke's *Repertorium Bibliographicum,* published in that year but written earlier, the codex is recorded as part of his collection. Among Clarke's listing of "Manuscripts in the Collection of the Marquis of Douglas and Clydesdale (now the Duke of Hamilton and Brandon)," is the following entry: "Dante Alighieri, MS. on vellum, oblong folio. Saec. XV. This fine manuscript written about the year 1450, contains the entire poem, with the exceptions of some Cantos of the *Inferno.* It is ornamented with 88 original designs supposed to be executed by the hand of Sandro Botticelli, or some other eminent Florentine artist."[51]

Douglas purchased widely on the Continent and particularly in Italy, but it is likely that he acquired the Dante codex in Paris. On a sheet of paper bound with the manuscript is a statement of the volume's contents, signed Gio. Claudio Molini, 27 April, Paris 1803.[52] Giovanni Molini was an Italian bookseller who had a shop in Paris. It is not certain that Douglas purchased the codex from the Molini firm, whose extant book catalogues do not record it. The firm's Paris catalogue of 1807 does not include a reference to this Dante, however—which suggests that, by then, the codex had been sold.[53] Thus, the Botticelli Dante may have been in the Hamilton collection as early as 1807.[54]

The Duke's precious manuscript was seen by few but became known to the public through Gustav F. Waagen (Director of the Royal Museum, Berlin),

who visited Hamilton Palace in 1850, when preparing the expanded edition of his *Treasures of Art in Great Britain*. Waagen's assessment of the Dante codex played a significant role in its subsequent history. He wrote:

> *La Divina Commedia,* large folio, of the second half of the 15th century; containing indubitably the richest illustrations existing of this great poem, each page having a picture; all, however, with the exception of one coloured page, consisting of drawings with the pen. Various hands, of various artistic skill, are discernible; that of Sandro Botticelli is very obvious: he is known to have studied Dante with great zeal, and to have furnished the drawings for Baldini's engravings in the Landino edition. While many of the drawings at the early part of the work are very interesting and spirited, the larger figures in the latter part are the finest and most original with which this poem has ever been illustrated. The publication of fac-similes of a selection of them, in woodcuts or lithography, now so easily accomplished, would be highly welcome equally to the lovers of Dante and of Italian art.[55]

In 1881, after years of riotous living and a fortune spent on horses and hounds, William Alexander Louis Hamilton-Douglas, the twelfth Duke of Hamilton (1845–1885), succeeded in depleting the resources of the House of Hamilton and was compelled to sell its collections of books, manuscripts, paintings, and art treasures.[56] The London press had a heyday with the Duke's bankruptcy, citing him as an example of Britain's degenerate nobility, and it took advantage of the Hamilton sales to provide the curious public with detailed descriptions of the ancestral family's treasures.[57]

Disposition of the Hamilton libraries was handled by Sotheby's and its paintings by Christie's, with auctions held from May 1882 through 1883.[58] Newspaper accounts and letters to the editor of the London *Times* before each sale reveal a consensus regarding the Hamilton collections: acquisition by the state of its most precious works was a matter of national honor. Claude Phillips, for example, in a letter to the London *Times* before the sale of the Duke's paintings, wrote: "It will be a lasting disgrace to the British nation if certain of the masterpieces comprised among the paintings are allowed to leave the country, the more so because in several instances the works referred to would fill up important lacunae in the National Gallery. If this occasion is allowed to slip, perhaps no similar one may again occur."[59]

Phillips advised the National Gallery to procure special funds for the Hamilton Palace sales, "as otherwise connoisseurs will probably have the mortification of seeing the gems of the collection adorn the Louvre and the galleries of Berlin, Brussels, and St.

Petersburg." The government agreed with such sentiments; before each sale, Parliament granted allocations to the nation's museums for the purchase of works deemed essential to their collections.[60]

The first collections to be dispersed were the Duke's Italian, Dutch, and Flemish pictures and a portion of William Beckford's Library, which had entered the Hamilton estate upon his death in 1844.[61] These sales, which took place in June and July, attracted large, international audiences, making the competition fierce. National museums aside from those in Britain were avid contenders for the Hamilton collections; and accounts of the auctions reveal an intense rivalry between Britain, France, and Prussia. The paintings of greatest concern to Britain were the Italian pictures. As the London *Times* reported, "It was universally felt that the best of these ought to be secured forever for the National Collection."[62] Most often mentioned was a large *Assumption of the Virgin* attributed to Botticelli and believed to be the altarpiece that Vasari asserted he painted for the heretical Matteo Palmieri (fig. 11). Claude Phillips, in his letter to the London *Times,* asserted that this "very important work of Sandro Botticelli, which is specifically mentioned by Vasari," was one of the four Italian paintings that "should on no account be allowed to leave the country." Subsequent letters supported Phillips and advocated that Botticelli's celebrated altarpiece be the nation's first buy.[63] The board of trustees of the National Gallery and its director, Mr. Burton, concurred with the public opinion. At their request, Parliament granted special funds for the purchase of paintings from the Hamilton Collection.[64]

On June 24, the day the Palmieri *Assumption* was scheduled for the auction block, Mr. Burton, flanked by two trustees, entered Christie's sales room to confront the National Gallery's "formidable opponents"—the agents for the Louvre, who had been expressly commissioned by its director to prevail in the "great contest" for the Botticelli *Assumption.* Tension mounted in the hushed salon as the bidding rose higher and higher. Finally, only two contenders remained—the representatives of the Louvre and of the National Gallery. When Mr. Gauchez, the agent for the Louvre, bid 4,400 guineas, there was a "very serious pause and some doubt"; then, when Mr. Burton volleyed back with a bid of 4,450 guineas, the audience broke into a "hearty round of applause." The final gavel sounded to Mr. Burton's bid of £4,777 10s., to the accompaniment of "such enthusiastic applause as has never been heard before in the great salon."[65] The National Gallery had vanquished the Louvre. Mr. Burton's bid was nearly £3,000 more than the second most expensive Italian painting

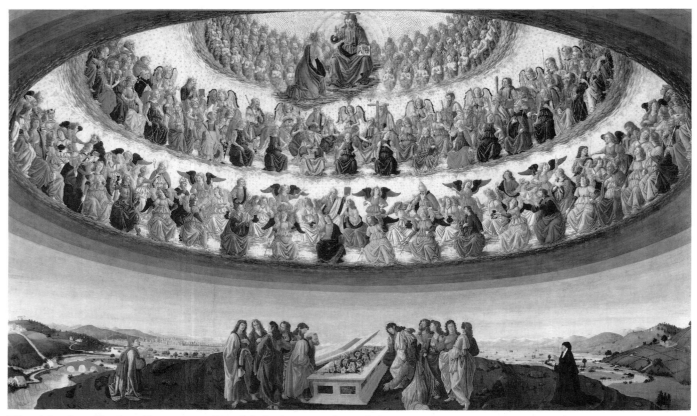

Fig. 11. Ascribed to Francesco Botticini. *Assumption of the Virgin*. ca. 1476. Tempera on panel. 89⅘″ × 148⅗″. Reproduced by courtesy of the Trustees, the National Gallery, London.

in the sale, Agnolo Bronzino's *Portrait of Eleanora of Toledo* (ca. 1545, Institute of Arts, Detroit), which brought £1,837 10s.[66] It was the highest price ever paid for a picture attributed to Botticelli.[67]

The bidding also reached unprecedented heights at the sale of the first portion of the Beckford Library. The total fetched for the 3,197 lots was £31,515, which, according to the London *Times,* established "the highest average price ever known of any of the greatest books sales."[68] This new record set the stage for the forthcoming sale of the Hamilton Library, which many held to be as valuable as the Beckford, despite its fewer number of volumes. Whereas the Beckford Library was composed chiefly of early printed books esteemed especially for their ornate bindings, the 867 lots of the Hamilton Library were composed of unique codices, most of which were richly illuminated. It was thus anticipated that the sale of the Hamilton manuscripts would break the record for the "highest average price for book sales" that the Beckford Library had set and would also establish new highs in the amounts paid for manuscripts.[69] John Ruskin, who had seen the Ham-

ilton manuscripts in 1853, anticipated a fierce competition for them and thought it likely that Britain's museums would not have the funds to acquire all of those manuscripts that were especially precious. Upon learning of the sale, he issued a circular "begging" his "friends" to bid for the manuscripts and soliciting donations from patriotic Britons so that he could secure those that the nation's museums could not afford. His knowledge of art and history, he maintained, equipped him to judge which manuscripts should not leave the country.[70] Undoubtedly, the Botticelli Dante was one of these.

Detailed descriptions of the Duke's "matchless collection of manuscripts" had to await the publications of Sotheby's sales catalogue, which was not expected before November. Early accounts of the Hamilton Palace treasures described the ducal library following Waagen's assessment of it in *Treasures of Art in Great Britain.*[71] Invariably, these singled out the *Commedia* with illustrations by Botticelli as the "gem of the manuscript collection." The London *Times* article on the Hamilton Palace libraries, written when the sales were first announced, reflects the esteemed

position of the Botticelli Dante:

> But the Italian manuscripts are even more interesting and of extreme rarity. One of these is unique, being the *Divinia Commedia* of Dante in folio, each page illustrated with a picture drawn in outline with the pen, and although by various artists, yet many are by the hand of the famous master Botticelli, who was a great admirer of Dante, and, as is well known, designed the drawings from which Baccio Baldini engraved his illustrations in the Landino edition . . . This manuscript, therefore, is a most interesting example of 15th century art, and the drawings are pronounced by Dr. Waagen to be the finest and most original illustrations of the kind ever produced.[72]

Sotheby's *Catalogue of the Magnificent Collection of Manuscripts from Hamilton Palace,* from which later descriptions of the collection were drawn, goes beyond the London *Times* in asserting the rarity and value of the codex. In contrast to Waagen, Botticelli's authorship of all of the drawings was assumed; and the expansive entry reflects his new celebrity:

DANTE ALIGHIERI, COMMEDIA

Manuscript on vellum by a Tuscan Scribe, written in the XVth Century (18 ¾ by 12½ inches), superbly ornamented with 88 exquisitely beautiful Designs by SANDRO BOTTICELLI, all except six the full size of the page (including a splendid Drawing of the Mouth of Hell in colours, and full-length portraits of Dante), half red morocco folio SAEC. XV (*circa* 1480). OF ALL THE MANUSCRIPTS WHICH HAVE EVER OCCURRED FOR SALE THIS MAY WITHOUT EXAGGERATION BE DESCRIBED AS THE MOST IMPORTANT, FROM AN ARTISTIC POINT OF VIEW. BOTTICELLI'S DESIGNS, ENGRAVED FOR THE DANTE OF 1481, HAVE ALWAYS BEEN ESTEEMED AMONG THE MOST PRECIOUS MONUMENTS OF ITALIAN ART, BUT THEY SINK INTO INSIGNIFICANCE WHEN CONSIDERED BESIDE THESE MARVELOUS WORKS, WHICH FOR POWER OF DRAWING, FERTILITY OF DESIGN AND TENDERNESS OF FEELING ARE UNAPPROACHED AND UNAPPROACHABLE. This highly valuable manuscript with its magnificant illustrations, has the *Purgatorio* and *Paradiso* complete, but wants in the *Inferno* Cantos I to VI and VIII to XV.[73]

Clearly, the climax of the manuscript sale would be the moment that the Botticelli Dante came upon the auction block. The contest for the *Commedia* codex promised to make the bidding war for the Palmieri *Assumption* preliminary to the main event in the international competition.

The chief contender for the Botticelli Dante was the Berlin Museum. Friedrich Lippmann, then the Director of the Kupferstichkabinett of the Königlichen Museen, Berlin, also recalled Waagen's estimation of the manuscript and determined to secure it for Prussia. Upon learning that the Hamilton manuscripts would be auctioned, Lippmann went to London to see them and traveled to Scotland to negotiate privately with the duke. As Douglas would entertain offers only for the entire manuscript collection, Lippmann applied to the crown prince and princess for a special allocation from the emperor's privy purse to acquire the manuscripts.[74]

Prussia's crown princess, however, was Victoria, the eldest daughter of Queen Victoria, whose marriage had not altered her devotion to Britain. Learning of Lippmann's negotiations, she wrote to her mother, warning her of the Germans' efforts to acquire the Hamilton manuscripts and imploring her to take action to secure the Botticelli Dante for Britain. Like the newspaper articles concerning the auctions, her letters indicate the extent to which the acquisition of precious works of art was tied to national prestige. On 23 July 1882, the crown princess wrote from Meran:

> I always forget to mention the sale of the Duke of Hamilton's works of art which I think such a pity; but the best and most valuable part of his possessions is going to be sold soon; it is his library—he has some books that are quite unique—amongst or rather before all others—a manuscript copy of Dante all illustrated in 88 pages by Sandro Botticelli. This extraordinary treasure ought not to leave England. The Berlin Museum would like to buy the whole collection for £88,000 if the parliament will vote the money. I must say I think it a shame that England should be spoiled of such a treasure and I do not understand the British Museum and the Bodleian Library at Oxford not making an arrangement with the Duke of Hamilton, and his not having the right patriotism to offer his treasures to our own national collections before foreigners treat with him for them. . . . I know there ought to be no delay as the sale will be before long. I could not help drawing your attention to this. . . . If our great English families are obliged to sell their unique collections at least I think, if possible, the nation ought to secure them. Mr. Gladstone as a lover of art and learning, would I am sure—even from a financial point of view—think money well invested that is spent on increasing the art collections of the nation. The day will come when these things can no longer be had and all is readily snapped up by the new collections of America and the Continent.[75]

She wrote again to her mother from Neues Palais on 2 October 1882:

> May I refer once more to the sale of the Duke of Hamilton's library—and that precious illustration of Dante by

Botticelli? I heard yesterday that it was again offered to the German [Berlin] Museum authorities in a lump; and the auction which was to have taken place in October or November will not come off I suppose! I cannot reconcile myself to the idea of this unique treasure leaving England for good—without even an attempt to secure it, how it will be regretted in later years. I fear there is a great hurry about it and that they are communicating by telegraph so I hope no time will be lost—in case it is to be bought for the British Museum. They boast here of having the finest collections of England over here in a few years! I own I should be very sorry.[76]

Queen Victoria responded to her daughter's entreaties. On 8 August 1882, her personal secretary, General Ponsonby wrote to Prime Minister Gladstone from Osborne: "The Queen has been informed that at the Hamilton Sale there are some very valuable books to be sold which Her Majesty hopes may be purchased for the British Museum and not allowed to be taken out of the Country."[77]

In his reply to Sir H. Ponsoby of 16 August, Mr. Gladstone asserted that acquisitions for the nation's museums were outside his province. His response is nonetheless significant: it reveals Gladstone's assessment of Britain's efforts to acquire works of art, his estimation of Botticelli, and his knowledge that the Hamilton codex at issue was the *Commedia* illustrated by Botticelli. Gladstone wrote:

> I hope to see you on Friday but in the meantime I write to say that I paid due attention to your note about the Hamilton Library, but that I have heard nothing on the subject from the Trustees of the Museum.
>
> It is sometimes said that in this country the State is illiberal to purchases connected with art and libraries. My impression is that we spend far more upon them than any other country, and that there is no library in the world—and in particular not the Bibliothèque Nationale though it is the first library in the world—which is endowed like that of the Museum.
>
> The Botticelli Dante is I believe an affair of many thousand pounds. But it derives its value I imagine almost entirely from its being in fact a collection of paintings by Botticelli; a great artist without doubt; but I can conceive a question whether in this view it is altogether an appropriate purchase for a National Library. At the same time, I do not venture to form that opinion. In truth it is difficult for any one connected with the Treasury to touch the initiative of these questions, there being another Department, namely the Museum Trust, of which it is the business to bring them before us when occasion arises.[78]

The efforts of Princess Victoria and the queen were in vain. The much anticipated auction of the Hamilton manuscripts was never held and publication of the Sotheby catalogue for it was suppressed. In October, Friedrich Lippmann, acting for the Prussian government, completed negotiations with the duke for the purchase of his entire manuscript collection for an unprecedented sum of £80,000 sterling ($400,000)—over one and a half million marks.[79] Adjusting for inflation, this amount today would be well over sixteen million dollars. If the twentieth-century growth of the art market were taken into account, the fortune that Prussia paid for the Hamilton Library in 1882 would match, if not surpass, the record prices for art that were set in the 1980s.[80] The Botticelli Dante set its own record, though an unofficial one, because the Berlin Museum did not divulge details of Lippmann's negotiations with the duke. In a report to the Trustees' Standing Committee of the British Museum, Mr. Thompson of the Manuscript Department wrote that "at least £20,000, if not more, was allowed for the Dante alone." The Prussians, he contended, "have paid an excessive price, and they have paid that price mainly to get possession of one unique manuscript."[81]

When the news became public in early November,[82] Britons were outraged to learn that the historical papers of the House of Hamilton would go to a foreign library.[83] No less were they mortified by the loss of the Botticelli Dante. The assessment of the codex in the London *Times* on 4 November, reprinted a month later in *The Bibliographer,* made explicit the value of the manuscript that Germany had snatched from Britain. Published after the sale to Prussia was a fait accompli, the description read as a eulogy to a lost treasure: "Above all others in the first class (those which are specially valuable from an artistic point of view) must be mentioned the manuscript of Dante's *Divina Commedia,* written in the fifteenth century, illustrated with upwards of eighty drawings by the hand of Sandro Botticelli. This priceless volume may, without exaggeration, be described as the most valuable manuscript in existence from its artistic interest, for it stands alone as an example of a literary work of the first order illustrated by an artist of the highest rank."[84]

In the weeks following the announcement, newspapers and literary journals were rife with grim accounts of the Germans' cackling over their coup and with demands for an explanation of the government's failure to secure the collection for Britain. Editorials and letters to the London *Times* called for legislation to prevent future "vandalism" of national treasures.[85] Such sentiments were augmented by reports from foreign correspondents that detailed the restrictions that various European countries had placed on the

export of art, with queries as to why such laws did not exist in Britain.[86] The report of the sale in *The Bibliographer* expressed the dissatisfaction voiced by many: "The news that the whole [manuscript collection] has been bought by the German Government comes upon the most patriotic Englishman like a shock. . . . The apathy of the English Government in respect to the purchase for the nation of artistic and literary treasures is well known, but one might have hoped that in the present instance it would have been aroused so as to have saved the country from the disgrace of parting with that which can never be replaced to a foreign state."[87]

The hue and cry was so great that on 2 November, and again on 28 November, the scandal of the Hamilton Manuscripts was addressed in the House of Commons.[88] This was to no avail, for on 26 October 1882 the volumes had been packed by the firm of Ellis and White for transport to Berlin, where they arrived by 4 November.[89] The fortune that Prussia paid for the manuscripts enabled the Duke of Hamilton to resume control of his estate on 25 November.[90] His gain was Britain's loss.

The British collections of Italian art, not to mention the holdings of the British Museum, had been acquired largely because of that country's weak economy and the attendant decline of its nobility.[91] Now the shoe was on the other foot, and it did not wear well. The booty of Britannia was being ravaged by other countries. Newpaper accounts did not observe the ironic symmetry of the situation, but it could hardly have been lost on the astute observer. Laws prohibiting works of art from leaving Britain were not enacted until 1939.[92] However, national recognition of their need was born in 1882.

NOTES

This article is based on a paper, "Botticelli and Dante in the Nineteenth Century," that I presented at the Interdisciplinary Nineteenth-Century Studies Sixth Annual Colloquium hosted by the Yale Center for British Art, April 5–6, 1991. Additional research at the University of Michigan in the summer of 1991 was made possible by the National Endowment for the Humanities, through their Summer Seminars for College Teachers program. I would like to express my gratitude to the NEH for providing me with time and access to an excellent library, which enabled me to expand the scope of this study. Thanks are also due to Dr. Peter Dreyer, who generously shared his knowledge of Botticelli, Dante, and MS Ham. 201 with me, to Paul Barolsky, who introduced me to the writings of Walter Pater, and to Liana Cheney, who encouraged me to write on Botticelli and Dante in nineteenth-century Britain.

1. Charles Eastlake Smith, ed. *Journals and Correspondence of Lady Eastlake*, 2 vols. (London: John Murray, 1985), 2:89. Quoted in John Steegman, *Consort of Taste, 1830–1870* (London: Sidgwick and Jackson, 1950), 239.

2. Michael Levey, "Botticelli and Nineteenth-Century England," *Journal of the Warburg and Courtauld Institutes* 23 (December 1960): 291–306. Levey's article provides a comprehensive account of Botticelli's *fortuna*. This paper is greatly indebted to it.

3. Francis Haskell, *Rediscoveries in Art* (Ithaca: Cornell University Press, 1976).

4. Frank Kermode, *Forms of Attention* (Chicago: University of Chicago Press, 1985).

5. See Herbert P. Horne, *Botticelli: Painter of Florence* (1908; reprint, Princeton: Princeton University Press, 1980); and Ronald Lightbown, *Sandro Botticelli*, 2 vols. (Berkeley: University of California Press: 1978).

6. For information regarding the codex and its acquisition by the Duke of Hamilton, see below, notes 49 and 64.

7. See Levey, "Botticelli and Nineteenth-Century England," 297–303, for Botticelli's *fortuna* in the eighteenth and nineteenth centuries.

8. Ibid., 300.

9. In 1857, Botticelli's *Mystic Nativity* was in the collection of Fuller Maitland, who sold it to the National Gallery in 1878 (see Lightbown, *Sandro Botticelli*, 2:100). For the painting's influence on Rossetti's *Blessed Damozel*, see Alicia Craig Faxon, *Dante Gabriel Rossetti* (New York: Abbeville Press, 1989), 209.

10. See Steegman, *Consort of Taste*, 73–74; and Levey, "Botticelli and Nineteenth-Century England," 296–97.

11. Levey, "Botticelli and Nineteenth-Century England," 292. Prior to 1815, the *Primavera* and the *Birth of Venus* were in the Medici villa at Castello (Lightbown, *Sandro Botticelli*, 2:51–52, 64).

12. See Steegman, *Consort of Taste*, 73–74; and Levey, "Botticelli and Nineteenth-Century England," 297, 303.

13. R. B. Gotch, *Maria, Lady Calcott* (London: John Murray, 1937), 263–64.

14. Ralph Nicholson Wornum, *Epochs of Painting: A Biographical and Critical Essay on Painting and Painters of all Times and Many Places* (London: Chapman and Hall, 1864), 160.

15. William Powell Frith, *My Autobiography and Reminiscences*, 3 vols. (London: Richard Bentley & Son, 1887–88), 2:90, Quoted in Levey, "Botticelli and Nineteenth-Century England," 305.

16. See Levey, "Botticelli and Nineteenth-Century England," 296, 301 n. 56; and Horne, *Botticelli: Painter of Florence*, xvii–xviii.

17. Horne, *Botticelli: Painter of Florence*, xviii. Noted by Levey, "Botticelli and Nineteenth-Century England," 301.

18. Lightbown, *Sandro Botticelli*, 2:28. William Rossetti said that his brother Dante bought the portrait then entitled *Smeralda Bandinelli* at Colnaghi's sale in March, 1867 for £20 and sold it for £315 in ca. 1880. See *Dante Gabriel Rossetti: His Family Letters, with a Memoir by William Michael Rossetti*, 2 vols. (London: Ellis & Elvey, 1895; reprint, New York: AMS Press, 1970), 1:264; see also *Rossetti Papers 1862–1870* (London: Sands, 1903; reprint, New York: AMS Press, 1970), 228. For the painting's sale to Constantine Ionides in 1880, see *Dante Gabriel Rossetti and Jane Morris: Their Correspondence*, ed. John Bryson and Janet Troxell (Oxford: Clarendon Press, 1976), 152.

19. *Rossetti: Family Letters*, 2:196.

20. *Rossetti and Morris Correspondence*, 97. Three of the *Nastagio* panels are in the Prado, Madrid; the fourth, *Marriage Feast*, is in a private collection. For their provenance, consult Lightbown, *Sandro Botticelli*, 2:49–50.

21. "For *Spring* by Sandro Botticelli (In the Accademia, Florence)." The sonnet was first published in Dante Rossetti's *Ballads and Sonnets* (1881). William Rossetti, in his letter to Herbert Horne, dated the poem ca. 1879–81 and asserted that his brother had "no direct knowledge" of the *Primavera* until ca. 1879, when a friend sent his brother "a well-sized photograph of it" (Horne, *Botticelli: Painter of Florence*, xviii). For the photograph of the *Primavera* that Charles F. Murray sent to Dante Rossetti in August 1879, see *Rossetti and Morris Correspondence*, 110.

22. *Rossetti: Family Letters*, 1:264. Levey, "Botticelli and Nineteenth-Century England," 301, observed that Dante Rossetti's enthusiasm for Botticelli may have influenced Swinburne, the first Englishman to write

at length about the artist. For Swinburne's association with the Rossetti brothers, see Catherine Morley, "Swinburne's 'Notes on the Royal Academy Exhibition, 1868,'" *Journal of Pre-Raphaelite Studies* 2, no. 2 (May 1982): 49–56.

23. In a letter to Jane Morris (August 1879), Dante Rossetti mentioned the newly discovered frescoes from the Villa Lemmi, and described a photograph of a *Madonna and Child* that corresponds with Botticelli's *Madonna del Libro* (ca. 1479, Museo Poldi-Pezzoli, Milan). See Bryson, *Rossetti and Morris Correspondence*, 110–13; and *Rossetti: Family Letters*, 2:365.

24. Walter H. Pater, "A Fragment on Sandro Botticelli," *Fortnightly Review* 14 (August 1870): 155–60; Pater's essay can also be found under the title "Sandro Botticelli," in *The Renaissance: Studies in Art and Poetry* (London: Macmillan, 1919; reprint, Chicago: Academy Press, 1977), 39–51.

25. See Samuel Wright, *A Bibliography of the Writings of Walter H. Pater* (New York: Garland, 1975), xv–xviii, 5, 9, 61–63; see also Robert Morris Seiler, *Walter Pater: The Critical Heritage* (London: Routledge & Kegan Paul, 1980), 47–91.

26. *Works of John Ruskin*, ed. E.T. Cook and Alexander Wedderburn, 39 vols. (London: George Allen, 1903–12), 22:291–490, 23; frontispiece, xxxv–xxxvii, xlix, 275–76, 478–79. Ruskin spent fourteen days making a watercolor drawing of Zipporah. As Levey, "Botticelli and Nineteenth-Century England," 295, has noted, Ruskin's fascination with Zipporah was probably sparked by A. F. Rio's discussion of the figure in his *La Poésie Chrétienne* (Paris: Debêcourt, 1836).

27. *Works of Ruskin*, 23:lxix, 265–66.

28. Gail Weinberg, "Ruskin, Pater, and the rediscovery of Botticelli," *Burlington Magazine* 129 (January 1987): 25–27.

29. Mario Praz, *Romantic Agony*, trans. Angus Davidson (London: Oxford University Press, 1933), 339, 399, 403; see also Levey, "Botticelli and Nineteenth-Century England," 304.

30. *Punch* 80 (January, 1881): x. See Haskell, *Rediscoveries in Art*, 175–77; Levey, "Botticelli and Nineteenth-Century England," 304; and Horne, *Botticelli: Painter of Florence*, xix.

31. John Addington Symonds, *Renaissance in Italy: the Fine Arts* (London, 1877; reprint, New York: Charles Scribner & Sons, 1901), 181 n. 1.

32. *Works of Ruskin* 22:423–24, 23:277.

33. Giorgio Vasari, *Lives of the Artists*, trans. George Bull (1963; reprint, London: Penguin Books, 1980). The Italian quotation in the text is taken from Giorgio Vasari, *Le Vite de' più eccellenti pittori, scultori, e architettori nelle redazione del 1550 e 1568*, ed. Paola Barocchi and Rosanna Bettarini, 6 vols. (Florence: Sansoni, 1966–71), 3:516–17.

34. Pater was elected to the Oxford Dante Society in December 1890. In 1892, he wrote the introduction to Prof. Charles L. Shadwell's translation of Dante's *Purgatorio*. See Thomas Wright, *The Life of Walter Pater*, 2 vols. (New York, 1907; reprint, New York: Haskell House Publishers, Ltd., 1969), 2:169–70. For Ruskin's assessment of Dante, see *Comments of John Ruskin on the Divine Comedy* (Boston: Houghton, Mifflin & Co., 1903).

35. Vasari, *Le Vite*, 5:396. For copies of the 1481 *Commedia* that contain the Baldini engravings, see Colomb de Batines, *Bibliografica dantesca* (Prato: Aldina, 1845–46) 2:345; and Arthur Mayger Hind, *Early Italian Engraving: A Critical Catalogue with Complete Reproduction of all the Prints Described*, 7 vols., 1938–48, 1:97–120. For the dates of the engravings, and a persuasive argument that most of them were executed between 1482 and 1487, see Peter Dreyer, "Botticelli's Series of Engravings of '1481,'" *Print Quarterly* 1:2 (June 1984): 111–15.

36. Walter Pater, *Renaissance: Studies in Art and Poetry* (London: Macmillan, 1910; reprint, Chicago: Academy Press, 1977), 52–54.

37. Ibid., 54.

38. Ibid., 55; see also Vasari *Le Vite*, 3:514. For the Palmieri *Assumption* and its subsequent attribution to Francesco Botticini, see Martin Davies, *National Gallery Catalogues: The Earlier Italian Schools* (London: National Gallery, 1951), 94–95. I would like to thank Gail Weinberg for her insightful observation of the relation between Pater's discussion of Botticelli's altarpiece and his ensuing treatment of Botticelli's *Inferno* illustrations.

39. Pater, *Renaissance*, 55.

40. Dante Alighieri, *Inferno*, vol. 1 of *The Divine Comedy*, trans. Mark Musa (New York: Penguin Books, 1984), 90. Verses paraphrased are from *Inferno, canto 3*, lines 35–42, 60.

41. Pater, *Renaissance*, 55.

42. Ibid., 56–57. Reviewers of *Studies in the Renaissance* were virtually unanimous in their criticism of *Pater's* interpretation of the *Madonna*

of the *Magnificat*. See Seiler, *Walter Pater*, 47–111.

43. *Works of Ruskin*, 27:371–72.

44. Ibid., 22:428–31, 23:266.

45. Ibid., 22:433–34.

46. Ibid., 434.

47. Horne, *Botticelli: Painter of Florence*, xvii–xvix, 122, 333–34. For Pater's influence on Horne, see Julie F. Codell, "Horne's *Botticelli*: Pre-Raphaelite Modernity, Historiography and the Aesthetic of Intensity," *Journal of Pre-Raphaelite and Aesthetic Studies* 2, no. 1 (Spring 1989): 27–41.

48. Paul Barolsky, *Walter Pater's Renaissance* (University Park: Pennsylvania State University Press, 1987), 188. See also 135.

49. For a full account of MS Ham. 201 and the six sheets from the codex in the Vatican (Biblioteca Apostolica, Reg. lat. 1896), consult the excellent study by Dr. Peter Dreyer, *Dante's Divina Commedia mit den Illustrationen von Sandro Botticelli* (Zurich: Belser Verlag, 1986). For errors in nineteenth-century descriptions of the MS, see ibid., 128 n. 38. Botticelli's manuscript drawings for Dante's *Commedia* have been dated from ca. 1480 through 1510, the year of the artist's death. See ibid., pp. 61–62, and Lightbown, II:173.

50. *Dictionary of National Biography*, 1967–68 edition, s.v. "Douglas, Alexander Hamilton."

51. William Clarke, *Repertorium Bibliographicum; or, Some Account of the Most Celebrated British Libraries*, 2 vols. (London: J. F. Dove, 1819), 27–28. A broadside for the volume dated 1814 in the Harvard University Library indicates that the text was written years prior to its publication in 1819.

52. Dreyer, *Divina Commedia*, 21.

53. Molini, Landi & Co. had shops in Florence, Paris, and London. See *Operette Bibliografiche del Cav. Giuseppe Molini (già Bibliotecario Palatino) con Alcune lettere di distanti personaggi al medesimo precedute dalle Notizie scritte da G. A.* (Florence: Molini, 1858).

54. The duke may have purchased the codex in 1802. See Zoltán Haraszti, "Fifteenth-Century Books," *More Books: The Bulletin of the Boston Public Library* 18, no. 3 (1943): 98.

55. Gustav F. Waagen, *Treasures of Art in Great Britain*, trans. Lady Eastlake, 3 vols. (London: John Murray, 1854), 3:307. For the inaccessibility of the Hamilton Libraries to scholars, see Sylvanus Urban, "Table Talk," *Gentleman's Magazine* 252 (April 1882): 509.

56. See Frederic Boase, *Modern English Biography* (London: Frank Cass & Co., 1912; reprint, 1965), 5:549–50; see also *British Sports and Sportsmen: Sportsmen of the Past*, 2 vols., ed. *Sportsman* (London, *Sportsman*, n.d.), 2:275. The duke sold his kennel of greyhounds in 1880, but this was not sufficient to cover his debts. He retained his horses, and won a number of races in the 1880s.

57. The London *Times* was circumspect regarding the factors that precipitated the Hamilton sales. *Illustrated London News*, *Bibliographer*, and *Gentleman's Magazine*, however, were not so kind. See, for example, *Gentleman's Magazine* 252 (April 1882): 509.

58. *Times* (London), 5 January and 6 February 1882. Both houses provided sales catalogues before the auctions. Catalogues that listed the purchasers and purchase prices were published after the sales.

59. *Times* (London), 30 May 1882. See also the letters by T. Tomlinson, *Times* (London), 5 June, 1882, and by "A Painter", *Times* (London), 7 June, 1882.

60. *Times* (London), 23 June 1882. Moneys appropriated for purchase of items from the Hamilton estate by the British Museum and acquisitions made from the Hamilton estate are recorded in the Museum's *Original Papers*, 8 July 1882: 3336, and 26 July 1882: 35916 *BM*, and in the *Minutes of the Trustees' Standing Committee*, 24 June 1882:16,031, and 29 July 1882:16,074 *BM*. I am indebted to Miss Janet Wallace, Museum Archivist, for making these papers available to me. For appropriations to other British museums, see *Hansard Parliamentary Debates*, 3d series, vol. 271 (1882), cols. 21, 204.

61. The Beckford Library came to Hamilton Palace through Susanna Euphemia Beckford, William Beckford's second daughter, who married Alexander Douglas in 1810. The Botticelli Dante bears no sign of Beckford's ownership and was kept in the room that contained the Hamilton Library. See Waagen, *Treasures*, 3:307; *Times* (London), 6 February 1882; Dreyer, *Divina Comedia*, 129 n. 41; and Seymour de Ricci, *English Collectors of Books and Their Marks of Ownership, 1530–1930* (Cambridge: Cambridge University Press, 1930), 68.

62. *Times* (London), 26 June 1882. For the eminent audiences at the sales of the paintings, see *Times* (London), 15 June and 19 June 1882. For those who attended the Beckford Library sales, see *Times* (London), 1 July; see also *Athenaeum*, 8 July 1882.

63. See *Times* (London), 30 May 1882. See also *Times* (London), 6 February and 5 June 1882. The Palmieri *Assumption* had been exhibited in the Old Masters Exhibition at Burlington House in 1873, at which time it was praised in the London *Times*.

64. Ibid., 26 June 1882.

65. Ibid.

66. *Athenaeum*, 1 July 1882. The top price in the sales of the Hamilton pictures was £5,145, which went for Rubens's *Daniel in the Lion's Den* (ca. 1615, National Gallery, Washington, D.C.).

67. The prices for paintings attributed to Botticelli rose in the 1870s but had never reached such a height. In 1874, the National Gallery (London) bought Botticelli's *Mars and Venus*, for £1,050 and in 1878, it paid £1,500 for the *Mystic Nativity* (see Lightbown, *Sandro Botticelli*, 2:55, 100.

68. *Times* (London), 18 July 1882. *Athenaeum*, 22 July 1882, provided a slightly higher total of £31,516 5s., and *Bibliographer* 2 (August 1882): 60 reported a slightly lower total of £30,516 5s, or "an average of nearly £10 per lot." The prices that Beckford's volumes fetched were higher than expected. Five months before the sale, the book dealer Henry G. Bohn estimated the entire library at £50,000; the first sale, representing approximately one-forth of the collection, brought in 63 percent of this amount.

69. For comparative assessments of the Beckford and Hamilton libraries, see the *Times* (London), 5 Jan. 1882, and *Bibliographer*, 1 (February 1882): 87. The 692 Hamilton MSS were divided into 685 lots in the Sotheby's sales catalogue. The Dante codex of *Commedia* was lot no. 201.

70. Ruskin visited Hamilton Palace in December 1853. See Mary Lutyens, *Millais and the Ruskins* (New York: Vanguard Press, 1967), 117–18, and *Works of Ruskin* 12:lxvii–lxviii, 192. For Ruskin's pamphlet (20 February 1882) appealing for contributions, see *Works of Ruskin*, 30:45, 57–58; *Letters of John Ruskin to Bernard Quaritch, 1867–1888* Charlotte Q. Wrentmore (London: Bernard Quaritch, Ltd., 1938), 54, 58–59; and *Bibliographer* 3 (December 1882–May 1883): 8.

71. *Bibliographer* 1 (February 1882): 86.

72. *Times* (London), 5 January 1882.

73. See Sotheby's *Catalogue of the Magnificent Collection of Manuscripts from Hamilton Palace* (London, 1882): 31; quoted in Dreyer, *Divina Commedia*, 22. My thanks to Dr. Peter Dreyer for making this catalogue available to me and for sharing his knowledge of Lippmann's efforts to acquire the codex.

74. *Times* (London) 4 November 1882. See also *Times* (London), 20 November, for speculations that payment for the Hamilton MSS would exceed the emperor's "private disposal fund" and that the forthcoming Prussian budget would include a special allocation for the MSS, "there being little doubt of its being cheerfully granted." For Lippmann's negotiations and the support of Prussia's emperor, crown prince and Ministers of Finance and Education, see *Bibliographer* 3 (December 1882): 50–51.

75. *Beloved Mama: Private Correspondence of Queen Victoria and the Crown Princess 1878–1895*, ed. Roger Fulford (London: Evans Brothers, Ltd., 1981), 122–23.

76. Ibid., 126.

77. Philip Guedella, *Queen and Mr. Gladstone* (New York: Doubleday, Doran & Co., 1934), 549.

78. *Gladstone Diaries, With Cabinet Minutes and Prime-Ministerial Correspondence*, ed. H. C. G. Matthew, 11 vols. (Oxford: Clarendon Press, 1990), 10:313–14. Mr. Gladstone wrote a second time to the Queen regarding the Botticelli Dante; for in a letter to her daughter dated 10 October the Queen enclosed a correspondence from him. A response by the crown princess dated 14 October suggests that Gladstone

had indicated that measures had been taken to secure the codex (see *Beloved Mama*, 127 n. 1).

79. There was great secrecy about the purchase price of the MS collection, and reports vary. The London *Times*, 1 and 20 November 1882, claimed the amount to be "£75,000, or one and a half million marks"; the correspondent from Berlin reported in the *Times* (London), 24 November 1882, that he had been "positively informed" that the sum paid was £80,000. *New York Times* (8 December 1882), reported the price as $400,000.

80. Julia Prewitt Brown, *Reader's Guide to the Nineteenth Century Novel* (New York: Macmillan, 1985), 7–8, 123 n. 7. Brown cites the studies of E. H. Phelps Brown and Sheila V. Hopkins in *Essays in Economic History*, ed. E. M. Carus-Wilson (New York: St. Martin's Press, 1966), 2:168–97. Brown's formula (n. 80) for calculating the twentieth-century dollar value of nineteenth-century British currency is based on the inflation rate of the 1960s. Consequently, the figure of sixteen million dollars that I have cited is much less than the 1990s equivalent of £80,000 in 1882.

81. Thompson to Trustees' Standing Committee of the British Museum, 8 November 1882, Original Papers no. 5155. Quotation is courtesy of the Trustees of the British Museum. My gratitude to Miss Janet Wallace for providing me with this material. Using Brown's formula, Mr. Thompson's estimation of £20,000 for the Dante codex would well exceed four million dollars today.

82. The first report of rumors that Prussia had purchased the Hamilton MSS appeared in the London *Times*, 1 November 1882, and was based on a story in the *National Zeitung*. The following day, the Berlin correspondent reported that the purchase had been "authoritively announced."

83. *Times* (London): 6, 8 December 1882. For Ruskin's anger over the loss of the MSS, see *Ruskin to Quaritch*, 60, and *Some Stray Letters of Ruskin to a London Bibliopole (Letters to Mr. F. S. Ellis, Sometime of New Bond Street, Now at Torquay)* (London: Private Printing, 1892), 72.

84. See *Times* (London), 4 November 1882, and *Bibliographer* 3 (December 1882): 5.

85. *Times* (London), 4 November 1882: "The literati and archaeologists are rubbing their hands in high glee." For other reports from Berlin, see the London *Times*, 2 and 6 November 1882.

86. *Times* (London), 20 and 27 November 1882.

87. *Bibliographer* 3 (December 1882): 4–5.

88. *Hansard Parliamentary Debates*, 3d ser., vol. 274 (1882), col. 659, and vol. 275 [(1882), col.] 204. The Museum Trustees responded to the questions raised in the House of Commons with claims of ignorance of Prussia's efforts to acquire the MSS. The Berlin correspondent for the London *Times* refuted these statements, reporting that the Trustees knew full well that Lippmann was negotiating with the duke.

89. For the shipping of the MSS, see *Bibliographer* 5 (January 1883): 50–51, and Dreyer, *Divina Commedia*, 21–22, 129 n. 40. For the MSS that were left in Britain and the disposition of those shipped to Berlin, see Helmut Boese, *Die lateinischen Handschriften der Sammlung zu Berlin* (Wiesbaden: Harrassowitz, 1966). MS Ham. 201 was subsequently divided between the Kupferstichkabinett's of the Staatliche Museen Preussischer Kulturbesitz in Berlin (Dahlem) and the Staatlichen Museen zu Berlin.

90. Report from Glasgow, 25 November, reported in *New York Times*, 26 November 1882.

91. Haskell, *Rediscoveries in Art*, 125–40. See also John R. Hale, *England and the Italian Renaissance: The Growth of Interest in Its History and Art*, rev. ed. (London: Faber & Faber, 1963).

92. Import Export and Customs Powers Act, 1939, c. 69.

Part II
European Influences on Pre-Raphaelite Art

Burne-Jones: Mannerist in an Age of Modernism

LIANA DE GIROLAMI CHENEY

FOR IANNI YANNAS

Within the pre-raphaelites group, edward Coley Burne-Jones stands out in his self-conscious alignment with the theories and formal devices of the Mannerist tradition, giving visible form a theory of art—his enactment of beauty—in a consciously Mannerist style. In *Due Lezzioni* (1547), Benedetto Varchi defined the intention of artistic creation of Mannerist artists as "an artificial imitation of nature."[1] The Mannerist painter strove to create an image of beauty by surpassing nature—arousing a spiritual emotion—thus creating an aesthetic ideal. With Neoplatonic doctrine in mind—"beauty consists of a certain charm," as something spiritual that transcends sensual experience and that makes us long for the origin of what we perceive—the Mannerist painters emphasized the ideal beauty in the mind of the artist rather than the reproduction of beauty discovered in nature.[2] By using elongated figures *(figura serpentinata),* sinuous rhythms, and unreal color schemes, forms evolved from reality but were transformed into fantasy.[3] The translation into an unreal space with no perspectival structure enhanced the ambiguity of that reality. Burne-Jones, favoring this concept, elaborated on the Mannerist aesthetic ideal by creating an idealized image that would combine beauty and would arouse love: "Only this is true, that beauty is very beautiful and softens, and comforts, and inspires, and rouses, and lifts up, and never fails."[4] Agnolo Bronzino's *Pygmalion and Galatea* (1529–30, Palazzo Vecchio, Florence, fig. 1) clearly embodies the Mannerist aesthetic ideals expounded by Benedetto Varchi in *Due Lezzioni* or *Paragone* (1547), while in *Pygmalion and Galatea* (1868–78, Birmingham City Museum and Art Gallery, England, figs. 6–9) Burne-Jones illustrates his assimilation of Bronzino's style and of the Mannerist idealization.[5]

Fig. 1. Bronzino. *Pygmalion and Galatea.* 1529/30. Oil on panel, 81 × 63 cm. Florence, Palazzo Vecchio.

103

One way in which Burne-Jones searched for the ultimate aesthetic ideal is exemplified by the Pygmalion legend originating from a series of drawings for William Morris's *Earthly Paradise* (1868), a compendium of classical and romantic tales interpreted in a medieval mode.[6] Following Morris's lead, Burne-Jones also evoked in his paintings a medieval atmosphere, associated with courtly love rather than with classical legend. The painter, however, relied on the refined grace of the *maniera* figure type and, in more subtle ways, drew inspiration from the *maniera* aesthetic that extolled artistic invention, deliberate control and artifice, as well as the calculated imitation of the art of the past.

Burne-Jones was, no doubt, fascinated with the rich imagery and the delight in decorative details found in Morris's writings; but, above all, there existed a sympathetic bond between the two men because both rejected the harsher realities of nineteenth-century materialism. The intensity of Burne-Jones's rejection is made obvious by his statement: "I mean by a picture, a beautiful romantic dream of something that never was, never will be—in a light better than any light that ever shone—in a land no one can define or remember, only desire."[7]

What story could serve Burne-Jones's purpose more fittingly than that of the legendary Pygmalion who sculpted an ivory image of a woman fairer than any that had yet been seen?[8] Certainly, Burne-Jones would not doubt that the sculptor came to love his own handiwork as though it were alive. Nor, apparently, did he question that ideal beauty may be realized through artistic invention and vivified by the efficacy of prayer, aided by divine intervention in

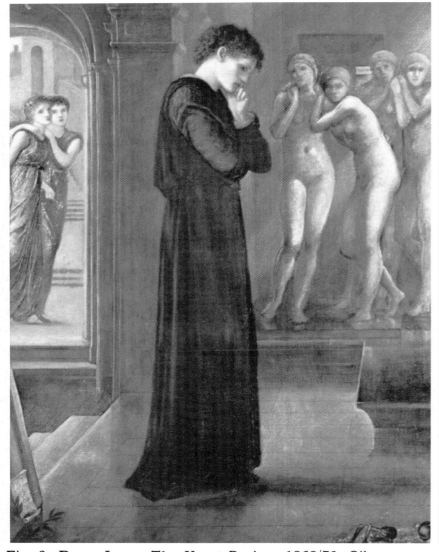

Fig. 2. Burne-Jones. *The Heart Desires*. 1868/70. Oil on canvas. 26 × 20″. Paris, The Joseph Setton Collection.

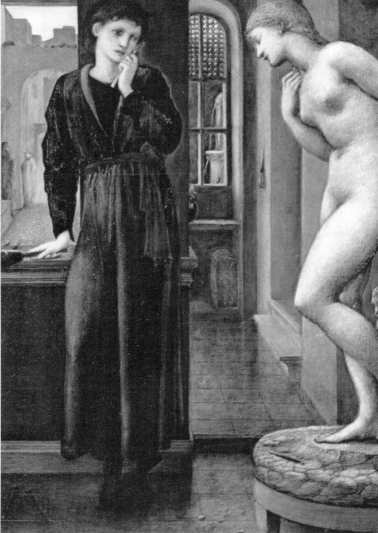

Fig. 3. Burne-Jones. *The Hand Refrains*. 1868/70. Oil on canvas. 26 × 20″. Paris, The Joseph Setton Collection.

the form of Venus—goddess of Ideal Beauty—or celestial love.[9] Even the eventual marriage of Pygmalion and Galatea spoke directly to Burne-Jones's concerns about the union of beauty and form. Taken as a whole, the narrative content celebrates the anguish and eventual triumph of the artist who turns away from harsher realities and seeks the comforting solace of beauty.

For Burne-Jones, the appeal of the Pygmalion legend is reaffirmed by his painting two series of the same subject. Between 1868–78 Burne-Jones executed two sets of four paintings on the Pygmalion legend: one version (1868–70, formerly in the Joseph Setton Collection, Paris, present location unknown, figs. 2–5) was commissioned by the Cassavetti family,[10] and the second version (1878, Birmingham City Museum and Art Gallery, England, figs. 6–9) was

completed later.[11] Burne-Jones's selection of the titles for these paintings—*Heart Desires, The Hand Refrains, The Godhead Fires,* and *The Soul Attains* (figs. 2–5, Parisian version; figs. 6–9, English version)—is a significant consideration in terms of his aesthetic sensibility and philosophy of love and is particularly telling with respect to the importance of Burne-Jones's contribution to the legend.

A brief comparative study of both versions underscores the stylistic versatility of the artist. The Parisian version (figs. 2–5) is executed in oils, while the English version (figs. 6–9) is done in gouache; the overall tonality in the Parisian version is greenish, while the English version is a mixture of blue and pink tones. In each version of *The Heart Desires* (fig. 2 from Paris with fig. 6 from England), the composition is similar—with the exception of the back-

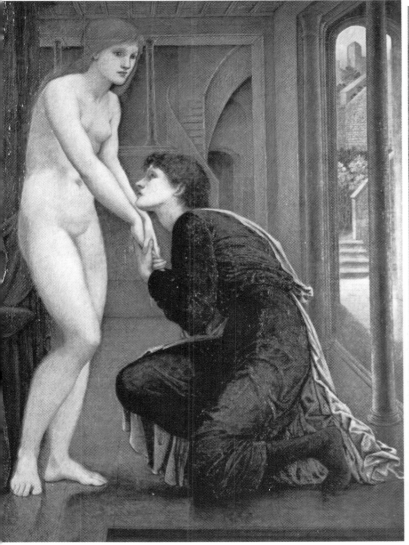

Fig. 4. Burne-Jones. *The Godhead Fires*. 1868/70. Oil on canvas. 26 × 20″. Paris, The Joseph Setton Collection.

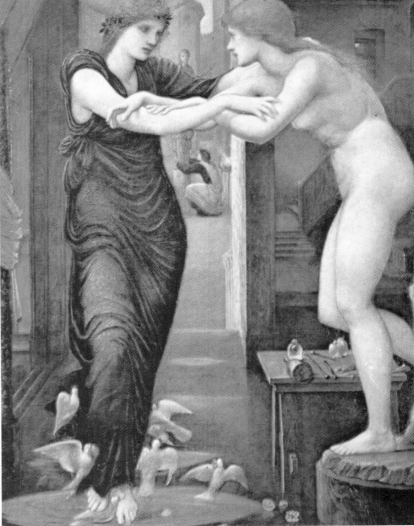

Fig. 5. Burne-Jones. *The Soul Attains*. 1868/70. Oil on canvas. 26 × 20″. Paris, The Joseph Setton Collection.

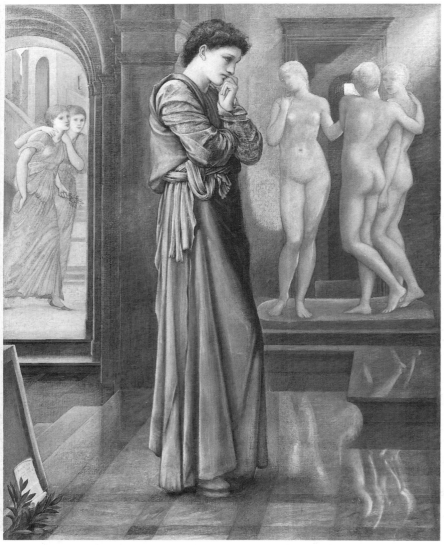

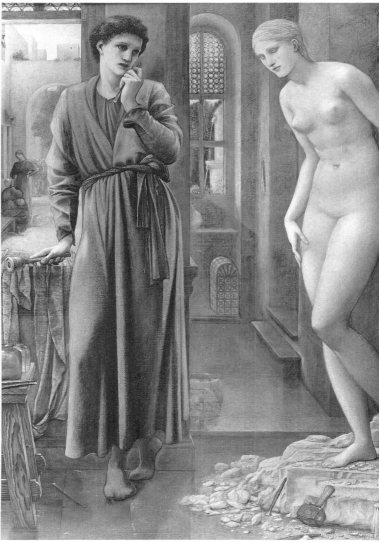

Fig. 6. Burne-Jones. *The Heart Desires.* 1878. Oil on canvas. 97.5 × 75 cm. The Birmingham City Art Gallery.

Fig. 7. Burne-Jones. *The Hand Refrains.* 1878. Oil on canvas. 97.5 × 75 cm. The Birmingham City Art Gallery.

ground, in which four simulated statues appear in the Parisian version.[12] The English version does not show the plinth with sculptural tools on the floor. In *The Hand Refrains* (fig. 3 from Paris with fig. 7 from England), the composition is also alike. However, the Parisian version shows the body of the Image in profile; and the Image rests on a wreath on the pedestal. The English version depicts the process of laboring—with the Image turning its face to the viewer while standing on a base. The loose stones and sculptural tools suggest that the sculpture is almost finished and that the artist has been working on it. In *The Godhead Fires* (fig. 4 from Paris with fig. 8 from England),[13] the two versions illustrate major differences in composition and theme. The Parisian version depicts a Venus without poetical reference—the myrtle is missing as well as the transpar-

ent garment. The English version presents an angelical Aphrodite, covered by transparent veils and holding an attribute of Venus in one hand. The colors are softened and diaphanous. The backgrounds of these scenes represent different aspects of the story: for example, only the Parisian version illustrates Pygmalion imploring Venus for his love in the background. The last scene from the *Pygmalion and the Image* series is *The Soul Attains* (fig. 5 from Paris with fig. 9 from England): In the English version, a rose is between the lovers, while a Flemish mirror attests to the transitoriness of life, the frailty of love, and the purity of the soul.

The Pygmalion paintings were first exhibited at the Grosvenor Gallery in 1879. Their chalky tones and Romantic expression disturbed the critics of the time. In 1893, the paintings were shown at the New

Fig. 8. Burne-Jones. *The Godhead Fires*. 1878. Oil on canvas. 97.5 × 75 cm. The Birmingham City Art Gallery.

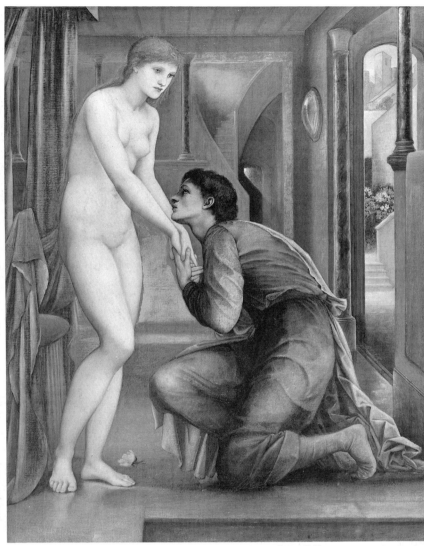

Fig. 9. Burne-Jones. *The Soul Attains*. 1878. Oil on canvas. 97.5 × 75 cm. The Birmingham City Art Gallery.

Gallery; they were sold in May 1895 for 3,675 guineas and again in July of 1898 for 2,800 guineas.[14] Numerous drawings were executed for both commissions, and most of the drawings are located at the Birmingham City Museum and Art Gallery (England). The eleven drawings in three frames meant to illustrate the Pygmalion legend of Morris's *Earthly Paradise* (now at the Birmingham City Museum and Art Gallery) were executed between 1865 and 1878 on tracing paper and were intended as designs for woodcuts for an edition that was never printed; however, the two sets of paintings (the Parisian and English versions) incorporate the drawings' composition and iconography. The drawings for *Pygmalion and the Image* were designed in three frames of eleven pencil designs on tracing paper for woodcuts. The designer and architect William A. S. Ben-

son commented on Burne-Jones's drawing process in the Pygmalion series: "The drawings are free and spontaneous as well as peculiar for they are executed upon tracing paper—a material not often used by the artist."[15]

In the first frame Pygmalion, solitary and despondent, is shown in his studio closed off from the world because the Cypriot maidens of his acquaintance—rather like Burne-Jones's own culture—did not meet the sculptor's high standards of physical and moral beauty. In the drawing, Pygmalion is in his studio in Cyprus—and this is repeated in the painting. In these compositions, the artist desires to invent a figure of some beauty greater than the ones already created: this is alluded to in the background of the sculptor's studio, where a collection of his own sculptures are in view (compare, for example, the

drawing of Pygmalion with the painting *The Heart Desires,* English version).

In the next two drawings, *Sculpting the Image* and *Completed Image,* Pygmalion is shown at work creating the ideal image of a woman. The second drawing represents Pygmalion carefully carving the Image from memory: invention surpasses imitation—a Mannerist concept—bringing forth, in Lomazzo's words, "the image reflected in the mirror of his own mind."[16] In the drawing of the *Completed Image,* as in the painting *The Hand Refrains,* Burne-Jones represented the finished creation of the Image and the satisfaction of the artist's accomplishments in the figure of Pygmalion admiring his completed creation. Burne-Jones's parallelism between the drawing and the painting denotes his concern with the artistic sense of judgment—which, in the process of an art form, is necessary in order to achieve an idealized image. This sense of judgment was also a well-established Mannerist ideal that was recognized and fostered by Pre-Raphaelite artists.

The following frames, *Image in a Niche* and *Pygmalion Despairs,* portray the artist suffering from a different kind of despair, for he has now placed the sculpture in a niche in his bedroom and has come under the spell of his own creation. In the last drawing from the first frame, Pygmalion is seen playing the organ to his muse. With this portion, Burne-Jones moved away from the quest to the creation of an ideal image to the experience of the created image itself. The aesthetic experience arouses the soul and emanates love; in this regard, Burne-Jones had obviously assimilated the Neoplatonic philosophy found in Mannerism and visualized his aesthetic concept of beauty. Burne-Jones's Pygmalion also expresses his agony of love through music—and in these ways, Burne-Jones deliberated between the concept of the real (Pygmalion's feelings) and the ideal (the sculpture of the Image).

The drawings in the second frame represent a passionate Pygmalion offering flowers and incense to the Image. The adjacent drawing shows how Pygmalion, unable to part from the presence of the Image, has placed his creation in a niche in his bedchamber. Pygmalion then turns despairingly to Venus for help—offering her rarefied flowers and incense, as confirmed in the drawings of *Venus* and *Offerings.* The third set of frames dramatizes Venus as she gives life to the Image. With her divine touch, Venus—appearing in a glory of purifying tongues of fire—endows the cold statue with life. At the touch of Venus, the Image takes life and is in the act of moving from the niche—her hair falling down and the spray dropping from her hand. In the painting *The Godhead Fires* (fig. 8) the stance of the figures is reversed.

These last drawings show Pygmalion returning sadly to his house, unaware of the intervention of Venus. As Pygmalion enters his studio, he finds his prayers fulfilled: the Image has been transformed into a woman. The next drawing represents the happiness of Pygmalion, as he embraces the Image in front of the altar of Hymen. Behind the lovers—Pygmalion and the Image—sits Venus enthroned, with an apple in her right hand and Cupid captured between her knees. The power of love has triumphed over artistic beauty—Pygmalion's passion for the Image has become more important than the creation of a perfect figure. In the simplified composition of *Soul Attains* (fig. 9), the emphasis is on the sculptor's recognition and acceptance that his creation has become reality and that his request for love has been fulfilled. Burne-Jones's painting represents the fusion of the natural form with the idealized image as a manifestation of the emotion of love.

The final frames of these drawings, *Lovers,* illustrates the events upon Pygmalion's return—embracing his bride by the altar of Hymen with the blessing of the triumphant, enthroned Venus. Here Burne-Jones has conveyed the impact of the power of love transforming beauty into vital reality. The parallelism of transformation is observed between Venus's creation and the divine intervention that makes the ideal (Beauty) into the real (the Image), as the sculptor Pygmalion like a divine creator, transforms and creates out of a mass of stone into a sculptural figure. These transformations (already implicit in the source for the iconography, Ovid's *Metamorphoses*) are paralleled with the representation of a material form through an idealized image into the expression of a spiritual sentiment, love itself.[17] These mutations repeatedly stem from Burne-Jones's imitation of classical writings—above all, Ovid's *Metamorphoses.* The transmutation is from physical matter to form, creation of form to ideal, expression of the ideal to sentiment, and sentiment of love into the aesthetic of beauty. Burne-Jones not only has assimilated Mannerist ideals in his visual imagery and theory of art, but he also has fused these ideals with his own theory of art, thus creating a new response to the Pre-Raphaelite movement. Burne-Jones had been influenced in his early style by the Pre-Raphaelites' search for a new art and by the study of nature; Ruskin's writings and criticism, too, had been of great significance for Burne-Jones. The notion that art might exist for its own sake, independent of some

moral purpose, did not initially appeal to Burne-Jones. Furthermore, in the *Pygmalion* series, he established new artistic criteria that would be emulated by late-nineteenth-century European artists, especially by French Symbolists.[18]

Burne-Jones utilized the amorous Pygmalion tale to focus on the theme of artistic creativity and, perhaps more characteristically, to reveal the very anxiety associated with artistic inspiration—the *furor poeticus* that informs the creative act. The poetic imagination of his creation and the manner in which he embodied them in his visual imagery created a work of art that contained beauty of form and color as well as "a powerful and overwhelming originality, and an unequalled grace and delicacy of fancy"[19]—a Mannerist conceit. In his writings, Vasari related the concept of *furor poeticus* to the creation of visual arts and stated, "Many painters . . . achieve in the first design of their work, as though guided by a sort of inspirational fire, something of the good and a certain measure of boldness, but afterwards, in finishing it, the boldness vanishes."[20]

The Pygmalion story gave Burne-Jones the opportunity to dwell on issues that were of great importance to him—namely, his understanding of artistic anxiety and of conscious deliberation, the necessity of artistic invention, and the love of the product of artistic creation. The story as illustrated by Burne-Jones emphasizes the power of creativity over unformed matter, the power of the image over nature. Art and the artist as lover make beauty itself live. As Burne-Jones visualized it, the story was not just about the transformation of sculpture into living flesh nor about the transformation of sculptor into lover as much as it was concerned with the transformation of artistic creativity into aesthetic sensibility. Earlier, Vasari had defined artistic creativity as richness of invention, absolute familiarity with anatomy, and the reduction of difficulty to facility; and these concepts pervade Burne-Jones's series.

Even Burne-Jones's working method suggests a link to the Mannerist aesthetic. As the designer-architect William A. S. Benson recounted, "Burne-Jones once informed me that before he began to execute a design he could always see it upon a black piece of paper as if it had been drawn in lines, and that his first operation was thus simplified into something like tracing."[21] Since the image reflected in the artist's mind was rarely given acceptable form in one try, Burne-Jones saved time and labor, according to Benson, by tracing the parts that he wished to preserve and by correcting the rest on tracing paper. Thus, Burne-Jones achieved that polished product,

perfect technique, and coolly calculated, controlled form that Sydney Freedberg and Craig Smyth have prominently associated with the *maniera*.[22] And as other scholars like John Shearman have asserted, *maniera* entails a refinement of and abstraction from nature—a concept brilliantly reinvented by Burne-Jones.[23]

The Pygmalion legend also fit neatly into Burne-Jones's understanding of artistic creativity as dependent on past art, for the Pygmalion saga was associated with a long tradition of images. As has been shown for Bluhm, the Pygmalion legend, originally based on Ovid's *Metamorphoses,* was elaborated in the Middle Ages in *The Roman de la rose* and *Ovid moralisé,* works that were frequently illustrated with woodcuts and miniatures, such as a Pygmalion and Galatea miniature (1370, Pierpont Morgan Library, New York) and the woodcut *Pygmalion and Galatea* by Christine de Pisan in *Cent hystoires de troyes* (1480, Bibliothéque Nationale, Paris). *Ovid moralisé* was reevaluated in the Renaissance and Mannerist periods in emblem books such as *Emblemata Tyrocinia,* which contains Tobias Stimmer's 1581 woodcut *Emblema 34.* If the Pygmalion legend had come under earlier heavy fire from some quarters in the nineteenth century (as suggested by Thomas Rowlandson's engraving of 1800 and Honoré Daumier's Lithograph of 1842), these attacks by skeptics obviously did not worry Burne-Jones; and the attacks may, in fact, have spurred him on to treat the subject.[24]

Burne-Jones revealed his delight in the Pygmalion narrative by creating a set of sequential scenes that encompassed various theoretical artistic concerns; as I have suggested, these concerns included artistic anxiety and deliberation in the creation of an artwork, the artistic quest for invention (as well as the sense of judgment), and the artist's desire to express an ideal in a form—in this instance, beauty in sculpture—with love as the outcome of the creation. As Burne-Jones himself rhapsodized, to him the ideal picture was a "romantic dream of something that never was, never will be—in a light better than any light that ever shone—in a land no one can define or remember, only desire."[25] In addition, Burne-Jones's very selection of titles also obviously conveys this aesthetic sensibility: *The Heart Desires, The Hand Refrains, The Godhead Fires* and *The Soul Attains.*

Burne-Jones and William Morris focused on the amorous aspect of the Pygmalion story in different ways. Burne-Jones considered his work, particularly the Pymalion series, as literary art—a painted poem

(ut pictura poesis). By contrast, William Morris elaborated on the natural setting described in the narrative poem—the landscape of earthly paradise. Furthermore, Burne-Jones heightened the amorous aspect to emphasize his own artistic creativity and aesthetic theory of beauty and love, thus de-emphasizing the illustration or depiction of nature. This is to say, according to Burne-Jones, for a painter the by-product of creating art was artistic anxiety, including the failures and successes of artistic inspiration and invention—a *furor poeticus* or *furor artisticus*.

The saga of Pygmalion and the Image takes place in an artist's studio where a sculptor falls in love with his own creation. The story deals with the power of creativity over matter as well the power of the image over the real. It contrasts the superiority of sculpture over painting—*ut pictura poesis*—a favorite debate during the Mannerist period that recalls Benedetto Varchi's *Due Lezzioni* of 1547. The narrative explains the multiple levels of transformation: of matter into form, of symbol into reality, of sculptor into lover; of mythological figure into woman, and of artistic creativity into aesthetic sensibility.

Recent scholarship on Burne-Jones by Maria Teresa Benedetti and Gianna Piantoni (from an exhibition at the National Gallery of Modern Art in 1986 in Rome) and by Andreas Bluhm contains successful discussions on the literary and artistic merits as well as the iconography of the story of Pygmalion.[26] However, none of these scholars analyzes Burne-Jones's aesthetic roots in Mannerism.

Malcolm Bell, one of Burne-Jones's first biographers (1898)[27]—as well as Benedetti and Piantoni one hundred years later—offered interesting insights on the selection of Burne-Jones's titles as well as the visual interpretation of his paintings. According to Bell, in *The Heart Desires* (figs. 2 and 6) Burne-Jones has portrayed the concept of unsatisfied idealization in the person of Pygmalion standing in the vestibule of his house and meditating on the vanity of life. A marble group of statues, the Three Graces, reinforces Pygmalion's preoccupation and simultaneously represents the coldness of beauty. The contrast between the spontaneity of real life and natural beauty, on the one hand, and intellectual or artificial beauty, on the other, is shown in the two young women passing by. Pygmalion, however, cannot find satisfaction with one or the other. In Morris's words, "Yet in the praise of men small joy he had / But looked abroad with downcast brooding face / Nor yet by any damsel was made glad."[28]

In *The Hand Refrains* (figs. 3 and 7), the second painting of the series, a doubting Pygmalion stands in front of the Image. Bell declared that "the ideal of the artist, the icy, and pure figure of the image, still devoid of soul, rests on the pedestal . . . while Pygmalion with the chisel in hand observes his own perfect creation; his eyes are pleased but his artistic anxiety wishes for something more."[29] Outside the artist's studio, women are busy with their daily chores, and a garden can be seen where a fountain pours water into a basin of marble. The constant pouring of water is paralleled by Pygmalion's own actions as he continues pleading to Venus for love.

The Godhead Fires (figs. 4 and 8), the third painting of the series, shows the scene of *The Apparition of Venus to the Image*. Moved by the prayers of Pygmalion, Venus, the goddess of love, carrying a branch of myrtle, visits his studio while he is away and infuses the marble statue of the Image with the fire of life. In addition, the goddess of love grants Pygmalion not only this precious gift of life but also the gift of love by leaving with the Image a branch of myrtle, symbolizing love and matrimony. The last painting, *The Soul Attains* (figs. 9 and 10), depicts the kneeling figure of Pygmalion. At last, the soul and the heart are united and rejoicing. The Image—as a woman and not a statue—knowingly bends over to kiss Pygmalion, whose dream is realized.

The overall composition of *The Soul Attains,* with some minor changes, is similar in both series, with the exception that in the Birmingham version of *Soul Attains* (fig. 9), a rose is found between the lovers and a Flemish mirror suggests the transitoriness of life as opposed to the durability of art. In this painting, especially, Burne-Jones presents the *ars longa, vita brevis* theme and the idea of the image mirrored in the artist's mind. With the Pygmalion legend, Burne-Jones was able to present the sculptor as one who can produce an image of such perfect feminine beauty that Love in the shape of Venus is moved to bring the statue to life. Significantly, beauty and art are united in the figure of a woman. Like the sculptor depicted in *The Soul Attains* (fig. 9), the painter kneels in homage to living beauty, both literally and metaphorically. A drawing for the kneeling Pygmalion (1878, Birmingham City Museum and Art Gallery, England, fig. 10) demonstrates the lyrical quality of the design in the painting.

While Burne-Jones's fascination with Greek art and myth may have been sparked by his studies of the Parthenon frieze (brought recently to the attention of the English public),[30] his consuming passion for the beautiful Greek sculptress, Maria Cassavetti Zambaco, no doubt also fired his interest.[31]

Fig. 10. Burne-Jones. *Pygmalion*. 1878. Pencil, touched with red chalk. 8¾ × 11⅛". The Birmingham City Art Gallery.

After leaving her husband in 1861, Zambaco became Burne-Jones's lover.[32] The ambiguity that Burne-Jones felt throughout the course of his life toward the kind of entrapment that the Victorian love/marriage ethic imposed even upon artists was expressed more and more in his art following the painful breakup of his affair with the sculptress. Their relationship caused a considerable stir at the time and reached a major crisis point in 1869 when Burne-Jones's wife became aware of this romantic situation.[33]

Maria Cassavetti Zambaco was an important influence on Burne-Jones's painting. She was the protagonist of many heroines in his pictures not only during their romance period, 1866–69 (when the subjects of many of his paintings had a personal meaning—for example, *The Garden of Hesperides*

[1869–72, Birmingham City Museum and Art Gallery, England], *Phyllis and Demophöon* [1870, Birmingham City Museum and Art Gallery, England], and *Beatrice* [1870, private collection], but also throughout his life (for example, *The Tree of Forgiveness* [1882, Walker Art Gallery, Liverpool], and *The Beguiling of Merlin* [1873–77, Lady Lever Art Gallery, Port Sunlight]. Penelope Fitzgerald devoted an entire chapter of her Burne-Jones book to the significance of the painting *Phyllis and Demophöon* during the period of Burne-Jones's infatuation with Maria Cassavetti Zambaco, stating that during that time the artist "began to try to break with Maria Zambaco, a process which he found painful beyond measure."[34] The pain projected itself through the myth of Phyllis and Demophöon. In this legend, the

queen of Thrace begs her lover, the son of Theseus, to return. But he delays, and she hangs herself, changing into an almond tree as she dies. When the queen's lover embraces the tree, it blooms with flowers and leaves. Moreover, Ovid's second Heroides, an imaginary letter from Phyllis to Demophöon threatening suicide—"Dic mihi quod feci? Nisi non sapientur amavi" ("Tell me what I have done, except to love unwisely?")—was, in fact, the epigraph that Burne-Jones gave to his picture a year later. This interpretation of the Phyllis to Demophöon letter clearly reflects the depths of Burne-Jones's amorous feelings for Zambaco.

In a letter written to Helen Mary Gaskell in 1893, Burne-Jones revealed the complexity of his emotions for Zambaco even after he fled from her: "The head of Phyllis in the Demophöon picture is from the same—and would have done for a portrait . . . don't hate [her]—some things are beyond scolding— hurricanes and tempests and billows of the sea—it's no use blaming them . . . no, don't hate—unless by chance you think your workmanship is bad; it was a glorious head—and belonged to a remote past—only it didn't do in English suburban surroundings—we are soaked in Puritanism and it will never be out of us and I have it and it makes us the most cautious hypocritical race on race."[35] Zambaco was beautiful, and the power of her love and beauty was evidently even worth the risk of Puritanism and the taint of sin in English suburban surroundings.

Fig. 11. Burne-Jones. *Maria Zambaco*. 1879. Gouache on paper. 76.3 × 55 cm. Neuss, Clemens-sels Museum.

Fig. 12. Burne-Jones. *Galatea*. 1878. Pencil. 6¾ × 7⅞″. The
Birmingham City Art Gallery.

That Burne-Jones was affected by Zambaco's
beauty is evident from her portrait in gouache
(Clemens-sels Museum, Neuss, Germany, fig. 11), in
which her companion is Cupid, whose arrow is
wrapped with a piece of paper inscribed with the
names of the two lovers: *Mary Aetat XXVI August
7th 1870 EBJ pinxit.*[36] The illustration in her illumi-
nated book depicts *Le Chant d'Amour,* an earlier
painting by Burne-Jones (1868, Metropolitan Mu-
seum of Art, New York). Burne-Jones's theme was
inspired by an old Breton song with the lines, "Hélas!
je sais un chant d'amour / Triste ou gai, tour à tour."[37]
The Greek muse appeared in many of Burne-Jones's
paintings of this period, including the *Cupid and Psy-
che* series, 1872–81, the *Phyllis and Demophöon*
paintings, and the *Pygmalion* series as Galatea or the

Image *(Head Study for Galatea* [1870, Birmingham
City Museum and Art Gallery, England, fig. 12.)][38]
 Burne-Jones's relationship with Zambaco must
have fascinated the artist on several levels—human,
artistic, and spiritual. Parallelism of these levels be-
tween Burne-Jones and Zambaco focuses not on
physical or gender issues but rather on the aesthetic
or artistic quest. For example, there were the trans-
formations of Pygmalion into Burne-Jones himself
(both ancient sculptor and contemporary artist fell
in love with created beauty—Galatea and Maria,
respectively) and of Galatea or the Image into Zam-
baco: for both artists, the two images and the imag-
ined and real female forms were the sources of their
pain, joy, suffering, and happiness. Or perhaps the
reverse analogies can be considered: for example,

Pygmalion could also be construed as Zambaco (ancient sculptor and contemporary female sculptress), with Galatea or the Image as Burne-Jones (an image of love created by Pygmalion much as Burne-Jones had created the Pygmalion series). The Pygmalion legend thus attests to the love of artist and model, their union, and the possibility of attaining the ideal.[39] Perhaps and more importantly for Burne-Jones, love, aesthetics, and art had the power to transform into another level of reality—the realm of artistic religiosity—the artist, the model, and their karmic union. The transformation of the statue is not only the triumph of art over nature, life over matter, but also of piety over moral failure.[40]

Another kind of union was emphasized in Burne-Jones's essay "Greatness and Style," published in the *Quarterly Review* (1856), in which he spoke of "the love of beauty." Such a comment also adhered to the Mannerist moral quest, for no aesthetic gave more importance to invention than Mannerism. Michelangelo's conception of love and beauty is reflected in his Rime 41: "Love seizes me and beauty keeps me bound."[41] The sixteenth-century sculptor found that love was the wish to find the origin of its source—the essence of beauty—because the image was in the artist's mind: this was the very conceit that would eventually be carved in marble in Burne-Jones's Pygmalion series. Vasari also echoed this concept, making beauty one of the critical components of art in the preface to *Lives of the Artists* (1550–68).[42]

Like much of Mannerist art, Burne-Jones's paintings provoke an appeal to the senses and an exploration of an elevated and purified beauty. Burne-Jones turned to the past because, as he said, "to love beauty nowadays is to be in torment. The world now wants very much to go back to barbarism; it is sick and tired of the arts; it is tired of beauty."[43] In 1893, Burne-Jones stated: "Nothing in all the world matters one bit except the making of a beautiful picture."[44] During the nineteenth century, Burne-Jones was not alone in the pursuit of purified beauty; however, he turned to that most stylish of styles, Mannerism, to press his fervent imagination into the dual service of beauty and love.

NOTES

1. Leatrice Mendelsohn, *Paragoni: Benedetto Varchi's Due Lezzioni and Cinquecento Art Theory* (Ann Arbor: UMI Research Press, 1982), 9 and 113. Benedetto Varch (1503–65) was a Florentine historian, poet, and philologist. The book of the *Due Lezzioni* is based on lectures Varchi delivered before the Accademia Fiorentina in 1547 and published in 1549 by the Florentine press Ap. L. Torrentino.

2. Marsilio Ficino, *Symposium*, I. 3. in *Opera* (Basel, 1561). For an understanding of Mannerist art theory, see D. Summers, *The Judgment of Sense* (New York: Cambridge University Press, 1987), and for a study on the impact of Marsilio Ficino's Neoplatonism and Renaissance art, see Liana Cheney, *Botticelli's Neoplatonic Images* (Potomac, Md.: Scripta Humanistica, 1993).

3. For a discussion on the Mannerist style, consult C. H. Smyth, *Mannerism and Maniera* (New York: Locust Vallery, 1962): J. Shearman, *Mannerism* (Baltimore: Penguin Books, 1967); S. Freedberg, *Painting in Italy, 1500–1600* (Baltimore: Penguin Books, 1971); and D. Summer, "Maniera and Movement: The *Figura Serpentinata*," Art Quarterly 35 (1972): 209–311.

4. William Gaunt, *The Pre-Raphaelite Tragedy* (New York: Harcourt, Brace and Company, 1942), 152. Probably Burne-Jones was aware of W. Pater's philosophical writings, particularly *Plato and Platonism* (London, 1893), 241–44, where Pater discusses Plato's ideas of Beauty and Nature. See also Robin Spencer, *The Aesthetic Movement: Theory and Practice* (London: Studio Vista Ltd., 1972), 37, and J. L. Carr, "Pygmalion and the *Philosophes*," *Journal of the Warburg and Courtauld Institutes* 23 (1960): 239–55.

5. Burne-Jones was familiar with and had studied the Italian painters of the fifteenth and sixteenth centuries because he had visited Italy three times. In 1858 he spent four weeks traveling throughout Italy. At this time he visited Genova, Pisa, Milan, Venice, and Florence (where he undoubtedly saw Bronzino's *Pygmalion and Galatea*). On the second trip in 1862 he traveled to Assisi, Arezzo, Rome, San Gimignano, Orvieto, Perugia, Cortona, Milan, Verona, Padova, and Parma, and he revisited Venice. On his third and last trip in 1873 he revisited Florence and traveled to Siena, Bologna, and Ravenna. Burne-Jones comments in particular on such artists as Botticelli, Fra Angelico, Ghirlandaio, Giorgione, Gozzoli, Luini, Mantegna, Perugino, Pollaiulo, Signorelli, Uccello,

Piero della Francesca, Orcagna, Leonardo, Andrea del Sarto, Bronzino, Michelangelo, Correggio, Parmigianino, Raphael, Titian, Tintoretto, Veronese, and, of course, Giotto. And his interest on Mannerist painters is in relation to Michelangelo's followers. As Burne-Jones states: "Do you know the real Michelangelos? So many of the studies were copied by Volterra and Bronzino that sometimes one gets let in." See GB-J, *Memorials of Edward Burne-Jones* (London: MacMillan Company, 1904), 19–27, and J. Christian, "Burne-Jones's Second Italian Journey," *Apollo* CII (November 1987), 334–37. See Robin Campbell, *Burne-Jones: The Paintings, Graphic and Decorative Work of Sir Edward Burne-Jones, 1833–98*, exhibition catalogue (London: The Arts Council of Great Britain, 1975), 91–95, entries 332–54, for a list and description of Burne-Jones's sketchbooks after Italian Renaissance and Mannerist painters during his travels in Italy. Of particular interest is Sketchbook No. 342, signed and dated *E. Burne-Jones 1866–7* from the Victoria and Albert Museum (E.5–1955), which contains numerous drawings after Michelangelo, Raphael, and Marcantonio Raimondi.

6. In 1865 William Morris asked Burne-Jones to design and illustrate the book *The Earthly Paradise*. Burne-Jones accepted this challenge and worked on the Pygmalion cycle during 1868–78. See Penelope Fitzgerald, *Edward Burne-Jones* (London: Hamish Hamilton Ltd, 1975), 98–100 and Helen Dore, *William Morris* (Secaucus, N.J.: Chartwell Books, Inc., 1990), 9, 76, and 107.

7. David Cecil, *Visionary and Dreamer: Two Poetic Painters, Samuel Palmer and Edward Burne-Jones* (Princeton: Princeton University Press, 1969), 143, quoting from a letter that Burne-Jones wrote to Morris.

8. The story of Pygmalion and Galatea is narrated by ancient writers such as Apollodorus: iii. 14.3; Ovid, *Metamorphoses*, x. 243ff; and, Arnobious: *Against the Nations* vi. 22. See Robert Graves, *The Greek Myths*, I (Baltimore: Penguin Books, 1955), 211–12. Pygmalion, legendary king of Cyprus, fell in love with Aphrodite. Because she would not lie with him, he made an ivory image of her (or a beautiful statue) and laid it in his bed, praying to her for pity. Entering into this image, Aphrodite brought it to life as Galatea. (*Galateia* is the Greek word for *milk-white*, alluding to the ivory or marble quality of the statue.)

9. The theme of Venus was a favorite subject with artists of the Aesthetic Movement during the 1860s, and Burne-Jones's painting

clearly shows this taste. For Burne-Jones as well as for the Victorians the depiction of a beautiful female expressing or arousing passion in the viewer was unacceptable; therefore, they portrayed women with angelic, beautiful, and ethereal qualities—a goddess of beauty such as Venus. (I do not agree with Cecil's position that Burne-Jones's women are sexless. I think his women express "amorous passion" through the transformation of sensuality into refinement of form and sexuality through sublimity of expression, emphasizing ideal beauty [Mannerist *grazia* or grace].) See Cecil, *Visionary and Dreamer*, 146; Spencer, *The Aesthetic Movement: Theory and Practice*, 37; and Michael Levey, "Botticelli and Nineteenth-Century England," *Journal of the Warburg and Courtland Institutes* 23 (December 1960): 299.

10. Burne-Jones met the Cassavetti family through his friendship with Constantine Ionides, founder of a Greek colony in London, who had fled from Constantinople to England after the Turkish war of 1815. During the 1860s the Ionides had prospered in Manchester and London through the establishment of a firm for importation of cotton and carpets. The Cassavettis, like the Ionides, were Greeks, who had taken refuge to London from Alexandria and who were cotton merchants. Constantine Ionides' cousin, Constantine Alexander Ionides, a patron of Burne-Jones, left his painting collection to the Victoria and Albert Museum in 1901. Furthermore the Cassavetti were also related to the Ionides. Their daughter Mary Cassavetti, born in Athens in 1843, was the granddaughter of Constantine Ionides. In 1860 she (Maria Cassavetti Zambaco) married a doctor, Demetrius Zambaco. from the Greek community in Paris, and she had two children. The unhappy marriage prompted her to return in 1866 to her family in London. Zambaco's mother Euphrosyne, called *Duchess* Cassavetti, was also a generous patroness of the arts. Upon Maria's return to London, she commissioned Burne-Jones to paint a portrait of his daughter and introduced her to Burne-Jones at his studio. When Burne-Jones met Zambaco he was struck by her Greek beauty. The *Duchess* Cassavetti also encouraged her daughter to continue pursuing her talents in sculpture and medal work. See Fitzgerald, *Edward Burne-Jones*, 112–1; Philip Attwood, "Maria Zambaco: *Femme Fatale* of the Pre-Raphaelites," *Apollo* 124 (July 1986): 31–37; and Andrea Rose, *Pre-Raphaelite Portraits* (Oxford: Oxford University Press, 1981), 21–29.

11. The English version was bought from the artist by Frederick Crave. In turn he sold the paintings to Christie. On 18 May 1895, Agnew bought them for 3,675 pounds sterling from Christie (catalogue entry 60–63), and in 1903 Sir John Middlemore presented them to Birmingham (Birmingham City Museum and Art Gallery).

12. Burne-Jones had signed and dated his series in the scrolls on the bottom left of the paintings: *E. Burne-Jones 1868/78*.

13. The English version is signed and dated: *EBJ 1878*. *The Godhead Fires* was engraved in mezzotint by C. W. Campbell. See Campbell, *Burne-Jones: The Paintings, Graphic and Decorative Work of Sir Edward Burne-Jones, 1833-98*, 54. See n. 11.

14. Ibid.

15. William A. S. Benson had posed for the head of Pygmalion in the Pygmalion series. See Campbell, *Burne-Jones: The Paintings, Graphic and Decorative Work of Sir Edward Burne-Jones, 1833–98*, 73, entry 218 for *Sketches for a Helmet*, pencil on tissue paper, 1880s, owned by Margaret Cooper.

16. Giovanni Paolo Lomazzo (1538–1600), a Milanese painter and theoretician, who, unlike Vasari, was not a storyteller. He wrote several books on theories of art, for example, *Trattato dell'arte della pittura*, II (Milan, 1584), 2. and *Ideal dell' Tempio della Pittura* (Milan, 1598). See Moshe Barasch, *Theories of Art: From Plato to Wincklemann* (New York: New York University Press, 1985), 270–91; Schlosser Magnino, *La letteratura artistica* (Florence: La Nuova Italia Editrice, 1977), 377 and 395–96; Erwin Panofsky, *Idea: A Concept in Art Theory* (Charlestown: South Carolina Press, 1972).

17. See n. 8.

18. The same sentiments were also felt by the French Symbolist writers and painters (Gustave Moreau and Odilon Redon) who searched for adequate sympbols to express both their dreams and experience. The French poet Théophile Gautier was one of the first Symbolist writers to distinguish and separate artistic and ethical values and criticize aestheticism. This new French and English artistic movement promoted the value of aesthetic sensation irrespective of the morality of its cause. Burne-Jones's lyrical and allegorical style did not harmonize with this type of aesthetic. According to Ironside's and Delevoy's writings on this subject, Gustave Moreau and Burne-Jones, as well as Redon, were pioneers from the start in Europe in the late nineteenth century: "Their visions excited the reverence of a cultivated section of the public whose mind was at once attuned to accept them." (See R. Ironside, Burne-Jones and Gustave Moreau," *Horizon* 1 [June 1940]: 406–20, and Robert L. Delevoy, *Symbolists and Symbolism* [Geneva: Skira, 1982], 38–41.) Ironside continues commenting on the poetic gravity, the suave nostalgia, and the romanticism of Burne-Jones as "illustrating veins of poetry in painting, which were developed later in the works of Gustave Moreau." The comparison between the French Symbolist painting of Gustave Moreau, *Orpheus and Eurydice* (Louvre) of 1865, with the Pre-Raphaelite painting by Burne-Jones, *Lamentation* (The William Morris Gallery) of 1868, reflects the impact that the British artist had on the European paintings.

Jean Moréas in the *Symbolist Manifesto* comments about these concerns in his discussion of the nature of a symbol: "To clothe the idea in a sensitive form which, nevertheless would not be an end in itself but which would remain subordinate to the ideas while serving to express it." (See Delevoy, *Symbolists and Symbolism*, 73–77.) In combining the ideal and the actual, the sought-after and the sensuous, both the Symbolist painters and Burne-Jones viewed woman as symbol of love and lust, the embodiment of purity (Venus) and of temptation (Salome or Pandora), for example, Burne-Jones's depiction of Venus or Galatea in the Pygmalion series, Moreau's *Salome* and Redon's *Pandora* (private collection, New York) of 1910. See Maria Teresa Benedetti and Gianna Piantoni, *Burne-Jones* (Rome: Gabriele Mazzotta, 1986), 75–81.

19. Malcolm Bell, *Sir Edward Burne-Jones* (London: George Bell & Sons, 1901), 70.

20. Giorgio Vasari, *Le vite dei più eccellenti pittori, scultori, et architetturi*, ed. Gaetano Milanesi, 9 vols. (Florence: G. C. Sansoni, 1970–74) V, 260, and Liana Cheney, *The Paintings of the Casa Vasari* (New York: Garland Publishing Press, 1985), 120–21 and 127.

21. GB-J, *Memorials of Edward Burne-Jones*, II, 81, for William A. S. Benson's comments.

22. See n. 3.

23. John Shearman, "Maniera as an Aesthetic Ideal," in *Studies in Western Art: Acts of the Twentieth International Congress of the History of Art* (Princeton: Princeton University Press, 1963), 200–221. (Reprinted in *Renaissance Art*, edited by C. Gilbert (181–221 [New York: Harper and Row, 1970].)

24. See Bernard Barryte, "Pygmalion: The Metamorphosis of His Legend," (Spring 1982), unpublished paper, for an excellent compilation of Pygmalion's images through the centuries, and Jane Davidson Reid, ed., *The Oxford Guide to Classical Mythology in the Arts: 1300–1990s*, vol. II (New York: Oxford University Press, 1993), 956–62.

25. Campbell, *Burne-Jones: The Paintings, Graphic and Decorative Work of Sir Edward Burne-Jones, 1833–98*, 11.

26. Maria Teresa Benedetti and Gianna Piantoni, *Burne-Jones: dal preraffaellismo al simbolismo* (Rome: Gabriele Mazzotta editore, 1986) and Andreas Bluhm, *Pygmalion: The Iconography of Its Artistic Myths between 1500 and 1900* (Bern: Verlag Peter Lang, 1988), 261–67.

27. Malcolm Bell, *Sir Edward Burne-Jones. A Record and Review* (London: George Newness Ltd., 1898).

28. Benedetti and Piantoni, *Burne-Jones*, 163, quoting Morris on the Pygmalion series.

29. Bell, *Sir Edward Burne-Jones*, 109–10.

30. Burne-Jones's sketchbooks from the period between 1864 and 1870 contained copies after the Elgin Marbles in the British Museum. See Campbell, *Burne-Jones: The Paintings, Graphic and Decorative Work of Sir Edward Burne-Jones, 1833–98*, 93. Entry 340 for the Sketchbook from the Victoria and Albert Museum (E2–1955) contains numerous drawings from the metopes of the Parthenon, and Kathleen Elizabeth Alexander, "A Sketchbook by Sir Edward Burne-Jones (M.A. thesis, Northwestern University, 1980), 13.

31. Luke Ionides, another cousin of Constantine Ionides, described Zambaco as having "glorious red hair and almost phosphorescent white skin," as seen in Burne-Jones's painting *The Tree of Forgiveness* (Walker Art Gallery) of 1882. Also Dante Gabriel Rossetti was hypnotized by Zambaco's beauty as he wrote in a letter of 5 May 1870 to Jane Morris: "I was not able to understand this earlier . . . she (Maria) is really very beautiful when one begins to study her face." See Benedetti and Piantoni, *Burne-Jones*, 163.

32. Fitzgerald, *Edward Burne-Jones*, 112–15 and 146–47.

33. See n. 10. Most of Burne-Jones's paintings and drawings date from 1870 to 1871. See Campbell, *Burne-Jones: The Paintings, Graphic and Decorative Work of Sir Edward Burne-Jones, 1833–98*, 46–47, entries 114–18, and Bettini and Piantoni, *Burne-Jones*, 164–65.

34. Fitzgerald, *Edward Burne-Jones*, 117–31, and Mary Lago, ed., *Burne-Jones Talking: His Conversations 1895–1898 Preserved by His*

Studio Assistant Thomas Rooke (St. Louis: University of Missouri Press, 1981), 10–11.

35. Ibid., 127.

36. Euphrosyne *Duchess* Cassavetti, the sitter's mother, owned this painting. It was sold to Maas by Christie on 19 November 1965. See Gisela Zick, "Un Chant d'Amour, zu einem Bildinis von Edward Burne-Jones in Clemens-Sels Museum, Neuss," *Neusser Jahrbuch* (1973): 21–34.

37. The Metropolitan Museum of Art version was shown at the Grosvenor Gallery exhibition in 1878. Burne-Jones executed several studies for this painting, for example, *The study for a Musician,* pencil and red chalk, signed and dated: *EBJ 1863,* lower left, owned by Earl of Oxford and Asquith. Another version of *Le Chant d'Amour* (private collection) signed and dated 1866, done in gouache, included a figure of Love on the right instead of a knight. Euphrosyne *Duchess* Cassavetti owned the design that was sold at Christie's on 19 November 1965. A watercolor version of *Le Chant d'Amour* (Boston Museum of Fine Arts) of 1865 includes all three figures as they appear in the Metropolitan Museum painting. See Campbell, *Burne-Jones: The Paintings, Graphic and Decorative Work of Sir Edward Burne-Jones, 1833–98,* 41, entries 86–87,

and Rose, *Pre-Raphaelite Portraits,* 18.

38. Pencil drawing, signed and dated, *EBJ 1970 study for GALATEA / in the series of / PYGMALION,* in the lower right. This drawing was a study for Galatea in *The Godhead Fires.* Burne-Jones executed other drawings for Venus inspired by the portrait of his beloved Maria Cassavetti Zambaco. See Benedetti and Piantoni, *Burne-Jones,* 165–65, entries 38–41.

39. See Ovid, *De Amore,* I, 4, "Arte regendus amor" and Benedetto Varchi, "Lezzioni otto sull'amore," in *Opere* I (Milan, 1834).

40. See R. Jenkins, *The Victorians and Ancient Greece* (Oxford: Oxford University Press, 1980), 141ff, for a discussion on erotic fantasy and art, and see Brooks Otis, *Ovid as an Epic Poet* (Cambridge: Cambridge University Press, 1966), 192.

41. Barsch, *Theories of Art,* 190–99, for a discussion of Michelangelo's concept of beauty in relation to Neoplatonism.

42. See n. 20.

43. Burne-Jones's essay "Greatness and Style," published in the *Quarterly Review* of 1856.

44. Lago, *Burne-Jones Talking,* 15.

Jewish Stereotype and Christian Prototype: The Pre-Raphaelite and Early Renaissance Sources for Simeon Solomon's Hebrew Pictures

NORMAN L. KLEEBLATT

CURRENT MULTICULTURALISM HAS PROMPTED THE study of marginalization for reasons of gender, ethnic origin, and sexual preference, making the artist's cultural 'otherness' crucial in this social history of art. Historical sources used by the artist as well as his choice of subject matter often provide useful entrées into the dialogue between the maginalized artist and the society that sets him apart. Although the Jewish artist's struggle for acceptance into the art world of the last century has been documented and even romanticized, few historians have examined the influence of stereotyping on the Jewish artist and the effect of such stereotyping on his art.

Simeon Solomon (fig. 1) provides an excellent vehicle for such analysis. For his fellow artists and contemporary critics, this painter and his early pictures of Old Testament themes symbolized the very essence of the Jew. Yet these early so-called Hebrew pictures borrowed conceptual ideas and formal elements from the Christian art of the Early Italian Renaissance, a period whose revival was just gaining momentum during Solomon's artistic genesis. Both contemporary and historical, these sources were quite alien to Solomon's early upbringing. While Solomon's use of Christian sources for his Hebrew Bible subjects might have paved the way for his eventual flirtation with Christianity, societal responses to Hebrew subjects demonstrate the ambivalent place of the Jew in an art world that was still predominantly Christian. Also revealed is the hedge that many Jewish artists experienced in their encounter with Christian iconography—an uneasy, yet fruitful, confrontation that continued through Abstract Expressionism.[1] En route to greater recognition and assimilation, Simeon Solomon himself revealed a number of ambivalences—sexual, religious, national, and aesthetic.

Simeon Solomon's early Pre-Raphaelite paintings were devoted mainly to subjects from the Hebrew Bible and are considered among the most unusual and highly inventive expressions of this iconography in British art. It would hardly seem unusual for a youth to press into iconographical service the biblical texts that he must have known through the typical religious training for a bourgeois Victorian Jew. Yet the Hebrew subjects and Solomon's obsession with them over a six-year period, from age seventeen through twenty-three, strike a highly unusual chord. By contrast with Solomon's all-encompassing involvement with the Hebrew Bible, the numerous New Testament works of the Christian Pre-Raphaelites functioned as part of a larger oeuvre that included subjects from medieval history and legend, amorous themes, and symbolic landscapes. For the young Solomon, these Hebrew Bible works affirmed the artist's understanding and acceptance of his Jewish faith and culture. And these works were immediately perceived as such by fellow artists and writers.

Until the early twentieth century, for a Jew to so openly identify himself with the religion of his birth was quite unusual in British art. Yet, Simeon Solomon was by no means Britain's first Jewish artist. While society pressured certain of Solomon's eighteenth-century coreligionists, such as Anton Mengs and Johann Zoffany,[2] into conversion in order to participate fully in a secular art world, the religious and civic emancipation in the nineteenth century favored the appearance of a small number of Jews on the British art scene. Simeon's coreligionist Solomon Alexander Hart, better known as a librarian at the Royal Academy and art critic, epitomized a more moderate example of religious identification and social assimilation. Although Hart painted the occasional Jewish subject, he carefully placed these

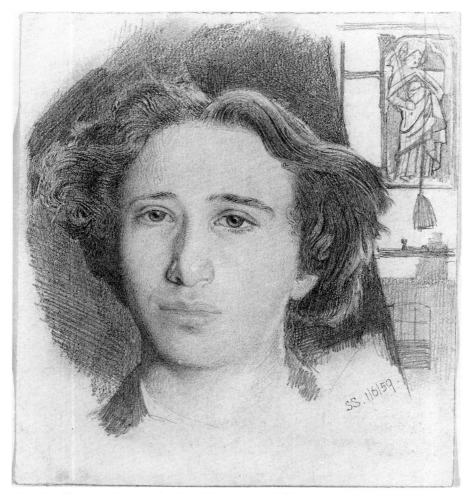

Fig. 1. Simeon Solomon. *Self-Portrait*. 1859. Pencil on paper. 16.5 × 14.6 cm. Tate Gallery, London.

offerings within a larger corpus of Christian and British ones. Themes linked with Judaism neither entered the work of Solomon's older brother Abraham nor that of his sister Rebecca—both accomplished painters fully recognized within London's art circles. Granted citizenship only during the 1830s, this group of first- and second-generation emancipated British Jews found acculturation rather than assimilation the norm. And acculturation simply meant keeping personal religion at arm's length from one's professional career.[3]

Victorian and Edwardian critics lavished considerable attention on Solomon's Hebrew works, which served as a qualitative barometer compared with the so-called deterioration of his later oeuvre. The critical vision of the later work had become strongly colored by association with Solomon's scandalous arrest for sodomy in 1873 and his refusal to repent and reconcile his life-style with normative Victorian morality. Because of this behavior, and the moralist reaction to it, an objective evaluation of Solomon's

later so-called Symbolist pictures has been nearly impossible until very recently. Time and again, in chronicles up to the mid-twentieth century, those writers who dared to tackle the tainted Solomon at all bemoaned the break with his earlier program of Hebrew iconography. They related this break to his being confused about his faith, and they associated the change of his subjects with his departure from conventional sexual mores. The critics—whether Christians or Jews—pronounced a veritable biblical curse on his late work, as if both the relative decline in the quality and the subjects demonstrating his possible religious apostasy could be read as a just retribution for a sinful lifestyle.

Why were Solomon's Hebrew Bible themes so closely linked with the artist's Judaism? After all, subjects from the Old Testament are the foundations of Western art. By which specific formal sources were the artist influenced? And how do the underlying themes of these biblical subjects relate to Solomon's psychological and chronological biography? The com-

plex exchange in the answers to these questions begins to explain why the pictures seemed so unusual and enigmatic when they were painted and why they were both praised and scoffed.

The connection that then-contemporary writers found by linking the artist and his art with his religion reflects nineteenth-century British literary tradition and social structures. As to Solomon's sources, naturally, the inspiration for these pictures often derived from Pre-Raphaelite pictures. Yet, a number of Solomon's compositions are obviously based on Early Italian Renaissance paintings that were then undergoing a revival in England. Solomon's deployment of these various models might be viewed as a Jewish artist's reaction to the hegemony of Christian iconography—as seen through Renaissance pictures, specifically, and in Western art, in general. These

pictures were as aesthetically appealing to Solomon the artist as its Christian subjects were taboo for Solomon the Jew. Examining the Hebrew pictures, one can perceive how Simeon extracted the aesthetic aspects of the Christian art that he admired—and how he transformed both the formal and conceptual qualities of this art into parables of his religious heritage and personal psychology.

The biblical works that Solomon created between 1857 and 1863 include frequent compositions of one, two, and three figures. On the whole, these biblical works seem to be conscious explorations of the psychological interactions between a small number of characters. The more striking and imaginative of these works are *Moses in His Mother's Arms* (1860, Robert Isaacson Collection, New York fig. 2), one version of *Ruth, Naomi and the Child Obed* (1860,

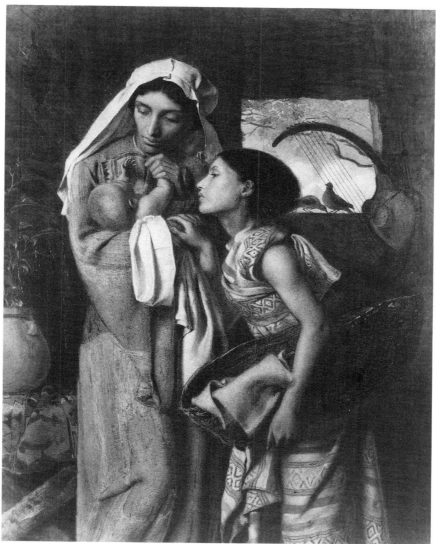

Fig. 2. Simeon Solomon. *Moses in His Mother's Arms.* 1860. Oil on canvas. 61 × 50.8 cm. Collection of Robert Isaacson, New York.

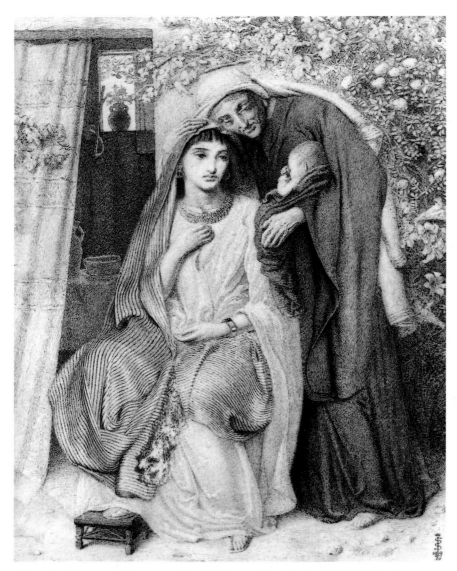

Fig. 3. Simeon Solomon. *Ruth, Naomi, and the Child Obed.*
1860. Pen and ink drawing. 29.2 × 22.5 cm. Birmingham
City Museums and Art Gallery, Birmingham.

Birmingham City Museum and Art Gallery, England fig. 3), and *Judith and her Attendant* (1863, private collection).[4] Works like *The Conjugal Reconciliation at the Altar* (1862, private collection, fig. 4) appear to convert such typical Old Testament subjects as *Isaac and Rebecca* (1863, Victoria and Albert Museum, London fig. 5) into a more pantheistic vision— linked to religious practice but without specific reference to any particular religion. There are also more common Hebrew subjects: several versions of *Isaac Offered* (1863, Mrs. Esther Salaman Hamburger Collection, London), *Nathan Reproving David* (1859, Victoria and Albert Museum, London fig. 6), *The Finding of Moses* (1862, Hugh Lane Municipal Gallery of Modern Art, Dublin), and *Queen Esther*

(1860, Robert Isaacson Collection, New York). These latter works, hardly uncommon images in the history of art, fit within general eighteenth- and nineteenth-century British traditions of biblical illustration.[5] There are few major dramas or grand spectacles within these biblical pictures. Solomon, following Pre-Raphaelite doctrine, picked his narratives precisely for their lack of heroism and for their intimacy.

An examination of the subjects prevalent in Solomon's treatment of the Old Testament reveals many that deal with exile and separation. The picture of *Moses in His Mother's Arms* has already been discussed as a metaphor for the exile of the Jewish Solomon in the gentile art world of Victorian England.[6] In his Hebrew Bible pictures, Solomon included themes

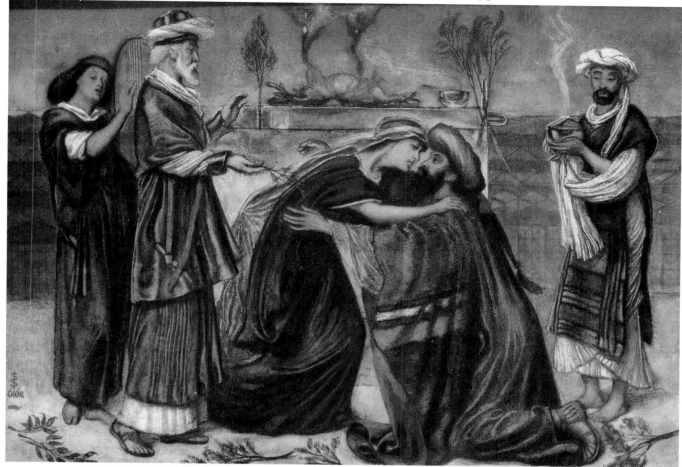

Fig. 4. Simeon Solomon. *The Conjugal Reconciliation at the Altar.* 1862. 25.4 × 35.6 cm. Private Collection.

expressing competition, reprisal, rejection, and conflicting love. But the theme of exile remained the recurrent leitmotif. His *Hagar and Ishmael* (1857, Lionel Lambourne Collection, London) shows the protagonists expelled from Canaan by Abraham. *By the Waters of Babylon* (1858, location unknown, fig. 7) pictures the Jews during their sixty-year exile from Israel. *Ruth and Naomi* (1862) essentially tells the story of two separate exiles and the compromises entailed by dual nationalities and complicated allegiances. The artist's *Queen Esther* is yet another exilic tale—this time about a woman so seemingly integrated into a foreign culture that she became queen of the realm, but who was nevertheless living within an alien culture.

For all of these depictions, Solomon's success was predicated on his so-called truth to nature. More specifically, he attempted a strong ethnographic veracity, and had to use those sources available to someone who had, until 1866, traveled very little outside England.[7] In fact, Solomon, unlike some nineteenth-century artists interested in painting subjects from the Bible, never traveled to the Near Eastern lands associated with biblical history. Yet, Solomon's biblical types were convincing to many Victorian critics for their psychological and physical realism and for their religious conviction.

As opposed to other English artists who treated biblical subject matter, Solomon did not have to search far for models of genuine descendants of Abraham. Following the example of the Pre-Raphaelites who used their family members as sitters for New Testaments figures, Solomon's Jewish-looking models may indeed have been his relatives.[8] His dark, ethnic types, along with the appearance of exotically appropriate costumes, architecture, and other trappings, were often construed by Victorian writers as a reflection of Solomon's intimate connection to and understanding of his religio-cultural heritage. Such critical observations, however anthropologically flimsy their premise may have been, attempted to set Solomon's work apart from that of his Christian colleagues. Essentially, the critics equated his work with his so-called race.

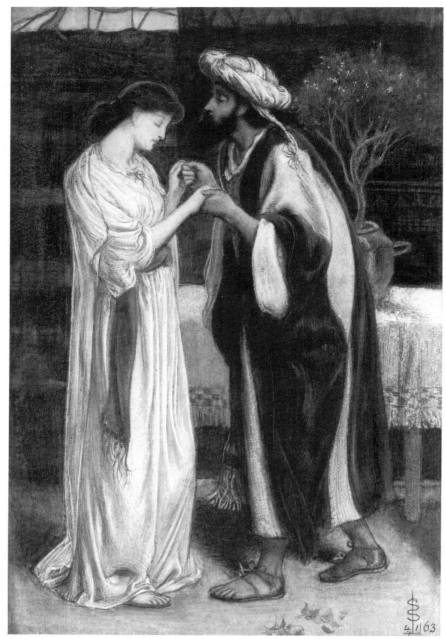

Fig. 5. Simeon Solomon. *Isaac and Rebecca*. 1863. Water-
color. 29.4 × 20.3 cm. Victoria and Albert Museum, London.

By contrast, William Holman Hunt certainly had been infinitely more careful than Solomon in his focused search for authentic character types and for accurate sources. This is evident in his depictions of architecture and trappings in his painting *The Finding of the Savior in the Temple* (1854–60, Birmingham City Museum and Art Gallery, England) and in his *Scapegoat* (1854, Lady Lever Art Gallery, Port Sunlight). Hunt's work was created to serve a Christian evangelical program. Yet, it was Solomon's biblical pictures—despite a lack of stated intent on the part of the artist—that were characterized as particularly Jewish or, as the Victorians more gently called it, Hebrew.

The power of Victorian stereotyping is conspicuous in the period quotations about Solomon and his work. Sir William Richmond referred to the artist as "a fair little Hebrew, a Jew of Jews, an Eastern of the Easterns" and said that his work was "ancient-looking and strangely imbued with the semi-barbaric life So strongly was this the case that they seemed to be written in Hebrew characters; no one but a Jew could have conceived or expressed the depth of natural feeling which lay under the strange,

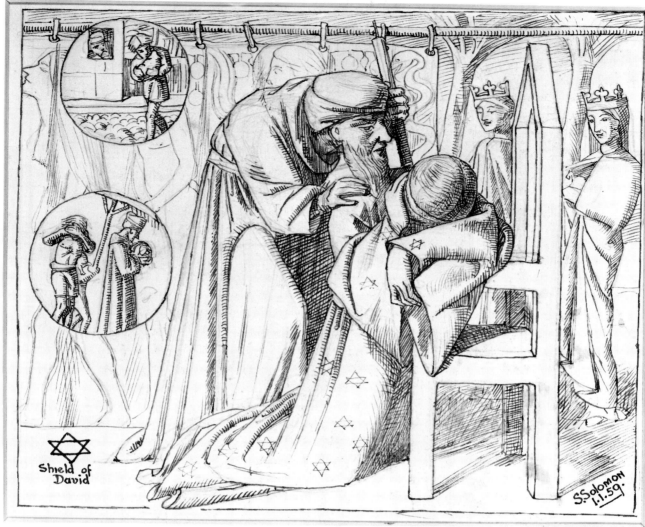

Fig. 6. Simeon Solomon. *Nathan Reproving David*. 1859.
Pen and ink over pencil. 14.9 × 17.6 cm. Victoria and Albert
Museum, London.

Fig. 7. Simeon Solomon. *By the Waters of Babylon*. 1858.
Location unknown.

remote forms of the archaic people whom he depicted."[9] Walter Pater referred to the artist as the "Hebrew painter." And Algernon Charles Swinburne also noted of Solomon's interest in "Jewish" art—albeit later in the century: "His work combines fervent violence of feeling or faith which is peculiar to the Hebrews It holds of East and West, of Greek and Hebrew. Grecian form and beauty divide the allegiance of his spirit with Hebraic shadow and majesty."[10] These views of both Solomon's work and person were certainly part of an ethnic stereotyping that prevailed throughout Europe—but one that had distinct precedents in Britain as well. These persistent references to Solomon's religion beg the issue of the part that Solomon might have played in his own image making. Unlike his brother Abraham, he seemed readily willing to acknowledge and even to flaunt his religion through both his obvious and obsessive iconography as well as the ethnic look he cultivated and the Eastern dress he occasionally sported.[11] As far as the artist's religious heritage was concerned, his surname alone was a dead giveaway.[12] In any event, why would Solomon—who had few qualms about the subsequent admission of his homosexuality—not be willing to confront the infinitely less charged subject of his minority religion?

Given Solomon's existence in this teeter-totter world of philo- and anti-Semitism, racism and nationalism, the artist's Hebrew pictures may have emerged to counter the overtly Christian propaganda of a number of Pre-Raphaelite masterpieces. Most notable among these propaganda pieces are Holman Hunt's *Scapegoat* and *The Finding of Our Savior*. (The latter was displayed in London in the spring of 1860).[13] Burne-Jones is known to have created devastating caricatures of Jews, and the inscription to "the savage minded" on Solomon's 1859 portrait of Burne-Jones may refer to these. Thus, Solomon's Hebrew works might be viewed as an antidote to the latent anti-Semitism within Holman Hunt's work or as an apologia for Solomon's own religious beliefs—or somewhere between these two poles. Either motivation might well have provoked Solomon's reaction to these early Pre-Raphaelite Christian themes, resulting in the preponderance of Hebrew subjects in his Pre-Raphaelite works.

Solomon's *Moses in His Mother's Arms* was certainly influenced by such Pre-Raphaelite models, which was unusual because it depicts a moment of maternal intimacy during the infancy of the Israelite leader who is more usually shown cast into or found amid the bulrushes. This work can be seen as analogous to the modest, symbol-laden depictions of the

childhood life of Jesus or Mary. Two paintings, for example, reflect the Pre-Raphaelite penchant for humble scenes in the early lives of New Testament protagonists: Rossetti's *The Girlhood of Mary Virgin* (1849, Tate Gallery, London, see Smith, fig. 1) and Millais's *Christ in the House of His Parents* (ca. 1850, Tate Gallery, London, see Faxon, fig. 3).

It is often argued that the Pre-Raphaelites really knew little of the work of the painters before Raphael. But the increasing availability and presence in Britain during the 1850s of the works of these earlier painters could not have escaped Solomon. The association of these earlier painters with a medieval past, the seeming naiveté of their art, and their genuine piety would have been very attractive to Solomon. However, the New Testament imagery so prevalent in the Renaissance art of these earlier painters would have been quite alien to Solomon, the young Victorian Jew.

The taste for artworks painted before 1500 had begun to grow during the 1840s, just prior to the establishment of the Pre-Raphaelite Brotherhood. Some historians believe that the hostile response to this group and the association of the name Pre-Raphaelite with these earlier Italian painters actually slowed the growing interest in the early Renaissance masters. Yet, there is no doubt that the 1850s and early 1860s offered dramatic new opportunities to encounter early Renaissance art in Britain.[14]

With the exception of William Roscoe's collection in Liverpool, there were very few works by Italian primitives in England during the 1840s. Few books contained illustrations of works by the Italian primitives, and those illustrations that did exist were actually quite crude. The paucity of English literature on these painters up to the 1840s is apparent from the extremely short available bibliography. Basically, there existed Ruskin's *Modern Painters*, Lord Lindsay's *Christian Art*, and Anna Jameson's *Sacred and Legendary Art*.[15] Only in the mid-1850s, after Sir Charles Eastlake's appointment as Director of the National Gallery in London, did works by the earlier masters enter that august institution. Giovanni Bellini's *Madonna and Child*, ca. 1489, was acquired in 1855 along with Perugino's *Three Panels of an Altarpiece: The Virgin and Child with Saints Raphael and Michael*, ca. 1499, in 1856.[16] Two Botticellis were purchased in 1855.[17] Hardly perceived as aesthetic ideals, these early works were added to the National Gallery's collection for the sense of completeness that they brought by demonstrating the development of Western art. They also served as proof of the linear aesthetic progress proposed in the posi-

tivist vision of nineteenth-century art history.[18]

Another indication of the greater interest in works of art painted before 1500 was the success of the Arundel Society's publications of art reproductions, which were another important source of visual information about the so-called primitive painters. Organized to elevate British taste by documenting masterpieces of Italian art still in situ, the Arundel Society was a rather sleepy organization in the 1840s. The society became increasingly popular during the 1850s and reached the height of its influence in the 1860s. Through the society's publication of art reproductions, available by subscription, one could see Giotto's Arena chapel frescoes, reproduced in portfolios from 1853, 1854, and 1860. Perugino's *Saint Sebastian* (1478, Louvre, Paris) was printed in 1856 and Fra Angelico's *Coronation of the Virgin* (ca. 1435, Uffizi Gallery, Florence) was published in 1864.[19] Admired by cognoscenti and aesthetes, an Arundel print is even recorded as hanging on the walls of the home of Oscar Browning, who would, in the late 1860s, become a friend of Solomon.

Information on the art of the early masters was also available in texts, either newly published or recently translated. Kugler's *Schools of Painting in Italy* was first translated in 1851 with a preface by Eastlake. Waagen, the noted German art historian and Anglophile, republished Kugler's book in 1860. Crowe and Cavalcaselle published their *Flemish Painters* in 1857, followed by their *Italian Masters* in 1862. All of these books contained few and rather crude illustrations.

The rediscovery of Botticelli, a nineteenth-century English phenomenon, was coming into full swing. Burne-Jones, a strong admirer of the Renaissance master, no doubt induced his friend Solomon to look closely at the quattrocento master's talents.[20] Even more profound in this renaissance of taste for the early Renaissance painters was the Manchester Art Treasures Exhibition of 1857.[21] This show attracted well over a million people to its resplendent display of art and artifacts during its run of several months. One of the more impressive parts of the exhibition—and one that provoked a great deal of discussion—was the number of pictures on view by early Italian painters. Never had a larger group of these works been exhibited under one roof in all of Britain. While the National Gallery was having trouble justifying its purchase of such works, at the Manchester exhibition were approximately 125 paintings executed by—or, at least, attributed to—such early Italian masters as Giotto, Masaccio, Pinturicchio, Mantegna, and Crivelli.[22] In fact, the organizer of the exhibition,

George Scharf, commented on the growth in Britain of interest in Italian art.[23] Of these 125 early Italian works, over one hundred treated New Testament themes, a quite natural phenomenon, given that the subjects were painted during a period dominated by Catholicism and the patronage of the Church.

There can be little doubt that Solomon, the aspiring artist, then aged seventeen, made the trip to this blockbuster exhibit. He easily might have gone in the company of his fellow artists, his roommates, and his older siblings Abraham and Rebecca. The immediate effect of the newly available Italian pictures must have been great, given their visual freshness by virtue of their being seen up close and in color. The piety and innocence of their subjects must have been astonishing to the young artist, whose very early work showed a particular interest in a medieval-like style not far in either character or chronology from these early Renaissance works. No doubt, the gilded halos on so many trecento and quattrocento pieces may have inspired a number of Solomon's drawings of that year in his sketchbook (Ein Harod, Israel). The Renaissance works may, indeed, have prompted his two rare, early drawings of Christian subjects done in the year of the Manchester extravaganza: one of Christ himself, the other entitled *The Favorite Apostle* (1857, Mishkan Le'Omanut Museum, Ein Harod Kibbutz, Israel, fig. 8). Within Solomon's sketchbook, the drawings for 1857 represent one of his first attempts at Christian subjects; yet these drawings are among the very few Christian images that Solomon would create in the next five years. The New Testament subject matter of the Renaissance art that he encountered must have struck him as being as alien as the Greek and Roman mythology introduced to him several years later. Neither seems to have been part of Simeon's early educational training.[24] Solomon's schooling seems to have followed educational patterns that were typical for assimilating Jews. With the emphasis on the Bible and English literature in his education, the former served as a means of cultural and religious identification and the latter as evidence of national patriotism.

The encounter with the barrage of Christian subjects must have been peculiar for the young artist. The tack that Solomon would soon take, whether consciously or subliminally, was to utilize only the formal aspects of these Christian sources for the compositions of his Hebrew Bible works. Many designs in Solomon's work during this earlier period of his life represent, in general outline—if not in wholehearted borrowing—the arrangements that appear in so many

Fig. 8. Simeon Solomon. *The Favorite Apostle*. ca. 1857. From Sketchbook. Pen and ink. Mishkan Le'Omanut Museum, Ein Harod Kibbutz, Israel.

chestnuts of early Renaissance subject matter: Annunciations, Visitations, and, not least, the Madonna and Child.

It is Solomon's *Conjugal Reconciliation at the Altar* that has a clear precedent in a work exhibited in Manchester. The model for this odd work has a curious source. Conceptually, it seems based on Botticelli's *Mystical Nativity* (ca. 1500, National Gallery, London), and compositionally on a detail of that work (fig. 9), namely, that of the angel embracing a mortal. The Botticelli painting was listed as number fifty-one in the Manchester catalogue then in the collection of W. Fuller Maitland. Ironically, *Mystical Nativity* had formerly been in the collection of William Young

Ottley, who was famous for his fascination with early Italian art—a fascination that culminated in his own engravings after Renaissance pictures. Given the identical posture of the embrace of Botticelli's mortal and immortal figures with that of Solomon's curious bride and groom, there can hardly be any question about Solomon's source. Solomon borrowed Botticelli's circular outline of the two embracing figures, the distance between the torsos of the embracing figures, the exaggeratedly long uncovered arm of the left-hand figures, and the draped, timeless robes. Even the tree that seems to emanate from the head of Solomon's groom has a counterpart in the branch that Botticelli's mortal carries. The early master's theme, at least in the detail, is the reconciliation of heaven and earth. This might have given Solomon the idea for his eccentric religious theme, which makes reference to no religion in particular but which may be seen to foreshadow Solomon's important poem of a few years later, *A Vision of Love Revealed in Sleep*.

With the beginning of Solomon's forays on the Continent, there was ever more fresh art that became available for the expansion of the artist's vocabulary. Whether Solomon went to Paris in 1857 is uncertain. He is known to have taken several trips to the French capital in the late 1850s in the company of his sister.[25] As with the former Botticelli comparison, there is a similarity—albeit not as striking—in both conception and composition between Solomon's *Isaac Offered* (1858, location unknown, fig. 10) and Michelangelo's *Dying Slave* (ca. 1513–21, Louvre, Paris). The obvious comparison here is the uppraised and twisted arm that had inspired so much art since Michelangelo. Had Solomon indeed seen this masterwork, it is doubtful that he could have missed the homoeroticism of the sculpture at a time when he himself was testing his sexual orientation. Here, Solomon seems to have transposed Michelangelo's sensual essay on death into a biblical parable for his own personal life. Perhaps it is Isaac (read Simeon) who is offering himself in sin rather than being offered as a sacrifice to the holy pact. For it is Abraham (read Abraham Solomon, the painter's brother and surrogate father) who seems to restrain the boy from movement. This could easily have reference to the social and even aesthetic constraints that Abraham seems to have placed on his younger brother. It is difficult to determine if the seventeen-year-old artist was aware that his subject was a prefiguration of the Crucifixion in Christian doctrine. Given his subsequent five-year-long obsession with themes from the Hebrew Bible, such works must be

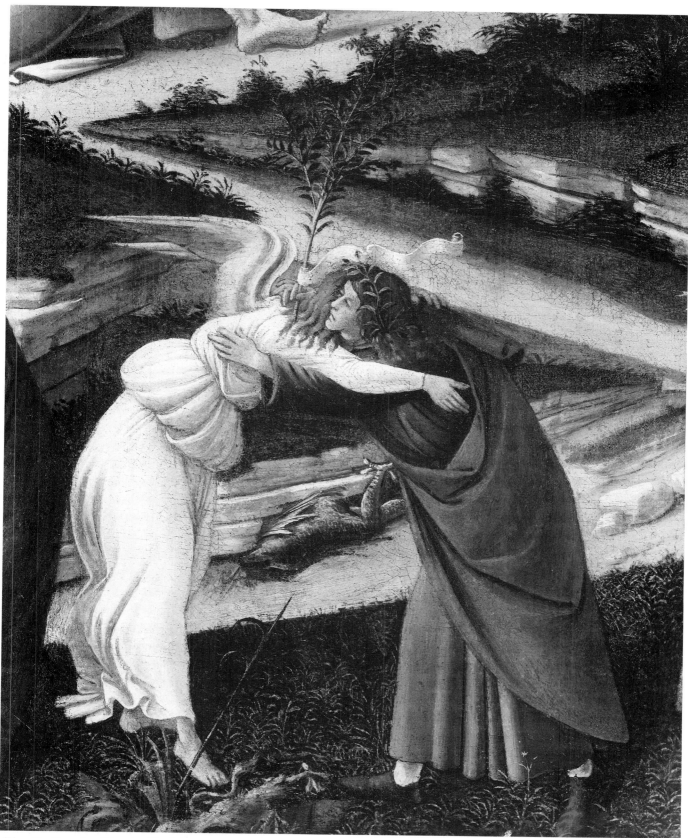

Fig. 9. Sandro Botticelli. *Mystical Nativity* (detail). c. 1500.
Oil on canvas. 108.5 × 75 cm. National Gallery, London.

Fig. 10. Simeon Solomon. *Isaac Offered*. 1858. Location unknown.

read in connection with his Jewish faith.

The proliferation of the images of the Virgin and Child in all their infinitesimal variations must nevertheless have had the greatest influence on Solomon. Here was a theme that had lost both its popularity and cogency in the baroque and classical art generally fashionable in the 1850s but was amazingly common in the works of the primitives. The Madonna and Child seems to have served Solomon as a source for numerous compositions. For works such as *Moses in His Mother's Arms* the artist could easily have looked to examples like Botticelli's *Madonna and Child* (1468, Louvre, Paris)—which Solomon might actually have seen on one of his Parisian trips—or Perugino's *Altarpiece* (ca. 1499, National Gallery, London) and Filippino Lippi's *Virgin and Child with*

Saints Jerome and Dominic (1485, National Gallery, London). He could have called to mind the profusion of Madonnas in the Manchester exhibition: included among these were similar subjects by—or, at the time, considered the work of—Giotto, Bartoldo, Verrocchio, Filippino Lippi, Botticelli, and Bellini, to name but a few.

Both *Ruth, Naomi, and the Child Obed* and *Moses in his Mother's Arms* certainly may be based on such Renaissance examples—and I am not the only one who has observed these similarities.[26] Solomon's infants within his *Moses* and *Naomi, Ruth, and Obed* are, contrary to Renaissance examples, almost completely hidden—tucked between the mother and the second female figure and, thereby, obscured and nearly suffocated. But a more careful examination of the meaning of the biblical stories within the context of Solomon's personal history provides fascinating and cogent analogies. The autobiographical nature of Solomon's art had already been alluded to by Seymour, who proposed the interpretation of *Moses in His Mother's arms* as a metaphor for the Jewish artist's "exile" within London's predominantly Christian art world.[27] Yet, the two women in each picture may refer to the two major female influences in Solomon's

early years—his mother and his sister Rebecca. Both tried to protect him from the outside world and, in a sense—given the Victorian response to Solomon's proclivities—to protect him from his anti-conformist desires. Solomon's father had died when Simeon was only fourteen, leaving the child under the protection of these two women and his older brother Abraham.

In summary, as Solomon matured as a young artist, he appears to have used subjects from the Hebrew Bible as a means of cultural identification and self-exploration. His exposure to Christian art explains his compositional sources, whose subjects were entirely submerged within the Hebrew Bible. Thus, Solomon was able to exploit those aspects of Christian art that he had seen, avoiding New Testament subjects themselves. Rather, he explored their conceptual themes, moral dilemmas, and, not least, their formal qualities. Given Solomon's later interest in Catholicism and his incorporation of Christian iconography into his art, this aesthetic flirtation with Christian art may have paved the way for an eventual escape from the taboo that Christianity, in general, and New Testament subjects, in particular, must have held for Victorian Jews.

NOTES

1. A fascinating extrapolation of these issues can be found in "The Jewish Jesus" by Ziva Amishai-Maisels in *Journal of Jewish Art* 9 (1982): 84–104.

2. Ishmael Israel Mengs, the painter and father of the better known painter Anton Raphael, was Jewish by birth, but he either converted from or abandoned Judaism. Anton Raphael Mengs is presumed to have been raised a Christian. See Cecil Roth, ed., *Jewish Art: An Illustrated History* (1961; rev. and enlarged ed. by Bezalel Narkiss, Greenwich, Conn.: New York Graphic Society, 1971), 190. Zoffany's roots are equally unclear, though Charles Spencer presents some facts that help support the idea that the artist was Jewish by birth. See Spencer's "Anglo-Jewish Artists: The Migrant Generations" in *The Immigrant Generations: Jewish Artists in Britain, 1900–1945*, exhibition catalogue (New York: The Jewish Museum, 1982), 21. For Mengs, see also p.Grafinger, Christine Maria, "Anton Raphael Mengs—Ein Künstler jüdischer Abstammung und das Papyruskabinett der Bibliotheca Apostolica Vaticana," *Journal of Jewish Art* 16/17 (1991): 30–45.

3. Howard Brotz, "The Position of Jews in English Society" in *Class, Status and Power: Social Stratification in Comparative Perspective*, 2d ed., ed. Reinhard Bendix and Seymour Martin Lipset (New York: Free Press, 1966), 350.

4. There are two versions of *Ruth, Naomi, and the Child Obed*, one a drawing of 19 September 1860, the other a painting dated 29 June 1861 (the latter was offered at a Christie's London sale in 1970).

5. T. S. R. Boase, "Biblical Illustration in Nineteenth-Century English Art," *Journal of the Warburg and Courtauld Institutes* 29 (1966): 349–67.

6. Seymour, Gayle Marie, *The Life and Work of Simeon Solomon (1840–1905)*, Ph.D. diss., University of California at Santa Barbara, 1986; Ann Arbor, Mich.: University Microfilms International, 1988, 58.

7. An example is Francis Frith's portfolio of photographs of Sinai and Palestine that were exhibited in an exhibition in Manchester at the time of the Art Treasures Exhibition in 1857. For a further analysis of English sources of Solomon's biblical pictures, see also Kenneth Paul Bendiner, *The Portrayal of the Middle East in British Painting 1835–1860*, Ph.D. diss. Columbia University, 1979.

8. Seymour, *Simeon Solomon*, 57.

9. Quoted from Bernard Falk, *Five Years Dead—A Postscript to "He Laughed in Fleet Street"* (London 1937), 321.

10. Algernon Charles Swinburne, "Simeon Solomon: Notes on His 'Vision of Love' and Other Studies" (originally published in 1871) in *A Pilgrimage of Pleasure: Essays and Studies* (Boston, 1913), 50–51 and 56–57.

11. An image of Solomon in Eastern costume can be seen in David Wilkie Wynfield's photograph of Solomon in Michael Bartram's *The Pre-Raphaelite Camera: Aspects of Victorian Photography* (Boston: Little, Brown and Company, 1985), 117, a considerable contrast from his rather anglicized appearance in the earlier *Self-Portrait* (fig. 1).

12. Contemporary social historians have also examined the first names of Jewish children as a means of determining acculturation and assimilation patterns among nineteenth-century Jewish populations. As such, the names of Solomon's brother Abraham and his sister Rebecca would be considered examples of those given by parents who were less assimilated than parents who chose children's names with either national or simply secular associations. For a study of rural French Jewry along these lines, see Paula Hyman, "The Social Contexts of Assimilation: Village Jews and City Jews in Alsace," in Jonathan Frankel and Steven J. Zipperstein, *Assimilation and Community: The Jews in Nineteenth-century Europe* (Cambridge and New York, 1992), 110–29.

13. Seymour, *Simeon Solomon*, 57.

14. Sir Francis Haskell, *Rediscoveries in Art: Some Aspects of Taste,*

Fashion and Collecting in England and France (Ithaca, N.Y., 1976), 51-54.

15. Lindsay Errington, *Social and Religious Themes in English Art 1840–1860* (New York and London: Garland, 1984), 255.

16. *The Athenaeum* 1497 (5 July 1856): 843 and *The Athenaeum* 1504 (23 August 1856): 1054.

17. T. S. R. Boase, "Biblical Illustration," 365.

18. Haskell, *Rediscoveries in Art,* 55.

19. Robyn Cooper, "The Popularization of Renaissance Art in Victorian England: The Arundel Society," *Art History* 1, 3 (September 1978): 270–75.

20. Michael Levey, "Botticelli and Nineteenth-Century England," *Journal of the Warburg and Courtauld Institutes* 23 (1960): 291–306.

21. Ulrich Finke, "The Art Treasures Exhibition" in *Art and Archi-* tecture in Victorian Manchester, ed. John H. G. Archer (Manchester, 1985): 102–126.

22. Theophile Thoré, *Trésors d'Art exposés à Manchester en 1857* (Paris, 1857). (Thoré was the pseudonym for Willi Bürger.)

23. George Scharf, *A Handbook to the Paintings by Ancient Masters in the Art Treasures Exhibition* (London, 1857), 2–5.

24. Issues of Solomon's early studies are mentioned in both Lionel Lambourne, "Simeon Solomon: Artist and Myth" in *Solomon: A Family of Painters* (London, 1985), exhibition catalogue, 24–25 and Seymour, *Simeon Solomon,* 19 and 46.

25. Pamela Gerrish-Nunn, "Rebecca Solomon," in *Solomon: A Family of Painters* (London, 1985), 21.

26. Seymour, *Simeon Solomon,* 62.

27. Ibid., 58.

The Influence of Icelandic Sagas on the Socialist Aesthetics of William Morris

LINDA JULIAN

NINETEENTH-CENTURY ENGLAND HAD NO MORE EN-
thusiastic medievalist than William Morris. His
early poetry, especially that written during his Pre-
Raphaelite phase, was based on themes from the
Middle Ages. His textiles, tapestries, stained glass,
and printing exploited medieval designs and meth-
ods.[1] Medieval themes and language influenced his
translations, his nonfictional prose, and his late prose
romances. And Morris's medievalism undergirded
his political thought, which increasingly reflected his
aesthetic philosophy. Beginning in 1877 with his first
public lecture, "The Decorative Arts," Morris wrote
about a hundred speeches, lecturing on art and poli-
tics until a few months before his death in 1896.[2]

After Morris had published his great Norse poem
Sigurd the Volsung in 1876, his literary efforts
turned almost exclusively to prose for the last two
decades of his life. Morris's transformation from poet
to prose writer coincided with the growth and inten-
sity of his involvement in politics. In the 1880s, Mor-
ris wrote several socialist books with Belfort Bax;
and from 1885 to 1890, he edited *Commonweal*, con-
tributing about 450 articles to it.[3] Morris's interest
in political activism and his growing sensitivity to the
lower classes seem to have merged with a developing
aesthetic philosophy that saw no separation between
art and politics. This aesthetic philosophy, greatly
influenced by Carlyle and Ruskin, incorporated atti-
tudes about art and heroism that Morris had discov-
ered in medieval literature, especially in Icelandic
sagas.

The result was a socialist theory with the value of
art at its center, and it was largely Morris's work
with the sagas that led him to this position. This con-
nection is noted by Ifor Evans, a twentieth-century
author who, in discussing *Sigurd the Volsung*, com-
mented that "Morris within the poem seems search-
ing for a philosophy of action. He found it on a
grander scale in the Icelandic poems, and he applied
it as seemed best to him in the socialism which oc-
cupied the later years of his life."[4] Theodore Watts-
Dunton, one of Morris's contemporaries, claimed
that "aestheticism is the primal source from which
all his [Morris's] energies spring,"[5] an observation
that further supports the theory that the quality of
the Icelandic tales—and of the culture that they re-
flect—largely accounts for Morris's extraordinary in-
terest in them. From 1869 to 1876, Morris and
Eiríkr Magnússon, who had taught Morris the Ice-
landic language, translated *Eyrbyggja Saga, Heimsk-
ringla, Kormáks Saga,* and part of *Egils Saga;*
translations of several other sagas were published. In
1870, their translation of the *Vǫlsunga Saga* ap-
peared—the first English translation of the saga that
formed the basis for much of Wagner's *Ring*. Morris
used the *Laxdaela Saga* as the basis for "The Lovers
of Gudrun" in his *Earthly Paradise*.

The influence of Icelandic literature on Morris's
themes and style can be understood fully only in the
context of Morris's conception of art as politics and
in the context of Morris's view of the importance of
narrative art—or the *tale*—as the supreme art form.
Morris referred to other arts in terms of narrative.
For example, in his lecture "Textile Fabrics" (1884),
Morris explained that "in the fine time of art what
the designer thought of was always in some way to
appeal to the imagination; in other words, to tell some
story, however imperfectly."[6] In another of his lec-
tures, "The Woodcuts of Gothic Books" (1892), he
expressed the same preoccupation with narration:
"All organic art, all art that is genuinely growing,
opposed to rhetorical, retrospective, or academic art,
art which has no real growth in it, has two qualities
in common: the epical and the ornamental; its two
functions are the telling of a story and the adornment
of a space or tangible object."[7] This definition of the

function of art explains the primarily narrative quality of Morris's own poetry, and it partly explains Morris's attraction to medieval literature—especially to the medieval Icelandic sagas.

Morris made his first trip to Iceland in 1871, largely to satisfy his curiosity about the sources of the sagas: "There is no art there at all but its strangeness and wildness; yet I have felt for long that I must go there and see the background of the stories for wh: I have so much sympathy & which must have had something to do with producing & fostering their strange imagination."[8] Following this trip, Morris wrote to Charles Eliot Norton:

> Truly it would all have been nothing but for the memory of the old story-tellers; nay I think without them the people would have long ago sunk into stolidity and brutality. . . . Then as to the look of the country, there is at least nothing commonplace about it; . . . its influence on the old story-tellers is obvious enough: often indeed the blank, barrenness of some historical place, and the feebleness of the life that has taken the place of the old tragedies would depress one for a while, till one remembered the lapse of years, and the courage and hope that had been there.[9]

This "courage and hope" contributed to Morris's political involvement: just as the "old story-tellers" had saved the Icelanders, so likewise, would art have the power to redeem the modern age in Morris's ideal socialist state.

Influenced by the Old Norse literature that he was translating, Morris increasingly relied on the *tale* as a symbol for life itself.[10] To Morris, a tale was the ultimate folk art—a story that patterned day-to-day existence and humanity's interaction with nature into a kind of beauty that was the only defense against despair. Morris considered even Norse mythology a piece of art: "It must be said that the Norse Gods are distinctly *good-fellows,* and really about the best mankind has made."[11] Morris believed that man's role was to shape nature by imposing on it a design—especially narrative design. (Thus, Morris's translation of *Beowulf* [published in 1895] is entitled, not *Beowulf,* but *The Tale of Beowulf.*) Holbrook Jackson, evaluating Morris's work in 1921, observed that Morris felt "a kinship with the saga-teller in that he also has used his art to reduce somewhat the evanescence of earthly life, if only by making tales";[12] and Jackson astutely observed that Morris's "central idea is design: design in art as a means towards design in life."[13]

Indeed, Morris's preoccupation with the tale as a tool of order and meaning is confirmed even in his letters. For example, in a highly animated letter to Louise Macdonald Baldwin (1873), in which he wrote about his second trip to Iceland, Morris recounted his experiences with a cantankerous old lady whom he called the "Flying Dutchwoman" and "an ungrateful & stupid old creature,"[14] ending the amusing description of her odd behavior with "now she is out of the story."[15] This statement, straight out of the sagas, was translated over and over by Morris in such works as *Grettir the Strong* and "The Story of Gunnlaug the Worm-Tongue and Raven the Skald."[16] A more striking instance of Morris's metaphorical use of the tale appears in a letter that he wrote to Rosaline Francis Howard (1874): "I do not believe they [the gods] will have it [the world] dull & ugly for ever: meantime what is good enough for them must content us: though sometimes I should like to know why the story of the Earth gets so unworthy."[17]

To Morris, the "story of the Earth" was a drama enacted by those who had the power to shape their lives for the good of all humanity. It is not clear whether he developed this view after translating some of the sagas or whether he was initially drawn to the sagas and Eddic poems because they embodied a philosophy and aesthetic that he already shared. What is clear is that Morris keenly recognized the dramatic power of the Icelandic tale-tellers and was determined to make the works of these storytellers available to his countrymen and to use the works as models for his own literary creations. In the preface to volume one of the *Saga Library,* Morris and Magnússon, justifying their commitment to Old Norse literature, commented on the dramatic qualities of Icelandic literature:

> *I, thou,* and *the other one,* with some small sympathetic audience to act before, are enough to make a drama, as Greek tragedy knew. Only the actors must be alive, and convince us . . . that they are so. For this quality the Icelandic Sagas are super-eminent; granted the desirability of telling what they tell, *the method* of telling it is the best possible. Realism is the one rule of the Saga-man. . . . There is nothing didactic and nothing rhetorical in these stories; the reader is left to make his own commentary on the events and to divine the motives and feelings of the actors in them without any help from the tale-teller. In short, the simplest and purest form of epical narration is the style of these works.[18]

Although Magnússon and Morris wrote this statement in the last decade of the latter's life, the sentiments expressed in it appeared twenty years earlier in Morris's letters and Icelandic *Journals.* Morris sought the supreme kind of narrative—both for its form and its substance—just as he sent to Italy for the best vellum to use for illuminated manuscripts

or just as he considered obtaining from Constantinople the dried bodies of kermes (female insects) so that he and Thomas Wardle might rejuvenate the medieval art of making a particular purple-red dye.[19] This drive for perfection was crucial to Morris, who wrote in a letter to Wardle (1876, the year in which *Sigurd the Volsung* appeared), "I mean that I can never be contented with getting anything short of the best, and that I should always go on trying to improve our good in all ways, and should consider anything that was only tolerable as a ladder to mount up to the next stage—that is, in fact, my life."[20]

The search for perfect materials and models characterized all of Morris's writing and craftsmanship; but this similarity of approach does not relegate Morris's literary work to the level of *craft,* as the word is defined today, namely, a less original, more mechanical kind of work than true art, which to modern prejudices requires individual imagination. To Morris, craft *was* art and work was art—that is, if the worker were allowed the pleasure of individual expression and enjoyment of the labor. All of Morris's crafts were subsumed within the "story of the Earth"; and no matter what form his crafts took—typography, furniture design, architecture, stained glass, fabric design—the driving force was literary, principally narrative. Thus, in discussing problems involved in the printing of fabric, Morris wrote: "The Glastrum is nicely drawn & tells its story well."[21] In arguing against the restoration of Canterbury Cathedral, he stated: "Where Canterbury Cathedral has been unrestored it is in as good a state as in the 13th century, and, man's work as it is, has hardly begun to perish yet, nor will it for many a hundred years, if only the roofs be well kept: where it is restored—well, let the ghost of the Norman tower tell that tale."[22] Here, too, in Morris's opinion, all arts and crafts embodied the story of humanity.

In a lecture entitled "Some Hints on Pattern Designing" (1881), Morris further clarified the importance of narration and its relationship to other arts:

For I suppose the best art to be the pictured representation of men's imaginings; what they have thought has happened to the world before their time, or what they deem they have seen with the eyes of the body or the soul. . . .

Stories that tell of men's aspirations for more than material life can give them, their struggles for the future welfare of their race, their unselfish love, their unrequited service: things like this are the subjects for the best art; in such subjects there is hope surely, yet the aspect of them is likely to be sorrowful enough: defeat the seed of victory, and death the seed of life, will be shown on the face of most of them.[23]

Certainly, Morris considered the pictorial quality of art important; but he valued even more the drama constantly emerging from human beings' heroic confrontation with an unsympathetic Fate and almost certain defeat at its hands. It was this kind of drama that Morris found consummately recorded in the sagas and Eddic poems.

To Morris—whose inclination, from the first, was toward narrative verse—the skill of the saga writers was a basic attraction. Morris said that the saga writers were "the best tellers of tales that have lived"[24] and that the culture represented by the sagas was a culture "of the bravest men and the best tale-tellers whom the world has ever bred."[25] To him, the greatest art was not only narrational but also political, Morris claiming, "In my mind, it is not possible to dissociate art from morality, politics, and religion."[26]

In Morris's speeches and articles, his various definitions of art elucidated this connection between art and politics, as is evident in his lecture "The Revival of Handicraft" (1888), in which he said that it was "impossible to exclude socio-political questions from the consideration of aesthetics."[27] In his lecture "Art under Plutocracy" (1883), he defined art as "man's expression of his joy in labour,"[28] adding that these words reflect the "teachings" of Ruskin (who was in the audience for this lecture). Similarly, in "The Socialist Ideal" (1891), Morris said that "when people once more take pleasure in their work, when the pleasure rises to a certain point, the expression of it will become irresistible, and that expression of pleasure is art, whatever form it may take."[29] In other lectures too, he reiterated the point that art was "some creation of man which appeals to his emotions and his intellect by means of his senses"[30] and that it was "beauty which man creates when he is most a man, most aspiring and thoughtful."[31]

One of Morris's most eloquent definitions of art appeared in *Commonweal:* "Art is man's embodied expression of interest in the life of man; it springs from man's pleasure in his life and as it is the expression of pleasure in life generally, in the memory of the deeds of the past, and the hope of those of the future, so it is especially the expression of man's pleasure in the deeds of the present; in his work."[32] Perhaps his most comprehensive explanation of art appears in "Art under Plutocracy" (1883): "And first I must ask you to extend the word art beyond these matters which are consciously works of art, to take in not only painting and sculpture, and architecture, but the shapes and colours of all household goods, nay, even the arrangement of the fields for tillage and pasture; the management of towns and

of our highways of all kinds; in a word, to extend it to the aspect of all the externals of our life."[33] According to Morris, because art belonged to every person, men and women must fight to attain the kind of environment in which art could flourish.

Morris thought that the environment in which people could practice true art had greatly deteriorated with the advent of capitalism. In this idea, Morris was strongly influenced by Karl Marx—especially by Marx's *Das Kapital,* which Morris read in 1883 and again in 1887.[34] Frederick Kirchoff has suggested that Morris found in Marx an explanation for the personally troubling inequality among social classes as well as an explanation for the exploitation of the worker forced to serve commerce.[35] In his lecture "How I Became a Socialist" (1894), for example, Morris maintained that, when he first read Marx, he was most drawn to the historical parts of *Das Kapital* and that he later tried to learn Marx's economic philosophy, largely under the tutelage of fellow socialists Belfort Bax, Henry Mayers Hyndman, and Andreas Scheu.[36] For Morris, however, the socialist vision was always aesthetic, as he made clear in his essay "The Socialist Ideal" (1891): "I assert first that Socialism is an all-embracing theory of life, and that as it has an ethic and religion of its own, so also it has an aesthetic: so that to everyone who wishes to study Socialism duly it is necessary to look at it from the aesthetic point of view."[37] Morris subscribed to Marx's economic theories because he saw that "so long as the system of competition in the production and exchange of the means of life goes on, the degradation of the arts will go on: and if that system is to last for ever, then art is doomed, and will surely die; that is to say, civilization will die."[38]

Morris believed that society should respect the workers' integrity and their freedom to create beauty through their labor; and he believed that workers, in response, would experience joy in creating beauty for society. Art could be produced only when laborers had leisure and a decent standard of living; and art could be produced only when people were in harmony with nature—conditions that he thought were impossible in his own age. For these beliefs he owed much to Ruskin. E. P. Thompson maintained that *The Stones of Venice,* which Morris became acquainted with at Oxford, "gave Morris a theory of art and society which was to influence all his later thought."[39] At Oxford, Morris often read aloud from Ruskin; forty years later, Morris still revered Ruskin enough to print the latter's *The Nature of Gothic* at the Kelmscott Press.[40] Not surprisingly, Morris, in his lectures, repeatedly credited Ruskin with greatly

influencing him. For example, in "How I Became a Socialist" Morris commented: "How deadly dull the world would have been twenty years ago but for Ruskin! It was through him that I learned to give form to my discontent. . . . The leading passion of my life has been and is hatred of modern civilization."[41] One literary historian, William Scott Durrant, said that one can see Morris's "spiritual genealogy in scriptural phrase, and say of him, 'Which was the son of Ruskin, which was the son of Carlyle.'"[42] The poet William Butler Yeats recalled that when he asked Morris "What had led up to his movement, he replied: 'Oh, Ruskin and Carlyle, but somebody should have been beside Carlyle and punched his head every five minutes.'"[43]

Morris was, however, aware of the differences between his philosophy and Ruskin's and referred to these differences in a letter to Robert Thomson (1884):

> You must understand 1st that though I have great respect for Ruskin, and his works (beside personal friendship) he is not a Socialist, that is not a *practical* one. [H]e does not expect to see any general scheme even begun: he mingles with certain sound ideas which he seems to have acquired instinctively, a great deal of mere whims . . . anyhow his idea of national workshops is one which could only be realized in a state (that is a society) already socialized: nor could it ever take effect in the way that he thinks it could.[44]

Here, Morris made clear the basic and most important distinction in the philosophies of the two men—the difference between theory and practice. Alice Chandler, in her book *A Dream of Order,* described well this difference in philosophies: "What Carlyle and Ruskin wrote, Morris lived."[45] Another difference that has been pointed out is the contrast between Ruskin's idea of paternalism and Morris's concept of fraternity.[46] A third important difference between the philosophies of the two men, noted by Holbrook Jackson, is that "Ruskin was a puritan and a moralist with Spartan tendencies a little worse for wear, but Morris was a frank Hedonist saved from preciosity by sheer love of life."[47] These characteristics of Morris's thought—activity, fraternity, and joy—were traits that Morris admired in both the medieval craftsmen and the Icelanders.

Morris wrote in *Commonweal* that "in the pre-commercial ages we had beauty without paying for it, [but] it has now become an article of the market, and . . . is so shamefully adulterated that we can scarcely buy it even for our money For my part, having regard to the general happiness of the race, I say without shirking that the bloodiest of violent

revolutions would be a light price to pay for the righting of this wrong."[48] Indeed, "the bloodiest of violent revolutions" was the only solution Morris saw to the nightmare of modern capitalism. Even this idea of violent social upheaval paralleled a concept in Norse mythology—namely, the idea of Ragnarok, or death of the gods and destruction of the world followed by the rebirth of the universe. In his only lecture on Iceland that has survived, "The Early Literature of the North—Iceland" (1887), Morris explained that the Norse gods

> are not immortal, but lie under the same fate as mankind. The day is to come when the forces of evil that they have chained and repressed shall at last break loose, and the good and evil of man's age and the Gods who have ruled over it shall meet in mortal conflict at last, and after fierce battle destroy each other. It is for this great battle that all valiant men on earth are preparing Before this great day of battle it will be evil days with the world.[49]

Morris alluded to Ragnarok in discussing the kind of destruction that he believed would herald an age of communal respect and joy.[50] In *Commonweal*, for instance, he wrote that "it is at least possible that all the old superstitions and conventionalities of art have got to be swept away before art can be born again; that before that new birth we shall have to be left bare of everything that has been called art."[51] Furthermore, in his lecture "The Lesser Arts" (1878), he described the fall and rebirth of art precisely in terms of Ragnarok: "While the signs of the last decay of the old art with all the evils that must follow in its train are only too obvious about us, so on the other hand there are not wanting signs of the new dawn beyond that possible night of the arts."[52]

Such a revolution would have to occur in order to restore to humankind the social environment necessary for the creation of art—a concept that, in his lecture "Art and Labour" (1884), Morris defined as "the human pleasure of life."[53] Like Ruskin and Carlyle, Morris believed that the medieval period produced art superior to that of his own age because both artists and artisans had more freedom of expression. Hand-made ornamentation was not rote and standard, as in the machine age, but directly reflected the interest and care of the maker. In Morris's view (and Marx's), nineteenth-century workers were alienated from their labor—slaves to machines and to an economic system that used even the bonds of family to protect private property.[54] Medieval laborers, on the other hand, were masters of their tools. They were also supported by a guild system that encouraged cooperation—rather than competition—

between workers. In his "Art and Industry in the Fourteenth Century" (1890), Morris particularly commented on guilds among "our Teutonic and Scandinavian forefathers" whose "change of religion from heathenism to Christianity did not make any difference to these associations."[55] In "Art under Plutocracy," he said of the guild system that it "had not learned the lesson that man was made for commerce, but supposed in its simplicity that commerce was made for man, which produced the art of the Middle Ages, wherein the harmonious co-operation of free intelligence was carried to the furthest point which has yet been attained, and which alone of all art can claim to be called Free."[56]

Morris often has been accused of escaping, through his art and politics, from a civilization that he hated into an ideal medieval world that did not, in fact, exist. His famous line—"The idle singer of an empty day"—from the introductory poem to the *Earthly Paradise* is sometimes quoted to dismiss Morris's serious interest in his own age and to suggest that his interest in medieval literature amounted mostly to escapism. A careful reading of Morris's prose shows that he saw clearly the faults of the medieval period, although he saw the age, even with these flaws, as far superior to his own and as an indication of a level of civilization that humanity, in his ideal socialist society, would surpass. This realization is expressed, for example, in his lecture "Art and the Beauty of the Earth" (1881): "Do not misunderstand me; I am not a mere praiser of past times. I know that in those days of which I speak life was often rough and evil enough, beset by violence, superstition, ignorance, slavery; yet I cannot help thinking that sorely as poor folks needed a solace, they did not altogether lack one, and that solace was pleasure in their work."[57] Morris and Belfort Bax, in their joint work *Socialism: Its Growth and Outcome,* wrote that "doubtless there was a rough side to the Middle Ages as to any other epoch, but there was also genuine life and progress in them."[58] To Morris and Bax the Middle Ages "had their own faults and miseries, their own uses and advantages, and they left behind them works to show that at least happiness and cheerful intelligence were possible sometimes and somewhere in them, even amongst that working class, which now has to bear the whole burden of our follies and mistakes."[59]

With regard to Iceland, Morris was equally aware that its society was imperfect. He and Bax cited Iceland as the key example of the theory that "the earlier stages of a new social development always show the characteristic evils of the incoming system . . . in

all early civilised Communities (recently emerged from group-organisations) usury and litigation are rampant as . . . the elaborate account of the life of the time given in the Icelandic sagas shows us."[60]

At the same time that Morris disclaimed the perfection of the medieval period, he asserted that the past was part of the present and that modern art could not exist outside the influence of the past. To him, modern art, no matter what its form, was either "a development or a degradation of forms used a hundred years ago."[61] Thus, for Morris, English culture, language, and art had steadily degraded Gothic culture.

With regard to literary art, Morris observed that "our own tongue became confused and to my mind degraded as the result [of] our dealings in various ways with the Latinized countries of the continent."[62] In his lecture "Early England" (1886), Morris commented that "we have lost the account of the mythology of the North from the Low German branch of the great Teutonic race: it is the feeblest and slenderest branch of the Goths that have been the story tellers of the race and not the Germans or the English."[63] Indeed, the Icelanders' regard for their own literary heritage evoked great admiration from Morris, who viewed the Icelanders' skill as far superior to that of his own countrymen. He noted that "the most illiterate [Icelanders] are absolutely familiar with the whole of the rich literature of their country, and know more of the Haralds and the Olafs of the tenth and eleventh centuries than most of our 'cultivated' persons know of Oliver Cromwell or William Pitt. Therefore I took upon these poor people with a peculiar affection and their country is to me a Holy Land."[64]

In addition to admiring the Icelanders' reverence for their language, Morris also praised the Icelanders' courage, another quality that he found wanting in his own age. Even the "good temper" with which the Icelanders met the harsh life of their climate and country required courage.[65] Equally courageous was the Icelanders' self-restraint: according to Morris, it "was a virtue sure to be thought much of among a people whose religion was practically courage"; and it was "a necessary virtue" before a man could "claim any respect in the Northern stories."[66] Certainly, the seeking of fame required courage, but only if the quest for fame incorporated true valour.[67] Referring to medieval society generally, in "Some Thoughts on the Ornamental Manuscripts of the Middle Ages" (ca. 1892), Morris wrote: "It has always seemed to me that the courage and dignity with which even bad men in the Middle Ages met a violent death is a strong confirmation of this reality of belief in the continuity of life."[68]

The dignity with which medieval laborers met their tasks also impressed Morris. He observed that even manual labor was respected among the Icelanders, and he cites examples of "mythical heroes" of Iceland who are famed for their work: "The greatest men lent a hand in ordinary field and house work . . . one chief is working in his hay-field at a crisis of his future; another is mending a gate, a third sowing his corn . . . another is a great house builder, another ship builder: one chief says to his brother one eventful morning: there's the calf to be killed and the Viking to be fought. Which of us shall kill the calf and which shall fight the Viking?"[69]

As he made clear in his lecture on Iceland, Morris also admired the communal political system of the early Icelandic society. The qualities valued by this society—especially the respect of one's fellow citizens—were the same ones that Morris valued and felt were necessary for the creation of art. He explained that "personal relations between men were what was considered. . . . The morality of the time was enforced purely by public opinion, a shabby or treacherous action was looked upon as something quite different from a legal offense."[70] He added that Icelandic society was "a different system to our politico-territorial system, and was based . . . on the equal personal rights of all freedmen."[71] Morris's use of the word *freedmen* certainly indicated his awareness that Iceland had a slave class; in this regard, scholar Gary Aho has questioned whether or not Morris considered the huge slave class that existed in Iceland during the time of the sagas. Aho also wondered whether or not Morris "took the sagas at their face value, believing the rationalizations, clutching at the laconic bravery and familial loyalties that are foregrounded in them, overlooking the cruel and rigid social system that the sagas had some share in preserving."[72] Certainly, this theory is plausible; but it is also plausible that Morris found the system flawed but still superior to most—a superiority attested to by the quality of the narrative art that it had produced in the face of debilitating climate and living conditions.

When Morris began to read the sagas in the 1860s, he did not initially look at the social injustice in the backgrounds of these stories. He looked instead at the power of the stories as stories. By the time that he had become a socialist in the late 1870s, Morris had identified art as the center of his political activity, not a by-product of it. Thus, it is unlikely that he would have revised his earlier thoughts about

the supremacy of Icelandic narrative art. In addition, Morris perhaps considered the medieval slave class far better off than the lower classes in his own age. This conjecture is supported by the observations of Morris and Bax that in the Middle Ages

> Whatever were the conditions of the life of the time, they produced an enormous volume of visible and tangible beauty. . . . The "misery" from amidst of which this came . . . must have been something totally unlike, and surely far less degrading than the misery of modern Whitechapel, from which not even the faintest scintilla of art can be struck, in spite of the idealising of slum life by the modern philanthropic sentimentalist and his allies, the impressionist novelist and painter.[73]

For Morris, great art could be produced only in a society in which communal bonds were foremost. In "The Socialist Ideal," he wrote that "the great mass of effective art, that which pervades all life, *must* be the result of the harmonious cooperation of neighbours" and that "the lack of co-operation . . . is an essential lack in the art of our epoch."[74] Morris's vision of the future, expressed in "How We Live and How We Might Live" (1885), thus seemed to mirror medieval Icelandic life as Morris conceived of it:

> I console myself with visions of the noble communal hall of the future, unsparing of materials, generous in worthy ornament, alive with the noblest thoughts of our time, and the past, embodied in the best art which a free and manly people could produce; such an abode of man as no private enterprise could come anywhere near for beauty and fitness, because only collective thought and collective life could cherish the aspirations which would give birth to its beauty, or have the skill and leisure to carry them out.[75]

In addition to the nurturing of art by a true community, a communal system would value the skill of the common man. In discussing Gothic art in general, Morris commented that "no craftsman, who is a real one, is despised in it [Gothic art]; there is room for every mind and every hand that belongs to a real man."[76] Ultimately—and through art—Morris concluded that "any other state of society but Communism is grievous and disgraceful to all belonging to it."[77]

Driven by his convictions, Morris worked unstintingly to bring about the revolution vital to the creation of a new order in which art could flourish. He contributed significantly to the cost of publishing *Justice* and *Commonweal*.[78] The sagas, in a small way, even provided money to promote Morris's political theories. Among the books that Morris sold to help fund *Justice* and *Commonweal* were, for example, some sagas from the Skalaholt Press.[79] The requisite

lecturing and political writing did not come easily to Morris. Georgiana Burne-Jones noted that "in his early addresses the difficulty [of speaking] was painful, but sheer weight and volume of meaning burst the barriers at last."[80] George Bernard Shaw, a friend of Morris's for twelve years and the only Fabian with whom Morris maintained a harmonious political relationship,[81] said that filling up the columns of *Commonweal* was for Morris a "grievous task" and that such writing "did not come easily and happily: he would never have written *Sigurd* if it had cost him half the hard brain work Socialism exacted from him. But that was how the idle singer of an empty day became a prophet and a saint."[82] Even Morris's personal attempts in 1882 to aid the Icelanders during a famine were politically frustrating.[83] Morris struggled through upheavals in the English socialist movement, breaking in 1884 with Henry Mayers Hyndman of the Democratic Federation and resigning in 1890 from the Socialist League and forming the Hammersmith Socialist Society. Morris's major quarrel with his fellow socialists was that he was unable to accept anything less than total revolution: he was not willing to work through Parliament to achieve change slowly nor was he willing to settle for what he considered easy concessions, such as shortened work days and better working conditions.

During the last five years of his life, Morris involved himself more intensely and much more directly in art than he had during the 1880s. In a then-contemporary portrait of Morris, Wilfrid Scawen Blunt recorded that in 1891 Morris "found his Socialism impossible and uncongenial" and had "thrown it wholly up for art and poetry."[84] Blunt, however, seems to have misunderstood Morris's vision. By 1891, involving himself less overtly in politics, Morris again directed his considerable energy into art—as he had in the 1860s and early 1870s—perhaps because he could see that only by producing art could he finally bring about the longing for beauty that would revolutionize society. It was in 1891, significantly, that Morris began two important artistic ventures: the publication of beautiful books at the Kelmscott Press and the translation, with Magnússon, of beautiful stories—Icelandic sagas—for the Saga Library.[85] Morris's method of attack on his countrymen's sensibilities had changed, but not his vision.

Morris's vision was, however, ultimately flawed. In what was surely a naive view of human nature, Morris assumed that in the new society all men would truly yearn to work—to create beauty. In addition, as Kirchhoff has pointed out, Morris thought

that everyone would be equally happy in a society that valued community more than it valued the individual.[86] William Fredeman put it well when he said that "one of the principal weaknesses of Marxist criticism is that it provides no accommodation for genius; thus the author of the longest poem in English writes himself into a corner, for he would, in his own terms, have no place in the new Jerusalem of *News from Nowhere*."[87] And no matter how unselfish Morris was in using his money to advance the socialist cause, he was still a capitalist making exclusive pieces of art for consumption far from the world of the English proletariat. Yet, Morris's socialist writing has been extremely influential; and the writing itself is now considered by some to be Morris's "most important literary work."[88]

In Morris's socialist works and in other nonfiction, Iceland does not figure prominently in a direct way. Only one lecture on Iceland survives, and the allusions to Iceland in other works are few. Yet Morris's reading and translating of the sagas brought into focus his earlier—and largely subconscious—socialist thought, inspired by Ruskin. The focus was always aesthetic. Alfred Noyes, Morris's contemporary, observed that Morris's socialism "was the slow, inevitable outcome of his artistic sincerity—it was forced upon him as an artist by the conditions of modern life."[89] Iceland inspired in Morris the artistic vision that affected his style and his message. That message may have been flawed—just as, in Aho's opinion, Morris's understanding of Iceland and the sagas was possibly flawed. But what counts is the aesthetic philosophy that emerged from his perception of Iceland, whether or not that perception was distorted.

Yeats said that Morris's "vision is true because it is poetical, because we are a little happier when we are looking at it; and he knew as Shelley knew, by an act of faith, that the economists should take their measurements not from life as it is, but from the vision of men like him, from the vision of the world made perfect that is buried under all minds."[90] Morris knew that the world of the sagas was imperfect and that Iceland was not ideal, but he claimed that it was "beautiful to a man with eyes and heart and perhaps on the whole the healthiest spot in the world."[91] Iceland and its narrative art were the best that an imperfect world had to offer.

NOTES

1. For recent discussions of Morris as a designer, see Joanna Banham and Jennifer Harris, eds., *William Morris and the Middle Ages* (Manchester: Manchester University Press, 1984); Linda Parry, *William Morris Textiles* (New York: Viking, 1983); Christine Poulson, *William Morris* (Secaucus, N.J.: Chartwell, 1989); Peter Stansky, *Rediscovering the World* (Princeton: Princeton University Press, 1985); and Ray Watkinson, *William Morris as Designer*, 2d ed. (London: Trefoil, 1990).

2. For a complete list of these lectures and the dates of delivery, see Eugene LeMire, ed., *The Unpublished Lectures of William Morris* (Detroit: Wayne State University Press, 1969). See also May Morris, "List of the Principal Lectures Delivered by William Morris," in *William Morris: Artist Writer Socialist*, 2 vols. (New York: Russell & Russell, 1936), 2: 638–40.

3. For a list of Morris's 443 signed articles in *Commonweal*, as well as 101 contributions he made to other periodicals and newspapers, see H. Buxton Forman, *The Books of William Morris Described with Some Account of His Doings in Literature and in the Allied Crafts* (1897; New York: Franklin, 1969), 196–216.

4. B. Ifor Evans, *English Poetry in the Later Nineteenth Century*, 2d ed. (London: Metheun, 1966), 126.

5. Theodore Watts-Dunton, *Old Familiar Faces* (London: Jenkins, 1916), 240–76.

6. *The Collected Works of William Morris*, 24 vols. (New York: Russell & Russell, 1966), 22: 293–94.

7. William Morris, *The Ideal Book: Essays and Lectures on the Arts of the Book*, ed. William S. Peterson (Berkeley: University Press of California, 1982), 26.

8. *The Collected Letters of William Morris* ed. Norman Kelvin, (Princeton: Princeton University Press, 1984), 1: 132.

9. Ibid., 152.

10. Peter Faulkner, "Morris's Poetry: From 'Guenevere' to 'Sigurd'" in *William Morris: Aspects of the Man and His Work*, ed. Peter Lewis, Proceedings of the 1977 Conference on William Morris Held at Lough-

borough University of Technology, 1978), 28–49, states that "Morris is not a first-rate poet because, partly, of his conception of himself as a poet, with its emphasis on the teller of tales" (47).

11. LeMire, *Unpublished Lectures*, 189.

12. Holbrook Jackson, *William Morris: Craftsman-Socialist* (London: Cape, 1926), 146.

13. Ibid., 148. Jackson, however, subscribes to the theory that Morris was essentially a "decorative artist" whose "literature was if not entirely, at least in the nature of a by-product" (31), an evaluation that severely undervalues Morris's writing.

14. Kelvin, *Collected Letters*, 1: 199.

15. Ibid., 200.

16. See, for example, *Collected Works*, 7: 38, 209 and 10: 11.

17. Kelvin, *Collected Letters*, 1: 230.

18. Morris and Eiríkr Magnússon, *The Saga Library: Done into English Out of the Icelandic*, 6 vols. (London: Bernard Quaritch, 1891–1905), x–xi.

19. Kelvin, *Collected Letters*, 1: 303.

20. Ibid., 334.

21. Ibid., 305.

22. Ibid., 376.

23. *Collected Works*, 22: 176.

24. LeMire, *Unpublished Lectures*, 194.

25. Ibid., 198.

26. *Collected Works*, 22: 47.

27. Ibid., 22: 332.

28. Ibid., 23: 173.

29. Ibid., 23: 262.

30. Ibid., 22: 235.

31. Ibid., 23: 103.

32. Ibid., 1: 18.

33. Ibid., 23: 164–65.

34. See Paul Thompson, *The Work of William Morris* (New York:

Viking, 1967), 230, and E. P. Thompson, *William Morris: Romantic to Revolutionary* (New York: Pantheon, 1977), 305–6, 355–57.

35. Frederick Kirchhoff, *William Morris* (Boston: Twayne, 1979), 114.

36. *Collected Works* 23: 277–78.

37. Ibid., 23: 255.

38. Ibid., 23: 172.

39. E. P. Thompson, *William Morris: Romantic to Revolutionary*, 33. Ruskin was not the only early socialist influence on Morris, though he was the major one. In 1883 Morris wrote that when he was in Oxford in 1853, Kingsley's works influenced him so that he "got into my head therefrom some socio-political ideas which would have developed probably but for the attractions of art and poetry" (Philip Henderson, ed., *The Letters of William Morris to His Family and Friends* [New York: Longmans, Green and Co., 1950], 185). Also in "How I Became a Socialist" Morris says he was influenced by John Stuart Mill, who had protested "Socialism in the Fourierist guise" (*Collected Works*, 23: 277–78). William Gaunt (*The Pre-Raphaelite Tragedy* [London: Cape, 1942], 191) suggests that Morris's socialism was "Pre-Raphaelite Socialism: it derived from that idea which lurked even in the original discussion of the long-evaporated Brotherhood—that everyone should be an artist"; Gaunt claims that Morris's "early attachment to King Arthur had led him irresistibly to Karl Marx. The Round Table was a preparation for Communism" (193). Watkinson (*William Morris*, 89) suggests that even the building of Red House in 1859, with Morris's intention of sharing the house with the Burne-Joneses and others, reflects the socialist thought of Pugin and Robert Owen.

40. Ruskin's book was the fourth publication at Kelmscott. The preface is dated 15 February 1892 (Forman, *The Books*, 220). See also J. W. Mackail, *The Life of William Morris*, 2 vols. (London: Longmans, 1899), 1: 46–47.

41. *Collected Works* 23:279. See also "The Prospects of Architecture," 1881 (*Collected Works*, 22: 140), "Art and Socialism," 1884 (*Collected Works*, 23: 202), and "The Lesser Arts," 1887 (*Collected Works*, 22: 5).

42. William Scott Durrant, "The Influence of William Morris," *Westminster Review* 149 (May 1908): 543.

43. For a good discussion of similarities and differences in Ruskin's and Carlyle's thought, see Chandler (cited in n. 45).

44. Kelvin, *Collected Letters*, 2: 305.

45. Alice Chandler, *A Dream of Order: The Medieval Ideal in Nineteenth-Century English Literature* (Lincoln: University Press of Nebraska, 1970), 217.

46. See Jeffrey Spear, "Political Questing: Ruskin, Morris and Romance," in *New Approaches to Ruskin: Thirteen Essays*, ed. Robert Hawison (Boston: Routledge, 1981).

47. Jackson, *William Morris*, 153.

48. *Collected Works*, 1: 37.

49. Lemire, *Unpublished Lectures*, 189. LeMire (*Unpublished Lectures*, 243) lists a lecture for which no text survives: "Iceland, Its Ancient Literature and Mythology," given at Sheffield on 14 September 1884.

50. Karl Litzenberg claims that Morris first uses Ragnarok as a simile or metaphor beginning even before 1876. See Litzenberg's "The Social Philosophy of William Morris and the Doom of the Gods," *Essays and Studies in English and Comparative Literature* (Ann Arbor: University Press of Michigan, 1923), 183–203, and "Allusions to the Elder *Edda* in the 'Non-Norse' Poems of William Morris," *Scandinavian Studies and Notes* 14 (1936): 1724.

51. "The Worker's Share of Art," *Commonweal* 1 (April 1885): 18. See also "Our Policys" *Commonweal* 2 (March 1886): 17.

52. Collected Works, 22: 12.

53. LeMire, *Unpublished Lectures*, 95.

54. William Morris and Belford Bax, *Socialism: Its Growth and Outcome* (London: Swan Sonnenschein, 1893), 7–8.

55. *Collected Works,* 22: 383.

56. Ibid., 23: 176–77.

57. Ibid., 22: 163.

58. Morris and Bax, *Socialism,* 77.

59. Ibid., 84.

60. Ibid., 41.

61. *Collected Works,* 22: 7.

62. LeMire, *Unpublished Lectures,* 57.

63. Ibid., 167.

64. Ibid., 181.

65. Ibid., 181.

66. Ibid., 185.

67. Ibid., 190.

68. Morris, *The Ideal Book,* 4.

69. LeMire (*Unpublished Lectures,* 184) identifies these, respectively, as King Sigurd Syr of *Heimskringla*, Arnkel Gobi of *Eyrbyggja Saga*, and Gummar Hamundson of *Njals Saga*, but he says the last example is not identified.

70. Ibid., 183–84.

71. Ibid., 184.

72. Gary Aho, "William Morris and Iceland," *Kairos* 1.2 (1982): 113.

73. Morris and Bax, *Socialism*, 83.

74. *Collected Works*, 23: 259.

75. Ibid., 23: 23.

76. LeMire, *Unpublished Lectures*, 148.

77. *Collected Works*, 23: 275.

78. E. P. Thompson, *Romantic to Revolutionary*, 313; Henderson, *Letters of William Morris*, 1x.

79. Gaunt, *Pre-Raphaelite Tragedy*, 201.

80. Georgiana Burne-Jones, *Memorials of Edward Burne-Jones*, 2 vols., 2d ed. (London: Macmillan, 1906), 2: 194.

81. An excellent and brief discussion of the relationship between Morris and Shaw is that by E. E. Stokes, Jr., "Morris and Bernard Shaw," *Journal of the William Morris Society* 1 (Winter 1961): 13–18.

82. George Bernard Shaw, *William Morris as I Knew Him* (New York: Dodd, 1936), 51–52.

83. Richard Harris, "William Morris, Eiríkr Magnússon, and the Icelandic Famine Relief Efforts of 1882," *Saga-Book of the Viking Society for Northern Research* 20 (1978–79): 31–41, goes into much detail about the political complexities of the Mansion House Relief Committee's efforts on the Icelanders' behalf.

84. Wilfred Scawen Blunt, *My Diaries: Being a Personal Narrative of Events 1888–1914*, 2 vols. (New York: Alfred A. Knopf, 1921), 1: 57.

85. *The Saga Library* appeared in six volumes between 1891 and 1905.

86. Kirchhoff, *William Morris*, 116.

87. William Fredeman, ed., "An Issue Devoted to the Work of William Morris," *Victorian Poetry* 13 (1975): xxviii.

88. For example, Kirchhoff, *William Morris*, 57.

89. Alfred Noyes, *William Morris* (London: Macmillan, 1908), 125–26.

90. William Butler Yeats, "The Happiest of the Poets," *Essays and Introductions* (New York: Macmillan, 1961), 63.

91. LeMire, *Unpublished Lectures*, 180.

Part III
European Connections with Pre-Raphaelitism:
People, Places, and Forces

Cardinal Wiseman, the Vatican, and the Pre-Raphaelites

HELENE E. ROBERTS

IN THE SUMMER OF 1848 SEVEN YOUNG MEN FORMED A Brotherhood dedicated to the revival of Pre-Raphaelite art. Because the Early Italian painting that they admired consisted primarily of religious subjects, their decision led them inexorably onto the precarious ground of religious controversies in their own time. That their domestic paintings of the Holy Family sewing at home or working in the carpentry shop should lead periodical critics to charge them with Mariolatry, idolatry, and pictorial blasphemy, and to suspect them of "a hidden and subversive form of Roman Catholic propaganda" can only be understood against the background of mid-century religious animosities.[1]

Although the seven Pre-Raphaelites were all Protestant in their backgrounds, they shared no single religious position. Their beliefs varied from the pious, but vacillating, faith of James Collinson to the unwavering skepticism of William Michael Rossetti. In 1847 Collinson, the most devout of the Brotherhood, attended Christ Church in Albany Street, the same High Anglican Church as was attended by Frances, Maria, and Christina Rossetti. But in 1848 Collinson fell under the spell of Cardinal Wiseman and converted to Catholicism. As a condition for his engagement to Christina, however, he returned to the High Anglican Christ Church, just before the formation of the Pre-Raphaelite Brotherhood. In 1850, when the engagement was broken, he again vacillated and rejoined the Catholic Church.[2]

Far different from Collinson were William Holman Hunt who described himself as a free thinker; Frederick George Stephens and Thomas Woolner, who seem to have been conventional Anglicans of no great religious fervor; and John Everett Millais, a High Anglican who attended Saint Andrew in Wells Street, a model church of the Cambridge Camden Society. Millais was curious about religion, fre-

quently attending sermons, sometimes two on Sunday, sometimes of differing denominations, including the Catholic discourses of Cardinal Wiseman.[3] Dante Gabriel Rossetti, like his brother, was not a believer, but had, through his mother and sisters, contacts with the High Anglican Church. His sensibility and his cultural and literary background led him to appreciate and express himself in religious symbolism. He chose *Art-Catholic* as a term to describe himself: Catholic in sympathy but only in art. Discussions and arguments on all subjects were a welcome part of Pre-Raphaelite Brotherhood meetings. Coventry Patmore remembered these meetings included discussions about religion.[4] Despite the differences of belief within the Brotherhood, the atmosphere must have been much friendlier than that which could be found in society at large on religious subjects.

England had a long history of religious controversy beginning at the Council of Whitby in 664. Frictions were greatly aggravated and deepened by Henry VIII's Anglican Reformation, the Elizabethan Settlement, and the rise of Puritanism. After the Restoration of Charles II in 1660, the Puritans were proscribed, only to continue in the late seventeenth century as Baptists, Presbyterians, Quakers, and Independents (later Congregationalists). In the next century Methodists and Unitarians emerged as Nonconformists; by 1851 these Dissenters had persuaded nearly half the churchgoers to attend their chapels. In the meantime the Anglican Church had divided into High, Low, and Broad factions. All of these denominations represented religious controversies which affected the acceptance of art with religious subject matter. In fact, religious zealotry had destroyed not only sacred works of art but also the whole tradition of religious art in England.[5] To complicate the matter further, Roman Catholicism experienced a revival in nineteenth-century England.

In the person of Cardinal Nicholas Wiseman, the long arm of the Vatican reached to the very bank of the Thames and threatened Victorian England with a Catholic bishop of Westminster. It was an intrusion that affected the whole of society, including the artistic world. Religious controversy complicated the interpretation of works of art and the loyalties of friends. By arousing hostility to anything even associated with the Church of Rome, controversies caused the members of the newly formed Pre-Raphaelite Brotherhood to change the direction of their art and resulted in the first defection from their ranks.

Nicholas Patrick Stephen Wiseman, as his biographer Sydney Wayne Jackman pointed out, combined those foreign qualities most likely to arouse English prejudices. Wiseman, the son of an Irish father, was born in Seville, Spain, and educated in Catholic schools, in England, and, more extensively, in Rome. When he returned to England as an adult in 1835, he came as an ordained Roman Catholic priest.[6] In the next decade his expanding girth, promotion to cardinal, and the wearing of the position's splendid regalia heightened this impression of strangeness. "When in full tog," one Catholic convert explained, "the cardinal looked like some Japanese God."[7] With his Ultramontane ideas, his fondness for Roman rituals, his florid manner of speaking, and his "penchant for pageantry, livery and elaborate ceremonial,"[8] Cardinal Wiseman seemed alien even to that small band of English Catholics who greeted him on his arrival. Furthermore, Wiseman brought foreign ideas with him, introducing new Roman doctrine and authority to the old-fashioned and insular Catholics of England. His Ultramontanism (meaning literally "beyond the mountains," namely, the Alps) sought to bind Catholic life more closely to Rome by a wide range of social and artistic, as well as religious, practices under the authority of the pope and the Vatican.[9]

As an ambitious man who wished to further the interests of Roman Catholicism in England, Wiseman faced imposing obstacles, not the least of which was the deep suspicions and ingrown prejudices of the English which resulted from three centuries of pervasive anti-Catholicism. What English schoolboy or schoolgirl had not heard of Bloody Mary, the Spanish Armada, the Gunpowder Plot, the Jacobite Invasions, and the Popish Plots, or read graphic descriptions of the grisly fate of Protestant heroes in John Foxe's *Book of Martyrs?* Since the days of Elizabeth, the English (though not all of the Stuart kings), had tried to eradicate the Catholic faith, its priesthood, its worshippers, and its art. Catholic superstitions, the priesthood, and lack of respect for the Bible bothered Protestants, but most of all, Protestants were worried about the presumed ambition of the pope to subvert the English state.[10] "No-Popery" was the battle cry of the anti-Catholics, and a general belief that evil emanated from the Vatican was instilled in every English child. "In books of all sizes, and from the pulpit of every Church," William Cobbett wrote in 1826 in his popular *History of the Protestant "Reformation" in England and Ireland,* "we have been taught, from infancy, that the 'beast,' the 'man of sin' and the 'scarlet whore,' mentioned in the *Revelation,* were names which *God himself* had given to the Pope."[11]

Although more tolerant attitudes had prevailed in the early nineteenth century, these attitudes also created their own backlash of anti-Catholicism. In 1829 the Catholic Emancipation Act was passed, thereby repealing a series of penal codes that had effectively barred Catholics from Parliament, from all civil and military offices, and from many legal transactions. The requirement of taking two oaths—one declaring against the doctrine of Transubstantiation, and the other, the Oath of Supremacy, denying both the temporal and the spiritual authority of the pope—had meant that no Catholic could successfully aspire to the many positions and activities that required these oaths.[12]

Catholics in England in the eighteenth and early nineteenth centuries were typically quiet, even reclusive, avoiding confrontation with Protestants and careful not to excite the ever present, but usually latent, hostilities to their system of belief. John Henry Newman in his sermon "Second Spring" described this quiescent time and a typical old Catholic believer.

> There, perhaps an elderly person, seen walking in the streets, grave and solitary, and strange, though noble in bearing, and said to be of good family, and a "Roman Catholic." An old-fashioned house of gloomy appearance closed in with high walls, and with an iron gate, and yews, and the report attaching to it that "Roman Catholics" lived there; but who they were, or what they did, or what was meant by calling them Roman Catholics, no one could tell—though it had an unpleasant sound, and told of form and superstition.[13]

In the sixteen years between 1835 and 1850, however, this peace and quiet was to be shattered. The governance of the Catholic Church in England had been under the *Apostolicum Ministerium* of 1753, which assumed worship was conducted primarily by chaplains in country houses. England was, in fact, a

"missionary district" governed by Vicars Apostolic. The rapid influx of Irish Catholic immigrants into England's burgeoning cities and the rapid increase of converts put increasing strains on this system of governance. The number of Catholics in England grew from an estimated 80,000 near the end of the eighteenth century to 750,000 by the census of 1851. By mid-century 80 percent of the Catholic population was Irish.[14] Protestant conversions to Rome also rose; by 1851 they had reached 10,000, an estimated 1,400 coming in 1850–51 alone. These converts played a much larger role than the Irish in defining the English Catholic Church and the hostility against it.[15]

Nicholas Wiseman played the major role in transforming English Catholicism and in promoting the Catholic revival that John Henry Newman called a "Second Spring." Not surprisingly, Wiseman was at the center of a number of controversies. In 1835, after success as a vice-rector and professor of Oriental languages at the English College in Rome, Wiseman visited England. In an effort to diminish the prejudices of the English against Catholicism, he gave a series of well-attended and well-received lectures aimed at explaining the doctrines of Catholicism to the mainly Protestant public. A year later he founded the *Dublin Review,* a quarterly which, despite its name, was published in London. It was to be scholarly and literate, a "serious vehicle for Catholic thought"[16] meant "to emulate and take issue with the . . . *Edinburgh Review*" and its Whiggish and rationalist point of view.[17] Wiseman wrote two articles for the first number, including one that was entitled "Philosophy of Art," and nearly seventy more in the course of his lifetime, including a number of informed and opinionated pieces on various aspects of the fine arts.

In 1840 Wiseman was given the title of bishop of Melipotamus, made president of Oscott College in Birmingham, and was appointed coadjutor of the Central District of the Roman Catholic Church in England. A gregarious and active man, with a wide spectrum of interests, Wiseman wrote, lectured, entertained, and traveled. Millias described one of Wiseman's lectures and expressed his own intention of going.

To-morrow (Sunday) Collins [Charles Allston Collins, the younger brother of the novelist Wilkie Collins] and myself are going to dine with a University man whose brother has just seceded, and afterwards to hear the Cardinal's second discourse. My brother went last Sunday, but could not hear a word, as it was so crowded he could not get near enough. The Cardinal preaches

in his mitre and full vestments, so there will be a great display of pomp as well as knowledge.[18]

Ever mindful of making converts to the faith, Wiseman particularly cultivated Tractarians, those followers of John Keble and William Pusey, who, with Newman, initiated the Oxford Movement of the 1830s and 1840s. A similar movement of Ecclesiologists, also interested in early Christian ritual and church decoration, formed in Cambridge. It was these High Anglican movements that provided most of the Roman Catholic converts. If they converted to Rome, Wiseman welcomed them to Oscott, just as he welcomed Newman in 1845.

Wiseman's activities, including the introduction of Roman rituals and his search for miracles and relics, made him a well-known and controversial figure who was often mentioned in the press. In the 1840s, his activities, though attracting interest and converts, aroused England's never totally dormant hostility to Roman Catholicism. In the fall of 1850, when the pope created a Roman Catholic hierarchy for England with Wiseman at its head, anti-Catholic sentiment reached its peak. Hostility erupted when the pope made Wiseman Archbishop of Westminster. The Church of England considered Wiseman's title an aggressive infringement upon its privileges. The Anglican Church already had two archbishops, Canterbury and York, and was the state church for all of England.

Although the step was taken primarily to give a stronger structure to the ecclesiastical administration of the growing Catholic population, the step seemed to many Protestants to be that ever-feared intrusion of the pope into English life and law. To assume an ecclesiastical title in an existing English geographical territory, if not illegal in terms of the Catholic Emancipation Act of 1829, was certainly inflammatory.[19] If this claim was not alarming enough, Wiseman exacerbated it by issuing a triumphant pastoral missive entitled "Out of the Flaminian Gate of Rome," a letter naming the counties that the Roman Catholic Church would "govern." It slighted the position of the Church of England and led Queen Victoria to ask, "Am I the Queen of England or am I not?"[20] In a series of articles, *The Times* of London called the restoration of the hierarchy "papal aggression," a phrase that rapidly gained common currency.[21] It was during this rising tide of religious controversy that the members of the Pre-Raphaelite Brotherhood exhibited their first religious paintings and attracted anti-Catholic sentiment in the critical press.

The number of anti-Catholic books and articles written during the 1840s is quite daunting. Titles

like *Essays in the Errors of Romanism* and *Popery: Its Character and Crimes* were common. Novels disclosed the horrors taking place in nunneries; Jesuits often served as the darkest of villains. Margaret Maison, in her study of Victorian religious novels, has written that, "few modern horror comics could equal, in crudity, sadism, hysteria and bloodcurdling violence, the story of Jesuits in popular fiction."[22] Equally popular in print and in paint were the stories of poor innocent girls persuaded against their natural instincts to languish in the forced chastity of a nun's life.[23]

Protestants traveling to Catholic countries did not waste the opportunity to point out what they perceived to be the absurdities and evils of religious practices. In *Pictures from Italy,* Charles Dickens, so adept at satire and caricature, presented Catholic rituals and practices in his own unique style. The widely reviewed *A Pilgrimage to Rome* by the fierce antipapist, the Rev. M. Hobart Seymour, went through four editions in the next three years. Seymour let few of the Church of Rome's egregious faults go unexamined, including a number of faults relating to the fine arts, among which he identified idolatry and Mariolatry.

A number of differences in belief divided the Protestants and the Catholics, and these differences related directly to religious imagery, ritual, and church decoration. Although there were variations within denominations, the basic divisions can be enumerated as follows:

1. Catholics believed that the Grace of God, directed through the ordained priests, the Holy Sacraments, and the good works of an Apostolic Church assured salvation. Protestants believed that salvation came through an individual's faith that in Christ's infinite mercies alone a sinful person is justified and saved.

2. Catholics believed that the pope wielded supreme authority in all matters of faith and morals; Protestants gave a much greater role to individual conscience.

3. Catholics worshipped the Virgin Mary and the saints. The Protestants believed that only God the Father, the Son, and the Holy Spirit should be worshipped.

4. Catholics believed that the Virgin Mary and the saints interceded between humans and God, and Protestants believed that only Jesus Christ mediated between God and humans.

5. Catholics believed that rituals, paintings, and sculptures were an important aid to religious worship. Protestants believed that religious truth was based in the Word of the Scriptures and that rituals, paintings, and sculptures were not only idolatrous, but, even worse, could be seductively poisonous to salvation itself.

6. Catholics created a pervasive religious mood by playing on the senses through the use of images, ritual, vestments, incense and candles while Protestants believed that God should be perceived through the spirit rather than through the senses.

7. Catholics believed that images were useful for instruction and evoked worshipful associations and responses which led to the worship of God. Protestants believed not only that it was idolatrous to depict God but that it was impossible to embody the spirit of God in imagery.

Attitudes toward religious imagery spanned this broad spectrum in mid-Victorian England. On one side were those—mainly extreme Dissenters—who condemned all attempts to visualize forms of the Deity. Dissenters argued that art relying on the sensuous rather than the spiritual was suspect. They defined idolatry as "the worship of the visible" that mistakes "forms for substances, symbols for realities."[24] Furthermore, they deemed it "absurd and foolish" to create images of God in human form. The image of humans that was known, Dissenters argued, was that of humans after the Fall. When God made humans in his own image, it was a very different image, one that could not be conceived by present-day humankind in their state of sin.[25] The Second Commandment was taken seriously. It was sacrilegious to try to visualize holy subjects.

Idolatry was not merely a term to be discussed abstractly in theological discussions but was perceived as a serious danger in England as well as in Rome. *The Christian Reformer* reported on a deputation of Anglican clergymen who, in 1846, objected to paintings in the National Gallery which depicted God the Father. Their objections were particularly aimed at Bartolome Esteban Murillo's *Holy Family,* now entitled the *Two Trinities* (fourth quarter of the 17th century, National Gallery, London, fig. 1).[26] The painting shows God the Father and the Holy Ghost in the upper part of the picture and Joseph, Mary, and Christ as a child in the lower part, with the child connecting both groups to form the trinities. Although Murillo's composition cleverly links the human and spiritual aspects of God, it was offensive to the clergymen to depict God the Father in a human form—or at all. The deputation was not successful, but the incident indicates the hostility that Protestants felt toward supposed idolatry.

At the other end of the spectrum, the Catholics

Fig. 1. Bartolome Esteban Murillo. *The Two Trinities (The Holy Family)*. Courtesy of the National Gallery, London.

argued that images not only informed those not able to read the Scriptures, but also focused the mind of all worshippers, leading them to higher and more spiritual thoughts. One Catholic explained that "the form of our Saviour, extended upon the Cross is a powerful lesson to the Christian," and that "the affections and thoughts raised in our minds by the sight of this object will surely [evoke] adoration, love, resignation, and obedience due to God."[27]

Cardinal Wiseman, realizing the depth of Protestant sensitivity on the subject of sacred imagery, tried to present a more acceptable view of image worship in his lectures in 1837.

> If I stood before the image of anyone whom I had loved and had lost, fixed in veneration and affection, no one would surely say that I was superstitious. Such is PRECISELY all that the Catholic is taught to believe regarding images or pictures set up in churches.[28]

His explanation is somewhat disingenuous, however, since Wiseman, at least at a later date, did try to impose the worship of even more saints and relics upon reluctant Old Catholics, an inconsistency that did not escape the *Eclectic Review*.

There was a seemingly endless discussion about Catholic practices, including the use of imagery in sermons, tracts, books, and the press. The intention was to shock the Protestant readers and turn them against the Roman Catholic Church. Protestant opposition also raised serious doubts about the direction in which the High Anglican Church was headed. Charges could be very extreme. In a review of J. Endell Tyler's *The Image Worship of the Church of Rome* in 1847, a critic for the *Eclectic Review*—a nonconformist, anti-Catholic, anti-Tractarian journal—stated: "There is no anomaly in the history of mankind more strange than the pretension of Romanism to identify itself with Christianity."[29] Most of the attacks were aimed, not at present Roman Catholic worship in England (since these churches had few images), but at existing Continental churches or at historical accounts of churches of past centuries. The fears that these type of charges aroused was that these Continental and historical practices would become prevalent in England.

The example of France, where the state Catholic Church was split into three main factions, the Gallican or old French traditionalists, the new Ultramontanists, and the Jansenists, also caused John Bull to bristle. The younger and more active Ultramontanists had codified their view of papal authority into an aesthetic of religious art and were busy decorating French churches with murals demonstrating their ideas in stiff and hieratic compositions, rife with symbolism. These French artists were opposed to all forms of naturalism, which they associated with modern ideas of positivism, progress, and change.[30] Many Englishmen, including Rossetti and Hunt, had visited France and had seen the new church decorations. Rossetti, especially impressed with Hippolyte Flandrin's not yet completed decorations of Saint-Germain-des-Prés in Paris, wrote to his brother William:

> Hunt and I solemnly decided that the most perfect works, taken *in toto,* that we have seen in our lives, are two pictures by Hippolyte Flandrin (representing Christ's Entry into Jerusalem, and his departure to death) in the church of S. Germain des Pres. Wonderful! wonderful!! wonderful!!![31]

Flandrin, himself a liberal Ultramontanist, provided one of the best examples of the serene, symbolic, ironic aesthetic of the movement and was closely associated with its goals. The images involved in his decorations in Saint Germain-des-Prés are excellent representatives of that particular style (fig 2).

The aesthetics of French Ultramontanism were also known in England through the writings of Alexis-François Rio. His *De la poésie chrétienne dans son principe dans sa matière et dans ses formes* was originally published in Paris in 1836, and although not translated into English until 1847 as *The Poetry of Christian Art,* it was widely written about in the periodicals. Anna Jameson and Lord Lindsey incorporated his ideas into English books about Early Italian painting. Rio charted the decline of Christian art from the simple faith-inspired art of the fourteenth century to the sensuous, naturalistic, and decadent art of the Renaissance. In England at midcentury this theme was reflected in much writing about art and was a mainstay of the Pre-Raphaelite doctrine.

But to Protestants, with their long history of iconoclasm, the revival of an art that captured an image of the divine spirit in paint and stone was deeply troubling. Against this background of religious controversy the Pre-Raphaelite Brotherhood's revival of religious painting proved to be a precarious enterprise. Moved by a desire to revolt against the teaching of the Royal Academy schools far more than by strongly held religious beliefs, they did not realize that they were entering a minefield of controversy. That they chose the name Pre-Raphaelite Brotherhood was also more happenstance than a deliberate ploy. Hunt reported that it was a name given them by fellow Royal Academy students when he and Millais criticized Raphael's *Transfiguration* (1520, Un-

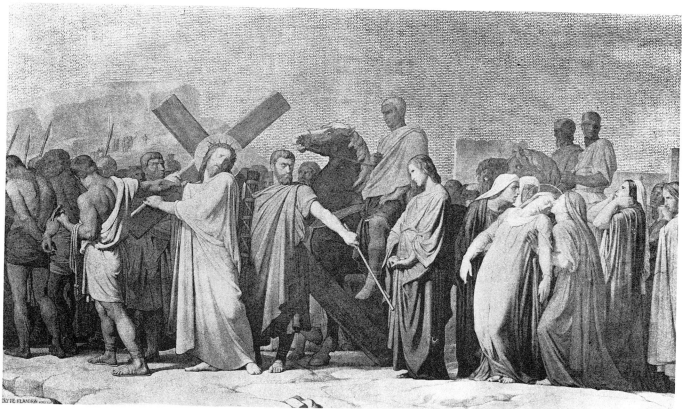

Fig. 2. Hyppolyte Flandrin. *La Montée au Calvaire*. Saint-Germain-des-Prés. 1847. From Louis Flandrin, *Hyppolyte Flandrin, Sa vie et son oeuvre* (Paris: Libraire Renouare, 1902, f.p. 133. Courtesy of the Fine Arts Library, Harvard University.

finished, Pinacoteca, Vatican, Rome).[32] According to member Frederic George Stephens, the name was chosen "more in fun than otherwise."[33] A statement by their close associate and advisor, Ford Madox Brown, concerning his own painting of a Madonna and Child called *Our Ladye of Good Children* (1847–61, Tate Gallery, London), may be extended to explain the intentions of the Pre-Raphaelite Brotherhood:

> To look at it too seriously would be a mistake. It was neither Romish nor Tractarian, nor Christian Art (a term then much in vogue) in intention: about all of these I knew and cared little. It was merely fanciful, just as a poet might write some Spenserian or Chaucerian stanzas.[34]

Given the heightened tone of religious controversy at mid-century, and the dislike of foreign influences, it seemed naive to believe that religious paintings could be judged neutrally or by artistic criteria alone.

The Pre-Raphaelites were not the first to exhibit religious paintings in England. J. M. W. Turner, John Martin, Francis Danby, and other Romantic artists,

for example, had painted memorable images of devastation and destruction based on the Old Testament. Other artists had successfully painted New Testament subjects without overtly negative comment from the press. Benjamin Robert Haydon's *Christ's Agony in the Garden* or William Dyce's paintings of the Madonna and of Christ wandering through a recognizable English landscape had attracted little negative criticism because of their subjects.[35] These paintings were judged by the critics on the basis of their artistic merit, with theology and religion playing little part in the critics' comments. There were, however, several differences between these paintings and those of the Pre-Raphaelites. First, the Old Testament paintings did not depict the Holy Family and both Old and New Testament paintings were narrative in purpose, rather than devotional. Second, they were painted in a more conventional style. And third, they were not painted at mid-century during the years of heightened religious controversy.

It was not until the reviews of the Pre-Raphaelite religious paintings in 1849—and even more so in

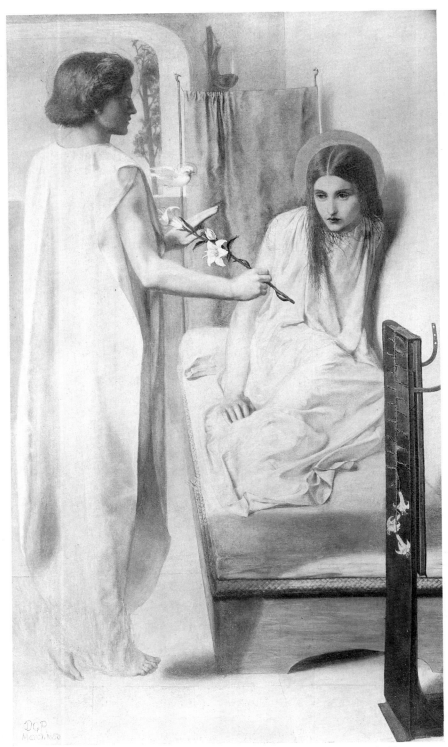

Fig. 3. Dante Gabriel Rossetti. *Ecce Ancilla Domini!*
1849–50. Oil on canvas mounted on panel. 42.6 × 41.9 cm.
Tate Gallery, London. Courtesy of Bulloz.

1850—that religious concerns began to creep into the language of art criticism. Although artistic issues were still discussed, a religious dimension had decidedly intruded into the hitherto select realm of the art reviews. In 1849, for example, a writer for the *Athenaeum* described Rossetti's *Girlhood of Mary Virgin* (1848–49, Tate Gallery, London, see Phelps Smith, fig. 1) as portraying "sacred mysticism" and having "spiritualized attributes." He compared Rossetti with "Florentine monastic painters" and endowed him with the reforming zeal of Savonarola.[36] The art critic of *Fraser's Magazine* maintained that Rossetti was a slave to the Early Christian style.[37] In the next year the religious association of Rossetti's painting was even more closely noted. A writer for *The Times* of London denounced Rossetti's *Ecce Ancilla Domini* (ca. 1850, Tate Gallery, London, fig. 3) as displaying the "most primitive style of Christian art: a hard Paganism and a flat Catholicism seem at best to meet like extremes." The critic compared the painting to "a leaf torn out of a missal," a work full of the "visible ferveur of the artist."[38]

These comments suggest that not only Rossetti but also the critics were aware of the new French Ultramontane church decorations and of the aesthetic principles upon which they were based. The reference to Florentine monastic painters and to the fervor of the artist may refer to Fra Angelico, who was one of the models of the Ultramontanists, a model not only esteemed by Rio and the Count de Montalembert but also as one of the Immortals listed by the Pre-Raphaelites. The example of Fra Angelico's piety, or fervor, was one of the most often repeated stories from Giorgio Vasari's *Lives of the Artists*. Vasari depicted the gentle and adoring Fra Angelico weeping as he paints a Crucifixion scene. Girolamo Savonarola, as well as Fra Angelico, was embraced by the Ultramontanists and admired for his condemnation and destruction of the sensuous and materialistic art of the Renaissance.[39] It is significant that both of these Ultramontanist cult figures were mentioned in the same sentence. *The Times* reviewer also evoked associations with the Ultramontanists in the description of the meeting of hard paganism and flat Catholicism, a description that fits the hieratic style of linear definition and lack of chiaroscuro favored by the French. The figure of Rossetti's Archangel Michael in *Ecce Ancilla Domini* is reminiscent of some of Flandrin's figures; however, the argument here is not the influence of the French on the Pre-Raphaelites but the similarity between the two as perceived by the critics—and therefore, the implication that in the heated atmosphere of the times the

Pre-Raphaelites were on the side of the Catholics.

The Times of London review was written before May 4, 1850, the date when the *Illustrated London News* published its scathing attack on the Brotherhood. Rossetti and Millais had signed their works with the initials P.R.B., but in accord with their spirit of secrecy and "fun," they had not revealed the meaning of the initials. Alexander Munro, however, had wormed the secret out of Rossetti and told his journalist friend Angus Reach what the initials meant. Reach then disclosed the secret in his gossip column "Town Talk and Table Talk":

> Has any casual reader of art-criticism ever been puzzled by the occurrence of three mysterious letters as denoting a new-fashioned school or style in painting lately come into vogue? The hieroglyphics in question are "P.R.B.," and are the initials of the words "Prae-Raffaelite Brotherhood." To this league belong the ingenious gentlemen who profess themselves practitioners of "Early Christian Art" and who—setting aside the Medieval Schools of Italy, the Raphaels, Guidos, and Titians, and all such small-beer daubers—devote their energies to saints, squeezed out perfectly flat—as though the poor gentlemen had been martyred by being passed under a Baker's Patent ironing machine; their appearances, being further improved by their limbs being stuck akimbo.[40]

In the remainder of the year hardly a favorable review of the Pre-Raphaelites was to be found. Identified with an unpopular style from a "superstitious priest-ridden age,"[41] the Pre-Raphaelites were seen as Roman Catholic and were burdened with all the associations of popery and foreignness that so repulsed the English. It was an identification that stayed with them. Millais complained in 1851: "My brother was with us to-day, and told me that Dr. Hesse of Leyton College understood that I was a Roman Catholic (having been told so), and that my picture of 'The Return of the Dove to the Ark' was emblematical of the return of all of us to that religion."[42] That their names were foreign—Rossetti (Italian) and Millias (French)—from countries that were Roman Catholic, did not help their cause nor did the fact that they had formed a secret society. The governing classes had an aversion to secret societies and oaths which they associated with possible revolutionary activities. For example, the memory still lingered in the public minds of the transportation of the Tolpuddle Martyrs (six agricultural laborers) to imprisonment in Australia in 1834 for their administering and taking secret oaths.[43] Initially and ironically, however, such criticism seemed to strengthen the Brotherhood's resolve. "Finding their antago-

nists—for such soon spring up, with and without reason—employed it as a term of reproach," Frederick George Stephens reported, "the members boldly adopted it as a pass-word, and resolved to make their works a protest on the conventional slipshod execution and feeling then the rule of art."[44]

In 1850 many of the journals that reviewed the annual spring exhibitions not only gave a great deal of attention to the individual Pre-Raphaelite paintings but also concentrated their introductory remarks on the Pre-Raphaelite school—and none of the comments were very complimentary. Ecclesiastical rhetoric crept into the critical discourse: a critic for *Blackwood's Edinburgh Magazine,* for example, called Rossetti "one of the high-priests of this retrograde school,"[45] while a critic for the *Athenaeum* referred to Millais's painting *Christ in the Carpenter's Ship* (ca. 1850, Tate Gallery, London, Faxon, fig. 3) as a "pictorial blasphemy."[46] A critic of *Blackwoods* saw Pre-Raphaelite work as imitating a time "when Art was employed in mortification of the flesh." As a result, there were seemingly "few ordinary observers," the critic declared, "who can look on it without a shudder."[47]

Unlike their reaction to Rossetti, what bothered the critics most about Millais's painting was that the sacred figures were all too realistic—"ugly," "graceless," and "disgusting."[48] The critics' descriptions bore little resemblance to the usual discussion found in art reviews: instead the critics fulminated about "diseased aspects," "splayed feet, puffed joints, and misshapen limbs," and "the dirty corrupted skin of an emaciated frame."[49] The descriptions of these critics seem more suited to the inmates of a poor house than to a painted depiction of the Holy Family in their workshop. Charles Dickens, in his infamous review of Millais's painting, asserted that the Virgin "would stand out from the rest of the company as a Monster, in the vilest cabaret in France, or the lowest ginshop in England."[50]

The outrage and the charge of blasphemy is understandable if one shared the Victorian belief that external appearance reflects the internal state of mind and soul. "No exalted sentiment can possibly be aided by either ugliness or disease," the critic R. N. Wornum declared in the *Art Journal;* according to Wornum, *"the most beautiful soul must have the beautiful body;* lofty sentiment and physical baseness are essentially antagonistic, even in the lowest sinks of poverty in the world, the purest mind will shine transcendent."[51] Idealization in religious painting was, moreover, a theme that also ran through Cardinal Wiseman's writing on art. "We want truth,

according to our noblest conceptions," he wrote in 1847, "the devout mind loves to contemplate the Incarnate Glory of heaven as the type of dignified and hallowed beauty." The figure of Christ, Wiseman argued, should be "all that humanity could ever contain of outward comeliness as expressive of inward perfection." Whether Christ is an infant, a youth, or a man, according to Wiseman, Christ's "effigy must be to the eye (so far as art can portray it) what loving thought of Him is to the soul, the combination of all that is nobly beautiful."[52]

Not only religion but science also supported the view. Although Dickens displayed a measure of typical Protestant anti-Catholicism in his *Pictures from Italy,* it is difficult to imagine that religious sentiments alone explained the excesses of vituperation displayed in his *Household Words* review. He also had political reasons for his criticism because he was an opponent of the Tory Young England group with which he mistakenly associated the Pre-Raphaelites in his review. His friendship with an opposing group of artists and critics played a part, but other factors also influenced Dickens's condemnation of Millais's painting. It was widely believed in mid-Victorian England that facial configuration and expression revealed inner character. The new discipline of anthropology had embraced the older belief in physiognomy and had elevated it to a "science." Flying in the face of religious sentiment, as Millais had done, was bad enough, but ignoring the dictates of physiognomy further compounded Millais's supposed sins. In another article in *Household Words,* Dickens declared that "Nature never writes a bad hand" and that "her writing, as it may be read in the human countenance, is invariably legible, if we come at all trained in the reading of it."[53] To a Victorian adept in physiognomy, the facial and bodily configuration of Millais's Holy Family would not only indicate a lack of nobility but would indicate kinship with the working classes. Even Dickens, so compassionate to the lower classes in his novels, balked at having sacred figures pictured as coming from their ranks. Millais's picture not only outraged religious, political, and scientific beliefs, it also crossed class lines. By choosing the setting of Joseph's carpenter's shop and by giving naturalistic rather than idealized physical and physiognomic characteristics to members of the Holy Family, Millais emphasized the humble origins of Jesus, Mary, and Joseph. He, in effect, made the Holy Family look like a working-class family. To many class-conscious Victorians this would suggest an ignoble and brutish character and thus an insulting and demeaning view of the Holy Family. The

painting was therefore described as a "pictorial blasphemy."

Millais's attempt to follow the Pre-Raphaelite precept of truthfulness to nature and find religious truth in the reality of wood shavings, tired faces, and workworn bodies pleased neither Protestants nor Catholics. Although not like the styles that came to be called *Realism* and *Naturalism,* Millais's painting not only had some common ground with those styles, especially in the depiction of the "ugly" but also was subject to some of the same resistance that these styles encountered, especially in regard to religious imagery. The resistance in France to the naturalism of the religious paintings of Delacroix or Manet, or even more graphically to those of Leon Bonnat and Antoine Etex, had some parallels in England.[54] The forces of Ultramontanism in both France and England decried the lack of idealism and symbolism in naturalistic representations of holy figures and associated a realistic style with Protestantism. In the furor of English mid-century religious controversy, however, the unusual style of *Christ in the Carpenter's Shop* elicited from critics a shocked negative response to the "ugliness," and given the context of other Pre-Raphaelite paintings, the critics judged Millais's style and subject to be Early Christian or Catholic.

A painting, very similar in subject to that of Millais, John Rogers Herbert's *Youth of Our Lord* (1847, Guildhall Art Gallery, London, fig. 4) had been exhibited in 1847. A comparison to Millais's painting is instructive. Herbert, a recent Roman Catholic convert, had gained considerable praise from the critics. "One of the most poetical and imaginative in this collection," the critic for the *Athenaeum* wrote, "this is one of the very few instances in the present Exhibition where the painter may be said to have made the language of his art subserve a high object."[55] The *Rambler,* the periodical of the Old Catholics, also noted the poetic quality of Herbert's work and praised it for historical accuracy.[56] In the *Dublin Review,* Cardinal Wiseman paid a great deal of attention to Herbert's painting. He was very taken with the subject of the painting, especially with the wood falling in the shape of the cross on the ground. "This naturally lights up a train of thought in the mind of the Divine Youth, who," Wiseman observed, "stands for a moment as if fixed in a painful trance." Wiseman was delighted with the idea and claimed it as a Catholic creation. "To the mere Bible-christian, it

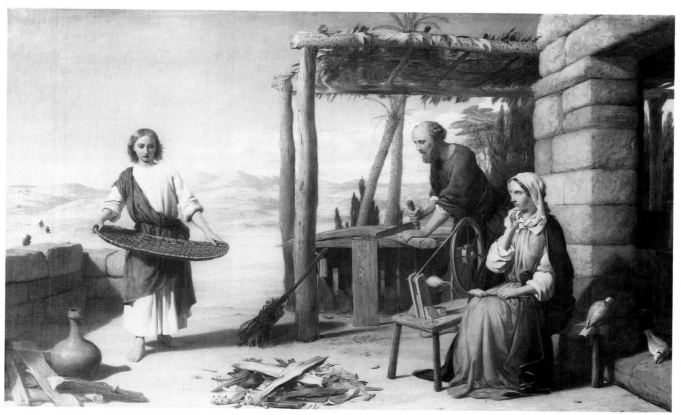

Fig. 4. John Rogers Herbert. *The Youth of Our Lord.* 1847.
Courtesy of the Guildhall Gallery, London.

may appear fanciful," he wrote, "but not so to the Catholic."[57] By "Bible-christian," he meant the Protestants, who were so ever-mindful of the exact text of the Scriptures. Although complimenting Herbert on the creativity of his typological symbolism, Wiseman, the former professor of Oriental languages, was pleased to point out that the fourth-century church father, Saint Ephrem the Syrian, had also voiced a similar idea.

As Herbert was a recent convert, his painting might be expected to gain praise from the Catholic press, but it also was viewed favorably, or it at least escaped the negative notice meted out to Millais in the Protestant press. Herbert's figure of Christ, as well as his figures of Mary and Joseph, was more idealized than Millais's. Furthermore, the outside setting of the painting avoids the immediate suggestion of laboring classes, and the mood in the painting is peaceful and serene. And, most importantly, in the year 1847, Herbert avoided the eye of the storm. Wiseman's article praising Herbert, although ostensibly a review of Lord Lindsey's *Sketches of the History of Christian Art* and of the 1847 Royal Academy exhibition, provided the means for him to explain his own ideas about a school of English Catholic art. In the article he tried to set up an aesthetic of Ultramontanism different from that of the Old English Catholics, the French Ultramontists, and the Protestants. He rejected the model of medieval art and chose the masters of the Renaissance.

One of the splits in the English Catholic Church occurred over the question of artistic style. While the Old Catholics, led by Pugin, looked to the English medieval tradition and the neo-Gothic revival, Cardinal Wiseman and many of the converts holding Ultramontane views looked to Renaissance Rome and modern Germany for their models. Newman's Brompton Oratory may serve as an example. The High Anglican Church, like the Old Catholics, embraced the medieval tradition. Wiseman, on the other hand, was almost as graphic as Dickens when he described the faults of Early Christian art:

> Feet twisted round, fingers in wrong order on the hand, heads inverted on their shoulders, distorted features, squinting eyes, grotesque postures, bodies stretched out as if taken from the rack, enormously elongated extremities, grimness of features, fierceness of expression, and an atrocious contradiction to the anatomical structure of man.[58]

Because he believed the English had few good chances to see good models of Christian art, Wiseman imported many German engravings of the Düs-

seldorf school and distributed them among the poor.

Wiseman also held up the model of nature: "Religious art does not look at time," he argued, "but at nature, which changes not, and at religion which is equally immutable."[59] Although Wiseman did not agree with the French Ultramontists' emphasis on a stiff hieratic style, preferring instead the work of the modern German Catholic painters, he did agree with their rejection of naturalistic art and their emphasis on the necessity of faith. There only could be a religious school of art, he declared, if there were religious artists "whose outward performances will be only counterparts of an inward devotion, so that what they strive to represent in form and colour shall be the visions of their own pious meditations, and the fruit of their constant conversation with things spiritual and holy."[60] It was this faith, as well as the rich tradition of religious art, he argued, that defined the difference between a Protestant and a Catholic religious art. "When England lost her faith," he wrote, "she lost her soul for art." The Protestant artist was condemned to failure. "The Protestant may aim well, and intend well, and struggle manfully, and study profoundly," he declared, "but he will only approximate to that achievement which is reserved, in all is triumphant success, for those who have the heritage of faith."[61]

In discussing *Sketches of the History of Christian Art* by the High Anglican Lord Lindsey, Wiseman criticized the use of the term "Christian mythology" by noting that Protestants lacked the necessary reverence for religious art, confusing the holy and sacred with the paganism of mythology. He approved, however, of Lindsey's contrasting of a Catholic art that did "exalt Imagination and repudiate Reason" with a Protestant art that did the reverse. According to Wiseman, Lindsey tried to place the Anglican Church in the "via media," harmoniously balanced between "Superstition" and "Scepticism."[62]

A writer for the *Rambler,* the periodical of the Old Catholics, may not have agreed entirely with Wiseman's Ultramontane ideas on art, but the Old Catholics agreed with his assessment of Protestant English art as soulless. In reviewing the work of William Mulready, "a painter after an Englishman's own heart," the *Rambler* reviewer described this soulless English art:

> An Englishman . . . forms all his theories, and fashions the whole code of his thoughts and feelings, upon the practical observation of positive reality, as he sees it in daily operation about him. He is a *Baconian* in every thing. He must have his *inductive* mode of getting at

things. . . . This is being what is generally called practical and sensible; but what in truth, is too often dry, superficial, unideal, unreal, and, in the end, absurd and mischievous to the last degree. . . . It becomes the parent of a mere soulless materialism when it intrudes beyond its province, and would fair bring down all things in heaven and earth to the rules of its cold and calculating philosophy.[63]

Could English artists devise a style that could incorporate spirituality with their Baconian passion for empirical fact? That sharply detailed representations of nature were required can be deduced from the severe criticisms of Turner's glorious, but impressionistic, later landscapes. Hunt and Millais, if not Rossetti, certainly could not be faulted for providing depictions of closely observed nature. But more was needed in religious painting than minute representations of natural details. The harsh critical response to the early paintings of the Brotherhood indicated that painters, while avoiding associations that evoked thoughts of popery, idolatry, Mariolatry, and Catholicism, still had to retain an idealism commensurate with their holy subjects. Responses to early Pre-Raphaelite attempts at harmonizing idealism and realism were confused, though generally negative.

These controversies, however, forced the Pre-Raphaelites to rethink their original concepts about religious painting. Rossetti, while retaining his interest in the medieval period, turned from biblical subjects to literary ones, gradually evolving his own vision of secular Mariolatry. Later, when his two early paintings were returned to him, he changed their appearance in order to make them look less medieval and less Catholic, replacing the medieval arched frame around the *Girlhood of Mary Virgin* with a more modern rectangular one. In a further effort to disassociate himself from any possible Catholic influence, Rossetti changed the Latin name of his painting *Ecce Ancilla Domini* to the *Annunciation* and altered the frame that had contained Latin mottoes too "Popish" in sentiment.[64] Millais exhibited one more religious painting, *The Return of the Dove to the Ark* (1851, Ashmolean Museum, Oxford) in 1851, but it was a sentimental treatment of a safe Old Testament subject. Henceforth Millais avoided biblical subjects, although he did paint several subjects of Huguenot religious persecution in a genre style.

Only Hunt picked up the gauntlet, sticking to religious paintings, and he eventually evolved a truly Protestant art that combined a Protestant iconography and realistic presentation. Following David Wilkie's suggestion, Hunt sought historical accuracy for his biblical painting in the modern Near East. As Marcia Pointon observed, "Archaeology could break with the corrupt conventions of a Roman Catholic Renaissance tradition of religious art."[65] Hunt not only used archaeological backgrounds to lend historical authenticity to his subject, but in *The Light of the World* (1851, Keble College, Oxford), he conceived of Jesus as making a direct appeal to the sinner, thus eliminating the Catholic mediation of priests, saints, and the Madonna. The painting was an appeal for introspection and for moral reformation of the sinner and was not a worship of Divine mysteries. The painting showed Christ as willing to help the sinner grow morally strong and redeem himself, rather than, as in most Catholic depictions, as a Christ crucified and sacrificed for the salvation of humankind. For the Catholic crucified Savior, Hunt had substituted the Protestant moral instructor and forgiving friend.

If most of the members of the Pre-Raphaelite Brotherhood responded to the Catholic presence in England at mid-century by backing away from their original religious paintings toward the safer ground of secular subjects, or pursued a more evolved Protestant program of iconography, one member, James Collinson, moved in the opposite direction. If Collinson is little remembered now, he was a promising young genre painter in 1848, having exhibited his *Charity Boy's Debut* (1847, sold at Christie's, October 26, 1979) at the Royal Academy in 1847, earning the praise of the critics for his attention to detail. The Rossetti family knew him because he attended Christ Church, Albany Street, a High Anglican church presided over by the Reverend William Dodsworth.[66] William Michael Rossetti reported that about the time of the formation of the Brotherhood, Collinson had come "under the influence of Cardinal Wiseman, and joined the Roman communion."[67] Hunt borrowed the copy of Ruskin's *Modern Painters* that belonged to Cardinal Wiseman "from a fellow student" at the Royal Academy.[68] Could it have been Collinson? Soon after, Collinson fell in love with Christina Rossetti and proposed to her. She accepted but only on condition that he return to the Anglican Church, which he did. By May 1850, Collinson had again changed his mind; the engagement was broken, and he returned to the Roman Catholic Church only months before the Rev. William Dodsworth's conversion.

In the same month Collinson wrote a formal letter to Dante Gabriel Rossetti declaring his intentions:

Dear Gabriel, I feel that, as a sincere Catholic, I can no longer allow myself to be called a P.R.B. in the brotherhood sense of the term, or to be connected in

any way with the magazine [the *Germ*]. Perhaps this determination to withdraw myself from the Brotherhood is altogether a matter of feeling. I am uneasy about it. I love and reverence God's faith, and I love His Holy Saints, and I cannot bear any longer the self-accusation that, to gratify a little vanity, I am helping to dishonor them and lower their merits, if not absolutely to bring their sanctity into ridicule.—I cannot blame anyone but myself. Whatever may be my thoughts with regard to their works, I am sure that all the P.R.B.'s have both written and printed conscientiously—it was for me to have judged beforehand whether I could conscientiously as a Catholic, assist in spreading the artistic opinions of those who are not. . . . I have been influenced by no one in this matter; and indeed it is not from any angry or jealous feeling that I wish to be no longer a P.R.B. . . . believe me, affectionately your's, James Collinson.—P.S. Please do not attempt to change my mind.[69]

Although he wrote this a month before Charles Dickens's review of Millais's *Christ in the Carpenter's Shop* and before the publication of the other negative responses to Millais's painting, Collinson may have guessed what the reception would be. To

"bring their sanctity into ridicule" would seem to refer to the nearly universal response to the depiction of the Virgin and Christ in Millais's painting.

Less than a year after his resignation from the Pre-Raphaelite Brotherhood, Collinson exhibited his painting *The Renunciation of Queen Elizabeth of Hungary* (1850–51, Johannesburg Art Gallery, fig. 5). Although this painting has frequently been called Collinson's one Pre-Raphaelite painting, it is really his one Roman Catholic painting, seemingly painted in protest against the Brotherhood version of religious painting. In contrast to his other paintings of contemporary genre scenes, Collinson used a historical religious subject from the thirteenth century in his *Renunciation*. For this work he not only changed his personal style of painting, but he chose a very Roman Catholic scene from a saint's life. Furthermore this *Renunciation* was a hagiographic painting, honoring the story of Queen Elizabeth of Hungary, a saint who gave up her worldly crown to worship at the feet of an image of the crucified Christ.

Many have mistakenly identified the scene of *Renunciation* as being based on Charles Kingsley's *The*

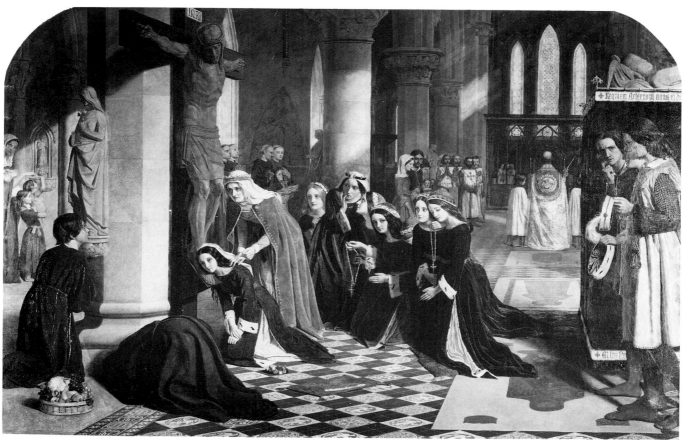

Fig. 5. James Collinson, *The Renunciation of Queen Elizabeth of Hungary.* 1851. Oil on canvas. 121.7 × 184 cm. Courtesy of the Johannesburg Art Gallery.

Saint's Tragedy, a verse drama about the life of Saint Elizabeth. But the scene that Collinson painted is described only in the version of Saint Elizabeth's life by the French Ultramontanist, Count de Montalembert, the first part of whose version was translated by Ambrose Phillips de Lisle, one of the leading members of the Old English Catholics and the translator of François Rio's *Poetry of Christian Art.* The difference is paramount in revealing Collinson's loyalties. Montalembert's version of Elizabeth's story is hagiographic and most respectful of her saintliness. In contrast, Kingsley's Protestant version contained a Catholic villain, Conrad, a priest who perverted Elizabeth's innate goodness and charity to the poor. In Kingsley's version, Conrad promoted a campaign of self-destruction and mortification of Elizabeth's flesh merely to ensure Elizabeth's canonization and satisfy his own ambition.

Collinson painted a scene that was described in great detail by Montalembert but was omitted from Kingsley's version. In this scene Elizabeth lays her crown on the floor at the feet of the image of the crucified Christ while she lays her cheek on his feet. Her husband's relatives try to restrain her and show some dismay at her action, as indeed, an English Protestant would. Running through anti-Catholic writing in nineteenth-century England was the threat of the Roman Catholic Church subverting the state. Saint Elizabeth's gesture of laying her crown at the feet of Christ firmly supports the superior place of religion over the secular state. A sketch for the painting highlights this important gesture by showing the crown placed on a fringed cushion as if offered in sacrifice. Collinson's illustration is similar in composition to the illustration by Édouard Hauser in Montalembert's version of the story (fig. 6). Hauser, a Roman convert and follower of the German Catholic painter Friedrich Overbeck, had been patronized by the Earl of Shewsbury, a supporter of Pugin. Collinson declared his Roman Catholic sympathies by using these sources and by changing his style. In the same year he joined the Jesuit College at

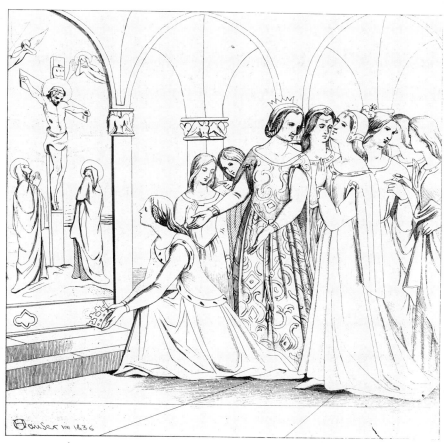

Fig. 6. Édouard Hauser, "A la vie de cette image du Sauveur moutant elle ora sa couronne," from Count Charles Forbes Rene de Montalembert, *The Chronicle of the Life of St. Elizabeth of Hungary* (London, 1839), f.p. 17. Courtesy of the Library of Congress.

Stonyhurst in Lancashire, but his religious indecision continued to plague him, for he left Stonyhurst several years later, eventually marrying John Rogers Herbert's sister-in-law and returning to genre painting.[70]

The Pre-Raphaelite Brotherhood might have taken a different course had the Vatican not sent Nicholas Wiseman to England. Certainly, without the controversies that Wiseman aroused, the early religious paintings of the Brotherhood artists might have received a more positive reception. The members of the Brotherhood might have been encouraged to continue in their early style and choice of subjects. Without the charismatic influence of Wiseman, Collinson might have continued his membership in the Brotherhood and his sleepy career of genre painting. Although the religious life of the nation was the primary change resulting from Cardinal Wiseman's activities, artistic life as well was affected by this engaging man whose interests and influence reached beyond the doors of the church into studios, academies, and the critical writings of the press.

NOTES

1. S. N. Ghose, *Dante Gabriel Rossetti and Contemporary Criticism* (Dijon, Impr. Darantiere, originally presented as the author's thesis, University of Strasbourg, 1929), 32.

2. Ronald Parkinson, "James Collinson," in *Pre-Raphaelite Papers*, ed. Leslie Parris (London: Tate Gallery, 1984), 61–63.

3. John Guille Millais, *Life and Letters of Sir John Everett Millais* 2 vols. (New York: Frederick A. Stokes Co., 1899), 1:92–93.

4. *Memoirs and Correspondence of Coventry Patmore*, ed. Basil Champneys (London: George Bell & Sons, 1900), 1: 90–91.

5. For a fuller description of early iconoclastic activities, see John Phillips, *The Reformation of Images: Destruction of Art in England, 1535–1660* (Berkeley: University of California Press, 1973).

6. S. W. Jackman, *Nicholas Cardinal Wiseman: A Victorian Prelate and His Writing* (Charlottesville: University Press of Virginia, 1977), 11.

7. Ronald Chapman, *Father Faber* (London: Burnes & Oates, 1961), 249. Quoted in Jackman, *Wiseman*, 20.

8. Bernard and Margaret Pawley, *Rome and Canterbury through Four Centuries: A Study of the Relations between the Church of Rome and the Anglican Churches, 1530–1981* (London: A. R. Mowbray & Co., 1981), 148.

9. For a fuller account of the life of Cardinal Wiseman, see Wilfred Ward, *Life and Times of Cardinal Wiseman* 3d ed., 2 vols. (London: Longmans, Green, & Co., 1898); Denis Gwynn, *Cardinal Wiseman* (Dublin: Browne & Nolan, Ltd., 1950); Brian Fothergill, *Nicholas Wiseman* (London: Faber & Faber, 1963); Richard J. Schiefen, *Nicholas Wiseman and the Transformation of English Catholicism* (Shepherdstown: The Patmos Press, 1984); and Jackman, *Wiseman*.

10. Edward Norman, *English Catholic Church in the Nineteenth Century* (Oxford: Clarendon Press, 1984), 18, 24.

11. William Cobbett, *History of the Protestant "Reformation" in England and Ireland* (Dublin, 1826), 2. Quoted by Norman, *English Catholic Church*, 15.

12. Norman, *English Catholic Church*, 34.

13. John Henry Newman, *Sermons Preached on Various Occasions* (London: Burns, Oates & Co., 1874), 172.

14. Norman, *English Catholic Church*, 124.

15. Robert J. Klaus, *Pope, the Protestants, and the Irish: Papal Aggression and Anti-Catholicism in Mid-Nineteenth Century England* (New York: Garland Publishing, Inc., 1987), 17–18.

16. Norman, *English Catholic Church*, 124.

17. Walter L. Arnstein, *Protestant versus Catholic in Mid-Victorian England: Mr. Newdegate and the Nuns* (Columbia: University of Missouri Press, 1982), 44.

18. John Everett Millais to Thomas Combe, December 16, 1850, Millais, *Life and Letters*, 1: 93.

19. Edward Norman, *Anti-Catholicism in Victorian England* (London: George Allen & Unwin, Ltd., 1968), 54.

20. Ibid.

21. For a fuller description of papal aggression, see Norman, *English Catholic Church*; Norman, *Anti-Catholicism*; and Derek Holmes, *More Roman than Rome: English Catholicism in the Nineteenth Century* (London: Burne & Oates, 1978).

22. Margaret M. Maison, *Search Your Soul, Eustace: Victorian Religious Novels* (London: Sheed & Ward, 1961), 169.

23. See Susan Casteras, "Virgin Vows: The Early Victorian Artists' Portrayal of Nuns and Novices," *Victorian Studies* 24 (Winter 1981): 157–84; Elaine Shefer, "The Nun and the Convent in Pre-Raphaelite Art," *Journal of Pre-Raphaelite and Aesthetic Studies* 6 (May 1986), 70–82.

24. *Christian Reformer*, 5, n.s. (1849): 594.

25. *Church of England Quarterly Review* 27 (1850): 181.

26. *Christian Reformer*, 4, n.s. (1849): 52.

27. Charles Comberbach and John Missing, *Idolatry of the Church of Rome discussed by the Rev. Charles Comberbach, Roman Catholic Missionary and Chaplain to Thomas Stonor, Esq. Stonor Park, Oxon., and the Rev. John Missing, M. A. Magdalene Hall, Oxford, Late Curate of Fasley, Bucks* (London: James Nisbet & Co., 1838), 43.

28. Quoted in *Eclectic Review*, 22, n.s. (1847): 728.

29. Ibid., 720.

30. See Michael Paul Driskel, *Representing Belief: Religion, Art and Society in Nineteenth-Century France* (University Park: Pennsylvania State University Press, 1992), especially 59–98.

31. *Letters of Dante Gabriel Rossetti*, ed. Oswald Doughty and John Robert Wahl, 4 vols. (Oxford: Clarendon Press, 1965), 1: 66.

32. William Holman Hunt, *Pre-Raphaelitism and the Pre-Raphaelite Brotherhood* 2d ed., 2 vols. (New York: E. P. Dutton, 1914), 1: 68.

33. Frederick George Stephens, *William Holman Hunt and His Works, A Memoir of the Artist's Life and a Description of His Pictures* (London: John Nisbet & Co., 1860), 12.

34. See *The Exhibition of Work, and Other Paintings by Ford Madox Brown, at the Gallery, 191 Piccadilly* (London, 1865), 4. Quoted in Wolfgang Lottes, "The Lure of Romish Art: Reflections of Religious Controversy in Nineteenth-Century English Art Criticism," *Journal of Pre-Raphaelite and Aesthetic Studies*, 1, pt. 2 (Spring 1988): 50.

35. C. M. Kauffmann, *Bible in British Art: 10th to 20th Centuries* London: Victoria and Albert Museum, 1977), 21–24.

36. *Athenaeum* (7 April 1849): 362.

37. *Fraser's Magazine* 11 (July 1849): 78.

38. *The Times* (15 April 1850): 5. Quoted in S. N. Ghose, *Rossetti and Contemporary Criticism*, 23.

39. Driskel, *Representing Belief*, 65–74.

40. *Illustrated London News* (4 May 1850), quoted by Ghose, 33–34.

41. *Art Journal* 12 (1 September 1850): 270.

42. Millais, *Life and Letters*, 1: 135.

43. See Joyce Marlow, *Tolpuddle Martyrs* (Frogmore, St. Albans: Panther Books Ltd., 1974).

44. Stephens, *Hunt and His Works*, 12.

45. *Blackwood's Edinburgh Magazine* 48 (1850): 82.

46. *Athenaeum* 1179 (1 June 1850): 590.

47. *Blackwood's Edinburgh Magazine* 48 (1850): 82.

48. *Athenaeum* 1179 (1 June 1850): 590.

49. *Blackwood's Edinburgh Magazine* 48 (1850): 82 and R. N. Wornum, "Modern Moves in Art," *Art Journal* 12 (1850): 271.

50. *Household Words* 1 (15 June 1850): 265–66.

51. R. N. Wornum, "Modern Moves in Art," 271.

52. *Dublin Review* 22 (June 1747): 492.

53. *Household Words* 5 (September 1854): 97, quoted in Mary Cowling, *Artist as Anthropologist: The Representation of Type and Character in Victorian Art* (Cambridge: Cambridge University Press, 1989) 287. See also Lindsey Errington, *Social and Religious Themes in English Art, 1840–1860* (New York: Garland, 1984).

54. Driskel, *Representing Belief,* 166–216.

55. *Athenaeum* 1020 (15 May 1847): 526–27.

56. *Rambler* 4 (January 1849): 94–95.

57. *Dublin Review* 22 (June 1847): 501–2.

58. Ibid.

59. *Dublin Review* 22 (June 1847): 491.

60. Ibid., 498.

61. Ibid.

62. *Dublin Review* 25 (1848): 388.

63. *Rambler* 2 (1848): 133.

64. Tate Gallery, *Pre-Raphaelites* (London: Tate Gallery Publications Department, 1984), 64–65, 73.

65. See Marcia Pointon, "Artist as Ethnographer: Holman Hunt and the Holy Land," ed. Marcia Pointon, *Pre-Raphaelite Review* (Manchester, Manchester University Press, 1989).

66. Parkinson, *Pre-Raphaelite Papers,* 62.

67. William Michael Rossetti, *Some Reminiscences* (New York: Charles Scribners & Sons, 1906), 1: 65, with thanks to Alicia Faxon for this exact citation.

68. Hunt, *Pre-Raphaelitism,* 1: 52.

69. Parkinson, *Pre-Raphaelite Papers,* 241–42.

70. Ibid., 73.

The Greek Connection—The Ionides Family and Their Connections With Pre-Raphaelite and Victorian Art Circles

JULIA IONIDES

MEMBERS OF THE IONIDES FAMILY WERE AMONG the principal art patrons and collectors in England in the second half of the nineteenth century. Although they became British citizens, they definitely remained part of the Greek community in London. Their different national characteristics were recognized by Dante Gabriel Rossetti when he sold a Botticelli painting, *Portrait of Smerelda Bandinelli* (ca. 1471, Victoria and Albert Museum), to Constantine Ionides. Rossetti wrote to his friend Jane Morris in 1880: "He [Constantine] is a Briton and no mistake—his being a Greek must be a matter of business."[1]

Constantine Alexander Ionides (1833–1900) was very much a Greek. He was closely involved with the Greek community and its church, and he may have shared fellow feelings with Rossetti about their foreign origins. Both the Rossetti and Ionides families had come to England to escape the problems in their home countries. Elizabeth Robins Pennell described such transplanted families as

> . . .those wonderful Greeks the story of whose conquest of London should one day be told. Ionides, Coronio, Spartali, Manuel were for long familiar names to artists whom they patronized with lavishness and intelligence. . . . They bought Whistler, they bought Fantin [Latour] . . . they bought Legros. In their generosity they would take their pictures down from their walls to send them for exhibition in the year's Academy. Here indeed were art patrons of the right sort, art patrons who used their own judgment and bought pictures, not for investment, but for their pleasure, and they showed a true critical appreciation as can be seen in the Ionides Collection in the Victoria and Albert Museum. Probably all these families are fast becoming too English to remember their Greek origin—another reason why their history as a little colony of art-loving foreigners in the midst of British Philistines should be written before it is too late.[2]

The main Greek colony in London dates back to the early nineteenth century. The branch of the Ionides family involved with Victorian art circles came from Constantinople, which was then under the rule of the Ottoman Empire. The family members managed to prosper; through their trade in cotton and yarns, they had contacts with Manchester and London. The wealthy Greeks from Constantinople were known as Phanaroites—the name comes from the Phanar district of the city in which they lived, near to the Patriarch's quarters. It was these Greeks who provided the administration for both the Patriarch and the Ottoman Empire.

In 1821 the Greeks launched their independence movement to free themselves from Turkish rule; this goal was not finally achieved until seven years later. The Ionides, wanting to protect their business interests as well as their families, came to London around 1815. They settled in the City of London, mainly in Finsbury Circus, alongside many of their compatriots. Neighbors in Finsbury Circus included the Spartali, Cassavetti, Manuel, and Coronio families.

On their arrival in England the Ionides family members were not known by that surname; following Greek tradition they were called only by their first or Christian names. The initial immigrant to England was Constantine John, who was named after his grandfather and father. The Turks had nicknamed him Ipliktsis, a trader in cotton and yarns. However, he discovered this nickname was "too much of a jaw-breaker for the Anglo-Saxon"[3]—and so he called the firm he established in London Tomas Argenti, after a friend and a colleague. Alexander C. Ionides wrote in 1927 that "Ionides merely means the Greek—with more emphasis on 'the'; Ion was the father of Hellen and after him the Greeks were called Hellenes."[4]

Constantine John Ipliktsis, later Ionides, and his

wife Mariora, had eleven children, most of whom came to England and then married other Greeks from among the Anglo-Greek community. The eldest surviving son, Alexander Constantine (1810–90), was an active force in the firm, and it was he who decided on the name Ionides. Alexander Constantine subsequently became a naturalized British citizen in December 1837.

The Ionides family maintained close links with their newly independent homeland. The motto of Ipliktsis's father regarding his income was "Spend a third, save a third, and give away a third—then give away the saved third." His son followed his example, giving generous donations to Greece for libraries, universities, and schools; today there is still the Ionides School at Pireaus in Athens.[5] These institutions requested portraits of their benefactor and from these requests came an important artistic connection. A portrait of Ipliktsis had been painted by a nineteenth-century artist named Samuel Lane. As it was considered satisfactory, it was decided that a copy should be made to send to Athens. Ipliktsis's son, Alexander Constantine, commissioned a young student named George Frederick Watts to make this copy for £10. The completed painting was so admired that the original was sent to Athens, and the copy stayed in England. This was the beginning of a long association between Watts and the Ionides. More than fifty portraits of the Ionides family were painted over five generations. As Wilfred Blunt wrote in his biography of Watts, "There was always another Ionides waiting in the queue to be painted as soon as a financial crisis obliged him to take time off from unprofitable 'High Art' and stoop to vulgar but lucrative portraits."[6] Often the family were shown in the dress of the homeland, as in the 1848 portrait of the young Maria Cassavetti (fig. 1); such pictures emphasized the Greek origins. Watts, as well as being a beneficiary of Ionides generosity, became a family friend and a frequent visitor to the splendid Ionides house at Tulse Hill.

The Ionides family had moved to Tulse Hill from Finsbury Circus around 1839 when more room was needed for the growing family. Today all traces of the house, which by all accounts was large and very splendid, are gone. Emma Niendorf, a young German girl, visited the Ionides home in 1855 when Alexander Constantine was Greek Consul. She wrote a description of her visit in "Aus London."

I am brought to a lovely drawing room, . . . full of paintings, marbles, bas-reliefs, medallions everywhere. . . . The Consul is a passionate art-lover, and one is especially enchanted to say this about a Greek.[7]

There is so little information about Tulse Hill that this eyewitness account is particularly valuable. By 1855 Alexander Constantine was well established as a collector, especially in the field of antiquities, when excavations in Greece were revealing more buried treasures. Among these finds were pottery grave figures from Boetia. Alexander Constantine owned a fine collection of these attractive small Tanagra statuettes. "Mr. Ionides being on the spot at the time was fortunate in securing the collection almost at first hand." Marcus Huish wrote in an article for *The Studio* in 1898.[8] When Alexander Constantine's son Alecco visited the Tanagra collection in the Louvre in Paris, he considered the Ionides Tanagras to be of superior quality.

Fig. 1. G. F. Watts. *Maria Cassavetti in Turkish Dress.* 1848. Oil on canvas. 49″ × 39″. Location unknown. Courtesy of Christie's, London.

When James McNeill Whistler saw these little figures with their detailed drapery and poses, he was so impressed that he made drawings of them. Marcus Huish, also a collector of the terracottas as well as Japanese prints, considered that the "sudden reappearance of these sculptures was for artists 'as startling an irruption [sic] as that of Japanese art.'"[9]

Alexander Constantine bought several paintings by Whistler. The contact with him began when Alecco (Alexander Alexander, 1840–98) and his brother Luke (Luke Alexander, 1837–1924) were in Paris in 1855. They had been sent there to learn French, an asset for all three Ionides sons in the international commercial world. In Paris, Alecco met the group of young English art students who attended Gleyre's *atelier* and lived in a studio on the rue Notre Dame des Champs. At that time the "Paris Gang," consisted of George du Maurier, Thomas Armstrong, Edward Poynter, and the Scottish artist, Thomas Lamont. Whistler did not live at the studio, but along with Alecco and Luke Ionides, he was a frequent visitor. From the letters of George du Maurier and his novel *Trilby* there is a great deal of information and insight given about the group, both in Paris and London.

When the Ionides brothers returned to England, they held open house at Tulse Hill for their Paris friends. Since the young artists who visited were usually short of money, the generous hospitality of the Ionides was greatly welcomed. Du Maurier alluded to the fact that the family behaved in a much more relaxed manner than their English counterparts would have done, yet they still retained their good "breeding." Their foreign origins, like du Maurier's and Whistler's in this respect, gave them more license than would otherwise have been permitted. However, even with this kind of freedom, the young girls of the family were expected to marry appropriately and according to family expectations, as shall be shown. More importantly, on these visits to Tulse Hill the artists had the opportunity to make contact with prospective patrons. The Ionides and their circle were becoming significant purchasers at this time. Alexander Constantine owned an early painting by Poynter, *Bunch of Blue Ribbons* (undated, location unknown), which was later joined by Rossetti's *Monna Pomona* (1864, location unknown). Du Maurier wrote to Tom Armstrong in February 1864 that "The Greeks are a providence to Jimmy (Whistler) and (Alphonse) Legros in buying their pictures."[10]

In 1848, the year of revolution in Europe, many artists took refuge in England; among them was Alphonse Legros. Whistler and Legros were close friends, and together with Henri de Fantin-Latour they all formed the "Society of Three". Whistler pressed for the advancement of the two Frenchmen, and when Fantin returned to France, he wrote urging him to do

> more floral arrangements of the *same size* for Ionides— he will pay you 150 francs a piece. Do them right away and you will have the money immediately. Now let me tell you—don't go spoiling your business which is growing by placing a small price on a big bouquet.[11]

Whistler was a thread linking the various elements and individuals. His artistic genius, generous nature, belligerent temperament, and sharp wit made him fall in and out of the groups continually; yet he was also supportive at various times. His close friendship with Legros, however, ultimately ended in a violent quarrel in Luke Ionides's office and the two artists never spoke again.[12]

A mutual love of blue and white china and oriental prints brought Whistler and Rossetti together. According to one contemporary account, "Mr. Murray Marks proposed to start a Fine Art Company with Alexander Constantine Ionides, Rossetti, Burne-Jones and Morris. Their object was to deal in pictures, prints and blue and white and decorating work. A secretary was engaged . . . but somehow that was the end of it."[13] Du Maurier reported to Tom Armstrong in October 1863 that:

> Jimmy and the Rossetti lot i.e. Swinburne, George Meredith & Sandys are thick as thieves . . . their noble contempt for everybody but themselves envelops me I know. . . . I think they are best left to themselves like all societies for mutual admiration of which one is not a member.[14]

"Mutual admiration" could not last at this pitch when two such strong egos were involved. When Whistler and Legros fell out, Rossetti supported the Frenchman since Du Maurier told Tom Armstrong that Legros spoke "of Rossetti as his best and most useful friend."[15]

Rossetti's first appearance at Tulse Hill was in 1863. This visit was colorfully described in the often quoted description by Tom Armstrong, who made the journey in an overloaded cab with Whistler, Rossetti, du Maurier, Legros, and others. On this "memorable" occasion, they met the beautiful Spartali sisters, Marie and Christine. Whistler persuaded Christine to sit for his large painting, *Princesse du Pays de la Porcelaine* (1865, Freer Gallery of Art, Washington, D.C.), and this photograph shows her beauty (fig. 2). Regarding Christine's sister, Marie, Tom Armstrong commented that:

Fig. 2. Photograph of Christine Spartali. Date and Photographer unknown. Photograph courtesy of Julia Ionides.

The elder sister, (Marie) well known afterwards as an artist, must have sat to several of these friends, but I never saw any representation of her in painting which gave any idea of her sweetness and stateliness.[16]

Marie Spartali was the model for a long list of paintings by Rossetti and Burne-Jones (fig. 3) as well as other artists, and she was photographed many times by Julia Margaret Cameron. Tom Armstrong was right, perhaps, when he said that no one could capture her character or dignity. Rossetti confessed to Jane Morris that Marie "is very difficult" to draw satisfactorily.[17] Marie Spartali's beauty remained compelling into old age. Her great niece remembered going to the theater with her when her aunt was about seventy years old. "As we entered the auditorium there was a breathless hush in everybody's con-

versation as they all turned to see her—she was very beautiful and dressed in the old style."[18] Marie Spartali's own paintings show the influence of Rossetti, but they also have a charm and character of their own and a great attention to detail. Although unusual for a woman of that time, Marie Spartali continued to paint and exhibit even after her marriage to the American writer and publisher, William James Stillman.

Marie Spartali's husband, William Stillman, though he gave up painting himself, did sit for Merlin in the Burne-Jones painting *The Beguiling of Merlin* (1873, Lady Lever Art Gallery, Port Sunlight, Liverpool), while Maria Cassavetti Zambaco, at that time Burne-Jones's mistress, modeled for Vivien, the enchantress.

Fig. 3. Edward Burne-Jones. *Marie Spartali*. Date unknown. Oil on canvas. 27″ × 19″. Location unknown. Courtesy of Sotheby's, London.

Maria Cassavetti, a granddaughter of Ipliktsis, added another dimension to the relationship between the Greek circle and the Pre-Raphaelites. Her father had died when she was young and left her an independent fortune (said to be £80,000—a genuine fortune in 1860). Du Maurier described the heiress as "of that rudeness and indifference that she will not even answer those who speak to her."[19] Constantine Alexander was Maria's cousin and guardian, but he did not seem to have had much influence over her. In 1861, she married Demetrius Zambaco, against everyone's advice, "a Greek of low birth in Paris."[20] After the birth of her two children, Maria returned to her mother in London and never again lived with her husband, though years later she did return to Paris to further her artistic career. She became a competent sculptor of medals, at one time was a pupil of Rodin, and produced an attractive portrait medal of her friend Marie Stillman.[21] The reverse of this medal shows a lily with the inscription "Sine Macula"—without blemish—a testimony to Marie's kind nature and to her cousin's high esteem for her.

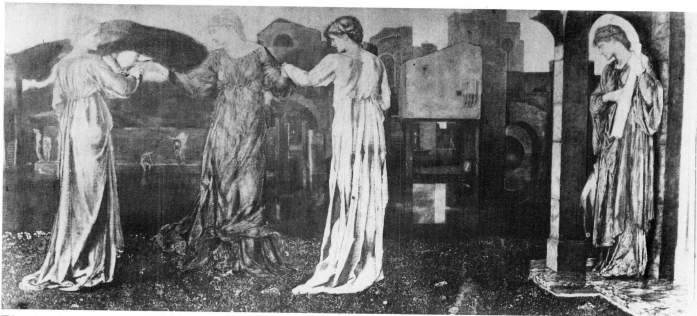

Fig. 4. *The Mill* by Edward Burne-Jones. Photograph of an early stage of the painting. Private collection.

In *The Mill* by Sir Edward Burne-Jones (fig. 4), Maria Zambaco is shown with her cousin Aglaia Coronio (née Ionides) and their close friend Marie Spartali Stillman. Here the three women, known as the "Three Graces" for their beauty, charm, and intelligence, dance in a friezelike line in front of a mill, and bathers are in the background. The painting is actually subtitled *Girls Dancing to Music by a River.* Maria Zambaco is in the center and Marie Stillman to the right. Constantine Alexander Ionides bought this painting directly from Burne-Jones for £905. At the same time Constantine Alexander also bought the monochrome *Cupid's Hunting Field* (ca. 1882, Victoria and Albert Museum) for £250. Behind the serenity of images like *The Mill,* however, were the real-life stories and events of the models. For example, Burne-Jones's friendship with Constantine Alexander only just managed to survive Maria Zambaco's affair with the artist.

During his affair with Maria Zambaco, Burne-Jones probably achieved a peak in his work which he never reached again. His drawings of her convey both the intensity of love for the sitter as well as an anguish for their doomed relationship. One painting in which Maria appears, *Phyllis and Demophöon* (1870, Birmingham Museum and Art Gallery) caused such a scandal when it was exhibited at the Royal Water-Colour Society that Burne-Jones resigned from the group. A large gouache, entitled *An Allegorical Portrait* (1870, Clemens-Sels-Museum,

Neuss, Germany), painted for Maria's mother, is so full of sadness that one owner could not live with it and turned it to face the wall.[22] The painting contains many of the symbols of love, but Maria's eyes belong to someone who seems to know that, for her, fulfillment will never come. Rossetti found Maria "extremely beautiful . . . when one gets to study her face. I think she has got much more so within the last year with all her love and trouble," as he told Jane Morris. Rossetti was satisfied with the portrait he did of Maria for a "delighted Burne-Jones."[23] However, the four known drawings of Maria by Rossetti do her no justice and make her appear too demure, with no hint of her impulsive nature.[24] In a family-owned photograph, with her mass of dark hair, she looks very much like Burne-Jones's drawings, and it is not difficult to understand why Burne-Jones was so bewitched by her. For him, Maria became the ideal figure, just as Jane Morris became the persona of Rossetti's pictures. In much of his work Burne-Jones incorporated his beloved Maria's large eyes, abundant hair, and lithe figure, even long after their affair had ended. It is not known for certain when the affair finished. Jeannette Marshall, daughter of the eminent anatomist, John Marshall, knew many members of the artistic circle and kept a diary for twenty-three years. In an 1888 entry she wrote that she was "rather exercised about Mme. Zambaco," on the discovery that Maria had a studio next to Burne-Jones. "I feel quite disgusted to think

that she is going on agn. [*sic*] in the old style."[25]

The third of the "Three Graces," Aglaia Ionides (later Coronio), was not an artist, but she played her part in encouraging her brothers to buy paintings. She had little money of her own compared to the wealth of her brothers, and her husband, Theodore Coronio, does not seem to have been wealthy. "Mrs. Coronio can at least plead poverty," Whistler wrote.[26] At that time Whistler was venting his fury on the rest of the Greek community, since he believed that they had profited from the purchases they had made from him when his prices were low. Some of the Greeks had sold their pictures after the successful retrospective exhibition at the Goupil Galleries in 1892, and Whistler wrote about "the disgusting way Cavafy and Alecco had behaved,"[27] conveniently forgetting the many times that Greek patrons had lent pictures to exhibitions and that the pictures had often been on loan for much longer than originally indicated.

Aglaia Coronio was usually described by contemporaries as beautiful and intelligent with a sympathetic manner; William Morris certainly appreciated her sympathy during the years when his marriage was in jeopardy due to his wife Jane's friendship with Rossetti. Despite Morris's letters and visits to Aglaia, often discussing his marital problems, the friendship between Aglaia and Jane does not seem to have been affected. For example, in 1878 William Morris wrote to Georgiana Burne-Jones about a boating party on the Thames with Aglaia and his family in which they all had to row home in the dark.[28] Many years later, in 1905, Georgie Burne-Jones confided to Sydney Cockerell that she had suggested to Jane that she (Jane) and "Mrs. Coronio could try being together for a few months; it is an audacious proposition, but Aglaia admires and I think is fond of Jane."[29]

The friendship between William Morris and Aglaia Coronio began when he taught her to read Chaucer and later to bind books. His visits and letters became frequent, and after an absence from London he would visit her at the first opportunity. Norman Kelvin, in the introduction to *Collected Letters of William Morris*, implies a sexual relationship between them,[30] but this does not seem totally credible. At the time Aglaia was living next door to her parents and brother, with more Ionides relatives nearby. She was not in a financial position to jeopardize her marriage, in spite of its unsatisfactory nature. Her niece, Euterpe Ionides Craies, described Aglaia's husband Theodore as "a good fellow, a wag and very handsome in his youth, but they were a sealed book to each other." Aglaia "charmed all the great men of

her day who found her most inspiring and helpful in their careers."[31] There is no doubt that Aglaia Coronio was a very important influence in Morris's life at a time when he was at a low point and needed someone to give him "bland flatteries . . . but I do rather wish she wouldn't butter me so," he wrote to his wife Jane.[32] It was not only William Morris who was a frequent caller at 1a Holland Park to see Aglaia. The album of signatures collected by her daughter contains most of the prominent people of the day in all fields. She regularly helped artists such as Watts and Rossetti to find materials needed for draperies. She was able to obtain these, as well as ingredients for dyes, through her contacts with merchants in London, Greece, and Turkey. "Thanks again for the bag of kermes, which I have given to Wardle to make into lake," Morris wrote to Aglaia.[33] At the time he was experimenting with using kermes instead of cochineal for red dyes. Burne-Jones, who was another of Aglaia's correspondents, wrote to her about his family news and praised her ability in finding fabrics and arranging dresses for models. He decorated his letters with pictures in his usual fashion; one showed him "climbing out of an overflowing bath and falling headlong. Not a pretty object," commented Aglaia's niece Penelope who lived next door.[34]

Apart from Burne-Jones's *The Mill*, the only pictures of Aglaia that have survived are two portraits by Watts and one by Rossetti. As her financial position was never very secure, Aglaia owned few works of art. During the painting of *The Day Dream* (Shields, *Rossetti working on the Day Dream*, 1880, Ashmolean Museum, fig. 5), Aglaia was a frequent visitor to Rossetti's studio. On 6 October 1879, Rossetti reported to Jane Morris: "Constantine Ionides looked in with his sister Aglaia on Saturday and commissioned me to paint the drawing over the mantelpiece of you seated in a tree with a book in your lap."[35] The commission resulted in *The Day Dream* (1880, Victoria and Albert Museum), one of Rossetti's last major works. Rossetti took over a year to complete the painting, and during that time Constantine and Aglaia were frequent visitors to the studio. "Aglaia told me that Constantine was immensely proud of his picture," Rossetti wrote to Jane.[36] At the same time Rossetti also designed a monogram for Constantine to use on his silver, linen, and stationery (fig. 6). Two designs were submitted: "I will make them more of the plain Roman character if you like, but I fancy these are distinct," Rossetti wrote to Constantine.[37] Aglaia exchanged gossip with Rossetti and gave him the latest news of the Greek circle, such as

the divorce of Christine Spartali.[38] Toward the end of her life, Aglaia suffered from depression, which was caused by the deaths of her close friends and family. The death of her only daughter, Opie, in 1906 was the final blow. Sydney Cockerell noted in his diary on 24 August 1906: "Philip Webb told me of the sad suicide of Mrs. Coronio on Monday as the result of her daughter's death."[39]

Over the years Anglo-Greek fortunes varied according to political situations and economic factors. Around 1861 Alexander Constantine's "business affairs were none too prosperous,"[40] and three years later he lost a great deal of money—possibly £120,000—in a financial crash. He then had to move from his house at Tulse Hill to Holland Park which was just being developed. No. 1 Holland Park was bought with his wife's (Euterpe's) diamonds. Euterpe Ionides was a daughter of the impoverished but aristocratic Sgouta family of Constantinople, who were descended from the Emperors of Byzantium. They had suffered during the Greek independence movement and lost their estates and money. Euterpe's grandfather was "crucified in his own gateway in 1821."[41]

At 1 Holland Park Alexander Constantine Ionides and his son Alecco created "an epoch making house," as it was called by a writer in *The Studio*.[42] Du Maurier told his mother that he had been invited "to dinner at the Greeks last Sunday in their new house at Kensington—such a stunner."[43] Over the years the newly built house, overlooking Holland Park, was transformed. Morris and Company carried out the main decoration over a period of time; accounts list the wallpapers, fabrics, and tiling that were supplied

Fig. 5. Frederic Shields. *Rossetti Working on the Day Dream*. 1880. Pencil. 7.2″ × 4.6″. The Ashmolean Museum, Oxford.

by the firm to furnish both the original house and the extension that Philip Webb designed.[44] The house was demolished after bomb damage in the Second World War.

A photograph taken in 1890 by the Bedford Lemere studio shows the stairs at Holland Park, with a Watts family portrait of Euterpe Ionides with three of her children, Constantine, Luke, and Aglaia (fig. 7). The stairs and ceilings are all decorated by Morris and Company. In another ca. 1895 photograph of another room (fig. 8), Burne-Jones's painting entitled *Flora* (1868–84, Owen Edgar Gallery, London) was hung. Maria Zambaco was the model, and it hung near a Watts portrait of Alecco's wife. *Flora*

Fig. 6. Constantine Alexander Ionides (CAI) monogram designed by Dante Gabriel Rossetti. Embroidered on damask. Photograph courtesy of Julia Ionides.

Fig. 7. Interior Holland Park. ca. 1895. Photograph by the Bedford Lemere Studios. Watts family portrait was destroyed after damage during the war; a replica is privately owned. Photograph courtesy of Julia Ionides.

had been commissioned by Alecco, who with his brother, Constantine, owned the largest collection of paintings and objects of art, much of which were sold in 1902 after his early death. The list of works sold at Christie's ranged from Bonington and Legros to Holbein.[45] In addition to *Flora,* Alexander Constantine owned *Pan and Psyche* (1869–79, private collection) and *Luna* (1869, location unknown) by Burne-Jones, as well as a replica of *Belcolore* (1868, private collection) and drawings by Rossetti. The house sounds rather overwhelming in its decoration and art collection, but it was much praised at the time. *The Studio* writer, Gleeson White, attributed

the success of the house to Alecco for recognizing the genius of men who had not yet attained worldwide reputations.

> It required no little courage for a man to include them (blue and white china, Tanagra figures for instance) in his scheme for a House Beautiful . . . for a layman to be among the first in recognizing the "new movement" is rare enough to be noted.[46]

Lewis F. Day concludes his article about the house in *The Art Journal* with the words

> Mr. Ionides is a Greek, and he has the love of a Greek for lovely things; but he is English-born, and has the

knack of building around him an interior such as even a Frenchman finds himself compelled to call by the English name of a "home."[47]

Although the financial fortunes of the Ionides fluctuated, there always seemed to be money to spend on beautiful things. It is not hard to understand their Greek enthusiasm for antiquities and even for Persian and Chinese plates and vases. The designs for Morris's carpets show the influence of the Persian rugs that Morris himself encouraged the Victoria and Albert Museum to purchase. More difficult to comprehend was the appeal of the contemporary artists to the family. Before moving on to the only extant Ionides collection, that of Constantine Alexander, now in the Victoria and Albert Museum in London,

it is perhaps useful to conjecture about some of the reasons for this interest.

First, it must be noted that the Ionides circle knew the young artists as friends and welcomed them as visitors to their homes. The artists needed to sell their pictures and to become known to a wider public, and in both these respects the Greeks could help them. These Greek families had a wide circle of influential friends; when they bought the pictures, they were helping the artists financially as well as helping to establish the artists' reputations. As businessmen, there surely must have been an element of speculation in what they bought. They bought Whistler's paintings at a time when he was little known in England and their risk proved to be worthwhile even in

Fig. 8. Interior Holland Park. ca. 1895. Photograph by the Bedford Lemere Studios showing *Flora* by Edward Burne-Jones. Photograph courtesy of Julia Ionides.

their own lifetime.

As businessmen, and not ashamed of it in class-conscious Victorian England, the Greeks probably enjoyed commissioning paintings from and influencing artists. They could see the work progressing on visits to the studio and could offer suggestions such as the one Constantine made when *The Day Dream* was being painted.[48] This involvement could give a feeling of satisfaction to a family who were neither professional artists nor from aristocratic English stock.

Along with the other patrons of Pre-Raphaelite art, the Ionides clan must have taken another factor into consideration: If they could see the painting being executed or knew the artist personally, there was no chance that it was a fake. This was always a problem with Old Masters and the English school of the eighteenth and early nineteenth centuries, particularly at this time when more people were collecting paintings. With the Pre-Raphaelites they could be sure of getting the "real thing." It is significant that in Constantine's collection are pictures thought at the time to be by Gainsborough and Constable. *Landscape with Cows* (undated, Victoria and Albert Museum, London) is now listed as "after Thomas Gainsborough," and *An Old Suffolk Mill—Moonlight* (undated, Victoria and Albert Museum, London), bought as a Constable, has been reattributed as "Artist unknown, 19th Century."[49]

As the eldest son and the father of eight children, Constantine Alexander Ionides had little time for collecting works of art in his early years. But according to his son, Alexander Constantine, Jr., "He was a man of wonderfully inspiring enthusiasms."[50] He made a great deal of money as a stock broker and then retired early from the city "to give the upbringing of his children his entire consideration."[51] After many different hobbies, "he took to collecting pictures, books and china." His picture collecting concentrated between the years 1878 and 1884.[52] In an enthusiastic letter to Robert Louis Stevenson, the writer W. E. Henley urged the ailing author to stay with Constantine, whose house at No. 8, Holland Villas Road in Kensington, had been placed at the disposal of Stevenson. Here he would be able to dine surrounded by paintings by Corot, Millet, and Diaz. Henley called Constantine one of the most selfish men he knew but also the most magnificent and generous.[53] Unfortunately Stevenson seems to have been too ill to take up the offer but his account of the house would have been fascinating.

Since the Ionides knew Holman Hunt and Millais, it seems puzzling that they were not represented in any of the Ionides collections. They could have bought the works of these artists at an early date at low prices. Constantine sold what was probably one of the most significant "modern" paintings that he owned—John Everett Millais's *Isabella* (1849, Walker Art Gallery, Liverpool). This has the initials PRB on the end of Isabella's bench. Constantine bought the painting from the Fine Art Society in London in 1881; his inventory for that year put a valuation of £1500 on it. Why did he sell it less than three years later? There are no clues in his correspondence, but his son wrote, "Before my father died, he sold six pictures—the *Isabella* of Sir John Millais, pastels of Jean François Millet and a painting by Corot. One day, talking over this matter, he told me that by this sale his whole collection had cost him some thousand pounds less than nothing."[54] Thus, monetary values appear to have prevailed over the consideration of a more rounded collection, and the original Pre-Raphaelites were represented only by Rossetti. Documentation seems to indicate that Constantine did not receive the insurance valuation price for the picture so this comment is puzzling; on the other hand, as he paid between £2 and £30 for most of his Rembrandt etchings, much of his large collection cost very little.

In a private memoir quoted by Alexander Ionides, Jr., Philip Meadows Martineau, a family friend, wrote of Constantine: "He was fond of art and collected valuable pictures, china and curios. He did not rely wholly on his own judgment, but sought the advice of experts and it is likely that his collection, which he has left to the nation, has grown in value. He bought an excellent house in the Second Avenue, Hove (Sussex) and built on to it a beautiful room in which it delighted him to welcome his friends and to show them its contents."[55]

The room, top lit by two domed skylights, was designed by Philip Webb. In a ca. 1896 photograph of this room (fig. 9), the pictures do not appear to be hung in any particular order.[56] A Fantin-Latour flower painting is next to *A Flemish Garden* (1864, Victoria and Albert Museum, London) by the Belgian artist Henri de Braekeller. Above, on a bracket, is a small version of Rodin's sculpture *The Thinker* (location unknown). In the center of the room is a terra-cotta statue by the French sculptor, Jules Dalou, and near that hangs Botticelli's *Smerelda Bandinelli*. Prominent on the left wall is *The Day Dream* alongside a river scene by Legros and a Watts portrait of one of the Ionides daughters. It is interesting to note that the lower edge of the Rossetti painting is hidden behind a small settee. In his correspon-

dence with Constantine, Rossetti gave strict instructions on the hanging of the picture and this would certainly not have complied. In another photograph *The Coronation of the Virgin* (ca. 1350, Victoria and Albert Museum, London) by Nardo di Cione hangs beside the Watts portrait of another daughter.

Today many of these pictures hang in the Victoria and Albert Museum in London. When Constantine left his collection to the museum upon his death in 1900, a report on it was written by his old friend, Tom Armstrong, then secretary to the Board of Education, South Kensington. He pointed to *The Mill* by Burne-Jones as being "of capital importance" and thought the acquisition of the French paintings would be an asset since they were "not at all represented in the public galleries in London."[57] Degas's *The Ballet Scene from Robert le Diable* (1876, Victoria and Albert Museum, London) was the first work by that artist to enter an English museum, but no mention was made by Armstrong of *The Day Dream* or the other works by Rossetti, his friend from Tulse Hill days. The terms of the will were criticized, but acceptance was urged. One condition was that the oil paintings should be "kept as one separate collection and not distributed over the museum or lent for exhibition. This gives the visitor a chance, almost unique in London, of seeing a collection as it was when it was formed almost a century ago, and evaluating the taste and perspicacity of the collector."[58] Constantine's solicitors valued the collection at £30,000 for probate purposes. His son maintained that the pictures were "originally . . . intended for the city of Athens,"[59] but there is no real evidence for this.

The collection is impressive in its breadth, encompassing two hundred Rembrandt etchings, as well as paintings by Degas, Delacroix, and Titian among others; the catalogue of the collection lists 1,156 items, consisting of 90 paintings, 300 drawings and watercolors, and 750 prints. There is a large number of drawings by John Flaxman, an artist much admired by Rossetti for his Greek figures. French artists, such as Corot and Courbet, were represented as well as those of the Barbizon school. Such a representation is mainly due to Alphonse Legros, who acted as advisor to Constantine and who knew many of the artists concerned.

Legros had met the Ionides family through Whistler. After the quarrel in 1867 between the two artists, friendships divided, and Legros moved closer to Constantine, as a portrait medal (fig. 10) executed in 1881, demonstrates. Whistler remained friends with Constantine's brother, Luke. Legros encouraged Constantine to purchase pictures from his French

Fig. 9. 23, Second Avenue, Hove, Sussex. ca. 1890. Photograph of the picture gallery designed by Philip Webb. Photograph courtesy of Julia Ionides.

friends, and he also kept an eye out for paintings while traveling, as evidenced by a letter which he wrote from Venice in 1873. There he had found "two paintings by Paul Veronese. They ask £100 for them."[60] Constantine also bought directly from France from the principal members of the Barbizon School—Jean François Millet, Theodore Rousseau, and Diaz de la Pena. This school rejected the "theatrical pretentiousness of official art" and "had the same concern for sincerity" as the Pre-Raphaelites. Although their paintings are different in both style and subject, like the Pre-Raphaelites they also painted on the spot to achieve the maximum "truth to nature."[61] Perhaps it was this directness and lack of

Fig. 10. Alphonse Legros. Medal of Constantine Alexander Ionides. 1881. 4″ diameter. Courtesy of the Coins and Medals Department, British Museum, London.

deception that appealed to Constantine, who was himself a direct man, with little time for social pretentiousness. He probably regarded both groups of painters as worthy of support for breaking away from the established system and having the courage to follow a course in which they strongly believed.

In some of the paintings owned by Constantine, there is a feeling of identification with the less privileged members of society, such as the peasants portrayed by Legros and Millet, and for the outsider. Did he regard himself as an alien in London and identify with these subjects? This feeling is displayed, for example, in the picture he purchased by Louis Le Nain, *Landscape with Figures* (ca. 1640, Victoria and Albert Museum) where a group of three peasants stands alongside a dismounted horseman who is resting. The peasants are dignified: one has a water carrier on her head, and there is a boy playing a flute.[62]

Although the Ionides family had made a lot of money in England, served as Greek consuls in London, and married into aristocratic Greek families, they were nevertheless "in trade" and were therefore

not part of the tightly regulated society of the time. This does not seem to have particularly concerned them; their overall impression is that anyone was welcome to visit the house as long as they could contribute some interesting conversation. An album owned by the family contained letters from a wide variety of people who visited Tulse Hill, such as John Stuart Mill, Ellen Terry, John Ruskin, George Sand, and Dr. Livingstone.

One prominent visitor was the violinist Joseph Joachim, whose uncle lived next door at Tulse Hill. The main musical connections for the family came through the younger daughter, Chariclea, whose husband Edward Dannreuther is known today for his championship of Richard Wagner and for founding the Wagner Society in England. When the Wagners visited England, they stayed with the Dannreuthers at Orme Square. An early reading of the manuscript of Parsifal took place there on 17 May 1877 in front of a small audience that included George Eliot and George Henry Lewes.

A music room had been built onto the house at Orme Square by Philip Webb. Morris was invited to

dinner to meet the Wagners, and as Cosima Wagner told Luke Ionides, "he treated the same subjects that her husband had treated in his music."[63] William Morris arrived with hands dyed blue from his indigo experiments. Since he was not an admirer of Wagner's music, the evening was probably not a success, at least for Morris. During Wagner's visit, Aglaia arranged for Cosima to visit the studios of Rossetti and Burne-Jones while her husband was rehearsing.[64]

After her marriage Chariclea continued to visit her family at Holland Park on Wednesday evenings when her father was "At Home." She wrote that "Morris, Burne-Jones and Rossetti (who came at 11 and stayed till 2 a.m.) brought their latest writings and read them to us. The last two read most beautifully, but Morris's reading was monotonous." Before her marriage Chariclea was very friendly with the Burnes-Jones family, but "afterwards I saw very little of them as my husband did not like him; he had rather the pose of a disembodied soul."[65]

Another connection with the Pre-Raphaelite artists came through Hugh Woolner, who married Mary, one of Luke's daughters, in 1912. He was the son of Thomas Woolner, the only sculptor of the original Pre-Raphaelite Brotherhood; the families had long been friends. The Woolners still own two beautiful Burne-Jones drawings of "Maisie," as Mary was known.

Artistic ability flourished in Luke's youngest child, Basil, who became an interior designer and is perhaps best known for the art-deco interior of the Savoy Theatre (London), which was destroyed by fire but is now faithfully restored. Basil's wife, Nellie, was a noted collector. She saved The Octagon at Orleans House (Twickenham, London) from demolition and presented it to the local borough.

Was art patronage of the Ionides, and their immediate circle, unusual among the Greek community in London? Timotheos Catsiyannis, bishop of Militoupolis, has written histories of some of the Greek families in London, and apart from family portraits and sculpture for funeral monuments, there appears to have been no significant art patronage within the Greek community. Perhaps the attitude of the other Greeks was best summed up in the following episode described by Alec Ionides:

> It was somewhere in the eighth decade of last century the Greek community determined to abandon the old Greek church in London Wall, and bought a plot of land in St. Petersburgh Place, Bayswater, with the idea of building the St. Sophia that has since been erected. Ned Burne-Jones, my father's friend, had previously confided to him the "dream of his life," viz. to decorate a Byzantine church, and when this idea of a new Greek church was started, there was little doubt that the two friends consulted together over the scheme of decoration. In any case, my father took to the elders of the community a proposal from Burne-Jones to the effect that he (B.J.) would, free of payment, decorate the interior of the Church, if they would provide the materials. Burne-Jones was little known to the Greek community and his proposal was "turned down." This I, personally, regret—for I feel that had it been accepted St. Sophia would have been one of the architectural gems of London.

Alec gives his reasons for this decision:

> From the second decade of last century, the Greeks of the London community were of two sorts. Those from Chios—the great majority—and those from elsewhere—a very small minority, consisting in 1832 of two families. The nature of those from Chios bid them occupy themselves in commerce to the exclusion of anything else. Those from elsewhere—including the Ionides—at times had other interests.[66]

Perhaps this is as good a reason as any and needs no further explanation.

NOTES

1. Dante Rossetti to Jane Morris, 16 May 1880. *Dante Gabriel Rossetti and Jane Morris: Their Correspondence,* ed. John Bryson and Janet Troxell (Oxford: Clarendon Press 1976), 152.

2. Elizabeth Robins Pennell, *Whistler the Friend* (Philadelphia and London: J. B. Lippincott, 1930), 141–42.

3. Alexander C. Ionides, *Ion: The Grandfather's Tale,* 2 vols. (Dublin: Privately printed, 1927), 4.

4. Ionides, *Grandfather's Tale,* 2:6.

5. Timotheos Catsiyanni, *Constantine Ipliktsis* (London: Privately printed, 1988), 22–23.

6. Wilfred Blunt, *England's Michaelangelo* (London: Hamish Hamilton, 1975), 12.

7. Quoted in Catsiyanni, *Constantine Ipliktsis,* 45.

8. Marcus B. Huish, "Tanagra Terracottas," *The Studio* 14.

(1898): 97–104.

9. Huish quote in Katherine A. Lochnan, *The Etchings of James McNeill Whistler* (New Haven: Yale University Press, 1984), 152.

10. Daphne du Maurier, *The Young George du Maurier* (New York: Doubleday, 1952), 30–31.

11. Gordon Fleming, *The Young Whistler* (London: Allen and Unwin, 1978), 209.

12. Luke Ionides, *Memories,* (Paris: privately printed, 1925), 41.

13. Elizabeth Robins, and Joseph Pennell, *Whistler, the Life* (London: Hamish Hamilton, 1909), 153.

14. Daphne du Maurier, *Young George du Maurier,* 216.

15. Ibid., 249.

16. Thomas Armstrong, *A Memoir* (London: 1913), 195.

17. Dante Rossetti to Jane Morris, 4 August 1869. In *Dante Gabriel*

Rossetti and Jane Morris: Their Correspondance, 8.

18. Irene Ionides to Julia Ionides, 1986. In the possession of Julia Ionides.

19. Daphne du Maurier, *Young George du Maurier*, 20.

20. Ibid.

21. For further details, see Philip Attwood, "Maria Zambaco, Femme Fatale of the Pre-Raphaelites," *The Medal* 10 (July 1986): 31–37.

22. Penelope Fitzgerald, *Edward Burne-Jones: A Biography* (London: Michael Joseph, 1975), 130.

23. Dante Rossetti to Jane Morris, 4 March 1870. In *Dante Gabriel Rossetti and Jane Morris: Their Correspondence*, 18.

24. See nos. 540–543 in Virginia Surtees, *The Paintings and Drawings of D. G. Rossetti, A Catalogue Raisonne*, vol. 1 (Oxford: Clarendon Press, 1971) 202.

25. Z. Schonfield, *The Precariously Privileged* (Oxford: Oxford University Press, 1987), 110–11.

26. James Whistler to Nellie Whistler (née Ionides), his sister-in-law, August 1892. Whistler letters, Glasgow University Library, GUL W711.

27. James Whistler to Alexander Ionides, August 1895, Glasgow University Library, I 104.

28. William Morris to Georgiana Burne-Jones, Summer 1878. *The Letters of William Morris to His Family and Friends*, ed. Philip Henderson (New York: Longmans, Green and Co., 1950), 274.

29. Morris Manuscripts, 86. 99. 00, National Art Library, Victoria and Albert Museum, London.

30. *The Collected Letters of William Morris 1848–1880*, ed. Norman Kelvin, vol. 3 (Princeton: Princeton University Press, 1984), xlii.

31. Euterpe Craies, privately owned Memoir, compiled 1945, 8.

32. William Morris to Jane Morris, 25 April 1870, *Letters of William Morris*, 35.

33. William Morris to Aglaia Coronio, 28 January 1880, *The Collected Letters of William Morris 1848–1880* (Kelvin), 556.

34. Peggy Hotchkis (née Ionides) to Charles Handley Reid, n.d. Privately owned letters.

35. Dante Rossetti to Jane Morris, 5 October 1879. *Dante Gabriel Rossetti and Jane Morris: Their Correspondence*, 122.

36. Dante Rossetti to Jane Morris, June 1881. Ibid., 176.

37. Dante Rossetti to Constantine Alexander Ionides, 25 January 1880. Privately owned letter.

38. Dante Rossetti to Aglaia Ionides, 24 September 1880, *Letters of Dante Gabriel Rossetti*, ed. Oswald Doughty and John R. Wahl, 4 vols. (Oxford: Clarendon Press, 1967), vol. 4, 1811.

39. Sydney Cockerell, 24 August 1906, Cockerell Diary, BM ADD MSS 52643.

40. Chariclea Dannreuther, privately owned typed Memoir, 1922, 4.

41. Ionides family tree compiled by Dorothea Butterworth, 1936. Copies are owned by members of the Ionides family.

42. Gleeson White, "An Epoch Making House," *The Studio* 12 (November 1898): 102–12.

43. Daphne du Maurier, *Young George du Maurier*, 244.

44. Accounts from Morris and Company to Alexander Ionides. Privately owned accounts were used for this research. There are also further accounts in the Victoria and Albert Museum National Art Library, Manuscripts, English Box, KK II (XIV). See also Philip Webb's drawings, dated 1888, of the additions to Holland Park in the Royal Institute of British Architects Library, London.

45. See Catalogue of Sale: Christie's, 15 March 1902.

46. Gleeson White, "An Epoch Making House," *The Studio*, (November 1898): 102.

47. Lewis F. Day, "A Kensington Interior," *The Art Journal* (May 1893): 144.

48. For further details of the painting of *The Day Dream*, see Julia Atkins, "The Day Dream," *Victoria and Albert Album*, 8 (Spring 1989): 33–38.

49. See CAI 109 and CAI 77 in *Summary Catalogue of British Paintings* (London: Victoria and Albert Museum, 1973), 52 and 164.

50. Ionides, *Ion*, 43.

51. Ibid., 46.

52. Ibid., 45.

53. W. E. Henley to R. L. Stevenson, dated 22 April 1884, Beinecke Rare Book and Manuscript Library, Yale University.

54. Ionides, *Ion*, 39.

55. Philip Meadows Martineau, Private Memoir, quoted on 52.

56. Details of the house and the hanging of the pictures from privately owned family letters and photographs.

57. Report by Thomas Armstrong, October 1900, Victoria and Albert Museum Art Library, London.

58. M. A. Kauffmann, *The Ionides Collection*, Victoria and Albert Museum Leaflet n.d. See also the Will of Constantine Ionides dated August, 1899.

59. Ionides, *Ion*, 15.

60. Alphonse Legros to Constantine Ionides, written from Venice, dated 18 March 1873. Private collection.

61. E. H. Gombrich, *The Story of Art*, 11th ed. (London: Phaidon, 1966), 386.

62. There is the same ambiguity about their presence as Picasso's *Family of Saltimbanques* (1905, National Gallery of Art, Washington D.C.). The figures in both pictures appear to have arrived there by accident not design. Unlike the figures in Millet's *The Woodsawyers* (1850, Victoria and Albert Museum, London) in which men and trees blend in harmony, the figures in Le Nain's painting are not in accord with their surroundings.

63. Ionides, *Memories*, 22.

64. Aglaia Coronio to Rossetti, Wednesday, 1877. Incoming letters of Dante Rossetti, V6T/1Y3, University of British Columbia.

65. Dannreuther, Memoir, 10.

66. Ionides, *Ion*, 47.

Pre-Raphaelites, French Impressionism, and John Ruskin:
Intersections at the Eragny Press, 1894–1914

ALICE H. R. H. BECKWITH

THE IMPRESSIONISTS WERE VICTORIAN. SUCH A STATE-ment, with its unaccustomed pairing of French artists and British chronology, startles while it enlightens. Claude Monet and Camille Pissarro lived in Victoria's England in 1870 and at other shorter periods of time until their deaths in the early twentieth century. There are visual and intellectual relationships between the English Pre-Raphaelites and French Impressionists. These artists discarded restrictions imposed by academic training, looking instead to contemporary life and nature for models. They experimented with avant-garde politics[1] and radical painting techniques, using form and color to convey attitudes and, thus, to move visual art beyond the simple controls of subject matter. Concern with celebrating spiritual values over postindustrial materialism inspired their portrayal of landscapes and medieval environments and their uses of history. Moreover, both groups nurtured a second generation interested in book design, resulting in two London-based printing houses established in the 1890s: William Morris's Kelmscott Press and Lucien Pissarro's Eragny Press. In addition, knowledge of and concern for John Ruskin's ethics and aesthetics linked Impressionists with Pre-Raphaelite art and ideas.

French interest in Ruskin and the Pre-Raphaelites provided the milieu from which sprang the most clear-cut visual and intellectual interrelationship between the Impressionists and the Pre-Raphaelites, namely, the books created by Lucien Pissarro and his wife Esther Bensusan at their Eragny Press between 1894 and 1914. Recognizing his unique role as mediator, Lucien Pissarro identified himself as a "channel artist," associating his oeuvre with England (where he lived, married, and worked from the 1890s onward) and with France, his birthplace, which he

explored and documented in drawings and paintings until his death in 1944.[2]

Lucien Pissarro's life and work experiences prepared him for the profession of art publishing in England, a country that he knew from his family's stay there in 1870 and from his sojourn in 1883–84 when he studied the language while working for a music publisher in London. In 1878, the year that some of William Morris's fabrics appeared in the Paris International Exhibition, Pissarro's encounter with English decorative arts occurred while he was working in a Paris warehouse that specialized in English textiles.[3] A second Paris employment that gave him vital information about color printing was with the Manzi publishers in 1887.[4] Furthermore, his marriage in 1892 to Esther Bensusan brought him an artist-partner who could engrave wood blocks, work the press, and also speak fluent English.

Pissarro's place in literary publishing has only recently come under investigation.[5] The research on his wood-engraving, begun by Alan Fern in the 1950s, is being enlarged upon now that the Pissarro Archive is organized at the Ashmolean Museum, Oxford.[6] My research indicates that Lucien Pissarro founded the Eragny Press in order to print avant-garde Symbolist poetry and works of earlier French literature, particularly the sixteenth-century Pléiade poets. In a heretofore unpublished letter to the Brussels publisher Edmond Deman, Pissarro discussed his intentions and his version of Jules Laforgue's *Moralitiés légendaires,* mentioning his interest in other Symbolist poets, such as Maeterlinck, Verhaeren, and Verlaine, as well as his interest in the French poets comprising La Pléiade.[7]

The Pissarro Archive at the Ashmolean Museum contains numerous other unpublished materials con-

175

cerning the Eragny Press and its significance. For instance, Henry Van de Velde and other well-known figures of the nineteenth-century Continental avant-garde appreciated Pissarro's books and openly encouraged him to surpass William Morris's Kelmscott Press. On receiving his copy of *The Queen of the Fishes*, Van de Velde wrote, "I am thinking . . . of our public's wonder when we religiously unfold the pages of this masterpiece before them." Continuing the spiritual metaphor, he opined, "I do not know of a more prized or exceptional work in the entire world. . . . This book has more merit in itself than all the books published by Morris." Turning to contemporary social issues Van de Velde concluded, "I have enjoyed the 'actualism' of your thinking—so much concerned with current ideal and material things . . . a singular thought—the role that you would play in the world were you to have at your disposal such royal means as W. Morris."[8]

Eventually Eragny authors included nineteenth-century English poets, such as Christina Rossetti and Robert Browning, who used images of natural landscape to inspire readers' spiritual development and concern for social justice. Lucien Pissarro was familiar with the works of John Ruskin and artists in the Pre-Raphaelite circle. In a biography of Dante Gabriel Rossetti, Pissarro stressed that artists need to "refresh themselves continually by the 'communion' with nature," quoting from Ruskin's 1851 pamphlet on the Pre-Raphaelites.[9] Pissarro also wrote a book, *De la typographie,* with Charles Ricketts, concerning book design and the influence of William Morris on the Arts and Crafts Movement. Furthermore, Esther and Lucien Pissarro were friendly with Morris's daughter May, and their unpublished correspondence is in the Ashmolean Museum.

The young Pissarro's formative years were extended by his father's career and familiarity with English art, because Camille Pissarro took an active part in his son's life as teacher and mentor. Although Lucien was not born until 1863, his father's activities in France date from 1855, when he arrived in France determined to become an artist. A key event in that year was the exhibition of Pre-Raphaelite paintings in the French International Exhibition. The new Pre-Raphaelite art in the exhibition attracted attention immediately. Fascination with English art after the 1855 exhibition drew Prosper Merimée to the Manchester Exhibition of 1857.

In addition to the Manchester Exhibition and Merimée's essay about it, 1857 was important as the publication year of Ruskin's *Elements of Drawing,* in which the author's system of color based on study of Turner's paintings, natural forms, and medieval manuscript art[10] read like an Impressionist manifesto, calling for "breaking one colour in small points through or over another." Ruskin advised "touches or crumbling dashes of rather dry colour, with other colours afterwards put cunningly into the interstices" and suggested "using atoms of colour in juxtaposition," urging modern painters to "lay the uppermost colours in rather vigorous small touches, like finely chopped straw." He insisted that "all the ordinary shadows should be of some colour,—never black"[11] This particular discussion of coloring is what the Impressionists' contemporary Wynford Dewhurst referred to when he attributed Impressionist color technique to Ruskin's *Elements of Drawing.* Robert Herbert noted that Dewhurst searched out Ruskin's essay after Monet referred to Ruskin as significant to Impressionism in a conversation at the Café Royal in London.[12] In a letter to Lucien, Camille Pissarro criticized Dewhurst's emphasis on Turner as an Impressionist source, but he was silent about Ruskin.[13] Dewhurst explained the visual and intellectual relationship between the Pre-Raphaelites and Impressionists as being based on the color theory and sociopolitical inspiration of Ruskin's writings. He described the Impressionists' "power to feel and express the strongest spiritual motion," and he signaled their mission to "depict beauty that elevates" and "cheers the viewer."[14]

A paradigmatic shift with respect to English thought and the French Impressionists began as early as 1964 in Robert Herbert's edition of John Ruskin's art criticism. Herbert opened his book citing quotations concerning the dehumanization of factory workers, the nineteenth-century spiritual crisis, and the problem that such a crisis presented to artists' imaginations: "Machinism, the division of labor, have transformed the worker into a simple automaton and have killed the joy of working. In the factory, the worker, tied to a machine which asks nothing of his brain, sadly accomplishes a monotonous task of which he feels only the fatigue. . . . One no longer wants gods, yet gods are essential to our imagination. We can't get around it, modern rationalism, if it is able to satisfy the learned, is a way of thinking incompatible with any conception of art." Discussing these quotations, Herbert warned against distorting nineteenth-century assumptions with those of the twentieth century. Nonetheless, readers assumed the quoted remarks were by John Ruskin. Deftly, Herbert revealed Pierre-Auguste Renoir as the source.[15]

Ruskin addressed fundamental issues that concerned both the Pre-Raphaelites and Impressionists.

He believed that human beings receive spiritual refreshment from looking at natural forms—flowers, trees, landscape, and that pure color contributed to the vitality of this psychic charge. Well known are the ways in which the transcendental philosophers from the Continent influenced the attitudes of nineteenth-century French artists,[16] but the importance of Ruskin's writings in nineteenth-century France is only recently being investigated.[17] With the 1990 exhibition of Monet's series paintings and Paul Hayes Tucker's accompanying catalog, a wide modern audience became aware of redefinitions by such historians as Robert Herbert and Richard Shiff of Impressionist artists' relationships with nineteenth-century culture.[18] Convincing his readers that Monet was intellectually active, Tucker reported on Monet's library of over six hundred books.[19] Of particular interest from Monet's library are John Ruskin's *Saint Mark's Rest* and a work by the Symbolist poet Jules Laforgue. Monet's ownership of works by these authors strengthens the contention that Lucien Pissarro's knowledge of Ruskin and his interest in Symbolist literature was in harmony with the interests of older members of the Impressionist circle.

The decade of the 1880s in France was particularly rich in publications related to Ruskin, his theories, and his relationships with the Pre-Raphaelites. These were the years when Lucien Pissarro came into his own as an artist, exhibiting in the Impressionist/Neo-Impressionist Exhibition of 1886. In 1881, the French translation of Ogden Rood's *Modern Chromatics* included sections on color taken from Ruskin's *Elements of Drawing*. Rood singled Ruskin out as the best contemporary color theorist for artists' uses.[20] Robert Herbert has recently reemphasized the significance of Rood's book.[21] Robert de la Sizeranne attributed "pointillisme" in the 1890s to *The Elements of Drawing*.[22] Indeed, Ruskin's manual continually held interest for artists in Impressionist and Neo-Impressionist circles as is indicated by the following excerpt from a previously unpublished letter from Paul Signac to Lucien and Esther Pissarro: "Vous avez bien voulu me promettre votre aide pour la traduction des *Elements of Drawing* de Ruskin."[23]

Ruskin's writings and lectures about medieval book illumination, beginning in 1854, also contributed to an intellectual climate that stimulated Morris's and Pissarro's interests in the book arts. With his Architectural Museum Lectures in 1854, Ruskin began his campaign to reform the book arts along the lines of medieval manuscripts. He encouraged this reform as a means of giving workers joy in their employment, teaching readers visual and intellectual discipline, and giving writers the inspiration that comes from knowing that their thoughts will be honored.[24] The importance of book design as a central metaphor in Ruskin's continuing campaign for visual and social reform has been discussed elsewhere.[25]

By 1881, knowledge of Ruskin's interests in Gothic manuscripts was so much a part of the French consciousness that Anatole France wrote *Le crime de Sylvestre Bonnard* with a thinly disguised John Ruskin as the central character. Sylvester Bonnard was an elderly philosopher, collector of illuminated manuscripts, and an admirer of medieval art and life. Ruskin even acknowledged the likeness and cited the story admiringly.[26] Two years later in a lecture at Oxford, Ruskin himself related the Pre-Raphaelite works of the 1850s to manuscript illumination, telling his audience that in the 1850s Dante Gabriel Rossetti "added to the before accepted systems of colour in painting, one based on the principles of manuscript illumination."[27] This history of Rossetti's involvement with medieval manuscripts has been traced by Alicia Faxon in her 1989 study of the artist.[28]

Continued reinvestigation of Ruskin and the Pre-Raphaelites kept the International Exhibition of 1855 alive in French memory even during the 1880s. Thirty years after the event, the excitement and fascination that the French felt at seeing Pre-Raphaelite art in 1855 was still palpable in Ernest Chesneau's recollections. Again and again in his book, *The English School of Painting*, Chesneau characterized English art as compelling. The attractive danger of English art was lack of control: rules were broken in subject matter, decorum, composition, and even coloring. Yet Chesneau envied the English for creating a truly national style, chiding his countrymen for their moribund painting.[29] Chesneau praised the moral purpose of Pre-Raphaelite artists and, in a deeper understanding of their purposes, reported their "reverential, almost devotional, representation of nature." He understood their landscapes to be a means of achieving a "union with Nature." He found in their work a respect for peasant life, which he identified as "the sweet and homely charm of country delights."[30]

Chesneau also commented on the use of color by the Pre-Raphaelite artists. Reading his description today suggests the pronounced influence that the Pre-Raphaelites' use of color had on late nineteenth-century French painters. To Chesneau, the Brotherhood

gave themselves up to a perfect glut of colouring. This

new epidemic raged from 1850 to 1870. In the pictures of the English school there was then a blinding clash of colour, a strife of incongruous hues; no softening tints, everywhere harsh tones set side by side with unexampled barbarity; blues and greens, violets and yellows, reds and pinks, placed in most cases quite by chance; a gashed face cut in two equal parts, one side violet, the other straw-coloured; or a pink ground, and a green rock.[31]

Chesneau's chronology of the Pre-Raphaelite orgy of color is especially interesting because it stops in 1870, the same year declared by Lucien Pissarro as the end of Pre-Raphaelite book illustration.[32] Twentieth-century scholars view the end of the 1860s as the time of the disbanding of the Pre-Raphaelite Brotherhood but also as the beginning of the widespread influence of the Pre-Raphaelites on other artists and particularly on book designers.[33] In 1870, second-generation Pre-Raphaelite artist, William Morris, and the Brotherhood's apologist, Ruskin, returned to Oxford University, the site of the group's most enthusiastic cooperative activities in the 1850s. Ruskin arrived to commence his appointment as Slade Professor and Morris to repaint the ceiling at the Oxford Union building.[34] More significantly, however, in 1870, Monet and Pissarro arrived in London, escaping the events of the Franco-Prussian War. Chesneau and Pissarro abrogated English influence by suggesting that the Pre-Raphaelites were no longer viable in 1870. As Harold Bloom has postulated about Charles Baudelaire and his attitude toward Victor Hugo, the anxiety of influence sometimes shapes what one artist says about an influential predecessor.[35] On the other hand, in the 1880s Chesneau also suggested that the art that "bewitched the French" in 1855 was the "commencement of a revival".[36]

Following Chesneau's description of Pre-Raphaelite color, some of his remarks relating poetry to painting were not in the English translation of La peinture anglaise. For example, in this regard he said that,

at the very moment when the most thoughtless of French painters suddenly became serious, i.e. when the artist set himself to paint, it seems that the young English painters of that time became crazy, if they were not crazy before, and put into their paintings the folly that might have bothered them in real life. They no doubt considered painting as a safety-valve (soupape de sûreté) guaranteeing their sanity.[37]

This quotation is significant because it represents English attitudes toward the role of the artist which were developed in the Oxford Movement whose

Tractarian poets John Keble and John Henry Newman developed a concept of the artist as sacred social worker. They described the use of art as a safety valve that allows the release of overpowering emotions brought on by experiencing the presence of divinity through landscape. In Lyra Apostolica, Newman used his poetry as a dynamic call to recognize and remedy social problems. Furthermore, Keble's nineteenth-century bestseller, The Christian Year, was eventually ornamented like a medieval prayer book;[38] and such visual transformation of a text through conventionalized natural ornament would recur in the book designs of William Morris and Lucien Pissarro.

William Morris arrived at Oxford University as an undergraduate in the early 1850s, intending to become an Anglo-Catholic clergyman in the Oxford Movement. Before graduation however, Morris converted his priestly mission into an artist's calling. He followed several careers in the arts: first as a Gothic Revival architect; then as a designer of stained glass, textiles, and wallpaper; and finally as a creator of works that he felt were as important to the human environment as beautiful houses, namely beautiful books.[39] Morris's interest in medieval books and their ornamentation began in the late 1840s and early 1850s, coincidental in time with the Tractarian's interest and his arrival at Oxford. His first known attempts at illuminating his own manuscripts were in 1850.[40]

Pre-Raphaelite interaction with the later (Anglo-Catholic) phase of the Oxford Movement was pronounced in the early 1850s.[41] J. E. Millais's Ophelia, one of the Pre-Raphaelite paintings that electrified the French art world at the Exposition Universelle in 1855 (1851–52, Tate Gallery, London, fig. 1), was painted when Millais was in close contact with Oxford Anglo-Catholics.[42] Although it is true that the subject of the painting is literary, taken from Shakespeare's Hamlet, the painting moves away from the academic stylizations expected in France and England in 1855. Tractarian intensity toward nature found visual equivalents here, while the then contemporary social problem of female suicide by drowning was equally frankly displayed. In the nineteenth century, "found drowned was a euphemism for female suicide."[43] Millais's critics suggested the subtext when they referred to the setting as a "weedy ditch."[44] Millais set an example for the young French Impressionists when he stood before nature and captured what he saw. There is no visual distance between the event and the viewer because the color is not mitigated by a mist of gray half-tones or black

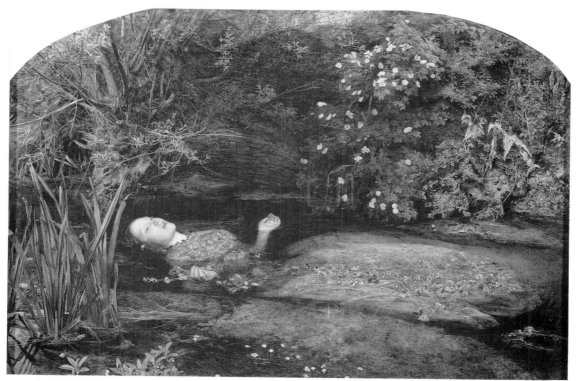

Fig. 1. John Everett Millais. *Ophelia*. 1851–52. Oil on canvas. 30×40". Courtesy of the Tate Gallery, London.

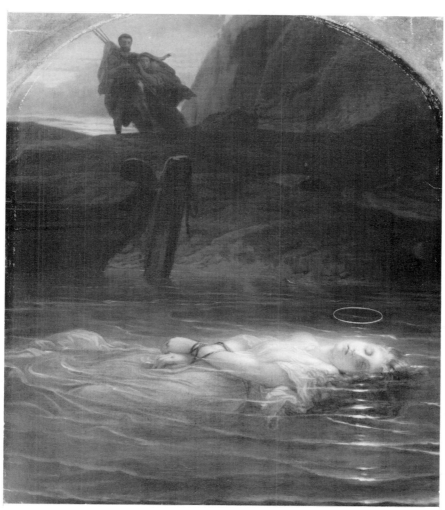

Fig. 2. (Hippolyte) Paul Delaroche and Lucien Przepiorski. *The Christian Martyr*. Oil on canvas. 47×37¾". ca. 1855. Delaware Art Museum, Wilmington.

Fig. 3. Lucien Pissarro. *Floating Ophelia*. ca. 1895–97. Red and black chalk on paper. 12 × 19″. Pissarro Archives, Ashmolean Museum, Oxford.

Fig. 4. Lucien Pissarro. *Queen of the Fishes*. 1894. Ink on paper. 7⁹⁄₁₆ × 5¹⁄₁₆″. By permission of the Houghton Library, Harvard University.

Fig. 5. Lucien Pissarro. *Ophelia* (first page opening *Moralités légendaires*, vol. 2). 1898. Ink on paper. 8¼ × 10½".
Private collection.

Fig. 6. Lucien Pissarro. *Salome* (first page opening *Moralités légendaires*, vol. 1). 1897. Ink on paper. 8³⁄₁₆ × 10".
Private collection.

Fig. 7. William Morris. *The Story of the Glittering Plain*, first page. 1891. Ink on paper. 8 × 5½″. Houghton Library, Harvard.

shadows. In London, when the work was first shown, crowds gathered every day.[45] Why? Because it asked a question, the same question that Shakespeare asked in *Hamlet*. What kind of society required such a sacrifice from its young women? Millais's work coupled Keble's Wordsworthian meditations on nature with the dynamic call to recognize and remedy social problems advocated by John Henry Newman. One can imagine the young Camille Pissarro, at the Exposition Universelle of 1855, standing transfixed in front of Millais's *Ophelia*.[46] The force of this work on

his developing Impressionist imagination and social conscience must have been powerful. Here he saw direct confrontation with nature, revolutionary treatment of subject matter, and extraordinary unmodulated color in a work that joined presentation of literary-historical moments with contemporary issues. Millais's painting contrasted radically with academic renderings of women and water, such as Paul Delaroche's *The Christian Martyr* (1855, Delaware Art Museum, Wilmington, fig. 2), painted in 1855. Delaroche's generalized natural environments are

typical of the kind of art that both Pre-Raphaelites and Impressionists renounced. It is interesting, however, that Delaroche represented a Continental link with English culture because he often painted subjects taken from Shakespeare or Sir Walter Scott.

Millais's combined concern with nature and society is found in the interest that John Ruskin, William Morris, and Lucien Pissarro had in ornamenting literature of ethical insight with the vines and flowers of Gothic Revival book ornamentation. The first two books, *The Queen of the Fishes* (1894) and *The Books of Esther and Ruth* (1896), produced by Lucien Pissarro's Eragny Press presented moral lessons from the folklore of the Valois region of France and from the *Old Testament*. Both volumes were ornamented with floral borders, and illustrations were placed on the page after the manner of medieval manuscripts.

However, the impact of Millais's *Ophelia* is even more directly suggested in Lucien Pissarro's first design for a frontispiece in the third Eragny Press book, a two-volume collection of Jules Laforgue's *Moralités légendaires,* a design that Pissarro created between 1897 and 1898. Pissarro's design for the frontispiece of the second volume of Laforgue's work was *Floating Ophelia* (1895–97, Ashmolean Museum, Oxford, fig. 3). He completed this design by placing a floral border around it and labeling it "Ophelia." Sometime later the floral borders and the label "Ophelia" were removed from the surface of the drawing, and the long horizontal edge above the feet was unfolded. Filed with the drawing at the Ashmolean Museum is a written record of the earlier condition of the drawing. Surrounding Ophelia with flowers and placing her in the water certainly accords with Millais's handling, but Pissarro did not copy Millais's composition. The raised empty arms of Pissarro's Ophelia not only echo the curving lines that were originally in the margin but also indicate Hamlet's absence. Pissarro may have intended the floating figure to be underwater, since he had perfected a method of suggesting underwater scenes in 1894 by using broken horizontal lines in *The Queen of the Fishes* (1894, Houghton Library, Harvard, fig. 4).

In the final version of the design for the frontispiece (1898, private collection, fig. 5), Pissarro chose not to make so obvious a response to the Pre-Raphaelite painting. Pissarro's finished design pictures a well-dressed young woman standing in an iris bed beside a riverbank, before her suicide. This less obvious composition provokes the question of why the young woman killed herself in a more subtle manner than Millais's painting depicts. In its completed form, Pissarro's portrayal of Ophelia is static and vertical and does not mirror the opposite text page. By changing his design, Pissarro transformed the linkage of the two-page opening. The change decreases the visual harmony with the symmetrical *Salome* frontispiece of the first volume (1897, private collection, fig. 6). This change suggests that another reason for the alternation in design may have been this desire to vary the format established by William Morris in his Kelmscott books. In 1891, Camille Pissarro warned his son against being overly influenced by the Pre-Raphaelites,[47] but Lucien Pissarro's typography, layout, and execution nonetheless were modeled after the Kelmscott volumes.

Morris's *The Story of the Glittering Plain* (1891, Houghton Library, Harvard, fig. 7) was the first book printed at the Kelmscott Press. With this book Morris established a visual format that became one of his legacies, namely, the asymmetrical decorated page. As stated in *Notes on the Kelmscott Press,* Morris's objective in opening a publishing house was to create beautiful books that were easy to read;[48] his larger objective was the presentation of basic civic and personal values. In looking for guidance on how to live in his own time, Morris studied the writings of earlier times. He searched for the truth from many sources and published such diverse writings as from Sir Thomas More to folk tales and from intellectual history to popular culture. He observed a cross section of the past and, beginning in 1858, wrote his own tales and poetry, lending historical ambience to his work through syntax, spelling, and (in his Kelmscott books) visual analogy. His new/old tale *The Story of the Glittering Plain* first appeared in 1890 in *English Illustrated Magazine,* but when it was published by Kelmscott the next year, Morris joined form and content to allow a mingling of visual associations with ancient texts. Enclosing the whole in a vine- and flower-filled border—accompanied by a vine-decorated, and enlarged initial letter—achieved both environmental and natural references. The importance of natural form was emphasized by allowing much of the margin to be filled, very appropriate in a volume that combined a meditation on nature and history. The size and placement of these margins, derived from medieval book design, reinforce further the historical ends. Morris used the past for comparison as a means of pointing out what he felt was lacking in his own times (much as Ruskin did), and this purpose also showed in his book designs.

The Eragny Press's *Moralités légendaires* is an example of the radical-traditional perspective on historical content and form shared by first and second

generation Pre-Raphaelites and Impressionists. It also provides an example of how these artists used forms with historical associations to make statements about contemporary society. Pissarro's choice of Laforgue's stories further illustrates the close interaction between poets and painters that was characteristic of both groups. Laforgue, a leader of the French Symbolist poets, wrote a sensitive interpretation of Impressionism during the early years of the movement.[49] Monet owned one of Laforgue's works; unfortunately, however, the copy in Monet's library disappeared during the renovation at Giverny, and the listing of it today does not indicate which of Laforgue's books Monet had. We know Pissarro took his version of Laforgue's stories from Gustave Kahn's magazine *La Vogue Artistique, Scientifique, et Sociale,* and original issues from 1886, annotated by Pissarro, are in the Pissarro Collection at the Ashmolean Museum due to the generosity of John Bensusan-Butt.

Laforgue aligned his intentions with English thought, calling himself the "definitive John Ruskin" in an 1883 letter to Charles Ephrussi, an important member of the French arts community who later became editor of the *Gazette des Beaux Arts.*[50] Laforgue was identified with Ruskin because both desired to establish the value of the transcendental over the material in life and art. The context of the letter suggests that Laforgue was being ironic because his inversions of history and canonical literature were more exaggerated than those of Ruskin.

In writing *Moralités légendaires,* Laforgue took earlier stories, analyzed and reconstructed them, using history against itself as a means of criticism. His technique is most comprehensible in the Perseus and Andromeda story, the third one in the first volume of the Eragny Press edition. In the original tale, Perseus, the handsome prince, saves Andromeda, the beautiful maiden, from a fierce dragon. Laforgue turns the story inside out by describing the friendship between Andromeda and the dragon, making Perseus appear ridiculous. Readers are led to ponder the value of friendship and are pushed to look beyond physical beauty to intellectual interest. This is a very compressed rendering of the story; however, even in such a simplified overview one can see how the original story served as a foil for an imaginative, if not provocative, reevaluation or reinvention.

Lucien Pissarro brought additional levels of meaning to Jules Laforgue's text by designing a visual armature around the stories. The conventionalized floral designs that ornamented bindings, frontispieces, and texts brought nature comfortably into the world of the literary artist. Very aware of his role,

Pissarro insisted on having total control over books from his press. For example, in 1904, he told the publishers Perris and Cazenove that he would only print books that he found appealing, reserving all design decisions for himself.[51] Several Eragny Press books have, in effect, three levels of interest: one is by looking at the books as simple objects, and a second level is by reading the text. The third level cannot be found in all texts, but it is present in the Laforgue volumes and in *Riquet à la houppe* (1907). This third level of understanding occurs upon reflection, after overcoming the startling experience of reading the fractured fiction. Reflection leads to recognition of continuity present in the nature-inspired ornamentation, which holds the text together despite the human struggle and dislocation described by the authors. Thus, in all Eragny books there is a visual commentary that can sometimes make reading the text a surprise.

Pissarro's artistic comment on Laforgue emphasized the natural world and female characters in two of the stories, with Salome opening volume one and Ophelia volume two. These women are the opposites characteristic of Symbolist poetry: the femme-fatale-philosopher-seducer and the femme enfant, a disappointed virgin who kills herself. A cognoscente of Symbolist poetry would have recognized the pair, but others might not. Moreover, Pissarro did not tell the reader any more than the names of the two women whose identities were not otherwise overt; and action took place in flowering and vine-filled margins or on pages that blossomed with printers' flowers marking the paragraphs. Book collectors, notorious for not reading their books, might never have known what explosive ideas they actually held in their hands.

"Question authority and investigate your assumptions" could be the slogan of Lucien Pissarro and Jules Laforgue. The ending to the Perseus and Andromeda story introduces a narrator who is questioned by his listener, thereby producing another level of criticism. The story becomes a work open to interpretation by the reader, commenting on itself and revealing its design. The parallel to Impressionist technique is intriguing to explore. When Monet painted a *Meule* (Grainstack [1890–91, Museum of Fine Arts, Boston, fig. 8]), arguably he did the same thing. Viewers looking at the network of brush strokes see how he built up the colors, and Monet's technical process is clear. At the same time, Monet's meditation on nature is participatory because it continuously comes into being and remakes itself as we move toward it or away from it. As in the *Ophelia* of

Fig. 8. (Oscar) Claude Monet. *Grainstack (Sunset)*. 1890–91. Oil on canvas. 28⅛ × 36½". Julaina Cheney Edwards Collection, the Museum of Fine Arts, Boston.

Millais, Laforgue, and Pissarro, the artist involves the reader in the experience of the work and strikes cultural chords while at the same time creating an immediate effect. Monet's version of the new reflecting on the old in the 1890s was to use radical transformations in technique while painting traditional icons of French culture such as the farm in *Grainstacks,* and the church in *Rouen Cathedral* (1894, Museum of Fine Arts, Boston). Monet, like Pissarro, was subtle: he did not tell viewers that his paintings were a meditation on nature and history, nor did he explain the psychic charge produced by the colors and subject matter. His paintings simply allow his audience to experience spiritual and intellectual refreshment, if they wish, and if they will spend some time in meditation as Paul Tucker has suggested.[52]

The last development in William Morris's book design was the introduction of a third color: blue. In his earlier books, he used red ink only occasionally as an accent on the black and white pages. Blue was appropriate to the forty-first Kelmscott book *Laudes Beatae Mariae Virginis* (1896), the text of which Morris took from a thirteenth-century English Psalter in his own collection, now in the Pierpont Morgan Library, New York.[53] This particular Psalter was comprised of poems of praise to the Virgin Mary, whose holy color was blue. There is no introduction to the Kelmscott *Laudes,* because Morris felt that such a scholarly apparatus was an intrusion.[54] He prided himself on bringing readers a direct experience of early literature and not using prefaces or introductions. Morris simply plunged the reader into the text on its first page, printing the text as he found it and believing that archaic spelling and sentence structure were part of an authentic reading. As in his

Fig. 9. Lucien Pissarro. Historiated initial U, *Riquet à la houppe*, p. 27. 1907. Ink on paper. 5¹⁄₁₆ × 4¹⁄₁₆". Houghton Library, Harvard.

earlier books, he used visual art to enshrine the text and introduce references to nature without altering the written word. Morris's book is thus not a copy of the earlier text but rather a re-creation that brought history into the contemporary moment. Morris died in 1896, and, therefore, he did not continue the experiment with color begun here. It was Lucien Pissarro who persisted, bringing a full range of colors into the Pre-Raphaelite, Impressionist, Ruskinian book.

In his 1888 autobiography *Praeterita*, Ruskin described medieval illuminated books similar to Morris's thirteenth-century Psalter as "fairy cathedrals." Recounting his discovery of the decorative arts in the 1850s, Ruskin exclaimed that such medieval manuscripts were filled with colored pictures, "stained glass windows," and all of the prayers, music, and associations of history. Best of all, he noted, these illuminated books could be carried around in a pocket.[55] The books of hours that Ruskin described were intended for private, individual meditation, with size, color, and use of special importance.

The Eragny Press *Riquet à la houppe* (1907) mimics the kind of Gothic book of hours praised by Ruskin.[56] It is small, fifty pages long, measures 13.8 by 10.9 centimeters, with only eighty copies printed. The cover of white vellum and blue holland paper is the most medieval looking of all the Eragny books. The text is a coloristic tour de force, particularly the five unique copies printed with Pissarro's specially mixed soft sage green and muted orange inks. The sage green printed text with orange printers' flowers is complemented by two full-page wood-engraved, historiated initial letters printed in red, blue, and yellow. The initials introduce and separate two versions of the story. In this volume, Pissarro achieved the color of the printed type and the harmony of color in the illustrations that he advocated in *De la typographie*.[57] Illustrated here is the second of these initial letters, the U (Houghton Library, Harvard, fig. 9). The letters take their origin from the thirteenth-century books so often described by Ruskin[58] such as the M from the Adoration-of-the-Magi in the *Beaupré Antiphonary* (ca. 1290 Walters Art Gallery, Baltimore, fig. 10). However, the color and design of

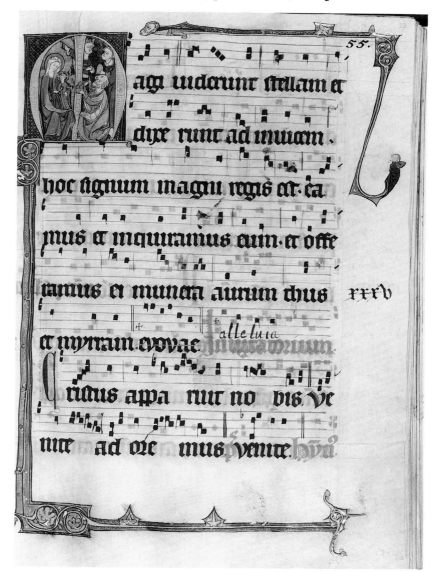

Fig. 10. Anon. Historiated initial M, *Beaupré Antiphonary*, fol. 28r. ca. 1290. Tempera, ink and gold on vellum. 19 × 13¼″. Walters Art Gallery, Baltimore.

Pissarro's page did not reproduce any previous book and serve as a superb example of Pissarro's desire to "graft modern decoration on the old tree", as he told Richard J. Jackson. In the same unpublished letter to Jackson, Pissarro defined his contribution to the nineties' printing revival as introducing a new use of colored wood-engravings.[59] Echoing early Pre-Raphaelite, Impressionist, and Neo-Impressionist technique, interpenetrating clear colors sing out from Pissarro's landscape. The line block printed in dark blue give Neo-Impressionist structure to the forms, while separate tones of blue, yellow, and orange hold their individuality. At the same time, blue laces yellow, yielding green, and orange-red breaks across that warm green. The image is a remarkable synthesis of artistic predecessors that remains a new contribution.

Riquet à la houppe, like *Moralités légendaires*, is an intellectual and visual surprise that sets history against itself for critical purposes. Pissarro did not write the two texts, but his juxtaposition of them and his commentary via ornamentation and illustration allowed him direct involvement in the reader's experience of the texts. All of the levels of intellectual and visual content and reference shared by Pre-Raphaelites and Impressionists are represented here. The essential theme is the value of a human being with "soul" (or esprit), i.e., a person with lively spiritual, intellectual, and visual awareness. The second theme concerns the relationship between men and women, reminiscent of how traditional definitions of male and female behavior were questioned in Laforgue's tales. This second theme was not resolved, but Pissarro did leave readers with much to meditate

upon and much to delight the mind as well as the eye. The whole is held together by repeated natural ornamentation. At first glance, the stories appear similar because the medievalizing ornamentation is uniform throughout the text. Form and content here achieve a unity with history and, in the end, are lightened by humor.

Two worlds collide in Pissarro's *Riquet à la houppe*, which begins, after the manner of William Morris, without a preface or introduction. At the end of the text in the colophon, Pissarro identifies the first author as Charles Perrault and the second as an unknown seventeenth-century writer whose manuscript is in the Mazarine Library (Paris). Charles Perrault, a respected seventeenth-century author best known for his literary fairy tales written for the court of Louis XIV,[60] composed his story in exquisite high-style French, beginning with "Once upon a time" and ending with a happy prince and princess. By contrast, the second version opens abruptly and ends without closure, thus leaving the young woman in an ironic, humorous situation, for she is unable to tell the difference between her lover and the King of the Ghouls. Spelling, syntax, and story line in this second tale suggest the vocabulary of a peasant or an earlier period in French history. Both the style of the second version and its location in the revered Mazarine Library promote its credibility, thus undermining Perrault's claim that his tale was adapted from one related by an authentic, ancient peasant woman, alias Mother Goose. The only changes in the Eragny text from the Mazarine manuscript are in punctuation and capitalization. Pissarro's prospectus for *Riquet à la houppe* (in the Pissarro Archive) states that the second version of the story "is nearer the legend of the Gnome Ruebezahl as Musaeus gathered it from the peasants of the Hartz mountains." For the Eragny texts of these stories, he returned to Gustave Kahn's periodical *La Vogue Artistique Scientifique et Sociale*, now in its new series of 1899. As with the source of *Moralités légendaires*, the issue of *La Vogue* that Pissarro annotated is in the Pissarro Archive of the Ashmolean Museum.

The unspoken question provoked by Pissarro's pairing of these texts is whose Middle Ages is more authentic? Is it the world traced by the *ancien régime* author Perrault or the story gathered from peasants? That Pissarro questioned the authority of the aristocrat's version does not mean that he wanted to forget about history but rather that he hoped to generate a wider understanding of who made history. His valuing of folk language and lifestyle connects the reader

with a new/old historical time-line while expanding audience attention to the life of the poor. Pissarro's wider vision of the Middle Ages is justified. Attention to the life of the poor and respect for the natural environment were aspects of the "change of heart" Francis of Assisi encouraged in his thirteenth-century followers. In *Riquet à la houppe*, Pissarro created a modern meditational text rubricated like a thirteenth-century manuscript Book of Hours. This was exactly the kind of new/old book that John Ruskin hoped Lucien Pissarro's generation would create.

Intimations of a connection between the Pre-Raphaelites and Impressionists bridged by Ruskin's writing and shared visual and intellectual goals were brought to the attention of the French and English public with renewed vigor in the 1890s and in the early years of the twentieth century when Lucien Pissarro was producing his most significant books. Robert de la Sizeranne's *Ruskin and the Religion of Beauty* first appeared as a series of three essays in *Revue des Deux Mondes* between 1896 and 1897. The essays were later published as a book in France in 1897 and translated into English in 1899. Sizeranne highlighted Ruskin's ability to bring aesthetic and ethical dimensions together in discussion of art objects, remarking of Ruskin's word painting that "we are not forced to quit the kingdom of form and color, because we would enter that of ideas."[61]

Discussing the importance of a direct and meditative experience of nature for a landscape artist, Sizeranne interrelated Ruskin, the Pre-Raphaelites, and the Impressionists. He analogized for his readers that Ruskin, whose writings "created Pre-Raphaelism," created word-paintings of nature that were "like Claude Monet painting his Meules." All three, Sizeranne suggested, "would not add one blade of grass he had not seen or before which he had not stood in rapture."[62] As mentioned previously, Sizeranne also attributed pointilliste color technique to Ruskin's *Elements of Drawing*.[63] Ruskin and Sizeranne's interpretations of him enjoyed widespread recognition in the early twentieth century. When the people of Venice chose to memorialize Ruskin in 1905, they asked Sizeranne to do so, and his lecture was translated into English the next year.[64] Sizeranne's writings introduced Marcel Proust to Ruskin, resulting in Proust's translations of *The Bible of Amiens* (1900) and *Sesame and Lilies* (1906).[65]

Sizeranne separated Ruskin's post–1860 ideas from a specifically Christian orientation, bringing his audience to understand that Ruskin's ethics were nonsectarian and universal. He described the importance to Ruskin and, by extension, to the Pre-

Raphaelites and Impressionists, of an art of natural forms that could reinvigorate the human spirit and lead people away from the worship of money. Stressing the importance of Ruskin's statement "There is no wealth but life," Sizeranne capitalized the quotation in his book. He understood Ruskin's definition of true national wealth as healthy people, clean water, and beautiful natural landscape.[66] Concern for the loss of these riches and values underlies the monologue in Ruskin's *Saint Mark's Rest,* where Ruskin called for a thoughtful and analytical meditation on the history of Venice, describing the city metaphorically as an ancient illuminated manuscript that should be read and examined for its historical lessons. He warned his readers that he wrote in haste, trying to capture his vision of Venice before it was destroyed by greed, pollution, and thoughtless development.[67] The French translation of *Saint Mark's Rest* appeared in 1908, when Monet bought it and went to Venice.[68] Using the technique of interlocking strokes of pure color that aligned his art with Rossetti's early works and with Ruskin's *Elements of Drawing,* Monet seized his brushes, confronted the history, art, and landscape of Venice, and captured his own meditation on nature.

Pre-Raphaelites and Impressionists alike shared this reverential approach to nature and an understanding of the influence of pure color on a viewer's mood and attention. With paintings that were colorful, awkward in pose and anatomy, and unconventional in subject matter, the Pre-Raphaelites gave the Impressionists a model of independent behavior. Pre-Raphaelite paintings did not look as if they were painted in a French academy, but they did inspire French artists. The Pre-Raphaelites and Impressionists shared an appreciation of the writings of John Ruskin, who understood art as a manifestation of the condition of an entire culture. Ruskin's view was not restricted to one form of art; instead, he discussed book decoration and architectural ornamentation as well as literature and easel pictures. He used historical references to criticize excesses of power rather than to glorify the most powerful, and he elevated fragile wild flowers, voiceless peasants and workers, and ancient buildings into the stuff of art. Lucien Pissarro went to England because he believed that there he would find a public who would appreciate his books and his values. With his Eragny Press, Pissarro succeeded in the campaign to revitalize book design that Ruskin began in 1854. Even today, Eragny Press books are a treasure to own, not only for their color and their references to nature, but also for their stimulating ideas.

NOTES

1. See Peter Stansky, *Redesigning the World: William Morris, the 1880s, and the Arts and Crafts* (Princeton: Princeton University Press, 1985). See also John Hutton, "'Les Prolos Vagabondent': Neo-Impressionism and the Anarchist Image of the Trimardeur," *Art Bulletin* 72, no. 2 (June 1990): 296–309.

2. *Times* (London), 12 July 1944, 7.

3. See W. S. Meadmore, *Lucien Pissarro* (New York: Alfred A Knopf, 1963), 45, and Linda Parry, *William Morris Textiles* (New York: Viking Press, 1983), 8.

4. *Camille Pissarro, Letters to His Son Lucien,* ed. John Rewald and Lucien Pissarro (New York: Paul P. Appel, 1972), 11.

5. *Dictionary of Literary Biography* "Eragny Press," vol. 112.

6. See Marcella D. Genz, "A History of the Eragny Press" (Ph.D. diss., University of California [Berkeley], 1990); Susan M. Ashbrook "Private Press Movement in Britain, 1890–1914" (Ph.D. diss., Boston University, 1991); and *Letters of Lucien to Camille Pissarro, 1883–1903,* ed. Anne Thorold (Cambridge: Cambridge University Press, 1993). Lora Urbanelli of the Museum of Art, Rhode Island School of Design, is preparing an updated catalogue raisonné of Lucien's woodcuts in collaboration with Alan Fern. See also Kristen Erickson, "Orovida Pissarro" (M. Litt. thesis, Oxford University, 1992), and also by Erickson, "Four Generations of the Pissarro Family," Exhibition Catalogue, Portland Gallery, London, 1993.

7. Lucien Pissarro to E. Deman, 15 August 1896, Pissarro Archive, Ashmolean Museum, Oxford.

8. Henry Van de Velde to Lucien Pissarro, 29 April 1895, Pissarro Archive, Oxford University.

9. Lucien Pissarro, *Rossetti* (London: T. C. and E. C. Jack), 80. A copy in a private collection has an inscription of 1908. *Complete Works of John Ruskin,* ed. E. T. Cook and Alexander Wedderburn, 39 vols. (London: George Allen, 1903–12), 12:358.

10. Alice H. R. Hauck, "John Ruskin's Uses of Illuminated Manuscripts and Their Impact on His Theories of Art and Society," (Ph.D. diss., The Johns Hopkins University, 1983), 197.

11. *Complete Works of John Ruskin,* 15:151–52, 154.

12. See Wynford Dewhurst, "What Is Impressionism?" *Contemporary Review* 99 (January–June 1911): 295–296. See also Robert Herbert, *The Art Criticism of John Ruskin* (1964; reprint, Gloucester, Mass.: Peter Smith, 1969), xiii.

13. Camille Pissarro, *Camille Pissarro: Letters to Lucien Pissarro,* 1972: 355.

14. Dewhurst, "What is Impressionism?" 292, 301.

15. Robert Herbert, *The Art Criticism of John Ruskin,* vii.

16. Michele Hannoosh, "The Poet as Art Critic: Laforgue's Aesthetic Theory," *Modern Language Review* 79 (July 1984): 553–69.

17. *Marcel Proust on Reading Ruskin,* intro. Richard Macksey (New Haven: Yale University Press, 1987), xviii–xx.

18. Richard Shiff, "The End of Impressionism," *Art Quarterly* (Autumn 1978): 338–79, updated in Charles S. Moffett, *The New Painting, Impressionism 1874–1886* (Geneva, Switzerland: Richard Burton SA, 1986), 61–93.

19. Paul Hayes Tucker, *Monet in the Nineties* (New Haven: Yale University Press, 1989), 11.

20. See Ogden N. Rood, *Modern Chromatics,* ed. Faber Birren (New York: Van Nostrand, 1973), 140, 279.

21. See Robert Herbert, *Georges Seurat* (New York: Harry N. Abrams, 1991), 390–91.

22. Robert de la Sizeranne, *Ruskin and the Religion of Beauty,* tr.

M. A. A. Galloway (New York: James Pott & Co., 1899), 218.

23. Paul Signac to Lucien and Esther Pissarro, ca. 1923–1924, Pissarro Archive, Ashmolean Museum, Oxford.

24. *Complete Works of John Ruskin*, 12:483–85.

25. Hauck, "Ruskin's Uses of Illuminated Manuscripts," 179–80.

26. *Complete Works of Ruskin*, 18:lxxxi, 26:347, 32:79, 34:705.

27. *Complete Works of Ruskin*, 33:268.

28. Alicia Faxon, *Dante Gabriel Rossetti* (New York: Abbeville Press, 1989).

29. Ernest Chesneau, *The English School of Painting*, tr. Lucy N. Etherington, preface and notes John Ruskin (London: Cassell & Co., Ltd., 1885), 171–72. First French edition as *La Peinture Anglaise* (Paris: A. Quantin, n.d.). Chesneau and Ruskin began corresponding in 1864.

30. Chesneau, *English School*, 1885, 252–53.

31. Chesneau, *English School*, 1885, 108.

32. Lucien Pissarro and Charles Ricketts, *De la typographie et de l'harmonie de la page imprimée, et William Morris et son influence sur les arts et metiers* (London: Hacon and Ricketts at Vale Press, 1897–98), 3.

33. Susan Casteras, et al., *Pocket Cathedrals, Pre-Raphaelite Book Illustration* (New Haven: Yale Center for British Art, 1991), 13.

34. K. L. Goodwin, "William Morris's New and Lighter Design," *Journal of the William Morris Society* 2, no. 3 (Winter 1968): 24–31.

35. Harold Bloom, ed., *Charles Baudelaire* (New York: Chelsea House, 1987), 3.

36. Chesneau, *English School*, 1885, 173–74.

37. Chesneau, *La peinture anglaise* (Paris: A. Quantin, n.d.), 113.

38. G. B. Tennyson, *Victorian Devotional Poetry* (Cambridge: Harvard University Press, 1981), 50, 91, 117–207.

39. William S. Peterson, *The Kelmscott Press* (Berkeley: University of California Press, 1991), 4.

40. Alfred Fairbank, "A Note on the Manuscript Work of William Morris," in *The Story of Kormak*, ed. William Morris and Eirikr Magnusson (London: William Morris Society, 1970), 53–72.

41. See Alastair Grieve, "The Pre-Raphaelite Brotherhood and the Anglican High Church," *Burlington Magazine* 111 (January–June 1969): 294–295. See also Julian Treuherz, "The Pre-Raphaelites and Medieval Illuminated Manuscripts," in *Pre-Raphaelite Papers*, ed. Leslie Parris (London: Tate Gallery/Allen Lane, 1984), 157.

42. Leslie Parris, *The Pre-Raphaelites* (London: Tate Gallery, 1968), 10.

43. Olive Anderson, *Suicide in Victorian and Edwardian England* (Oxford: Clarendon Press, 1987), 43.

44. Susan P. Casteras, *English Pre-Raphaelitism and Its Reception in America in the Nineteenth Century* (Rutherford, N.J.: Fairleigh Dickinson University Press, 1990), 80–81.

45. Ibid.

46. Janine Bailly-Herzbert, "Chronology" in *Pissarro* (London: Arts Council of Great Britain and the Museum of Fine Arts Boston, 1980), 59.

47. Camille Pissarro to Lucien Pissarro [July 8, 1891], *Camille Pissarro Letters*, 179.

48. William S. Peterson, *The Ideal Book* (Berkeley: University of California Press, 1982), 75.

49. Hannoosh, "The Poet as Art Critic," 554–55.

50. Jules Laforgue to Charles Ephrussi, 12 December 1883. *Oeuvres completes de Jules Laforgue*, 5 vols. ed. Georges Jean-Aubry (Paris, 1925), 5:61.

51. Lucien Pissarro to Perris and Cazenova, 6 May 1904, Letterbook 1, part 1, p. 265. Pissarro Archive.

52. Tucker, *Monet in the Nineties*, 94.

53. Alice H. R. H. Beckwith, *Victorian Bibliomania: the Illuminated Book in Nineteenth-Century Britain* (Providence: Museum of Art, Rhode Island School of Design, 1987), 25.

54. Peterson, *The Kelmscott Press*, 235.

55. *Complete Works of John Ruskin*, 35:490–91.

56. Alice H. R. H. Beckwith, "Fairy Tales and French Impressionism: Medieval Content in Eragny Press Books," *The Year's Work in Medievalism*, ed. Ulrich Muller and Leslie Workman, vol. 5 (Salzburg: Institute für Germanistik, in press).

57. Lucien Pissarro and Charles Ricketts, *De la typographie*, 6, 9.

58. Alice H. R. Hauck, "John Ruskin's Uses of Illuminated Manuscripts, the Case of the Beaupré Antiphonary," *Arts Magazine* 56 (September 1981): 79–83.

59. Lucien Pissarro to Richard J. Jackson, 6 October 1907, Pissarro Archive.

60. Jack Zipes, *The Trials and Tribulations of Little Red Riding Hood: Versions of the Tale in Sociocultural Context* (South Hadley, Mass.: Bergin & Garvey, 1983), 2.

61. Sizeranne, *Religion of Beauty*, 92.

62. Sizeranne, *Religion of Beauty*, 103–4, 189.

63. Sizeranne, *Religion of Beauty*, 218.

64. See Robert de la Sizeranne, *Ruskin at Venice: A Lecture Given during the Ruskin Commemoration at Venice, September 21, 1905*, tr. Mrs. Frederic Harrison (London: George Allen, 1906).

65. *Marcel Proust on Reading Ruskin*, xviii–xx.

66. Sizeranne, *Religion of Beauty*, 258–59, 247.

67. *Complete Works of John Ruskin*, 24:203–5.

68. John Ruskin, *Le Repos de Saint-Marc, Histoire de Venise pour les rares voyageurs qui se soucient encore de ses monuments*, tr. K. Johnson (Paris: Hachette & Cie., 1908). My thanks to Elisabeth Russell for finding this volume for me in Monet's library.

Part IV
Continuations of the Pre-Raphaelite Tradition

Millais's Bubbles *and the Problem of Artistic Advertising*

LAUREL BRADLEY

On the occasion of John Everett Millais's funeral in 1896, Arthur Symons lamented the painter's failure to live up to his early promise: "The Burial of Millais in St. Paul's should have been an honour done to a great painter . . . [instead] it was but an honour done to a popular painter, the painter of *Bubbles* and other coloured supplements to Christmas numbers."[1] In his comments about Millais, Symons anticipated the judgments of twentieth-century Pre-Raphaelite scholarship. Customarily, the early work by the major painters of the Brotherhood—John Everett Millais, Dante Gabriel Rossetti, and William Holman Hunt—is valorized over later production. The years between 1848 and 1854 are celebrated as a golden moment of unified purpose, radical stylistic innovation, and ground-breaking iconography. For this brief period, the Pre-Raphaelite Brotherhood seems to have conformed to the avant-garde paradigm emphasized by histories of nineteenth-century French art.[2] The avant-garde Pre-Raphaelites are celebrated for their oppositional group identity, their glorification of direct response and contemporary-life themes, and their highly colored, two-dimensional style. Confronted with the dissolution of the brotherhood—and its members' increasingly divergent aims and images—scholars have often written of a sustained lapse from youthful ideals.[3] The 'progressive' Modernist agenda had apparently been betrayed.

Millais's *Bubbles* (1885–86, A. and F. Pears Company, London; on loan to the Royal Academy of Arts, London), bought by A. and F. Pears Company and used in a campaign to advertise soap—became the symbol of Millais's sin against his avant-garde beginnings. Very simply, Millais sold out: by allowing a Victorian "marriage between art and commerce," the painter clearly turned his back against the spiritual rewards of Art and embraced the more concrete joys of money. Furthermore, Millais's painting-turned-advertisement has come to represent all the ills of the Victorian art world that resisted Pre-Raphaelite reform. Millais's picture is constantly brought in as evidence of the sentimental vapidity that plagued later nineteenth-century English painting. Such art, the standard interpretation goes, was good for nothing but the tainted task of selling soap and other banal commodities.

This judgment is based on idealized notions about the nature of 'true' Modern art—notions that are, in fact, incomplete and misleading. According to this interpretation, Modern—that is, French—art in the nineteenth century resisted commodification by stretching the bounds of taste ever beyond the reach of a (mass) bourgeois audience. Interestingly enough, however, this argument glorifies the connection between advanced art and commercial imagery—but in very different terms from what one encounters with late Victorian art. Discussions of works by Edward Manet, the Impressionists, and some of the Post Impressionists have stressed the productive link between 'high' art and 'lowly' images—including advertisements—as for example, in this passage from the Museum of Modern Art's recent *High and Low Art* exhibition: "The story of the interplay between modern art and popular culture is one of the most important aspects of the history of art of our epoch. It was central to what made modern art modern at the start of this century."[4] But because the French avant-garde artists were supposedly using—rather than being used by—the emerging practices of advertising, their activity has been judged different, or 'good,' while the Victorians are left to wallow in their 'badness.' It is time to abandon this rhetoric. Artists and advertisers were engaged in a dynamic interaction during the late-nineteenth century in England and on the Continent. The relationship needs more study. This paper positions *Bubbles* in its proper con-

text: the practice of Artistic Advertising emergent in England around 1880, which developed against the background of Victorian fine art reproduction practices. This article will highlight the particular circumstances under which Art met Commerce in later Victorian England and then will sketch in a few connections to parallel situations on the Continent.

In nineteenth-century England, cheap art reproductions—made ever more widely available by advances in printing technology and the proliferation of illustrated periodicals—vied with exhibitions as the primary means of presenting art to audiences. By the latter part of the century, the type of connection between viewer and artwork had changed radically. The earlier or traditional situation was characterized by the viewer gazing at unique works of art in a gallery or private home. In many cases, what became typical by late century was a viewer 'consuming' a fine-art reproduction presented in a mass-circulation magazine or 'reading' an advertisement that highlighted a work of fine art in the same periodical. Ultimately, the habit of consuming paintings as prints and as printed advertisements affected the type of pictures produced. As Symons understood, *Bubbles* is a prime example of what these new popular patterns of art consumption created.

Millais was not the only highly respected English artist to 'work for' the advertising trade. Several things are accomplished by discussing *Bubbles* in conjunction with selected advertisements adapted from pictures by other members of the Royal Academy. First, such a discussion forces one to judge Millais as an embodiment of the Academy—which he was for most of his career (Associate Royal Academician, 1853; Royal Academician, 1863; P.R.A. 1896)—rather than as a lapsed rebel against that institution. And by considering *Bubbles* in relation to 'high art' advertisements, Millais's picture can be transformed from a symbol of personal failure into evidence of a crisis in the Victorian art world and in its institutions during the last quarter of the nineteenth century.

Artistic Advertising, pioneered in England around 1880, refers to printed advertisements in which the text was subordinated to a large-scale, 'artistic' image. Artistic Advertising marked a change in emphasis from the text-driven methods characteristic of the earlier nineteenth century to the more visual strategies still predominant today. The artistic value of these advertisements was established by using the services of a recognized fine artist and pictures that clearly participated in the conventions of 'high-art' practice. The viewer of these advertisements—

which for the most part represented a qualitative advance in the visual appeal of the medium—gained new respect for the commodity because of its halo of 'high culture' and may even have acknowledged a debt of gratitude to the manufacturer for supplying so lovely a picture—gratis—for his or her pleasure.

Although identifiable to their public, Artistic Advertisements were a rather vague category. Because 'high-art' subjects and themes in England were not all that clearly differentiated from images conceived in humbler contexts, the best way for the advertiser to communicate his elevated ambition was by picking an artist with R.A. (Royal Academician) or A.R.A. (Associate Royal Academician) affixed to his name—indicating full or associate membership in the Royal Academy. The list of Royal Academy members whose work was used by advertisers is rather short: John Everett Millais, William Powell Frith, Henry Stacy Marks, George Dunlop Leslie, Herbert Herkomer, Edward Poynter, and a few others. Other artist-illustrators—some of whom exhibited at the annual Royal Academy exhibitions—were tapped by advertisers; their names tend to be displayed less prominently, if at all, in advertisements. The academicians' participation elevated the entire enterprise to the level of cultural rather than mere commercial endeavor.[5]

While English Artistic Advertisements appeared as postcards and posters on hoardings, their most significant context for this discussion was the illustrated weekly magazine—most notably *The Graphic* and *Illustrated London News* (the latter hereafter abbreviated *ILN*). These periodicals—*The Graphic* established in 1869 and *ILN* over two decades earlier—incorporated lively illustrations into text pages. Such a visual editorial orientation suggested a similar approach to advertisements. The impact of these Artistic Advertisements was considerable in an era when most printers were still bound by the narrow columns characteristic of newspaper layouts.[6] Even before the flowering of more visual advertising strategies, the publishers of these magazines developed the practice of offering fine-art reproductions to their readers, usually in their Christmas numbers. Significantly, the same type of picture became the basis for the Artistic Advertisement.

Although not the first effort in the genre, Millais's *Bubbles* is virtually synonymous with the practice of Artistic Advertising, even today. A likeness of Millais's grandson Willie James, painted in 1885–86, was not presented at the yearly Royal Academy exhibition but sold directly to William Ingram, publisher of *ILN*, who intended to offer the image as a

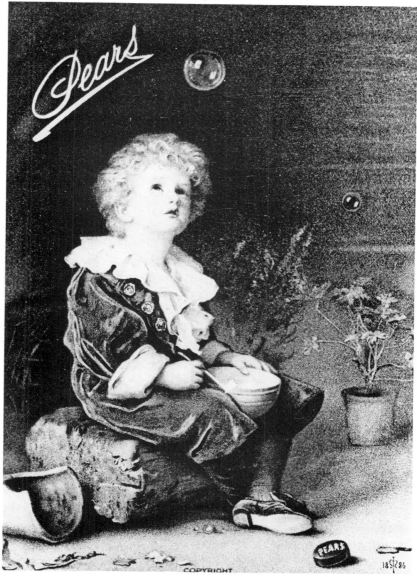

Fig. 1. Pears' Soap Advertisement. ca. 1886. 7×5".
Adapted from John Everett Millais's *Bubbles*.

color reproduction in his magazine. But before *Bubbles* ever appeared to the hundreds of thousands of *ILN* readers, the picture and copyright had changed hands. Its new owner was A. and F. Pears: the company's vice-president T. J. Barratt acquired the picture for £2,200, with the intention of modifying it for use in an advertisement. The adaptation simply involved adding a bar of Pears's soap to Millais's foreground and scrawling the company name across the top of the image. The academician's picture was thus subtly transformed from a vehicle for enjoying the wonder children experience before the fragilest natural phenomenon to a prosaic means of identifying the source of the soap bubbles—namely, the bar of Pears's soap (fig. 1). When the *ILN* finally

brought out their color reproduction of Millais's picture in the 1887 Christmas number, the original painting was identified as belonging to Messrs. A. and F. Pears of London.

It is well known that this advertisement generated a controversy about the appropriateness of such marriages between Art and Commerce that raged from the initial publication of *Bubbles* to after the artist's death. The arguments for and against the practice will be considered in due course. But in order to properly understand *Bubbles* as 'art' in its specifically Victorian context, we must recall that the picture was originally purchased for publication as an art reproduction rather than as an advertisement. Although the fact is often forgotten, it appeared in

the *ILN* Christmas number along with three other color supplements. *Bubbles* was reproduced as a double-sized image; the other color pictures were standard page size. The Millais painting was not given the very large sheet—nearly four times normal size—used, for example, for *Cherry Ripe* in the 1880 *Graphic*. This was due to the publisher's judgment about the limited appeal of male as compared with female subjects: "From many years' experience of the public taste in these coloured pictures I had found out that 'boy' subjects were not nearly so saleable as those introducing the opposite sex. For this reason, *Bubbles* was given away on a smaller scale than usual."[7]

From the very early days of the Victorian period, fine-art reproduction served as the primary "medium of communication" between the artist and the public.[8] The print-trade's expansion was fueled by several factors: advances in printing technology that brought the price of a single engraving down to a very reasonable level, the rapid growth in literacy and changing reading habits, and campaigns for improved standards of taste.[9] Aggressively entrepreneurial print-sellers—including Ernest Gambart, Henry Graves, and Thomas Agnew—made pictures available through their shops. Their influence is well summarized by Jeremy Maas:

> It is impossible to over-estimate the importance of this trade in the Victorian art world . . . it was the printsellers . . . who carried an artist's representation into every home in the country and to all four corners of the globe; it was they who brought prosperity to the artists, and of course, to themselves. When a single picture was bought by an individual and cherished in the privacy of his own home, replicas of it in the form of prints rendered cheaper when the more durable steel plate was introduced after 1820, often sold in their thousands reaching a public the size of which now seems scarcely credible.[10]

In addition, other avenues opened up between prints and the people. These included the art unions—the earliest founded in 1836—that distributed fine-art prints to subscribers.[11] *The Art Journal* (inaugurated as *The Art Union Journal* in 1839), the first monthly periodical devoted to the fine arts in Britain, presented a steady diet of fine-art engravings to its readers.

Responding to popular tastes, print publishers favored images rich in narrative incident, conventional morality, and appealing national types. The most successful Victorian artists—including William Powell Frith and Edwin Landseer—were highly skilled in creating the kind of pictures packed with pleasing

incident and pathetic sentiment that sold well as prints.[12] However, the strong connection between the Victorian aesthetic mainstream and the print trade did not preclude a relationship between the 'avant-garde' and the useful middleman. Because print sellers were the most effective agents for getting art to an audience and maximizing profits, all manner of artists dealt with them. Indeed, even members of the 'radical' Pre-Raphaelite Brotherhood contracted with these publishers, who then arranged for the engraving and distribution of prints after such pictures as Hunt's *Light of the World* (1851–54, Keble College Chapel, Oxford) or Millais's *A Huguenot* (1853, Makins Collection) and *The Order of Release, 1746* (1853, Tate Gallery, London).[13]

The wide availability of art through engravings was hailed as a good thing, part of a cure for the earlier British failure to properly support the visual arts. Print publishers were extolled as public servants.[14] Frederick G. Stephens, for example, wrote in 1860: "Indeed a national service is rendered by the publication of really noble transcripts from noble pictures. . . . Where the picture cannot go, the engravings penetrate."[15] The art unions were founded as part of a campaign to educate the public so that they would appreciate art and support artists. *The Art Journal* preached a similar sermon, which was backed up by engravings and reviews of the latest fine-art reproductions.

Print reviews reveal the type of benefits that were understood to flow from these pictures to their owners. During the earlier Victorian decades when prints figured prominently in the campaign to elevate visual-arts standards, reviewers seldom emphasized the fact that these were mere reproductions—poor substitutes for the real thing. Prints were clearly understood to resonate powerfully with the uplifting values of the originals. The effect of the prints was generally described in moral rather than aesthetic terms, thus demonstrating the premium placed on didactic narrative at this time.[16]

As the century advanced, English art won long-sought support in a popular audience. The annual Royal Academy summer exhibitions were extraordinarily well attended, all manner of periodicals ran reviews of the exhibitions over several weeks, private galleries proliferated, and international exhibitions regularly highlighted the fine arts in special pavilions. The eager public gained a convenient source of additional images with the growth of the illustrated press during the 1850s and 1860s. Weekly and monthly periodicals—including *Punch, Illustrated London News, Household Words, Corn-*

hill, and *Once a Week*—used fledgling and more established artists (regular exhibitors at the Royal Academy) for a variety of tasks, from illustrating fiction to caricaturing social mores.[17] Art reproductions in wood engraving, offered in the context of exhibition reviews, were supplemented by special full-page pictures in *ILN* and later, in *The Graphic.* Echoing the earlier boosters of the print business, commentators remarked about the value of such journals in "spreading a taste for art."[18] A typical judgment was rendered by Mason Jackson in his 1885 study on the pictorial press, which, he wrote, was "not an unimportant factor in diffusing the purifying and softening influence of art."[19]

Color printing was a valuable innovation for periodical publishers—making their product more appealing and, making in some ways, the works of art that they offered closer to the originals. Using a wood-block process, *ILN* pioneered seasonal color supplements in 1855.[20] The early Christmas numbers were plagued by technical difficulties, but by 1863 the problems had been ironed out. That year's wildly popular centerfold *Little Red Riding Hood,* based on James Sant's 1860 painting, demonstrated how the well-chosen picture, even crudely reproduced, could boost circulation dramatically.[21] Garish wood engravings were the norm for color supplement reproductions until the mid-1880s, when chromolithography and other processes gradually took over.[22]

In 1869, William Luson Thomas launched *The Graphic* in direct competition with *ILN.* He not only adopted the *ILN* practice of special oversized art features at Christmas time but encouraged a more realistic approach to illustration. Art, then, enhanced the appeal of the magazine on more than one level. In a sense, the magazine's readers received free fine-art reproductions, and illustrations based on the unstintingly truthful ethos bolstered the credibility of the news features.[23] This formula proved highly appealing: the magazine "regularly outsold all the serious journals combined."[24] However, claims for artistic quality may have been overstated, as Hartley Spatt has pointed out. Even though pictorial reportage often rose above the ordinary during the early years, the pictures chosen for the special supplements were more sentimental than naturalistic, more iconic than narrative.[25] Millais's art—which had shifted from the intense, and intensely narrative, visions of his Pre-Raphaelite period to more broadly painted, art-historical–looking portraits and portrait-like pictures—was the ideal source for the most prestigious of these pictures.

Indeed, the two publishers Ingram and Thomas competed for the latest cute progeny of the artist, beginning with *Puss in Boots.* According to Ingram of *ILN,* this picture

> as a supplement, was an enormous success, and was followed by one of the most charming children pictures which has ever been produced—namely, *Cherry Ripe,* by the same artist, brought out by our enterprising rivals, the *Graphic.* In keen rivalry, we (*The News* and the *Graphic*) produced Christmas after Christmas several of Sir John Millais's beautiful children subjects. . . . [T]he country is indebted to the enterprise of the two leading illustrated papers for several of Sir John Millais's beautiful children portraits.[26]

In total, six holiday supplements presented Millais's pictures. The four brought out by *ILN* were *Puss in Boots* (1878), *Northwest Passage* (1885), *Little Miss Muffet* (1886), and *Bubbles* (1887). The features in *The Graphic* were *Cherry Ripe* (1880) and *Cinderella* (1882).

Ingram, who certainly contributed greatly to Millais's popularity by making his pictures so readily available in cheap color reproduction, claimed credit for the very formula behind Millais's charming children resonant with emotional appeal and art-historical pedigree. In fact, Millais himself had evolved this approach, beginning in contemporary dress with the nearly narrative *My First Sermon* (1862, Guildhall Art Gallery, London) and *My Second Sermon* (1863, Guildhall Art Gallery London) and moving through *Souvenir to Velasquez* (1863, Royal Academy of Arts, London)—distinguished by its broad, "art-historical" brush—to pictures like *Cherry Ripe* and *Bubbles,* inflected with references to eighteenth-century, English old masters.[27] These pictures represent a major type within Millais's later oeuvre. Other categories included (a) adult portraiture, (b) literary and historical efforts featuring one or two figures, and (c) the rare, but powerful, empty landscape.

By the time that *Bubbles* appeared as an advertisement and an original canvas, Millais was at the top of his profession, making around £30,000 a year. In 1885, he became a baronet, the first artist so honored. The Grosvenor Gallery staged a career retrospective of the painter's work in 1886. This type of one-artist show—in Victorian times, generally reserved for deceased artists—helped to consolidate Millais's reputation as a living English old master, proper heir to Sir Joshua Reynolds, the first President of the Royal Academy.[28] Millais, the honored academician, coexisted with Millais, "our most popu-

lar painter."[29] Although difficult to accept today, Millais's popularity, which was encouraged by the wide availability of cheap prints of his paintings, did not seriously undermine his credibility as a great artist. Clever publishers forged mutually beneficial partnerships with Millais, whose prestige and pictures helped to sell magazines and whose talents and services were well paid for by magazine publishers.

Negative criticism about prevailing art-reproduction practices emerged very slowly. The habit persisted of praising for public service the print publishers—a group now claiming some magazine publishers as honorary members. However, differences in technical quality between the various reproductive media were undeniable. The metal-plate engraving, executed by such a master craftsman as Samuel Cousins over many months, would yield a much more refined impression of a painting than the rapidly produced wood engravings common to illustrated journalism. This and other problems were underlined by a growing number of art critics and a few artists themselves.

Critiques of reproduction practices focused on issues of audience, quantity, and technical quality. Occasionally, a critic would go further, musing about the more profound effect of this oversupply of images on art and art consumption. Negative arguments frequently hinged on the apparent desire of publishers to appeal to the widest possible audience. Instead of supporting challenging work that could ultimately elevate untutored tastes, publishers were accused of merely responding to existing trivial values. As John Ruskin observed in his testimony before an 1868 Parliamentary Select Committee, this publishing practice ultimately caused a "want of refinement" in pictures exhibited at the Royal Academy because artists were being forced by economic circumstances to rely on patronage "from the manufacturing districts and from the public interested in engravings;—an exceedingly wide sphere, but a low sphere."[30] William Davies, writing for *Quarterly Review* (1873) several years later, also implicated slapdash reproduction in his general indictment of English art:

> The deterioration of Art among us is in some measure also due to the number of drawings continually in preparation to be poured from the press in the shape of cuts for our periodicals, newspapers, and illustrated books. . . . If we had a tenth part of this numerous progeny well conceived, thoroughly digested, and faithfully wrought out, it would be infinitely cheaper at the price paid for mere quantity, and would give us more than ten times the pleasure; the national taste might become cultivated instead of vitiated, and some noble purpose

of Art might be served. As it is, we are flooded with slovenly workmanship, or with a shallow and easy facility which is still worse, unrelieved by any touch of mental power or the slightest sense of spiritual meaning.[31]

One positive, if radical, solution to this perceived negative situation was posed by artist James McNeill Whistler. In the 1880s, he offered his prints as a corrective to the creeping mediocrity encouraged by mass production and popular subjects. Under the banner of Art for Art's Sake, Whistler targeted a hoped-for elite as an audience for fine-art prints. The 'art' value of the standard reproductive engraving depended on a work in another medium—namely, painting; the printmaker/craftsman was valued to the degree that his technique did not detract from the picture's legibility. By contrast, Whistler's lithographs and etchings celebrated what an 'artist' could do as a printmaker; autograph gestures and other displays of technical originality became the new measures of value.[32]

In 1875, Ruskin aptly dramatized the effect of popular patterns of art consumption on contemporary art. In his *Academy Notes,* Ruskin likened the Royal Academy summer show to a set of *Graphic* centerfolds!!

> The Royal Academy of England, in its annual publication, is nothing more than a large coloured *Illustrated Times* folded in saloons, —the splendidest May number of the *Graphic,* shall we call it? That is to say, it is a certain quantity of pleasant, but imperfect, 'illustration' of passing events, mixed with as much gossip of the past, and tattle of the future, as may be probably agreeable to a populace supremely ignorant of the one, and reckless of the other.[33]

It is not surprising that Millais, whose posthumous fortunes were plagued by Symons's and others' dismissals of him as the "painter of *Bubbles* and other colored supplements to Christmas numbers," bore the brunt of Ruskin's more specific criticisms in this review. As Kristine Garrigan has pointed out, Millais was finally judged as a man of great talent corrupted by the demands of "a mechanistic, materialistic society."[34] But even if Millais's paintings and other holiday supplement pictures had been more challenging and intellectually ambitious, their high cultural messages would have been diluted by the new patterns of consumption. In 1873, William Davies described the effect of this context, by noting "the dissipations of ephemeral literature, which do not allow men's minds to settle long on any one consideration, however important it may be; the constant flow of fugitive ideas that submerges all things in its course; an inconsiderate and superficial haste, which prevents

repose and permits nothing to be done with thoroughness."[35] His was indeed prescient recognition that the medium becomes the message!

Although Ruskin, Whistler and others argued persuasively about the negative influence of art-reproduction practices on art, theirs was not the majority opinion. For the most part, the Victorian art audience happily and uncritically consumed pictures that were created to please. Yet gradually and inevitably, the interest of this loyal public began to wane. As anecdotal realism lost impetus, various currents surfaced in its stead. Nothing clearly dominated during the last quarter of the nineteenth century. After Ruskin abandoned art criticism to concentrate on more purely economic issues, no visionary critic with his broad appeal emerged to redirect the course of late-Victorian art. Institutional leadership was virtually absent—by this time, the Royal Academy had effectively opted out of an intellectual leadership role.[36] Living artists, who had grown used to social respect and solid middle-class incomes, were buffeted by the winds of economic depression and aesthetic uncertainty.[37] Many artists began to search for new subjects, new sources of income, new formats for art production. Their problem was to figure out what the audience wanted—an audience whose tastes had been tutored by illustrated journalism. This audience had difficulty distinguishing between an authentic or original work of art, on the one hand, and a reproduction on the other—or a work executed with an eye to the highest intellectual and formal principles opposed to the more accessible, so-called pretty picture.

Artistic Advertising was launched on the sea of transition when artists were suffering insecurity and the advertising profession was on the rise. Whereas at midcentury the advertising profession was clearly on the margins of respectability, as more and more firms adopted its services in an economy increasingly oriented toward consumption, the profession's standing improved. One major signal of England's economic shift from production to consumption was the widespread introduction to brand names, especially "into the area of basic household commodities and foodstuffs."[38] To make one product stand out from an array of very similar ones, "manufacturers of repeat-purchase household products rapidly developed into some of the heaviest advertisers."[39] Soap was one of the first markets to become fully permeated by advertising. Art was a key element in strategies designed to lend distinction to the mundane product. Furthermore, art's noble 'aura' helped to counteract any residual disdain for the advertising professional.

Two key players—lauded as pioneers in early advertising histories—were Thomas J. Barratt and William Hesketh Lever. In 1856, Barratt joined Pears (a firm dating back to 1789), raising the advertising budget from virtually nothing to £80,000 annually—and eventually up to £126,000. Lever, whose Lancashire family business of grocery wholesaling expanded into soap manufacturing in 1885, launched his Sunlight brand with methods heavily influenced by Barratt's. Lever's advertising expenditures ultimately surpassed Pears's. Lever eagerly competed in the art collecting arena as well—becoming especially identified with championing the English school of painting.[40]

The use of 'high art' to sell humble commodities generated a controversy that can prove useful to the modern scholar. The various arguments for and against the practice provide keys to the conflicting

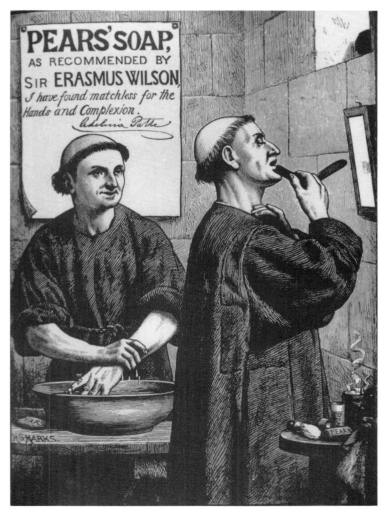

Fig. 2. Henry Stacy Marks. *Cleanliness Is Next to Godliness.* Late 1870s. 8 × 5½". Pears' Soap Advertisement. From *Illustrated London News.*

and sometimes poorly defined ideals that shaped the late-Victorian art world. This paper will take up those arguments and consider them in the light of a few key Artistic Advertisements.

Millais's *Bubbles* is indeed the most famous example of Artistic Advertising. This appealing picture of a young boy blowing bubbles was painted in sonorous old-master browns by the English artist considered in his day most worthy of a place in future artistic pantheons. *Bubbles,* however, does not represent the first conversion of an artful image into a powerful marketing tool. In the late 1870s, the vice-president of Pears approached Henry Stacy Marks, newly elevated Royal Academician (1878; A.R.A. in 1871) who specialized in humorous incidents set in the Middle Ages. The result was *Cleanliness Is Next to Godliness* (fig. 2), an advertisement featuring quaint types and picturesque historical detail—the old-time setting implying that the product's value was long established. Such nostalgic appeals are stock-in-trade of advertisers even today. The story line of the advertisement further enlivens the merchant's message: these tonsured monks—who not only keep their faces but also their heads clean-shaven—have great need of a lubricating soap to ease their toilet; their recommendations therefore, should carry (divine) weight. This picture was commissioned for Pears's specific use, making the circumstances of production different from Millais's *Bubbles,* which was originally intended as a painting to be framed and hung, but was sold with a copyright for reproduction—and sold again with a copyright that conferred permission to adapt the picture to the owner's purposes. Millais did not design his picture to be an advertisement, although he may have conceived it with the periodical market in mind—and must, at some point, have approved the changes wrought by Pears.[41]

Although Millais never designed a picture specifically for the use of an advertiser, the impact of his cherubic child formula on advertisements was strong. Pears followed its 1886 *Bubbles* advertisement with *More Bubbles* the next year, commissioning artist Édouard Frere to design a female version of Millais's wonder-struck little boy. When this advertisement appeared in the 10 December 1887 *ILN,* the connection to the earlier Millais picture was spelled out in the text. The links between colored pictures offered as 'art'—part of the editorial content of the magazine—and advertising imagery were also often very close.[42]

Millais's *Little Miss Muffet* is a useful example of the dialogue—ever conducted to the advertiser's advantage—between the commercial and editorial sides of these magazines. *Little Miss Muffet* made two appearances in the 1886 Christmas supplement of *ILN*—as a large, fold-out color print (fig. 3)—and was reduced and humorously caricatured in an advertisement for Judson's Gold Paint. Not a regular advertiser, the pigment manufacturer—in its practice of collecting and elaborately framing the holiday color supplement—apparently recognized a golden opportunity for pushing its product. The cartoonist presented a two-frame narrative (fig. 4): in the first part of the advertisement ("with apologies to Sir John Millais, Bart."), a discriminating gentleman evaluates the condition of the frame while a rather disgruntled Miss Muffet looks on; in the second part, an aged artisan-owner touches up the frame with—what else?—Judson's Gold Paint. Carrying home the point is an adaptation of the original nursery rhyme: "Little Miss Muffet, Who sat on a Tuffet / Made a Picture both Charming and Quaint / By the time She was Thirty / the Frame was quite dirty/ They renewed it with Judson's Gold Paint!" Because the paint advertiser was able to so clearly link his advertising images to the fine-art supplement, the Millais picture was transformed into an extension of the sales appeal. Conversely, the paint advertisement honored the publisher's strategy of using special supplements to expand circulation. The entire magazine became bound up in the project of selling—selling products and selling the magazine as product.[43]

The controversy surrounding Artistic Advertising was at its most intense from the late 1880s through the 1890s. Formal and informal position papers appeared throughout this period in art magazines and more general publications. The controversy hinged on whether any marriage between Art and Commerce could be appropriate. Arguments focused on the benefits of such a relationship to the partners, as well as the effect on the audience. Did all parties benefit mutually? Or was this a case in which one party exploited the other? Which party was the prime beneficiary—the artist, the advertiser, or the audience?

First, consider the audience. Most Victorian observers agreed that artistic advertising had a salutory effect on the audience and that the ordinary man on the street could not help but benefit from advertisers' use of great artists. This view was stated unequivocably by William Blake Richmond, portraitist and Slade Professor of Painting (1879–82), who believed that Artistic Advertising was "a most powerful weapon for disseminating good art in the most public manner possible."[44] According to Millais, Artistic Ad-

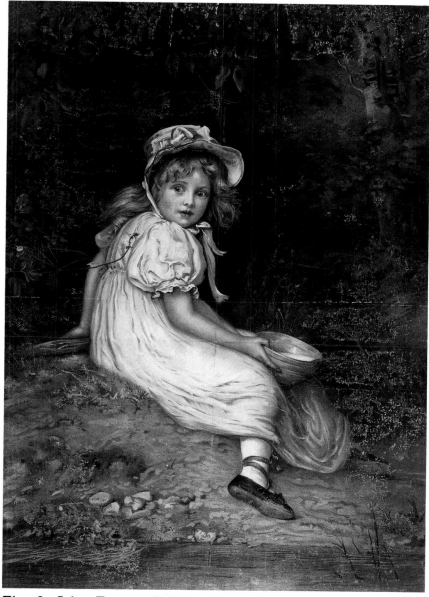

Fig. 3. John Everett Millais. *Little Miss Muffet*. 1886. 26½ × 19″. Color engraving after the 1885 painting, *Illustrated London News*. December 25, 1886.

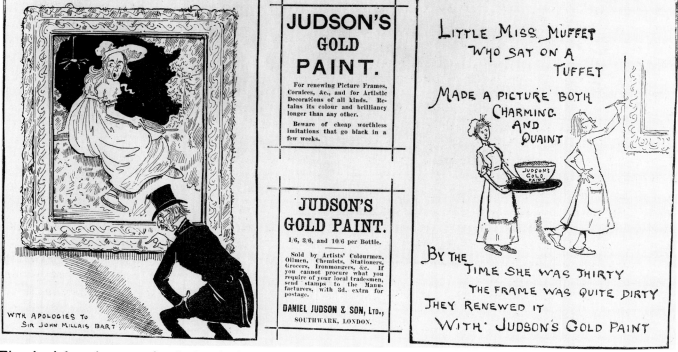

Fig. 4. Advertisement for Judson's Gold Painting. 8 × 11″. From *Illustrated London News*. December 25, 1886.

vertising would counteract the "atrocious vulgari-
ties"[45] of most visual sales appeals and could even
foster improved aesthetic standards among members
of a public not disposed toward art-gallery visits.

This argument is constructed on the same scaffold
of reasoning that earlier supported the widespread
dissemination of reproductive engravings. The ad-
vertisers, like the print sellers, were credited with
educating public taste by making available officially
sanctioned examples of art. Advertisers themselves
enthusiastically replayed these arguments. Accord-
ing to their reasoning, Artistic Advertising furthered
the cause of culture in a highly efficient manner; in-
deed, by the late nineteenth century, advertisers had
become the *most effective* means available for fur-
thering the cause of art. In 1889, Thomas Barratt
wrote to the *Pall Mall Gazette:* "I maintain that we
personally can do more good for the spread of art
and culture than your Royal Academy or your end-
less galleries."[46]

This rationale was caricatured in George Gissing's
In the Year of Jubilee. In that 1895 novel, the adver-
tising man Luckworth Crewe fancies himself a patron
of the arts. To educate the popular taste, he dreams
of sponsoring a lecture series with "a few leading
men," Edward Burne-Jones and William Morris
among them. His vision of art is wrapped up in a
boosterish faith in progress, which he observes in
art, technology, and a rising standard of living. He
identifies advertising as a primary vehicle for en-
couraging this beneficial force. The advertising man
makes his position clear in a speech to a reluctant
property owner, who resists allowing a billboard to be
planted in his backyard. Crewe brings him around:

> Look here . . . my dear sir, you're impeding the prog-
> ress of civilization. How could we have become what
> we are without the modern science and art of advertis-
> ing? Till advertising sprang up, the world was barba-
> rous. Do you suppose people kept themselves clean
> before they were reminded at every corner of the bene-
> fits of soap? Do you suppose they were healthy before
> every wall and hoarding told them what medicine to
> take for their ailments? Not they indeed! Why, a man
> like you,—an enlightened man, . . . ought to be proud
> of helping on the age.[47]

The impact of Artistic Advertising on the status
of art was of vital concern since victory over apathy
and ignorance had been so recent. Marion H. Spiel-
mann, editor of the *Magazine of Art,* delivered his
judgment on the matter in these terms in 1889:
"Most men . . . are surely of the opinion that Art,
like Truth, can only dignify and beautify that with
which it comes into contact, and that . . . commerce

. . . has everything to gain, and art nothing to lose, by
the union."[48] In other words, Art was of so elevated a
nature that it could not be defiled; thus, any sphere
of activity would benefit from an arranged 'marriage'
with Art.

Maria Corelli, in an often-quoted passage from
her *Sorrows of Satan,* strenuously disagreed. In the
first edition of the 1895 novel, Corelli challenged the
notion that art, and the dignity of an artist, could not
be tainted by bad company: "I am one of those who
think the name of Millais as an artist was marred
when he degraded himself to the level of painting
the little green boy blowing bubbles of Pears soap.
That was an advertisement, and that very incident
in his career, trifling as it seems, will prevent his ever
standing on the dignified height of distinction with
such masters in art as Romney, Sir Peter Lely,
Gainsborough, and Reynolds."[49]

Once Corelli learned that Millais had not willfully
collaborated in the commercialization of his picture,
she retracted her censure. Corelli's vision of art as a
noble activity was similar to Spielmann's. But she
suspected that Art's luminous aura was too fragile to
survive the "descent" to the mundane level on which
commerce was transacted. The editor of *The Maga-
zine of Art,* by contrast, was confident that art's
power was sufficient to alchemically transform
anything into cultural gold with which it came into
contact.

Since Millais's position remained difficult to pin
down, it was left to his son, with the 1899 *Life and
Letters,* to posthumously defend the painter's "purity
of intention." Claiming that his father was horrified
at what the soap company had done to *Bubbles,*
he recalled the unexpected visit of Pears manager,
Thomas J. Barratt:

> To my father's astonishment he called at the studio one
> morning with specimens of the coloured engraving that
> they proposed to publish as an advertisement of their
> wares. My father was furious. He protested strongly
> against this utilisation of his art; but knowing that he
> had no power to prevent their using the picture in any
> way they liked, he at last consented to look at the speci-
> mens. Their excellence tended somewhat to assuage his
> wrath; he admitted . . . that the work was admirably
> done, and with an expression of his regret at the pur-
> pose to which it was to be turned the interview ended.[50]

A series of letters published in the London *Times*
during November 1899 undermines the credibility
of this account. Persuasive witnesses wrote for either
side—although testimony seems to have been
weighted toward the case of Millais as willing hus-
band to Dame Commerce. Supporting the son's ver-

sion is a letter from Richardson Evans, Honorary Secretary of the National Society for Checking the Abuses of Public Advertising (N.S.C.A.P.A.): "About the painter's general feeling on questions of this kind, there should be no room for doubt. He was one of the first members of our council. . . . I understood him to be half amused and half annoyed at the . . . calmness of those who, while practising systematically—without scruple or apparent remorse—wholesale and gross disfigurement, canted about encouraging art."[51] Evans's advertising man is the consummate hypocrite embodied in Gissing's Luckworth Crewe. The major target of N.S.C.A.P.A.—claiming as members artists William Holman Hunt, William Morris, Walter Crane, and Sir John Millais—was the erection of signs and hoardings, what Evans called "the March of Disfigurement." Millais could conceivably have been sympathetic to this cause, even while smiling upon the more private presentation of artistic advertisements in magazines; but there is no other evidence besides his name on a very prestigious list of N.S.C.A.P.A. members that he took an activist position on matters of visual pollution.[52]

Thomas J. Barratt, William Ingram (original purchaser of *Bubbles*), and Charles Deschamps all wrote to contradict John Guille Millais's version of his father's views. According to Barratt, Millais had enthusiastically endorsed the project of adapting his painting to Pears's purposes and, furthermore, had offered to champion the needs of advertisers among his fellow artists. In Barratt's account, Millais had dismissed the possible dangers that associating with commerce might hold for an artist, with the following words: "What . . . nonsense!! I will paint as many pictures for advertisement as you like to give me commissions for and I will write you a letter for publication marking my appreciation of the excellent way in which you have dealt with my picture."[53]

This letter had never been written. Charles Deschamps, secretary for the British-art section of the 1899 Paris Exhibition, was therefore moved to write the London *Times* about his experiences with Millais. According to Deschamps, when the issue was raised of whether or not the painting *Bubbles*—after its use by Pears—was an appropriate choice to represent British art at an international exhibition, Millais replied vigorously "Nonsense, why not? It is an admirable reproduction and is a credit to Messrs. Pears, and to my picture, which is a good one."[54]

What were Millais's views? Millais most likely had no serious objection to the use of his picture for the task that Pears had assigned. Since the early 1860s, Millais had shown himself eager to address a wide audience and to command a large income from a variety of sources, including copyright sales to mass-circulation periodicals. But, while certainly a pragmatist, Millais knew his livelihood was based on a reputation as an ambitious artist of the highest order. In his maturity, even his rebellious Pre-Raphaelite youth served to bolster his position as a living master of the English school of painting: those early efforts had been fighting gestures of a young man dedicated to putting English art back on its worthy Realist path—the celebration of Nature being one of the highest ideals of English culture. If *Bubbles*, therefore, was judged to be a lapse, not for its original content, its easy sentimentality, and obvious historicizing, but because it had been used in advertising, then Millais would most likely have pronounced against the practice. He may have said so in private to his son late in life. Ever sensitive to the public pulse, Millais might have recognized that the brief honeymoon period for Art and Commerce was over and that the couple would drift apart. But, in fact, judging from published arguments for and against Artistic Advertising, there was no consensus against the practice. And public opinion had not yet decisively turned against the type of art so easily co-opted for the purposes of selling soap. Most readers of Pears's *Bubbles* advertisement were happy to receive a virtually free print of a picture by the future President of the Royal Academy. And Millais accepted popularity as the price of gaining an audience.

In England, the advertiser in search of arresting images to sell products worked within the dominant picture-making institution of the day—namely, the Royal Academy.[55] The advertiser adapted already painted pictures or commissioned an academician to glorify an object for sale. Design followed art. In France, a different set of strategies emerged in the advertising field. Briefly summarized, the designer rather than the artist set standards. The lithographer and commercial printer Jules Cheret exerted the critical influence. His lively poster designs—emphasizing bright colors, bold shapes, curving lines, and the full integration of image and text—began to appear in the 1860s and 1870s in Paris. His eye-catching outdoor advertisements for music halls and other popular entertainments—for example, *Bal au Moulin Rouge* (1889, fig. 5)—were imitated and modified by other prominent late–nineteenth-century French designers, including Eugène Grasset, Henri de Toulouse-Lautrec and Théophile Alexandre Steinlen. The poster captivated avant-garde artists and the public, including Seurat; and, in the

Fig. 5. Jules Cheret. *Bal au Moulin Rouge*. 1884. Color
Lithograph. 23½ × 16½". Rutgers University Art Gallery,
New Brunswick, N.J.

1890s, the poster became 'art'—exhibited by deal-
ers, cherished by collectors.[56]

Cheret's fresh approach, conditioned early on by
his exposure to design-reform ideas in England,[57] ul-
timately triumphed in England, as it had in France
and elsewhere on the Continent.[58] By the 1890s, a
breed of skilled poster artists had emerged, including
Aubrey Beardsley, Dudley Hardy, the Beggarstaff
Brothers, and John Hassall. For their designs—for
example, Hassall's ca. 1900 Colman's Mustard ad-

vertisement (fig. 6)—these poster artists are clearly
indebted to Cheret's ideas that consisted of the bold,
positive use of the white page, the simplification of
elements, the sweeping curves connecting forms, and
the integration of image and text.[59]

It is too simple and misleading to attribute the
ultimate triumph of so-called good design in England
to French influence. Connoisseurs in France who
popularized the poster movement in the 1890s will-
ingly acknowledged the value of occasional earlier

English efforts.[60] In 1889, the highly successful academician William Powell Frith published a convincing appeal in which he encouraged advertisers when putting together a promotional campaign, to use specialists—that is, designers—not pictures designed for 'high-art' purposes.[61] M. H. Spielmann, the editor of *The Magazine of Art,* responded to Frith's article. Spielmann's response may explain why Frith's countrymen in the advertising business were slow to reject the practice of Artistic Advertising. What the advertiser lost, by using an advertising designer or illustrator, was the cultural cachet implicit in fine-art's 'aura' and the dignity it lent to even the lowliest product. Furthermore, the advertiser traded an arguably more effective image, on the one hand, for the publicity value attendant on procuring a popular picture for marketing uses, on the other. The ever practical Spielmann reminded his readers of the perceived necessity

> felt by the trader for novelty or audacity in advertisement. For that reason ... the purchase of "popular" pictures will probably always find the greatest favour with the advertiser, for he thereby not only commands attention by the fitness of the work to the recommendation of his wares, but also trades upon the affection or esteem of the public for the artist, and their admiration for his work in general; while, moreover, he makes the world talk of his coup, and enlists, maybe, their gratitude by making them laugh at his ingenuity, or by placing before them a work of sterling merit and considerable beauty.[62]

In Germany, as in France, the poster movement ultimately set the tone for visual advertising strategies. It is worth bringing into this discussion—for purposes of comparison with the Pears *Bubbles* campaign—at least one striking example of the fine artist cooperating with a manufacturer to produce advertisements. Franz von Stuck was a highly successful member of the Munich art establishment. Like Millais's paintings, von Stuck's early works were branded examples of advanced taste. In the early 1900s, Stuck's cast of mythological characters—nymphs, nature spirits, centaurs—began to appear in an advertising campaign to promote Odol Mouthwash (see fig. 7) in the Munich-based art and music magazine *Der Jugend*. The mouthwash manufacturer, an avid collector of Stuck's art, hoped to confer on his personal-hygiene product some of the timeless flavor and mythopoeic aura surrounding Stuck's beasts and maidens.[63]

Although the Artistic Advertisement did not ultimately prevail in England, it offered a potential source of revenue to Victorian artists during the last

Fig. 6. Advertisement for Colman's Mustard. John Hassall. *The Mustard Girl.* ca. 1900. Color Lithograph. 22 × 18". John Johnson Collection, Bodleian Library, Oxford.

quarter of the nineteenth century. Shifting tastes resulted in falling revenues for Victorian genre painters, including Millais and members of the St. John's Wood Clique, which claimed Henry Stacy Marks.[64] This reduction in revenue was difficult to accept for a group that had been living as affluent middle-class professionals. These English artists then sought out new strategies to maintain their incomes and their respectable social status. The easiest route to continued prosperity was portraiture,[65] a genre in which Millais was well established. Advertising in its 'artistic' embodiment would, therefore, seem to have arrived at just the right time. In the late 1870s, Marks received a lucrative commission from Pears; his anecdotal historical approach—both pretentiously learned in its period detail and intentionally familiar

Fig. 7. Advertisement for Odol mouthwash adapting Franz
Stuck painting. 5½ × 4″. From *Der Jugend*, 1905.

in its choice of moments—fit perfectly with the need
of a soap maker in search of an image. Pears's mes-
sage could fill the vacuum of meaning at the center
of this latter-day form of history painting. Yet instead
of exploiting this situation, Marks changed direction
completely in the 1880s, turning from anecdotal
historical-genre subjects to decorative panels for do-
mestic interiors.[66]

In the final reckoning, Millais—even though he
did not paint *Bubbles* as an image to sell soap—
played the role of advertising artist more fully than

Marks. Although Millais (who became President of
the Royal Academy in the last months of his life)
never suffered financially from the softening art mar-
ket, he was not insensitive to the conditions that
might make artists turn to portraiture—or that might
motivate them to design soap ads. The ultimate
measure of Millais's lucrative sensitivity to popular
taste is his holiday-supplement pictures. His
juvenile charmers,[67] reproduced and stapled inside
Christmas issues, sold a spectacular number of maga-
zines. The purveyors of Pears and Sunlight soap,

advertising within the covers of the same periodicals, did not misappropriate a subject ludicrously unfit for their commercial purposes. They simply took an already commercially conceived image and shifted its purpose from the sale of magazines—and the promotion of Millais's popularity—to enhancing the prestige of a particular brand of soap.

Millais instinctively understood how art was defined by new patterns of consumption. The concept of 'high art' as a sphere of noble endeavor transacted on a plane far above that of normal human activity had never taken deep root in England, as is evident in the failure of history painting. What the English loved was a domestic art—an art that enhanced the daily circumstances of their lives. Once the visual arts were firmly established in nineteenth-century England, it was clear that the romantic notion that a good artist must be impoverished was not considered credible. Artists won the battle for recognition as middle-class professionals; the higher their prices, the more worthy they appeared in the public mind. The association of art and money—of good art producing good income for its creator—was confirmed by distribution practices. The interdependence of the artist and the dealer/print sellers underlined the mercantile character of Victorian art. This connection was intensified, in some cases, by the activities of the mass-circulation magazine publishers and advertisers. Vague high-minded ideals continued to define art as an ennobling experience—educational in both moral and aesthetic terms. But the reality of new throw-away patterns of consumption did not encourage viewers to ponder the exact nature of the lessons that they were learning. Seemingly, it was sufficient to surround oneself with art—often simply by reading a magazine[68]—and its valuable 'benefit' would make itself felt.

After his embrace by the Royal Academy and his artistic and financial crisis of the late 1850s,[69] Millais was happy to embody the inherited hierarchical distinctions of institutional art. But because of his credibility—enhanced by the manifest idealism of his youthful rebellion—he could gesture downwards without fear of falling from his elevated perch. The painter lived in both worlds—the Olympian realm of Ideal Values and the cozy arena of English life. But the controversy that survived him and *Bubbles*,—and that became more heated after his death—makes clear that the painter had, in fact, been teetering on the brink.

Millais had been the quintessential Victorian artist, with a wide—nearly unified—audience behind him. He died as Modernism gained hold. Reformers from Whistler to Clive Bell and Roger Fry, leaning on Continental examples, brought much needed clarity to the muddy pond of Victorian aesthetic theory. But a major tenet of their theory—that Art's mysterious power relied on the separation of art from daily life[70]—cast virtually all of Victorian art into aesthetic purgatory. Only the most avant-garde work could maintain any claim on 'true art.' After the long and hard campaign for public support for the arts had apparently been won, the public was rejected for its demeaning influence. Art—which could no longer engage with mere Commerce except on the level of design reform—lost its appeal to and relevance for most of the English. An elite embraced Art and created quiet 'temples' for their aesthetic meditations. The broad public was left with what the Modernists were to define as "kitsch," including favorite Victorian pictures, as well as old and new advertisements that ever more clamorously colonized the imagination.[71]

NOTES

1. Arthur Symons, "The Lesson of Millais," in Robert L. Peters, *Victorians on Literature and Art* (New York: Appleton-Century-Crofts, 1961), 321.

2. On the notion of the avant-garde, see Linda Nochlin, "The Invention of the Avant-garde: France, 1830–1880," *The Politics of Vision: Essays of Nineteenth-Century Art and Society* (New York: Harper and Row, 1989), 1–18. Among the most explicit discussions of the PRB as a group of Modernist rebels is Herbert Sussman, "The Pre-Raphaelite Brotherhood and Their Circle: The Formation of the Victorian Avant-garde," *The Victorian Newsletter* (Spring 1980): 7–9.

3. Each artist "sinned" differently. Rossetti, who painted variations on the same sensuous female theme over and over again, is judged least harshly because of his influence on the younger aesthetic generation. Hunt became tiresomely pedantic and pictorially overwrought.

4. Kirk Varnedoe and Adam Gopnik, introduction to *High and Low:*

Modern Art and Popular Culture (New York: Museum of Modern Art, 1990), 19. Another scholar offers a similar, if more complex, argument; Thomas Crow, in "Modernism and Mass Culture in the Visual Arts," in Francis Frascina, ed., *Pollock and After: The Critical Debate* (New York: Harper and Row, 1985), 233, opens his essay with the observation: "From its beginnings, the artistic avant-garde has discovered, renewed, or re-invented itself by identifying with marginal, 'non-artistic' forms of expressivity and display."

5. On *artistic advertising*, See Frank Presbrey, *The History and Development of Advertising* (Garden City, N.Y.: Doubleday, 1929), chap. XII; Jean-Pierre Navailles, "L'art et la publicité à la fin de l'époque victorienne," *Gazette des Beaux-Arts*, 105 (May-June 1985): 197–204; William Sharpe, "J. E. Millais' *Bubbles*: A Work of Art in the Age of Mechanical Reproduction," *The Victorian Newsletter* 70 (Fall 1986): 15–18.

6. Presbrey, 94–97.

7. Quoted in *Great Victorian Pictures* (London: Arts Council of Great Britain, 1978), 60. Pears addressed this "gender gap" by following *Bubbles* with *More Bubbles* in 1887, as revealed in this essay.

8. Phrase from "The Publications of Mr. Alderman Moon," *Art Journal* 2 (January 1850): 30.

9. Anthony Dyson, "Images Interpreted: Landseer and the Engraving Trade," *Print Quarterly* 1 (March 1984): 29–30; and Anthony King, "George Godwin and the Art Union of London 1837–1911," *Victorian Studies* 8 (December 1964): 102–3.

10. Jeremy Maas, *Gambart: Prince of the Victorian Art World* (London: Barrie and Jenkins, 1975), 28.

11. King, 101–30.

12. On the Victorian print trade, see London, *Great Victorian Pictures;* Rodney K. Engen, *Victorian Engravings* (London: Academy Editions, 1975); and Hilary Guise, *Great Victorian Engravings: A Collectors Guide* (London: Astragal Books, 1980).

13. Hunt contracted with Ernest Gambart for the publication of *Light of the World* in 1854; the print was not issued until 1858. See Maas, 66–68. Millais and Henry Graves agreed on the terms of publishing *The Order of Release, 1746* in June 1853. The print was not issued until 1856, along with the reproductive engraving of *A Huguenot*. The owner of the latter picture had negotiated independently with Graves on the terms of reproduction. See Malcolm Warner, "The Professional Career of John Everett Millais to 1863, With a Catalogue of Works to the Same Date," Ph.D. thesis (Courtauld Institute of Art, University of London, 1985), 76ff.

14. For example, "The Publications," *Art Journal Journal* 12 (1850): 30.

15. Stephens is referring to prints after paintings by William Holman Hunt in an 1860 pamphlet, quoted in Maas, 122.

16. For example, see John Ruskin, "Notes on the Present State of Engraving in England," *Works*, eds. E. T. Cook and A. Wedderburn (London: George Allen, 1903–12), XXII, 470, who found "that practically at this moment I cannot get a *single* piece of true, sweet, and comprehensible art, to place for instruction in any children's school!"

17. See Paula Gillett, *Worlds of Art: Painters in Victorian Society* (New Brunswick, N.J.: Rutgers University Press, 1990), 246, on magazines providing an economic cushion for fledgling artists.

18. King, 109.

19. Mason Jackson, *The Pictorial Press: Its Origin and Progress* (London: Hurst and Blackett, 1885), 304.

20. The initial color supplement special, offering four pictures, was published to celebrate reaching sales of two hundred thousand copies per issue. C. T. Courtney Lewis, *The Story of Picture Printing in England during the 19th Century* (London: S. Low, Marston and Co., 1928), 83–84: "Bad as the prints are as works of art, the public took to them, and they could hardly be produced fast enough." For the next twenty years, "some of the worst colored illustrations of our history [were] produced."

21. *Great Victorian Pictures*, 73.

22. Lewis, 84.

23. Harry Quilter likened the *Graphic* illustrational approach to the Pre-Raphaelite creed in the shared commitment to "truth." "Some *Graphic* Artists," *Universal Review* 2 (1888): 94–104: "The principle of getting rid of convention, which, briefly put, is the beginning and end of the pre-Raphaelite creed, is exemplified in nearly every illustration in this number" (98): "The real change which the *Graphic* artists effected in illustrated journalism lay in this fact, that they introduced the idea of making their weekly records into pictures, not by the old conventional methods, but by treating their subjects according to natural fact" (102).

24. Hartley S. Spatt, "The Aesthetics of Editorship: Creating Taste in the Victorian Art World," in *Innovators and Preachers: The Role of the Editor in Victorian England*, ed. Joel H. Wiener (Westport, Conn.: Greenwood Press, 1985), 46.

25. Ibid., 53–56.

26. *Times*, letter (22 November 1899): 7.

27. For a discussion of the eighteenth-century (English Old Master) inflections of Millais's child subjects, see my Ph.D. thesis entitled "Evocations of the Eighteenth Century in Victorian Painting," New York University, 1986.

28. The Millais exhibition followed a major Reynolds retrospective staged at the Grosvenor in 1883–84. On the one-man exhibition as part of an emergent method of constructing an artist as (Modernist) genius, see Gordon J. Fyfe, "Art Exhibitions and Power during the Nineteenth Century," in *Power, Action and Belief: A New Sociology of Knowledge?* ed. John Law (London, Routledge and Kegan Paul, 1986), 38–39.

29. This phrase is from a very insightful article by Emilie Isabel Barrington, "Why Is Mr. Millais Our Popular Painter," *Fortnightly Review* 32 (1882): 60–77.

30. Ruskin, XIV, 483.

31. William Davies, "The State of English Painting," *Quarterly Review*, 134 (April 1873), in *Victorian Painting: Essays and Reviews*, ed. John Charles Olmsted (New York: Garland, 1980), III, 326.

32. Martha Tedeschi, "For the Few or the Many? Whistler and the Reform of the Print Trade in Late-Victorian England," paper delivered at the Interdisciplinary Nineteenth Century Studies annual conference, 1991, New Haven, Conn.

33. Ruskin, XIV, 263.

34. Kristine Ottesen Garrigan, "'The splendidest May number of the *Graphic*': John Ruskin and the Royal Academy Exhibition of 1875," *Victorian Periodicals Review* 24 (Spring 1991): 27.

35. Davies, 327.

36. H. C. Morgan, "The Lost Opportunity of the Royal Academy: An Assessment of its Position in the Nineteenth Century," *Journal of the Warburg and Courtauld Institutes*, 32 (1969): 410–20; Fyfe, 20–44.

37. Gillett, esp. chap. 2 and 4.

38. On the early phase of this shift, see Neil McKendrick, John Brewer, and J. H. Plumb, *The Birth of a Consumer Society* (London: Europa, 1982). Another study charting the impact of the consumer society on an artist's self-promotional strategies is Regina Gagnier's *Idylls of the Marketplace: Oscar Wilde and the Victorian Public* (Stanford, Calif.: Stanford University Press, 1986).

39. T. R. Nevett, *Advertising in Britain: A History* (London: Heineman, 1982), 67, 72.

40. Ibid., 72–74. See also Charles Wilson, *The History of Unilever* (London: Cassell and Co., 1954), I, 9–44.; *Lord Leverhulme: A Great Edwardian Collector and Builder* (London: Royal Academy of Arts, 1980), esp. Edward Morris, "Paintings and Sculpture," 14–37.

41. This was a copyright law requirement.

42. The connection between advertising and editorial content was brought home to readers when *Bubbles* finally came out as an *ILN* supplement in December 1887. The inscription "from the celebrated picture. The property of Messrs. A and F Pears of London" confirms the primary function of the image as a Pears advertisement.

43. Very few nineteenth-century commentators recognized the encroachment by advertisers on the editorial content of the magazines. One exception is H. J. Palmer, who decried the practice of "masked advertisement"—blurring the boundaries between editorial and advertising content of periodicals. See "The March of the Advertiser," *The Nineteenth Century: A Monthly Review* 41 (January 1897): 135–41.

44. Quoted by M. H. Spielmann, "By the Editor," *Magazine of Art* 13 (1889): 427.

45. J. G. Millais, *The Life and Letters of Sir John Everett Millais* (London: Methuen, 1899).

46. Morris, 14.

47. George Gissing, *In the Year of Jubilee* (London: Sidgewick and Jackson, Ltd., 1911), 74.

48. Spielmann, 426.

49. Quoted in London, *Great Victorian Pictures*, 60.

50. J. G. Millais, 189.

51. Richardson Evans, *The Times* (24 November 1899): 7.

52. On N.S.C.A.P.A., see Nevett, 117, and Richardson Evans, 1893.

53. Thomas Barratt, *The Times* (17 November 1899): 14.

54. Charles Deschamps, *The Times* (23 November 1899): 15.

55. Thomas Richards in *The Commodity Culture of Victorian England: Advertising and Spectacle, 1851–1914* (Stanford, Calif.: Stanford University Press, 1990), 254, makes the point that earlier advertisers "worked within the dominant institutions of the age and adapted them to their own ends. And there was no reason not to; the public they addressed reposed its confidence in the monarchy, empire, and professional elites in a way that no advertisers could take for granted after World War I."

56. Publications on the "Modern Poster" or the "Poster Revival" include Robert Goldwater, "'L'Affiche Moderne': A Revival of Poster Art after 1880," *Gazette des Beaux-Arts* 22 (December 1942): 173–82; Robert Koch, "The Poster Movement and 'Art Nouveau,'" *Gazette des Beaux-Arts* 50 (November 1957): 285–96; Philip Dennis Cate and Sinclair Hamilton Hitchings, *The Color Revolution: Color Lithography in France 1890–1900* (New Brunswick, N.J.: Rutgers University Art Gallery), 1978.

57. Cheret worked in London from 1859 to 1866 designing for perfume manufacturer Eugene Rimmel who, as a member of the Royal Society of Arts, was an active campaigner for design reform. See Bradford R. Collins, "The Poster as Art; Jules Cheret and the Struggle for

the Equality of the Arts in Late 19th century France," *Design Issues* 2 (1985): 42–43.

58. W. S. Rogers, a British designer and connoisseur, acknowledged French priority in artistic poster design in his 1914 essay, "The Modern Poster: Its Essentials and Significance," originally published in the *London Journal of the Royal Society of Arts* 62 (23 January 1914): 186–92. Reprinted in *L'Affiche Anglaise: Les Années 90* (Paris: Musée des Arts Decoratifs, 1972).

59. See Charles Hiatt, *Picture Posters* (London: George Bell, 1896), chaps. VII and VIII; Diana and Geoffrey Hindley, *Advertising in Victorian England 1837–1901* (London: Wayland, 1972), 68–79; Nevett, 86–89.

60. For example, see Octave Uzanne, "Les Affiches Etrangère," *La Plume* 155 (1 October 1895): 409–16.

61. W. P. Frith, "Artistic Advertising," *Magazine of Art*, 13 (1889): 423. Frith's article was written partly in response to his own experience as a reluctant "advertising artist." His 1889 painting *The New Frock* was converted to a Sunlight Soap ad, "So Clean."

62. Spielmann, 426. Direct comparisons between the state of French and British advertising design in the later nineteenth century are difficult to make because of great differences in publishing practices, the advertising profession, and patterns of consumption in the two countries. In England, the most ambitious ad campaigns for brand name consumer products addressed a national audience through the illustrated press and posters. Such unified campaigns were less effective in France because the consumption of soap, mustard, and so on, was more fragmented by class and region. Furthermore, the periodical press was not fully developed as an advertising venue in the late nineteenth century. There were very few large display ads in magazines such as *L'Illustration*, which otherwise closely resembled British general interest weeklies. Department stores did advertize prominently but usually ran cataloguelike illustrations rather than something more "artful." The poster, encouraged by an 1881 law protecting hoarding, was the most dynamic arena for innovation in France. One of the few articles comparing French advertising practices with those elsewhere is Daniel Pope, "French Advertising Men and the American 'Promised Land,'" *Historical Reflections* 5 (1978): 117–38.

63. Henriette Vath, "Zur Instrumentalisierung Stuckscher Bildideen in der Reklame um die Jahrhundertwende: Odol'hommage a Stuck," in *Franz von Stuck* (Munich: Museum Villa Stuck, 1984), 174–81.

64. On the St. John's Wood Clique, see Bevis Hillier, "The St. John's Wood Clique," *Apollo* 79 (June 1964): 490–95. Another member of this group, G. D. Leslie, painted *This Is the Way We Wash Our Clothes*. The 1887 picture of a woman in eighteenth-century dress was bought by William Lever from the Royal Academy exhibition and adapted for use in an advertisement.

65. The case of Frank Holl is instructive, as Paula Gillett describes in chap. 4.

66. For Marks's biography, see *Great Victorian Pictures*, 56, and James Dafforne, "British Artists: Henry Stacy Marks," *The Art Journal* 22 (1870): 362. Marks, who designed at least one other advertisement for Pears—even while characterizing himself as a "bourgeois, philistine, soulless creature"—did not mention his contributions to late Victorian advertising in his two-volume autobiography. See H. S. Marks, *Pen and Pencil Sketches* (Philadelphia: Lippincott, 1894), II, 80.

67. For discussion of Millais's most successful holiday supplement picture, *Cherry Ripe*, see my "From Eden to Empire: John Everett Millais's *Cherry Ripe*," *Victorian Studies* 34 (Winter 1991): 179–204.

68. Kristine Garrigan, 28, makes a similar point in her discussion of the impact of Henry Blackburn's *Academy Notes*, published beginning in 1875 with thumbnail sketches of most of the R.A. pictures: "By stressing both the unique authenticity of his product and the enthusiastic participation of artists in its manufacture, Blackburn implied that his handbooks had a special aesthetic and archival legitimacy. Moreover, by creating a market among consumers who were either 'unable' to visit the Exhibition or who 'wish[ed] to save time and trouble examining its contents' when they did attend, he implied that his rudimentary illustrations were somehow acceptable substitutes for the originals, enabling purchasers to construct (or reconstruct) a viewing experience and permanently 'possess' these works into the bargain. Finally, the language of indiscriminate encomium in the brief accompanying commentaries posited aesthetic worth that the illustrations simply did not validate. Yet among uncritical purchasers, conditioned to the kind of 'disposable' viewing that periodical reproduction encouraged, this discrepancy would assumedly be neither particularly apparent nor very important. The inexpensive presence of Blackburn's *Academy Notes* in their parlors were satisfactory compensation for the absence of the paintings themselves."

69. See M. Warner, 89–150, esp. "Conclusion," 140–150.

70. Clive Bell's 1914 essay, "The Aesthetic Hypothesis," argues that the carrier of "aesthetic emotions" in an art work is its "significant form": "In each, lines and colours combined in a particular way, certain forms and relations of forms, stir our aesthetic emotions. These relations and combinations of lines and colours, these aesthetically moving forms, I call 'significant form'; and 'significant form' is the one quality common to all works of visual art." He differentiates pictures appealing on the level of content, "that interest us and excite our admiration" (for example, Frith's *Paddington Station*) from those empowered by "significant form": (p. 71) and makes clear that only some people are "capable of appreciating" a good work of visual art; those who cannot "feel pure aesthetic emotions remember pictures by their subjects; whereas people who can, as often as not, have no idea what the subject of a picture is" (p. 74) from Francis Frascina and Charles Harrison, eds., *Modern Art and Modernism: A Critical Anthology* (New York: Harper and Row, 1982).

71. Rachel Bowlby, writing about the literary marketplace, remarks on the extreme irony of this situation: "The same developments which were binding commerce and culture closer together, making commerce into a matter of beautiful images and culture into a matter of trade, a sector of commerce, also, paradoxically, led to the theoretical distinction whereby they were seen not just as heterogeneous terms but as antithetical in nature. The 'absolute' value of 'art for art's sake' versus the monetary values of commerce became a standard opposition in contemporary debates." *Just Looking: Consumer Culture in Dreiser, Gissing and Zola* (New York and London: Methuen, 1985), 9.

Aubrey Beardsley, the Last Pre-Raphaelite

GAIL S. WEINBERG

FOR A REVOLUTIONARY MOVEMENT, PRE-RAPHAELITISM was relatively long-lived. Beginning in 1848, it persisted in one form or another until the start of the twentieth century, changing its character to some degree from decade to decade, but continuing to exert an influence on English and Continental art. In 1857, when the movement was on the verge of dissolution, it gained a new lease on life when Dante Gabriel Rossetti went to Oxford to paint the walls of the Oxford Union Debating Society, helped by some of his new disciples, with scenes from Malory's *Le Morte d'Arthur*. Of these new disciples, the most influential were William Morris and Edward Burne-Jones, whose variations on Rossetti's style were to influence the course of Rossetti's own work in the late 1850s.

Although Burne-Jones and Morris were only about five years younger than Rossetti, they are usually called the "second generation" of Pre-Raphaelites. Aubrey Beardsley, then, would represent the third generation, and in this case, at least, the dates are right. Born in 1872, Beardsley was almost forty years younger than Burne-Jones, although the two men were to die within months of each other, in 1898. Afflicted with tuberculosis, Beardsley did not live past the age of twenty-five, but within that brief span he produced a body of work that was not only broadly influential in the context of European art, especially in the formation of the international style of Art Nouveau, but was also remarkably varied in character.

Working at the very end of the nineteenth century, Beardsley recapitulated at high speed that century's interest in historic revivals. Neo-medieval, neo-Renaissance, neo-rococo, neo-Baroque—his style underwent numerous transformations, but his historic references have tended to be overlooked because of the success with which he transformed his sources and the impression of daring modernity which his art conveyed. Nonetheless, throughout Beardsley's career, his work, like that of his Pre-Raphaelite precursors and their Continental contemporaries, betrayed constant evidence of the influence of earlier European art, especially that of the early Italian Renaissance.

Beardsley began his career as an avowed disciple of the Pre-Raphaelites. His first commission, an illustrated edition of Malory's *Le Morte d'Arthur*, intended to rival the productions of William Morris's Kelmscott Press, was strongly Pre-Raphaelite in character, and Beardsley owed the very existence of his career in art to Edward Burne-Jones. The style of Beardsley's early work shows the influence not only of the English Pre-Raphaelites but of the early Italian painters whom the Pre-Raphaelites admired and emulated. Therefore, his exposure to early Italian art was twofold—both in its own guise and as an element in the style of the Pre-Raphaelites. Throughout his life, even after his discipleship to Burne-Jones waned, Beardsley continued to show the influence and to value the work of the early Italian painters whom the Pre-Raphaelites had cherished.

In the summer of 1891, within one week two events occurred that were to be decisive for the nature and even the fact of Beardsley's career as an artist: his visit to Frederick Leyland's London townhouse at 49 Prince's Gate and his visit to the studio of Edward Burne-Jones. Early in July 1891, Beardsley wrote to a friend, G. F. Scotson-Clark: "Yesterday I went to Mr Leyland's house. His collection is GLORIOUS."[1] Beardsley's sketch ("Going thro' the rooms," 1891, location unknown, fig. 1) of this event shows his sister Mabel and himself exploring the Prince's Gate mansion, observed by an impassive footman.[2] The formality of Leyland's staff was evidently a point to be noticed. When William Ro-

Fig. 1. Aubrey Beardsley. *"Going thro' the rooms": Beards-ley's Visit to Frederick Leyland's Mansion.* Photograph of original drawing. 1891. Present location unknown. Reproduced in *The Uncollected Work of Aubrey Beardsley*, with an introduction by C. Lewis Hind. (London: John Lane; N.Y.: Dodd, Mead and Co., 1925). 6½" × 7¼". By permission of Houghton Library, Harvard University.

thenstein visited Leyland's house with a friend, Arthur Studd, "the bell was answered by a major-domo, with powdered hair, yellow livery with heavy knots across the shoulders and noble silk-clad calves, so impressive a figure, that Studd in presenting the letter of introduction at the door, instinctively took off his hat."[3]

Leyland was a great collector of old masters, including a proportion of early Italian paintings unusual for his day, as well as a great patron of Dante Gabriel Rossetti and Edward Burne-Jones, so that his mansion was, in a dual sense, a Pre-Raphaelite

paradise. Beardsley began his list of Leyland's paintings, interspersed with frequent exclamation marks, with eleven paintings by Rossetti, including Leyland's version of *The Blessed Damozel* (1875–79, now in the Lady Lever Art Gallery at Port Sunlight),[4] *Mnemosyne* (1881), *Lady Lilith* (1868) and *Veronica Veronese* (1872) (all in the Bancroft Collection at the Delaware Art Museum), and *The Sea Spell* (1877, Fogg Art Museum, Cambridge, Mass.). He followed this with a list of eight paintings by Burne-Jones, including *Merlin and Vivien* (1870–74, also in the Lady Lever Art Gallery), *The Mirror of*

Venus (1873–77, now in the Gulbenkian Foundation, Lisbon), and *Day* and *Night* (1870, both now in the Fogg Art Museum). He ended his list of Pre-Raphaelite pictures in Leyland's collection by noting G. F. Watts's portrait of Rossetti (ca. 1871, National Portrait Gallery, London), Ford Madox Brown's *The Entombment* (1868, Faringdon Collection, Buscot Park) and *Chaucer at King Edward's Court* (1851–68, Tate Gallery, London), and *The Eve of Saint Agnes,* by John Everett Millais (1863, now in the collection of Her Majesty the Queen Mother).

For his list of Leyland's old masters, Beardsley began with five paintings by Sandro Botticelli—a Madonna (Leyland owned three Madonnas attributed to the master) and the four panels of scenes from Boccaccio's tale of Nastagio degli Onesti (1483, three are now in the Prado and one is in a private collection).[5] He continued his account with two paintings by Fra Filippo Lippi, a Madonna and an Adoration of the Magi,[6] and pictures by "Giorgione, Memling, Luini, Vinci, Vecchio, Costa, Rubens etc." Leyland also owned two paintings by an artist who, like Botticelli, was to exercise a great influence on Beardsley—Carlo Crivelli. One was the beautiful painting of *Saint George and the Dragon* (1470, now in the Isabella Stewart Gardner Museum, Boston).

Following his list of the collection, in a page omitted from the printed text of this letter, Beardsley summed up his impressions of this experience, singling out his favorite paintings:

> The house itself of course is grand, very dark. I was there about two hours. The Burne Jones pictures are perhaps the most interesting in the collection. The two Pictures of Ford M. Brown are quite extraordinary, very preraphaelite. The "Chaucer at Court" a small round picture with about 30 figures, is the best. I enclose Hasty impression of it. If I can get a photo I will send you one.[7]

Even before his visit to Leyland's mansion, Beardsley had been exposed, through Scotson-Clark, to another notable collection of Pre-Raphaelite paintings, that of J. Hamilton Trist of Brighton, and, in his next letter to Scotson-Clark, Beardsley expanded on his enthusiasm for Leyland's Pre-Raphaelites, stating:

> I have not yet got over the Leyland collection. I thought I had told you how much I liked the two pictures of Ford Madox Brown which I saw there. The colouring is extremely preraphaelite; his "burial of Christ" might easily be taken for an early Flemish painting. F.M.B. was only 8 years Rosetti's [sic] senior, & as you know D.G.R.'s master. . . . By the way I don't agree with you that Rossetti is "infinitely preferable" to E. B. Jones. However I share your admiration of Veronica Veronese,

which is I think in every respect his most perfect and beautiful single figure painting.[8]

As important to Leyland as the paintings which he owned—perhaps more so—was the setting in which they were displayed. Leyland's rival as old-master collector and Pre-Raphaelite patron, William Graham, was a profuse and disorderly accumulator. "He bought paintings so largely," his daughter recalled, "that our house in Grosvenor Place was literally lined with them in every room from floor to ceiling; old and modern, sacred and profane; they stood in heaps on the floor and on the chairs and tables."[9] In contrast, Leyland, aided by his architect Norman Shaw, his decorator Thomas Jeckyll, and his adviser, the dealer Murray Marks, meticulously supervised his décor, regarding paintings as only one element of an *ensemble* composed of gilded Spanish leather wall-coverings, buhl cabinets, blue-and-white china, and cloisonné enamel vases.[10] So much more important was the whole to him than its parts that Leyland did not scruple to reject paintings by Rossetti if they were a few inches too small or too large for the place he had allotted to them in his decorative schemes.[11] "He really is not a collector," Charles Augustus Howell cavilled, "and only buys a thing when he wants it for a certain place. He is never taken with the beauty of a certain pot or anything, he only sees that such and such a corner requires a pot and then he orders one."[12]

Although the mansion itself and all its contents were sold at auction in 1892 after Leyland's death, with the aid of photographs taken by H. Bedford Lemere before the dispersal of the collection it is still possible to recreate Beardsley's experience in walking through the rooms.[13] Lemere's photographs show the house to be richly but, for the period, not profusely decorated and rigorously ordered—tondo calling to tondo across the barrier of a Florentine cassone or a Venetian commode. In hanging his collection, Leyland seems to have exercised a form of segregation: Rossetti's and Burne-Jones's paintings hung in the entrance hall, on the staircase wall, and in two of the three interconnecting drawing-rooms upstairs, while the old masters hung in Leyland's study and in the third salon—"The Italian Room" (fig. 2).[14]

Curiously enough, in Beardsley's first flood of enthusiasm, he omitted mention of the painter who left the greatest impact on the house, and, in time, on Beardsley's style, the serpent in this Pre-Raphaelite paradise, James Abbott McNeill Whistler. Whistler's imprint was everywhere in 49 Prince's Gate, from the dado panels of the staircase, painted in imitation

Fig. 2. Photograph of the West Salon ("The Italian Room") in the Leyland Mansion. ca. 1892. Reproduced from the catalogue published by Osborn and Mercer, London, 17 June 1892, for the sale of the Mansion, formerly the residence of the Late F. R. Leyland, 49 Prince's Gate, S.W. 7½" × 9½". By courtesy of the Board of Trustees of the Victoria and Albert Museum.

of aventurine lacquer, to the portraits of Mr. and Mrs. Leyland, now appropriately separated (he at the Freer, she at the Frick), for the couple had been divorced since 1879.[15] Ironically, Leyland is now chiefly remembered for a commission that he never authorized, but that is nonetheless Whistler's masterpiece for him, the famous Peacock Room, now in the Freer Gallery. This glorious extravaganza of peacocks and their plumes, in harmonies of blue on gold and gold on blue, had originated as a mere trifling touch-up, to bring the décor of Leyland's dining room, intended for the display of his collection of blue-and-white china, into harmony with Whistler's own painting, *La Princesse du Pays de la Porcelaine* (1863–65, now reunited with the room at the Freer

Gallery, Washington, D.C.).[16] The Peacock Room even seems to have contributed to the Leylands' divorce. Incensed at the extent of Whistler's painted interventions and at the price which he charged for them, Leyland forbade Whistler to come into contact with his family, an edict that Mrs. Leyland flouted.[17]

The omission of the Peacock Room from Beardsley's catalogue of Leyland's paintings was only momentary. In his second letter to Scotson-Clark, Beardsley noted that "Whistler has a large painting in his Peacock Room [and how furious Leyland would have been at this casual use of the possessive, ascribing ownership of the room to the painter, not the patron]. I suppose this is what you mean by the Jap Girl painting a vase. The figure is very beautiful

and gorgeously painted, the colour being principally old gold,"[18] illustrating his praise of *La Princesse du Pays de la Porcelaine* with a sketch in gold and blue of Whistler's painting hanging on a wall decorated with peacocks.[19]

In the same letter, Beardsley made his praise of Whistler concrete by noting a new purchase: "I have just got hold of a gem in the shape of an etching by Whistler dated 1859."[20] Within a month of Beardsley's praise of the Peacock Room, he mentioned admiringly Whistler's *Miss Alexander* (*Harmony in Grey and Green: Miss Cicely Alexander*, 1872–73, Tate Gallery, London)—"a truly glorious, mysterious, and evasive picture," and his portrait of his mother (*Arrangement in Grey and Black: Portrait of the Painter's Mother*, 1871, Musée du Louvre, Paris), "the curtain marvellously painted, the border shining with wonderful silver notes."[21] Again he illustrated his praise with a sketch (now lost) of *Miss Alexander* (9 August 1891, location unknown) and a drawing of *Whistler's Mother* (9 August 1891, location unknown).[22] It was not, however, the Whistler of these reticent portraits nor of the misty Nocturnes but the decorator of the Peacock Room, with its bold contrasts of light and dark and its swinging proto-Art Nouveau curves, who was to influence Beardsley's style, in time helping to terminate the Pre-Raphaelite period of Beardsley's art.

The second crucial event of July 1891, Beardsley's visit to Burne-Jones's studio, took place a week after his visit to Leyland's mansion. This was evidently premeditated, for in his letter describing his impressions of 49 Prince's Gate, perhaps inspired by his assessment that "the Burne Jones pictures are perhaps the most interesting in the collection," Beardsley announced, "I am going to Burne-Jones next week."[23] On Sunday, 12 July, he made good his intention, and wrote the next day:

> Yesterday (Sunday) I and my sister went to see the Studio of Burne-Jones, as I had heard that admittance might be gained to see the pictures by sending in one's visiting card. When we arrived however we were told that the Studio had not been open for some years and that we could not see Mr Burne-Jones without a special appointment. So we left somewhat disconsolately.
>
> I had hardly turned the corner when I heard a quick step behind me, and a voice which said, "Pray come back, I couldn't think of letting you go away without seeing the pictures, after a journey on a hot day like this." The voice was that of Burne-Jones, who escorted us back to his house and took us into the Studio, showing and explaining everything. His kindness was wonderful as we were perfect strangers, he not even knowing our names.

> By the merest chance I happened to have some of my best drawings with me, and I asked him to look at them and give me his opinion. . . . After he had examined them for a few minutes he exclaimed, "there is *no* doubt about your gift, one day you will most assuredly paint very great and beautiful pictures. . . . All are *full* of thought, poetry and imagination. Nature has given you every gift which is necessary to become a great artist. I *seldom* or *never* advise anyone to take up art as a profession, but in your case I can do nothing else." And all this from the greatest living artist in Europe.[24]

Beardsley's dramatic narration indicates his awe before his idol of the moment, and the titles of the drawings, which he so disingenuously "happened" to have with him "by the merest chance," are Pre-Raphaelite—"Saint Veronica on the Evening of Good Friday," or even Rossettian—"Dante at the Court of Con Grande della Scala" or "Dante Designing an Angel." Rossetti's death in 1882 had paradoxically given the public more exposure to the artist's work in the form of memorial exhibitions held the following year than his reluctance to exhibit in public had afforded during his lifetime.[25] In addition, photographs of Rossetti's paintings now existed; Beardsley congratulated G. F. Scotson-Clark on his "luck in getting those Autotyped Rossettis."[26] In addition to Beardsley's exposure to Leyland's Rossettis, his friend and patron the Reverend Alfred Gurney, the Vicar of St. Barnabas, Pimlico, owned Rossetti's drawings of the *Death of Lady Macbeth* (1875, Ashmolean Museum, Oxford) and *A Vision of Fiammetta* (ca. 1877, location unknown).[27] Also Rossettian in subject was Beardsley's early drawing of "Annovale della Morte di Beatrice" (1891, location unknown), showing a frieze of figures watching Dante drawing an angel on the anniversary of the death of Beatrice.[28] The influence of Rossetti, as well as of Blake (himself an influence on Rossetti), can be seen in Beardsley's early drawing, dated about 1890 by Brian Reade, of *Dante in Exile* (location unknown).[29]

Rossetti had been Burne-Jones's mentor, and, at first, his idol; "he was so fascinating," Burne-Jones said, "that he could bring over whatever man he chose."[30] Under the influence of both Rossetti and Ruskin,[31] Burne-Jones's career progressed, like Rossetti's, in stages of historic revivalism. When Rossetti became Burne-Jones's mentor in the mid 1850s, Rossetti was going through a "chivalric Froissartian" phase, both in the style of his watercolors—deeply influenced by medieval manuscript illumination—and in his literary sources, most notably Malory, whose *Le Morte d'Arthur* provided the subject matter for the culminating works of this period, the mu-

rals of the Oxford Union. To this influence was joined that of Dürer, whose prints, recommended to Burne-Jones by his close (and persistently intervening) friend John Ruskin, clearly inspired the work of Burne-Jones's first phase, intricately detailed medievalizing black-and-white drawings like *Sir Galahad* (1858, Fogg Art Museum, Cambridge, Mass.).[32]

Ruskin's rejection of medievalism and his espousal of Venetian art in the late 1850s and 1860s was shared both by Rossetti, whose female portraits of this time showed the influence of Titian and Palma Vecchio, and by Burne-Jones, whose *Chant d'Amour* both in the watercolor version (1865, Museum of Fine Arts, Boston) and in the oil painting (1868–77, Metropolitan Museum of Art, New York), displays a lyrical Giorgionesque feeling in the figures and the landscape, testifying to the effect on him of a "study trip" to Italy taken in 1862 with Ruskin for the express purpose of copying Venetian art.[33]

By the time that Beardsley met him, Burne-Jones had evolved the characteristic style of his maturity that caused him to be called "an English quattrocentist." From the 1870s on, the elongated figures, shallow rectangular spaces, and friezelike composition of Burne-Jones's paintings clearly show the influence of such late-fifteenth-century artists as Botticelli, Signorelli, Carpaccio, and Mantegna. As early as his first trip to Italy in 1859, Burne-Jones had begun to copy the works of early Italian painters. A sketchbook dating from this period includes copies from Benozzo Gozzoli, Ghirlandaio, Filippino Lippi, Carpaccio, and Botticelli,[34] while, in 1859, as John Christian has pointed out, "Carpaccio and Botticelli were both artists Ruskin had not yet 'discovered.'"[35] Ruskin himself admitted that he did not discover Carpaccio until 1869 and then under Burne-Jones's influence,[36] and Ruskin's espousal of Botticelli in the 1870s seems to have owed its impetus to his reading of Walter Pater's article on Botticelli, published in the *Fortnightly Review* in 1870.[37]

The influence of early Italian art, memorialized by the name the Pre-Raphaelites had assumed, was not confined to English artists. Burne-Jones's contemporaries in France were also rediscovering early Italian art. Even before Degas's prolonged trip to Italy in 1856 to 1859, he had copied Mantegna's *Pallas Expelling the Vices* (ca. 1499–1502) in the Louvre.[38] During his trip to Italy, Degas was in constant correspondence with his friend Gustave Moreau, who shared and encouraged his taste for early Italian art. Both Moreau and Degas copied the frescoes by Benozzo Gozzoli in the Campo Santo at Pisa, which, through the medium of Lasinio's engravings,

had determined the character of Pre-Raphaelitism at its inception. Degas mentioned Botticelli's *Primavera* (1478, Uffizi Gallery, Florence) to Moreau and Degas's copy of Botticelli's *Birth of Venus* (ca. 1486, Uffizi Gallery, Florence) is exquisite in its linear precision, as well as accurate in its proportions.[39]

In Italy in the late 1850s, Moreau made numerous copies of early Italian art, including works by Botticelli, Pollaiuolo, Mantegna, Signorelli, Ghirlandaio, and Carpaccio.[40] His large copy of Carpaccio's fresco of Saint George and the Dragon (1502–8) in San Giorgio degli Schiavoni, Venice, a fresco that had the honor of being copied by Ruskin himself, is one of the surprises of the Musée Gustave Moreau. Moreau's *Oedipus and the Sphinx,* his great success of the Salon of 1864 (Metropolitan Museum of Art, New York), clearly betrays the influence of Quattrocento painting in the long flat face and body and stiff posture of Oedipus, such a startling contrast to the perky, though predatory, rococo figure of the Sphinx, and critics at the time discerned and even descried the influence on Moreau of Carpaccio and Mantegna.

Even Degas's friend James Jacques Joseph Tissot, who would make his name during the 1870s by his paintings of fashionably clad society women and their suitors done in England, had been impressed during a trip to Italy in 1862 by Carpaccio, Bellini, and Mantegna, and a drawing ascribed to Tissot (Museum of the Rhode Island School of Design) not only copies the heads of a group of figures in Botticelli's *Adoration of the Magi* (ca. 1475) in the Uffizi, but also attempts—in the medium of lead pencil with white heightening on greyish-blue paper—to recreate some of the qualities of late-fifteenth-century drawings in silverpoint.[41]

Although Burne-Jones largely shared Rossetti's sources, two factors made Burne-Jones's exposures to early Italian art more numerous than Rossetti's. Rossetti's opportunities to see early Italian art had been limited by his refusal to travel to Italy, though his trip to France and Belgium in 1849 with Holman Hunt exposed him to early Italian and early Flemish painting, to which he reacted enthusiastically. Early Italian art was also available to Rossetti in reproductive form, early in his career in the medium of prints, most notably in the case of Carlo Lasinio's engravings of the frescoes in the Campo Santo, Pisa, and, by the 1870s, in the medium of photography. Charles Fairfax Murray, who performed the same function for Ruskin, supplied Rossetti with such photographs as that of Botticelli's *Primavera* which inspired Rossetti to write his sonnet to the painting.[42] In contrast to Rossetti, Burne-Jones traveled to Italy four times:

in 1859, 1862, 1871, and 1873, noting after the third of these trips that "now I care most for Michael Angelo, Luca Signorelli, Mantegna, Giotto, Botticelli, Andrea del Sarto, Paolo Uccello, and Piero della Francesca."[43]

Another factor that might seem trivial—the fact that Burne-Jones was five years younger than Rossetti—nonetheless greatly increased Burne-Jones's ability to see early Italian painting during his formative years on his homeground, specifically in the National Gallery. Malcolm Warner has pointed out that during the formative years of the Pre-Raphaelite Brotherhood, between 1848 and 1853, during and shortly after the period when Rossetti, Hunt, and Millais were students at the Royal Academy, the Academy shared the premises of the National Gallery in Trafalgar Square and that therefore the paintings in the collection were constantly and closely available to the Pre-Raphaelites, though at this date the collection of the National Gallery included few early Italian and early Flemish paintings (the notable exception being one masterpiece in the "Pre-Raphaelite" taste, Jan van Eyck's *Arnolfini Wedding* [1434], acquired by the Gallery in 1842).[44] Early Italian paintings would not be bought in significant quantity by the National Gallery until Sir Charles Eastlake's term as director from 1855 to 1865.

Burne-Jones was extremely fond of the National Gallery "to which," his wife recalled, "his mind and soul constantly turned as a hallowed place,"[45] and he had opportunities to see it given to few, afforded by his friendship with Ruskin: "We paid our visit to him [in 1858] in the basement of the National Gallery, where he was working at the classification and preservation of the Turner bequest of drawing. . . . He shewed us, too, some old pictures lately brought back from Italy by Sir Charles Eastlake, but not yet hung."[46] Burne-Jones's paintings revealed the influence of the National Gallery's acquisitions. *The Death of Procris* by Piero di Cosimo (ca. 1500), acquired in 1862, has been suggested as a source for Burne-Jones's *Pan and Psyche* (1869–74, Fogg Art Museum, Cambridge, Mass.),[47] while Mantegna's *Virgin and Child with the Magdalen and Saint John the Baptist* (ca. 1500), purchased in 1855,[48] seems to have contributed to Burne-Jones's *King Cophetua and the Beggar Maid* (1884, Tate Gallery, London), for the Beggar Maid's scanty vest recalls the similar garment of the Baptist, with its appropriate overtones of holy poverty.

Besides trips, prints, photographs, and public collections, other sources had been available to the Pre-

Raphaelites for viewing early Italian paintings. Throughout the century, auctions were an important source of exposure to old masters. William Michael Rossetti noted that Dante Gabriel Rossetti's poem, *For an Annunciation, Early German,* was inspired by a painting that his brother saw at auction,[49] and Burne-Jones accompanied the director of the National Gallery to the auction of Alexander Barker's paintings in 1874 and to the sale of the Hamilton Palace Collection in 1882.[50] English private collections of old masters were also available to the Pre-Raphaelites in the form of old-master exhibitions, a nineteenth-century innovation,[51] first at the British Institution from 1815 to 1867 and, from 1870 on, at the Royal Academy. Unfortunately, there is no evidence that the Pre-Raphaelites attended the British Institution old masters exhibition of 1848, the year of their founding, which presented a novelty—an entire roomful of early Italian and early Flemish painting. However, William Michael Rossetti noted that his brother's poem on Leonardo's *Madonna of the Rocks* was inspired, not by the version (1483) in the Louvre but by the version then belonging to Lord Suffolk (ca. 1506, National Gallery, London), which William stated that Gabriel had seen when it was exhibited at the British Institution, where it was shown in 1851 and 1858.[52]

Such resources were available to any member of the art-loving public. In addition, Rossetti and Burne-Jones had a special resource: their access to the collections of their patrons, William Graham and Frederick Leyland, which were rich in early Italian art. Graham's taste in old masters was especially close to Burne-Jones's; Graham wrote to Rossetti in 1874, "I do think of all the old masters Botticelli and Mantegna give me the most pleasure."[53] Pre-Raphaelite patrons were even willing to lend some of their treasures to the artists they patronized; William Graham loaned Burne-Jones an *Allegorical Scene* (now attributed to Michele da Verona, but then attributed to Carpaccio, ca. 1500, collection of the Earl of Oxford and Asquith),[54] while Lord Elcho, from whom Watts borrowed a Venetian landscape, loaned Burne-Jones a *Virgin and Child* (then given to Mantegna, although now ascribed to Francesco Bonsignori, ca. 1500, the Earl of Wemyss and March, Gosford House, Scotland).[55] The elongated figures and dreamy, wistful expressions of the Virgin and Child are especially close to the sensibility of Burne-Jones's own paintings.

But, of course, the collections most accessible to the Pre-Raphaelites were their own. Rossetti owned some old masters, among which some were early Ital-

ian, including a twelve-sided *desco da parto* of the *Triumph of Chastity* (attributed to Apollonio di Giovanni, ca. 1450, North Carolina Museum of Art, Raleigh, N.C.), which Ellis Waterhouse called "an enchantingly pre-Raphaelite work."[56] The most notable of Rossetti's acquisitions was his Botticelli portrait of Smeralda Bandinelli (ca. 1471, Victoria and Albert Museum) that Waterhouse has singled out as the "possible inspiration for some of Rossetti's fancy female half-lengths."[57] Most conspicuously, this painting has left its mark on Rossetti's *La Donna della Finestra* (1879, Fogg Art Museum, Cambridge, Mass.) in which the sitter's pose and costume, as well as the setting, are closely modeled on Rossetti's Botticelli.

Burne-Jones, too, collected old masters in the Pre-Raphaelite taste. Charles Eliot Norton gave him a panel, attributed to Giorgione, which, on cleaning, proved to depict Europa and the Bull.[58] A painting of the *Coronation of the Virgin* by the School of Botticelli (ca. 1500, Metropolitan Museum of Art, New York) has been designated as from Burne-Jones's collection, while a sales catalogue of paintings from his collection, sold by his son, includes a *Crucifixion* by Sano di Pietro (date and location unknown), an *Annunciation with Raphael and Tobias* by the School of Botticelli given to Burne-Jones by William Graham (date and location unknown), and Burne-Jones's own twelve-sided *desco da parto* of *Diana and Actaeon* (attributed to Paolo Schiavo, ca. 1440, Williams College Museum of Art, Williamstown, Mass.).[59] A watercolor by Burne-Jones's studio assistant, T. M. Rooke, of Burne-Jones's dining room shows this delightful painting, which depicts several naked ladies huddled together in a Gothic hot tub, hanging over a cabinet designed by Philip Webb and painted by Burne-Jones early in his career with the theme of "Good and Bad Animals."[60]

If Frederick Leyland's contemporaries could describe him as realizing "his dream of living the life of an old Venetian merchant in modern London,"[61] then Burne-Jones, too, seemed to have lived the life of an early Italian painter in modern London. His practice of using studio assistants was in the Renaissance tradition as was the variety of his commissions, for he produced not only paintings but also designs for mosaics, stained glass, and tapestries. His working method was thoroughly Renaissance, for each painting was preceded by compositional sketches, drawings from the nude, and meticulous studies of drapery. For Beardsley, then, Burne-Jones presented the perfect picture of a Pre-Raphaelite artist in both senses. Not only did he serve as an exemplar in his

own person of a Renaissance artist, but in addition, Burne-Jones's taste for early Italian art was evident, not only in its manifest influence in his work, but in such details as the paintings with which he surrounded himself. Consistent in his tastes to the last, toward the end of his life, a few years after he met Beardsley, Burne-Jones mused that if he had his life to live over again, his goal would be "to try and paint more like the Italian painters. And that's rather happy for a man to feel in his last days, to find that he's still true to his first impulse."[62]

Beardsley's sketch of Burne-Jones, dated 12 July 1891 (fig. 3), a memento of his dramatic first meeting, depicts an enigmatic, whimsical, quixotic figure, with that touch of melancholy which characterized Burne-Jones's caricatures of himself.[63] This initial meeting was intended by Burne-Jones to be the first of a series. "You must come and see me often," he told Beardsley on this occasion, "and bring your drawings with you."[64] He soon followed this statement with a four-page letter, advising Beardsley on art schools and promising "to see your work from time to time, at intervals, say, of three or six months."[65] "I can tell you," Beardsley wrote Scotson-Clark, "I am not a little pleased at getting so lengthy an epistle," adding fondly that Burne-Jones's "spelling is somewhat funny, his writing execrable."[66]

The role of mentor was one that Burne-Jones treasured, as Rossetti had been a mentor to him, and as Renaissance artists had counseled their apprentices: "I do like young things to come to me, and spare no pains with them: and after all it is for them I paint. If ever they would look at me as I have looked at Mantegna, what a well-rewarded ghost mine would be."[67] His role as mentor, however, was one that would present difficulties, especially in the case of Beardsley, for Burne-Jones had a very well-defined agenda and expectations, and he expressed himself to his disciples not merely by praise but also in forthright criticism, often ill-received: "The young men and women who bring their work to me . . . won't stand the slightest rebuking. I can hardly tell them of a fault."[68]

From the beginning, Burne-Jones expected that Beardsley's drawings would not be self-contained works in themselves, as they would prove to be, but "would make beautiful paintings,"[69] and the course of work he recommended was largely one that would include training at variance with Beardsley's natural tastes and inclinations: "I know you will not fear work, nor let disheartenment languor you because the necessary discipline of the school seems to lie so far away from your natural interest and sympathy.

Fig. 3. Aubrey Beardsley. *Sketch of Sir Edward Burne-Jones*. Print (No. 2 of 8 copies printed for James Tregaskis, London, 1899.) After original drawing. 1891. Present location unknown. 6⅞″ × 4⅛″. Princeton University Libraries.

You must learn the grammar of your art and its exercises are all the better for being rigidly prosaic."[70] At first, Beardsley fell under Burne-Jones's spell. "I am very glad that you've had a sight of the immortal EBJ," he wrote Scotson-Clark. "Is he not gentle and charming?"[71] However, Beardsley seemed never to

have been under any illusions about the closeness of their relationship, writing to A. W. King, "Burne-Jones' letter I enclose herewith. It doesn't prove much, except that I know him and that he has taken an interest in my work."[72]

Beardsley's work of the period was similarly very

much under Burne-Jones's spell. Such early drawings as *Hamlet Patris Manem Sequitur* (1891, British Museum, London) and *Perseus and the Monstre* (1891, location unknown) echo Burne-Jones's enclosed spaces, elongated figures, and swathed draperies.[73] These are still very much student drawings, and Beardsley mentions the *Hamlet* drawing as being included in "a grand show of drawings" that he is putting together in August 1891 "for my visit to Burne-Jones on his return from holidays."[74] Beardsley was beginning to find his own style in the slightly later and more skillful *Perseus* (ca. 1892, location unknown), in which both the subject matter and the face, hair, and figure of the standing hero show the influence of such paintings by Burne-Jones as *Phyllis and Demophöon* (1870, Birmingham City Museum and Art Gallery), which Beardsley had seen in the Leyland collection, added to a motif of briars taken from the *Century Guild Hobby Horse*.[75] The closeness of Beardsley's style to Burne-Jones's was a matter of common notice early in his career. William Rothenstein remembered "Conder and myself chaffing Beardsley about the influence of Morris and Burne-Jones on his work, and Beardsley saying that while Burne-Jones was too remote from life he was inimitable as a designer. 'Imitable Aubrey!' I agreed, 'imitable surely?' a jest that delighted Aubrey."[76]

Burne-Jones was not the only artist of the older generation to come into contact with Beardsley, although their relationship was by far the most significant. Soon after meeting Burne-Jones, in October 1891, Beardsley went to see G. F. Watts, then over seventy, and commented: "He is a disagreeable old man, however very nice to me. He strongly dissuaded South Kensington for art training, and spoke emphatically on the subject of self-culture."[77] More productive was Beardsley's meeting in Paris in the summer of 1892 with the artist who can be called the French equivalent of Burne-Jones—Puvis de Chavannes. In a letter to his former housemaster, A. W. King, Beardsley included an account of this meeting clipped from his old school paper in which Puvis was reverently identified as the president of the Salon des Beaux-Arts.[78] The "immortal" Puvis, as Beardsley called him, was evidently impressed with Beardsley's drawings; Puvis introduced Beardsley "to a brother painter as 'un jeune artiste anglais qui a fait des choses étonnantes!' I was not a little pleased, I can tell you with my success."[79] The contact may have been due to Burne-Jones, for although Burne-Jones and Puvis never met, they were on good terms by letter, and toward the end of 1891, Puvis had invited Burne-Jones to exhibit in Paris.[80]

Beardsley's most incongruous admirer among older artists was Sir Frederic—not yet Lord—Leighton, the president of the Royal Academy. In August 1894, when Beardsley was already a well-known artist and the art editor of *The Yellow Book,* Leighton commissioned some drawings from him,[81] and Beardsley seems to have been pleased: "I have just had a charming note from Sir Frederick [sic] Leighton expressing his admiration for my little efforts, and the interest with which he looks forward to a sight of my Tannhäuser."[82] At Beardsley's invitation, Leighton, somewhat incongruously, contributed two drawings to the first number of *The Yellow Book.*[83]

Also evident in Beardsley's art at this period was the influence not only of Burne-Jones but also of the early Italian painters that influenced Burne-Jones. Beardsley's *Litany of Mary Magdalen* (1891, The Art Institute of Chicago) suggests in the figure of Mary Magdalen an indebtedness to the figure of Saint John in Mantegna's engraving of *The Entombment* (early 1470s).[84] Although Brian Reade dates this drawing as having been done shortly after Beardsley's first visit to Burne-Jones's studio, Beardsley mentions the drawing the week before the visit.[85] In his study of Mantegna, Beardsley did not need to be confined to the inspiration of prints. In September 1891 he urged Scotson-Clark to come to Hampton Court with him "and see one of the grandest collections of paintings in England . . . Mantegna's tremendous *Triumphs of Caesar* are there— an art training in themselves."[86] Beardsley derived motifs from Mantegna's *Triumphs of Caesar* (1484–94, Hampton Court Palace) throughout his career. In mentioning in the same letter that he was "studying the life and works of Mantegna," Beardsley took care to note that "Mantegna had inspired Burne-Jones all along."[87] Yet, in a sentence omitted from the printed text of this letter, Beardsley made it clear that he was not wholly indebted to Burne-Jones for his admiration for the Hampton Court Mantegnas. "I saw them many years ago and was much wrought with them, even then,"[88] he stated, appending at the bottom of the page a tiny self-portrait, arms semaphoring and hair standing on end in excitement, dwarfed by Mantegna's series of vast canvases.

By the early 1890s, the vogue for early Italian paintings was general in England, and there was frequent opportunity to see them in London in auctions, like the sales in 1892 of the collections of Frederick Leyland and of Lord Dudley, and at the annual old masters exhibitions of the Royal Academy, the Burlington Fine Arts Club, and the New Gallery. The

"triumph of the primitives" was signalized by the exhibition of Early Italian Art, generously classed as from 1300 to 1550, held at the New Gallery in 1893–94, which consisted of 1,585 objects, including paintings, drawings, books, illuminated manuscripts, ivories, majolica, armor, embroideries, and furniture. Burne-Jones loaned to the exhibition the Botticelli *Annunciation* that he had been given by William Graham and an early printed book illustrated with woodcuts, and William Morris loaned four early books. Among the 266 paintings were pictures by a veritable catalogue of early Italian painters, including Fra Angelico, Antonello da Messina, Cimabue, Ghirlandaio, Giotto, Fra Filippo Lippi, Mantegna, Pinturicchio, Signorelli, and Verrocchio. They included Rossetti's Botticelli portrait of Smeralda Bandinelli, now owned by his friend Constantine Ionides, to whom he had sold it, and paintings that had belonged to William Graham and Frederick Leyland, among them Graham's Piero di Cosimo of *Hylas and the Nymphs* (ca. 1500, Wadsworth Atheneum, Hartford) and one of Leyland's panels by Botticelli of the story of Nastagio degli Onesti.

George Moore, writing an essay on the exhibition entitled "Long Ago in Italy," urged his readers to "come to the New Gallery. We shall pass out of sight of flat dreary London, drab-coloured streets full of overcoats, silk hats, dripping umbrellas, omnibuses. We shall pass out of sight of long perspectives, of square houses lost in fine rain and grey mist. We shall enter an enchanted land, a land of angels and aureoles; of crimson and gold, and purple raiment; of beautiful youths crowned with flowers; of fabulous blue landscape and delicate architecture."[89] The next year's old masters exhibition at the New Gallery was devoted to Venetian Art, and among the 883 objects in the exhibition was *The Rape of Europa* attributed to Giorgione and loaned by Sir Edward Burne-Jones.

In contrast to the paucity of early Italian art that the first generation of Pre-Raphaelites would have encountered in the National Gallery, by the early 1890s the collection contained many important early Italian paintings, and Beardsley took full advantage of it. As his mother testified, "many an hour did he and his sister spend in the National Gallery, fixing their attention only on the Pre-Raphaelite pictures."[90] At the time the museum did own two important works by Rossetti, *Ecce Ancilla Domini* (1850, Tate Gallery, London), purchased in 1886 at the William Graham sale, and *Beata Beatrix* (1864–70, Tate Gallery, London), given to the museum in 1889 by Lady Mount-Temple, but Mrs.

Beardsley's reference was to the museum's now impressive collection of early Italian art, which included paintings by Fra Angelico, Paolo Uccello, the Pollaiuoli, Mantegna, Piero della Francesca, Giovanni Bellini, and Carlo Crivelli.[91]

Robert Ross testified that Beardsley knew both the National Gallery and the British Museum "with extraordinary thoroughness"—perhaps too much thoroughness—for Beardsley told Ross of Burne-Jones's remark that Beardsley "'had learnt too much from the old masters.' A few days afterwards [Beardsley] produced a most amusing caricature of himself being kicked down the stairs of the National Gallery by Raphael, Titian, and Mantegna, whilst Michael Angelo dealt a blow on his head with a hammer. This entertaining little record, I am sorry to say, was destroyed."[92]

A favorite painter of both Burne-Jones and Beardsley, as he had been of Rossetti, was Botticelli, and the catalogue of the National Gallery written in 1888 and published in 1890 listed eight paintings attributed to Botticelli, including one newly ascribed to him, the *Portrait of a Young Man* (mid 1480s), purchased at the Northwick sale in 1859 as by Masaccio. This group included two works purchased during the 1870s when the "cult of Botticelli" had begun: the most important secular work in the collection, the *Mars and Venus* (mid 1480s), purchased at the Alexander Barker sale in 1874, and the most important religious work, the *Mystic Nativity* (1500), purchased from Fuller Maitland in 1878.[93] The most concrete testimony to the influence of Botticelli on English artists of the period is Walter Crane's *Renaissance of Venus* (1877, Tate Gallery, London), which was described by Beardsley when published in *The Yellow Book* during his term as art editor as "a divine Walter Crane (his only great thing)."[94]

Beardsley's interest in Botticelli was recorded in an anecdote told by Aymer Vallance as occurring in the spring or summer of 1893.[95] Beardsley noted that his fellow students at the Westminster School of Art tended to modify the figure types of the models before them according to their own appearance. "In fact, he remarked upon the universal tendency to reproduce one's own personal type, and that he supposed it had always been so. 'Not, surely, in the case of Botticelli?,' I asked, and on his replying in the affirmative, I suggested that it would be an interesting experiment to reconstruct Botticelli's portrait from the materials supplied by his own works."[96] In spite of the opportunities afforded Beardsley to see works by Botticelli in the National Gallery, the imaginary portrait of Botticelli (fig. 4) that Beardsley

Fig. 4. Aubrey Beardsley. *Sandro Botticelli*. Photograph of
original drawing. 1893. Present location unknown. Repro-
duced in *The Early Work of Aubrey Beardsley,* with a prefa-
tory note by H. C. Marillier. (London and New York: John
Lane, 1899). $9'' \times 5''$. Department of Printing and Graphic
Arts. The Houghton Library, Harvard University.

presented to Vallance[97] bears little resemblance to Botticelli's own works or to any of the figures suggested as portraits of him or as his own self-portraits.[98] Rather, the image of the artist arguably seems to be indebted to the facial types and feeling of Simeon Solomon's late works, whose influence can also be discerned in some of Beardsley's early works, like *Adoramus Te* (1892, location unknown) or *The Christmas Carol* (1892, location unknown).[99]

Beardsley's first major public commission, for which he was hired in the autumn of 1892, for illustrations to a new edition of Malory's *Le Morte d'Arthur* was not only a project very much in the Pre-Raphaelite taste, but it was intended by its publisher J. M. Dent to rival the publications of William Morris's newly formed Kelmscott Press (which had been founded early in 1891). The *Morte d'Arthur*, which had supplied the subject matter for the frescoes of the Oxford Union, was a work beloved by Beardsley early in his career: "I am now deeply engaged in Mallory's [sic] 'Morte d'Arthur,'" he wrote Scotson-Clark, "a glorious book, I assure you."[100] The illustrations were to be reproduced, not by the Kelmscott Press method of wood engraving, but by the new process of photomechanical engraving. However, even the Kelmscott Chaucer itself, which would be the most famous of Morris's productions, was not free of mechanical intervention in its genesis, no matter how much of a "pocket cathedral" it looked. First Burne-Jones's drawings were photographed in pale copies called platinotypes, and reinforced by an assistant first in pencil and then in ink. The resulting drawing, whose effect was quite different from Burne-Jones's original soft lines and gentle shading, was then rephotographed onto a wood block before it was engraved.[101] All this technology was resorted to in order to obtain a result that looked as though it had been printed by Aldus Manutius. Beardsley's pen-and-ink style, however, was ideally suited to mechanical reproduction. It is the Kelmscott Chaucer to which the *Morte d'Arthur* presents a natural comparison, but it was not published until 1896, several years after the *Morte*, which appeared in twelve parts in 1893 and 1894. However, Burne-Jones's first illustrations for a Kelmscott book, *The Golden Legend*, appeared in November of 1892,[102] and the Kelmscott formula was set from the start. Based on medieval manuscripts and early printed books, their format contained a central figural scene, by Walter Crane or Burne-Jones, surrounded by Morris's elaborate woodcut borders.

In the spring or early summer of 1892, Aymer Vallance, a friend of both Morris and Beardsley, had

tried to bring Beardsley into the Kelmscott fold. "Morris had recently told me of the difficulty he experienced in providing suitable illustrations for his Kelmscott books, naming in particular the reprint he was then contemplating of 'Sidonia the Sorceress.'"[103] The subject, taken from a book by William Meinhold, had afforded the occasion for two of Burne-Jones's most striking early watercolors, *Sidonia von Bork* and *Clara von Bork* (1860, Tate Gallery, London). Vallance recalled:

> I believed that if Beardsley could but make a good impression on Morris my object would be attained. To this end I persuaded Beardsley to make a drawing of Sidonia, which being added to his portfolio, I took him to show the collection to Morris. So far as I can recollect, it was in the spring or early summer of 1892 that Beardsley and I made our way to Hammersmith one Sunday afternoon, and Morris, with his usual courtesy, looked through the drawings we had brought. But it was instantly evident that they had failed to arouse in him any particular interest. Beyond remarking: "I see you have a feeling for draperies, and I should advise you to cultivate it," Morris's reception of Beardsley was almost discouraging. The boy was disappointed. He was peculiarly sensitive, and he felt that he had been repulsed.[104]

This was the more wounding because Beardsley had been enthusiastic about Morris's own work, noting early in his career to Scotson-Clark that "I am reading Morris' 'Earthly Paradise' which is simply enchanting. If you have not read it you must take it away with you when you come."[105]

Although Beardsley had thus been, in effect, "disowned" by Morris, his early plates for the *Morte*, like *Merlin and Nimue* (1893–94, Museum of Fine Arts, Boston, fig. 5),[106] adhere to the layout and the "medieval manner" of the Kelmscott Press. The figure style and costumes are based on Burne-Jones's *Merlin and Vivien* (1870–74, Lady Lever Art Gallery, Port Sunlight), which Beardsley had seen in Leyland's house, and the composition refers to Burne-Jones's *Love and the Pilgrim* (1877–97, Tate Gallery, London). Yet the illustration already shows the tension between the influence of Whistler and that of Burne-Jones governing Beardsley's early work. It is ironic that both Whistler and Burne-Jones were to be great and conflicting influences on Beardsley's early work, for by now they were personal antagonists; Whistler had never forgiven Burne-Jones for testifying in favor of Ruskin at the Whistler-Ruskin trial.

The simplification and stylization of the border for *Merlin and Nimue* hint at Beardsley's first post–Pre-

Fig. 5. Aubrey Beardsley. *Merlin and Nimue* (illustration for Malory's *Le Morte d'Arthur*). 1893–94. Pen and India ink. 12″ × 9⅜″. Hartley Collection. Courtesy of Museum of Fine Arts, Boston.

Fig. 6. Aubrey Beardsley. *How Sir Tristram Drank of the Love Drink* (illustration for *Le Morte d'Arthur*). 1893–94. Black ink and graphite on white paper. 11⅛″ × 8⅝″. Courtesy of the Fogg Art Museum, Harvard University Art Museums. Bequest of Scofield Thayer.

Raphaelite style, his "Japonesque" manner, formed, like his Pre-Raphaelite style, under a twofold influence—not only under the influence of Whistler's Japonaiserie, but also under the direct influence of Japanese prints. In a later illustration, *How Sir Tristram Drank of the Love Drink* (1893–94, Fogg Art Museum, Cambridge, Mass., fig. 6),[107] Beardsley completely abandoned the neo-medieval manner in which he began the *Morte* for his highly stylized Japanese manner, with its large flat areas of black and white, abstract floral motifs, and swinging Art Nouveau curves. This style characterized Beardsley's next project, the illustrations for Oscar Wilde's *Salome,* which he began during the eighteen months that he devoted to the *Morte.*

Another illustration for the *Morte, How La Beale*

Fig. 7. Aubrey Beardsley. *How La Beale Isoud Wrote to Sir Tristram* (illustration for *Le Morte d'Arthur*). 1893–94. Pencil, pen, and brush and black ink in a decorative border. 11″ × 8⅝″. In the collection of Frederick R. Koch, New York. Photograph, Christie's Images, St. James's, London SW1 6QT.

Isoud Wrote to Sir Tristram (1893–94, collection of Frederick R. Koch, New York, fig. 7),[108] was characterized by the same simplification and stylization and showed as well the influence of another historic source that had also influenced Burne-Jones and Morris, namely, the early printed book entitled the *Hypnerotomachia Poliphili* by Francesco Colonna, published in 1499 in Venice by Aldus Manutius. As early as 1866, when William Allingham visited Burne-Jones (who was working on the illustrations for a never-completed project, an illustrated version of Morris's *Earthly Paradise*),[109] Allingham noted that Burne-Jones owned a copy of this book and that, under its influence, Morris and Burne-Jones were working in a style that Allingham called "New Renaissance."[110] The interior scenes of the *Hypnerotomachia* (fig. 8), with their flat blank areas of space,

firm lines, and compressed perspective, served as a prototype for Beardsley's plate down to the details of the furnishings.

In spite of the change in style in Beardsley's illustrations over the great and daunting length of the project, it was clearly the initial closeness of his effort to its Pre-Raphaelite roots that infuriated the founder of the Kelmscott Press: "It must have been about the close of 1892 or the beginning of 1893, when a few of the earliest drawings for the 'Morte d'Arthur' were already printed," Aymer Vallance recalled.

> I could not prevail upon Beardsley to accompany me to Morris's house a second time, but I took a proof of one drawing of which I felt convinced Morris could not fail to appreciate the merits. It was the illustration which represents the Lady of the Lake telling Arthur

Fig. 8. Photograph of plate from Francesco Colonna. *Hypnerotomachia Poliphili*. 1499. 4⅛″ × 5″. By permission of Houghton Library, Harvard University.

of the sword Excalibur . . . I can only say the result was such that convinced me once for all of the futility of hoping to bring about any co-operation between Beardsley and Morris, who was so indignant at what he deemed an act of usurpation not to be allowed, that it was only by the prudent advice of Sir Edward Burne-Jones, as I afterwards learnt, that Morris was prevented from writing a letter of angry remonstrance to the publisher. "A man ought to do his own work" was the line Morris took in what he said to me at the time.[111]

Vallance concluded that Morris chose to treat Beardsley as a rival instead of an ally. Perhaps perceiving the compliment implied by Morris's assessment of him as a rival, Beardsley was unfazed, at least on the surface, by the master's wrath: "William Morris has sworn a terrible oath against me," he claimed, "for daring to bring out a book in his manner. The truth is that, while his work is a mere imitation of the old stuff, mine is fresh and original. . . . Yet," he continued, "I still cling to the best principles of the P.R.B. and am still the beloved of Burne-Jones, who . . . has given my *Siegfried* a place of honour in his drawing room."[112]

In the same letter, Beardsley noted that *Siegfried* (1892–93, Victoria and Albert Museum, London) was to be reproduced in an article by Joseph Pennell in the *Studio* of April 1893, but the undoubted sensation of this article was its reproduction of Beardsley's illustration inspired by the recently published French edition of Oscar Wilde's *Salome*.[113] This illustration, "J'ai baisé ta bouche, Iokanaan" (1893, Princeton University Library), in Beardsley's new Japanese manner, earned him the commission to illustrate the English translation of Wilde's play, and it soon gained him—and his new style—European notoriety. So quickly was Beardsley's style developing that by the time this edition was published the illustration of this scene in the text was even simpler and more stylized, the Art Nouveau curves were broader and deeper, and the remnants of Beardsley's "hairline manner" were now completely abandoned for clean sharp lines and unbroken areas of flat black and white.[114]

The end of Beardsley's work on the *Morte d'Arthur* marked the end of his avowedly Pre-Raphaelite period but not of his interest in the Pre-Raphaelites' Renaissance sources. His illustrations for *The Yellow Book* largely continued the Art Nouveau manner of *Salome*, but Beardsley maintained that he worked in "seven distinct styles at once" and Pre-Raphaelite influence continued to appear in his work. Using the pseudonym of "Philip Broughton,"

Beardsley published in *The Yellow Book* a drawing of his hero, Mantegna, done in a deceptive style of full chiaroscuro, with only a flat floral pattern in the lower left appearing like a talisman for the initiate.[115] This can be contrasted with a drawing that predates his work for *The Yellow Book*, done in his earliest Japanese manner, showing Raphael Sanzio, full-length, in flattest black and white, reduced to a figure in a pattern (ca. 1892, Princeton University Library).[116] The most startling drawing that Beardsley did for *The Yellow Book*, the *Mysterious Rose Garden* (1894, Fogg Art Museum, Cambridge, Mass., fig. 9), revealed a variety of Pre-Raphaelite sources. Beardsley described this drawing as one of a number of projected biblical scenes—this being an Annunciation.[117] The maiden to whom the strange visitor is whispering sinful secrets has the elongated proportions that Burne-Jones had derived from Botticelli. The trellis of roses suggests a woodcut by Burne-Jones for "The Story of Cupid and Psyche" in William Morris's *The Earthly Paradise*,[118] while the visitor's robe echoes the flowered, ripple-edged garment of Flora in Botticelli's *Primavera*.[119]

In contrast to Beardsley's Japanese style, his work for *The Yellow Book*'s successor, the *Savoy*, was marked by Beardsley's recourse to new historic influences, evoking periods largely unexplored by the Pre-Raphaelites. The *Savoy* published chapters of an expurgated version of Beardsley's unpublished novel, *Venus and Tannhäuser*, now called *Under the Hill*, written in a consciously "dix-huitième" manner, and a typical illustration, the Abbé Fanfreluche,[120] is clothed and drawn in a mélange of seventeenth- and eighteenth-century styles, much influenced by the eighteenth-century prints that Beardsley avidly collected.[121] The unused title page (ca. 1895, Fogg Art Museum, Cambridge, Mass., fig. 10) for the earlier version of the novel, however, is gravely Renaissance in style and obviously indebted to the architectural motifs of the *Hypnerotomachia Poliphili*,[122] while the *Fruitbearers*, published in the *Savoy*,[123] recalls the processional scenes of Mantegna's *Triumphs of Caesar*, as well as the trellised garden settings of the *Hypnerotomachia*.

Beardsley's illustrations for the *Rape of the Lock*, like *The Baron's Prayer*, date from the same period as his work for the *Savoy* and are his finest exercises in his soufflé manner of rococo pastiche, while in his last project, an illustrated edition of Ben Jonson's *Volpone*, once again he evolved a new style of historic allusiveness. The drawing of *Volpone Adoring His Treasures* (1898, Princeton University Library) evokes the solemnity and solidity of seventeenth-

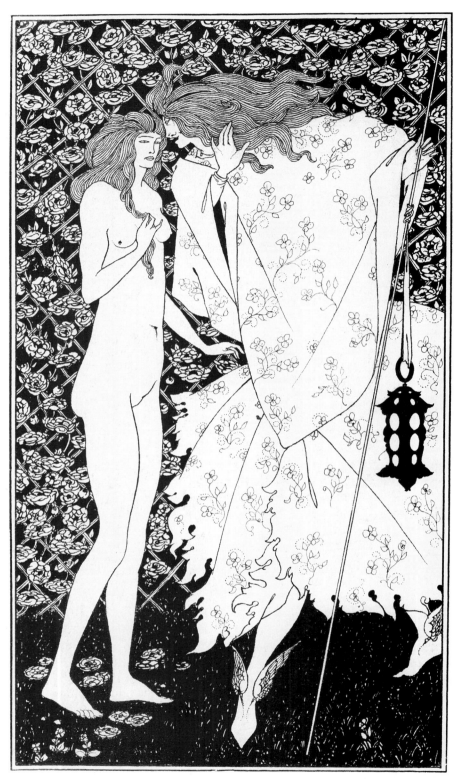

Fig. 9. Aubrey Beardsley. *The Mysterious Rose Garden* (illustration for *The Yellow Book*). 1894. Black ink and graphite on white paper. 8⅞″ × 4⅞″. Courtesy of the Fogg Art Museum, Harvard University Art Museums. Bequest of Grenville L. Winthrop.

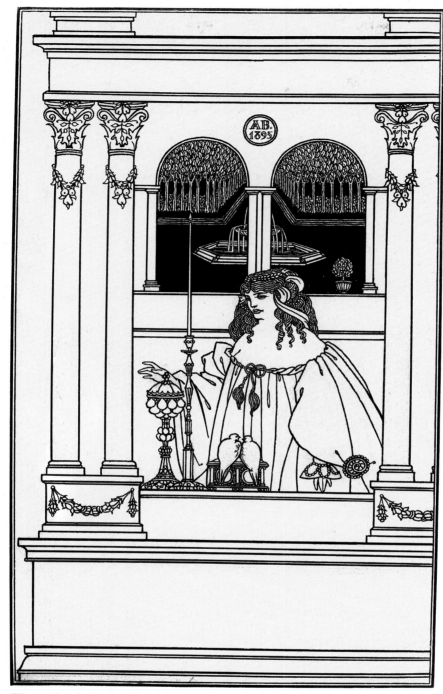

Fig. 10. Aubrey Beardsley. Frontispiece design for *The Story of Venus and Tannhäuser*. 1895. Black ink and graphite on white paper. 11⅝" × 7". Courtesy of the Fogg Art Museum, Harvard University Art Museums. Bequest of Grenville L. Winthrop.

century art, freshened by the daring area of pure white of Volpone's cloak.[124] This art seems far removed from the Pre-Raphaelitism of the *Morte d'Arthur;* indeed, at this time, Beardsley wrote to Leonard Smithers, who was planning a new maga-

zine, "On the art side I suggest that it should attack *untiringly and unflinchingly* the Burne-Jones and Morrisian medieval business and set up a wholesome seventeenth and eighteenth-century standard of what picture making should be."[125] In the same let-

Fig. 11. Photograph of Aubrey Beardsley in his hotel room
at Menton. Present location unknown. Reproduced in Au-
brey Beardsley, *Under the Hill, and Other Essays in Prose
and Verse by Aubrey Beardsley*. London: John Lane Pub-
lisher. The Bodley Head, 1904. 5½″ × 6¼″. By permission
of Houghton Library, Harvard University.

ter, there are signs that Beardsley is also rejecting
the influence of the other great mentor of his early
years, Whistler, for he asks Smithers, "Have you set-
tled definitely on calling it the *Peacock?* As a title I
rather fancy *Books and Pictures.*"

If Beardsley had now rejected Burne-Jones,
Burne-Jones had now, in turn, rejected Beardsley.
Shortly after Beardsley's death and shortly before
his own, Beardsley's former mentor expressed his
disappointment with the later trend of Beardsley's
career, and revealed the moment of their mutual dis-
illusion:

> That was the day he was so stupid and conceited, and
> I let him see pretty plainly that I wasn't anxious to be
> troubled with him any more. . . . I asked him how he
> was getting on with the book he was decorating—King
> Arthur that was—and he said he'd be precious glad
> when it was done, he hated it so. So I asked him, why
> did he do it, and he said because he'd been asked. He
> hated the story and he hated all medieval things [this
> was obviously the most terrible blasphemy to Burne-
> Jones]—and I said, how could it be successful work
> then. I never saw such a pitiful exhibition of vanity in
> my life. I wondered why it was he took the trouble to

come and see me, unless it was to shew off and let me
know my influence with him was over. As if it mattered
in the least whether it was or not.[126]

But Beardsley's letters in his last months con-
tained references to Mantegna, Botticelli, Pinturic-
chio, and even that early favorite of the Pre-
Raphaelites, Benozzo Gozzoli.[127] A photograph (fig.
11) taken at the end of Beardsley's life, shows him
in the hotel room in Menton, in which he was,
shortly, to die, gazing at a whole wall of engravings
by Mantegna[128] of the kind that had influenced
Burne-Jones and had inspired Beardsley at the start
of his career. As this photo suggests, even after
Beardsley had formally abandoned his discipleship
to Burne-Jones, he never lost his interest in or his
respect for the kind of early Italian art that had been
responsible for so much of the character and direc-
tion of the Pre-Raphaelite movement from its incep-
tion. In regard to the persistence of his tastes as well
as to the origins of his style, it might not then be an
exaggeration to identify Aubrey Beardsley as "the
last Pre-Raphaelite."

NOTES

For help at all stages of this project, I am deeply indebted to Miriam Stewart, Assistant Curator of Drawings at the Fogg Art Museum and organizer of the 1989 exhibition of Beardsley's drawings held at the Arthur M. Sackler Museum, Harvard University.

1. Letter to G. F. Scotson-Clark [July 1891] in Henry Maas, J. L. Duncan, and W. G. Good, eds., *The Letters of Aubrey Beardsley* (Rutherford, N.J.: Fairleigh Dickinson University Press, 1970), 19. Hereafter cited as *Letters*.

2. Reproduced in Miriam J. Benkovitz, *Aubrey Beardsley: An Account of His Life* (New York: G. P. Putnam's Sons, 1981), 39.

3. William Rothenstein, *Men and Memories: Recollections of William Rothenstein 1872–1900* (New York: Coward McCann, Inc., 1931), 97.

4. An earlier version of *The Blessed Damozel* (1871–78), painted for William Graham, is now in the Fogg Art Museum, Harvard University Art Museums.

5. Ronald Lightbown, *Sandro Botticelli* (Berkeley and Los Angeles: University of California Press, 1978), vol. 1, 70; vol. 2, 47–51 (nos. B35–B38).

6. The *Adoration of the Magi* was attributed to Fra Filippo's son, Filippino Lippi, in the sale of Leyland's collection at Christie's on 28 May 1892. This painting (lot 97 in that sale) is now in the collection of the Art Institute of Chicago, attributed to Raffaello Botticini, and dated ca. 1495. One of the Madonnas Leyland owned attributed to Fra Filippo Lippi (lot 105) is now in the Gardner Museum, Boston, attributed to Pesellino, dated ca. 1450.

7. Letter to G. F. Scotson-Clark [July 1891]. Gallatin Beardsley Collection, Princeton University Libraries. Printed with permission of the Princeton University Libraries.

8. Typescript of G. F. Scotson-Clark's transcript of Beardsley's letters to him. John Lane file of material relating to Aubrey Beardsley. General Manuscript (Misc.) Collection, Princeton University Library, Letter 2. Transcripts of seven of Beardsley's letters are included in this file, only a few, Scotson-Clark noted, of the many Beardsley wrote him: "How could I peer into the future and imagine that the letters of *my* friend would be of interest to the public at large." Beardsley's enthusiasm for Brown's *Chaucer at King Edward's Court* is manifest in his description of one of his own works of the period: "Dante at the Court of Con [*sic*] Grande de la Scala," which he describes as "a composition of about 45 figures, almost a bird's eye view, in a circular frame, 6 inches in diameter." Scotson-Clark, Letter 2. In the biography *Aubrey Beardsley—Prior to 1893* accompanying the transcripts of these letters, Scotson-Clark claimed at least partial credit for Beardsley's enthusiasm for the Pre-Raphaelites: "I became clerk in an old established wine merchants the owner of which, as luck would have it, was not only an amateur painter, but a picture collector and had one of the finest collections of Pre-Raphaelites in England. He had recently retired from the business which was in the hands of his son, Herbert Trist who was just as fond of art as his father. He did all he could to encourage my leaning toward painting and it is he that both Beardsley and I have to thank for our first knowledge of Rossetti. It was a new outlook for me—one of which I lost no time in acquainting Beardsley. Together we collected everything we could dealing with the Pre Raphaelites. Mr Trist lent me Rossetti's Poems, allowed me to make pencil copies of his paintings and those of Burne Jones and Ford Maddox [*sic*] Brown" (printed with permission of the Princeton University Libraries). Beardsley's definition of Pre-Raphaelitism, as he wrote to Scotson-Clark, was "Painting things as they *are*" Scotson-Clark, Letter 5. For information on the Trist collection, in Brighton, see Cosmo Monkhouse, "A Pre-Raphaelite Collection," *Magazine of Art* 6 (1883): 62–70. J. Hamilton Trist's paintings were sold at Christie's on 9 April 1892, but many of the paintings were bought in by his son and reappeared at Christie's on 23 April 1937 at the sale of Mrs. Trist's collection. The collection included seven works by D. G. Rossetti, among them *King René's Honeymoon: Music* and *Regina Cordium*, *A Lamentation* by Burne-Jones, and versions of *King René's Honeymoon: Architecture* and *Elijah and the Widow's Son* by Ford Madox Brown, as well as *Pomegranates* by Albert Moore (Guildhall Art Gallery, London) and several works by Arthur Hughes, including *The King's Orchard* (Fitzwilliam Museum, Cambridge).

9. Frances Horner, *Time Remembered* (London: William Heinemann Ltd., 1933), 5.

10. In addition to the auction of Leyland's paintings, Christie's allotted another day's sale on 26 May 1892 to his "valuable and extensive collection of old Nankin Porcelain, Old Chinese Enamelled Porcelain and Cloisonné Enamels, Decorative Objects, Furniture, and Tapestry."

11. Francis L. Fennell Jr., ed., *The Rossetti-Leyland Letters: The Correspondence of an Artist and His Patron* (Athens: Ohio University Press, 1978).

12. Oswald Doughty and John Robert Wahl, eds., *Letters of Dante Gabriel Rossetti* (London: Oxford University Press, 1965–67). Letter from Charles Augustus Howell to Ford Madox Brown, 4 March 1873, included in editorial note to No. 1313, page 1144, vol. 3 (letter from Dante Gabriel Rossetti to Ford Madox Brown, also 4 March 1873). Cited in M. Susan Duval, "F. R. Leyland: A Maecenas from Liverpool," in *Apollo* 124, no. 294 (n.s.) (August 1986): 110.

13. Four of these photographs, now in the National Monuments Record, London, are reproduced in Nicholas Cooper, *The Opulent Eye: Late Victorian and Edwardian Taste in Interior Design* (New York: Watson-Guptill Publications, 1977).

14. For Leyland's collection, see Val Prinsep, "First Paper.—Rossetti and His Friend," 129–34; Lionel Robinson, "Second Paper.—The Leyland Collection," 134–38, in "The Private Art Collections of London: The Late Mr. Leyland's in Prince's Gate," *The Art Journal* 54 (May 1892); and Theodore Child, "A Pre-Raphaelite Mansion," *Harper's New Monthly Magazine* 82, no. 487 (December 1890): 81–99. This latter article, prepared with Leyland's help, affords a room-by-room tour through the mansion.

15. Duval, 114.

16. On the Peacock Room, see Susan Hobbs, *The Whistler Peacock Room* (Washington, D.C.: Freer Gallery, 1980); David Park Curry, *James McNeill Whistler at the Freer Gallery of Art* (New York and London: W. W. Norton, 1984); and David Park Curry, "Total Control: Whistler at an Exhibition," in *James McNeill Whistler, a Reexamination*, ed. Ruth E. Fine (Washington, D.C.: National Gallery of Art, 1987): 67–82.

17. Duval, 114.

18. Letter to G. F. Scotson-Clark [July 1891], *Letters*, 21. Beardsley's description of *La Princesse du Pays de la Porcelaine* as "a Jap Girl painting a vase" may have been elicited by a reference by Scotson-Clark to another early painting by Whistler in the *Japonaise* style, *Purple and Rose: The Lange Lizjen of the Six Marks* (1864, Philadelphia Museum of Art).

19. For this illustration, see Sales Catalogue, Anderson Auction Galleries, New York, 18 December 1928 (lot 200), 40, mentioned in *Letters*, 21. For a color reproduction, see *The Uncollected Work of Aubrey Beardsley*, with an introduction by C. Lewis Hind (London: John Lane. The Bodley Head Limited, 1925): no. 58.

20. Letter to G. F. Scotson-Clark [July 1891], *Letters*, 21.

21. Ibid. [9 August 1891], *Letters*, 25.

22. Sales Catalogue, Anderson Auction Galleries, New York, 18 December 1928 (lot 203), 42. Scotson-Clark shared Beardsley's enthusiasm for Whistler, and the two young men had collaborated on an essay in Whistler's style: "We painted a small figure picture between us—a Japanese girl in a blueish kimona against a blueish curtain—a sort of 'Whistler.'" Scotson-Clark, *Biography*, 6.

23. Letter to G. F. Scotson-Clark [July 1891], *Letters*, 20.

24. Letter to A. W. King [13 July 1891], *Letters*, 21–23.

25. This has been pointed out by W. E. Fredeman in lectures given at the University of Toronto and in connection with an exhibition on *The Lady of Shalott* held at Brown University. The Rossetti memorial exhibitions took place at the Royal Academy, the Burlington Fine Arts Club, and the "Rossetti Gallery."

26. Letter to G. F. Scotson-Clark [August 1891], *Letters*, 27. For information on photographs of Rossetti's works made during his lifetime and after his death, see Alicia Craig Faxon, "Rossetti's Reputation: A Study of the Dissemination of His Art through Photographs," *Visual Resources* 8, no. 3 (February 1992), 219–45.

27. Gurney's Rossettis are mentioned in Beardsley's letter to G. F. Scotson-Clark [July 1891], *Letters*, 19. Virgina Surtees, *The Paintings and Drawings of Dante Gabriel Rossetti (1828–1882): A Catalogue Raisonné*. 2 vols. (Oxford: Clarendon Press, 1971), vol. 1, 141 (No. 242B), and 149 (No. 252A). For information on the Reverend Alfred Gurney, see Malcolm Easton, "Aubrey Beardsley and Julian Sampson, an Unrecorded Friendship," *Apollo* 85 (January 1967): 66–67. Cited in Benkovitz, 38. His sister-in-law, Mrs. Russell Gurney, was also one of

Beardsley's patrons (*Letters*, 26).

28. A. E. Gallatin, *Aubrey Beardsley: Catalogue of Drawings and Bibliography* (New York: The Grolier Club, 1945), 24 (No. 181). Reproduced in R. A. Walker, *Some Unknown Drawings of Aubrey Beardsley* (London: R. A. Walker, 1923).

29. Brian Reade, *Aubrey Beardsley* (New York: The Viking Press, 1967), 312 (No. 17).

30. Mary Lago, ed., *Burne-Jones Talking* (Columbia: University of Missouri Press, 1981), 49.

31. John Christian, "'A Serious Talk': Ruskin's Place in Burne-Jones's Artistic Development," in *Pre-Raphaelite Papers*, ed. Leslie Parris (London: The Tate Gallery, 1984), 184–205, 255–58.

32. John Christian, "Early German Sources for Pre-Raphaelite Designs," *Art Quarterly* 35 (Spring-Summer 1973): 56–83.

33. John Christian, "Burne-Jones's Second Italian Journey," *Apollo* 102 (November 1975): 334–37.

34. See *Burne-Jones* (London: The Arts Council of Great Britain, 1975), 91 (No. 333).

35. John Christian, "'A Serious Talk,'" 198.

36. John Ruskin, *Modern Painters*, vol. II, in *The Works of John Ruskin*, ed. E. T. Cook and Alexander Wedderburn (London: George Allen, 1903–11), vol. IV, 356.

37. Gail S. Weinberg, "Ruskin, Pater, and the Rediscovery of Botticelli," *Burlington Magazine* 129, no. 1006 (January 1987): 25–27.

38. Richard Thomson, *Degas: The Nudes* (London: Thames and Hudson, 1988), 21 (plates 10, 11). Degas's copy of the figure of Venus from Mantegna's *Pallas Expelling the Vices* dates from 1855 and is in the Ashmolean Museum, Oxford.

39. Thomson, 25 (plates 16, 17). The copy by Degas after the figure of Venus in Botticelli's *Birth of Venus* dates from 1859 and is in the collection of Marianne Feilchenfeldt, Zurich.

40. Paul Bittler and P.-L. Mathieu, *Catalogue des dessins de Gustave Moreau* (Paris: Editions de la Reunion des Musées Nationaux, 1983).

41. See exhibition catalogues *19th Century French Drawings and Oil Sketches* (New York: W. M. Brady & Co., Inc., 1991), No. 32, and *James Jacques Joseph Tissot 1836–1902, A Retrospective Exhibition* (Providence: Museum of Art, Rhode Island School of Design, 1968), No. 41.

42. John Bryson and Janet Camp Troxell, eds., *Dante Gabriel Rossetti and Jane Morris: Their Correspondence* (Oxford: Clarendon Press, 1976), 110.

43. G. B-J. [Georgiana Burne-Jones], *Memorials of Edward Burne-Jones* (New York: The Macmillan Company, 1906), 2 vols. in 1, vol. 2, 26. Hereafter cited as *Memorials*.

44. Malcolm Warner, "The Pre-Raphaelites and the National Gallery," *The Huntington Library Quarterly* 55, no. 1 (Winter 1992): 1–11. I am indebted to the kindness of Malcolm Warner for copies of two prepublication drafts of this important article.

45. Lago, 120.

46. *Memorials*, vol. 1, 175, cited by John Christian, "'A Serious Talk,'" 193. Christian feels this reference is to the early Florentine and Sienese paintings purchased from the Lombardi-Baldi collection by the National Gallery in 1857. See also Martin Davies, *National Gallery Catalogues: The Earlier Italian Schools*, 2d ed. revised (London: The National Gallery, 1961), 565–67.

47. Martin Harrison and Bill Waters, *Burne-Jones* (New York: G. P. Putnam's Sons, 1973), 116. For information on *The Death of Procris*, see Davies, 420–22 (No. 698).

48. Davies, 329–30 (No. 274).

49. William M. Rossetti, ed., *The Works of Dante Gabriel Rossetti* (London: Ellis, 1911), 661. Hereafter cited as *Works of Rossetti*.

50. Penelope Fitzgerald, *Edward Burne-Jones, a Biography* (London: Michael Joseph, 1975), 155, 186–87.

51. Francis Haskell, *Rediscoveries in Art* (Ithaca: Cornell University Press, 1976), 157.

52. *Works of Rossetti*, 663.

53. Oliver Garnett, *William Graham: Pre-Raphael Collector and Pre-Raphaelite Patron*, a lecture delivered at the Mellon Centre (21 March 1985), 5. I am deeply indebted to Oliver Garnett for sending me the text of this lecture, which was cited in Mary Bennett, *Artists of the Pre-Raphaelite Circle, the First Generation* (London: Lund Humphries, 1988), 179. Mr. Garnett's uniquely valuable research on William Graham will appear in a forthcoming volume of proceedings of the Walpole Society.

54. Garnett, 7. See also Tancred Borenius, "Michele da Verona,"

Burlington Magazine 39, no. 220 (July 1921): 3–4.

55. See exhibition catalogue, *Pictures from Gosford House Lent by the Earl of Wemyss and March* (Edinburgh: The National Gallery of Scotland, 1957), 7, 10 (No. 3).

56. Ellis Waterhouse, "Holman Hunt's 'Giovanni Bellini' and the Pre-Raphaelites' Own Early Italian Pictures," *Burlington Magazine* 123, no. 941 (August 1981), 474. I wish to thank Adeline Tintner for drawing my attention to this important article.

57. Ibid.

58. *Memorials*, vol. 2, 19–20. When this painting was exhibited at the New Gallery, 1894–95 (No. 94), Bernard Berenson described it as "the merest wreck [which] could never, at the best, have been more than a daub by Andrea Schiavone." Bernard Berenson, *The Study and Criticism of Italian Art* (London: George Bell and Sons, 1901), 137.

59. See sales catalogue, *Catalogue of Valuable Pictures and Drawings*, Sotheby's, London, 8 December 1926, lots 54 through 57. The *desco da parto* is lot 56. See S. Lane Faison, Jr., *Williams College Museum of Art: Handbook of the Collection* (Williamstown, Mass., 1979), No. 15, plate 15. Further information supplied by the Williams College Museum of Art. Burne-Jones's Botticelli *Annunciation* (lot 54) reappeared in Sotheby's sale of 27 March 1963 (lot 76) as the property of Clare Mackail.

60. Charlotte Gere, *Nineteenth-Century Decoration: The Art of the Interior* (New York: Harry N. Abrams, Inc., 1989), 290–91 (No. 338).

61. Child, 82.

62. Lago, 136–37.

63. Reproduced in Lago, plate 12.

64. Letter to A. W. King [13 July 1891], *Letters*, 22.

65. Letter to G. F. Scotson-Clark [July 1891], *Letters*, 23–24.

66. Scotson-Clark, Letter 5.

67. *Memorials*, vol. 2, 226–27.

68. Lago, 177.

69. Letter to A. W. King [13 July 1891], *Letters*, 22.

70. Letter to G. F. Scotson-Clark [July 1891], *Letters*, 24.

71. Ibid. [ca. September 1891], *Letters*, 28.

72. Letter to A. W. King [Postmark 25 August 1891], *Letters*, 28.

73. Reade, 312 (No. 22). See also *Hail Mary*, Reade, 312 (No. 21), for Beardsley's approximation of Burne-Jones's figure type. Scotson-Clark testified that Beardsley was working in the Burne-Jones manner before his visit to the painter: "He gave me a pencil drawing of a 'Burne-Jones' head which he called the Frog Lady, but which was labeled 'La Belle Dame sans merci' (we were Keat's [*sic*] mad at that time)." Scotson-Clark, *Biography*, 6.

74. Letter to G. F. Scotson-Clark, 9 August 1891, *Letters*, 24–25.

75. *Perseus* is reproduced in Reade, plate 26. The motif of briars appears in Selwyn Image's title page to *The Century Guild Hobby Horse* (1884), reproduced in John Russell Taylor, *The Art Nouveau Book in Britain* (Cambridge, Mass.: The M.I.T. Press, 1966), 58.

76. William Rothenstein, *Men and Memories: Recollections 1872–1938*, ed. Mary Lago (Columbia: University of Missouri Press, 1978), 82.

77. Letter to A. W. King, 13 October [1891], *Letters*, 30.

78. Ibid., 9 December [1892], *Letters*, 37.

79. Letter to G. F. Scotson-Clark [ca. 15 February 1893], *Letters*, 43–44.

80. *Memorials*, vol. 2, 224–25.

81. Leonée and Richard Ormond, *Lord Leighton* (New Haven and London: Yale University Press, 1975), 118.

82. Letter to F. H. Evans [Postmark 20 August 1894], *Letters*, 73.

83. Ormond, 118.

84. Reade, 312 (No. 20).

85. Letter to G. F. Scotson-Clark [July 1891], *Letters*, 20.

86. Ibid. [ca. September 1891], *Letters*, 28–29.

87. Ibid. [ca. September 1891], *Letters*, 28. For Burne-Jones's familiarity with the collection of paintings at Hampton Court, see John Christian, "Burne-Jones Studies," *Burlington Magazine* CXV, no. 839 (February 1973), 106–9.

88. Letter to G. F. Scotson-Clark [ca. September 1891]. Gallatin Beardsley Collection. Princeton University Libraries. Printed with permission of the Princeton University Libraries.

89. George Moore, "Long Ago in Italy," *Modern Painting* (London and Felling-on-Tyne: The Walter Scott Publishing Co., Ltd., n.d.), New Edition, enlarged, 282.

90. Ellen Beardsley, "Aubrey Beardsley," *A Beardsley Miscellany*, selected and edited by R. A. Walker (London: The Bodley Head, 1949), 77. Cited in Brigid Brophy, *Beardsley and His World* (New York: Har-

mony Books, 1976), 44.

91. A testament to Beardsley's interest in early Italian art at the time is his early pencil drawing of *The Virgin and the Lily,* which is a veritable blueprint of a Quattrocento altarpiece, with the Virgin standing holding the Child among kneeling saints and standing angels, set in an architectural surrounding with a shell-like niche carried on columns above and predella panels below, depicted as carved or painted on a solid three-part base (Gallatin, No. 203, 26). Reproduced in *The Early Work of Aubrey Beardsley,* with a prefatory note by H. C. Marillier (London: John Lane. The Bodley Head, 1912), n.p. In an early letter to Scotson-Clark, Beardsley describes a painting he is working on, "Cephalus & Procris," as being "in early Italian style." Scotson-Clark, Letter 2. The subject suggests that it was inspired by Piero di Cosimo's *Death of Procris,* in the National Gallery. See n. 47 above.

92. Robert Ross, *Aubrey Beardsley* (London: John Lane. The Bodley Head, 1909), 17–18.

93. Davies, 99–101 (No. 915), and 103–8 (No. 1034).

94. Letter to F. H. Evans [27 June 1894], *Letters,* 72.

95. Aymer Vallance, "The Invention of Aubrey Beardsley," *The Magazine of Art* 22 (May 1898): 362–69.

96. Ibid., 367.

97. Reproduced in Vallance, 365.

98. For pictures suggested as being self-portraits of Botticelli, see Rab Hatfield, *Botticelli's Uffizi "Adoration": A Study in Pictorial Content* (Princeton: Princeton University Press, 1976), 100.

99. Reproduced in *The Early Work of Aubrey Beardsley.*

100. Scotson-Clark, Letter 5.

101. Edward Hodnett, *Image and Text: Studies in the Illustration of English Literature* (London: Scolar Press, 1982), 200. See also Duncan Robinson, *William Morris, Edward Burne-Jones and the Kelmscott Chaucer* (London: Gordon Fraser, 1982).

102. See exhibition catalogue, *William Morris and the Art of the Book* (New York: The Pierpont Morgan Library, 1976), 128–29 (No. 79). See also William S. Peterson, *A Bibliography of the Kelmscott Press* (Oxford: Oxford University Press, 1984) and William S. Peterson, *The Kelmscott Press, a History of William Morris's Typographical Adventure* (Berkeley: The University of California Press, 1991).

103. Vallance, 363.

104. Ibid.

105. Scotson-Clark, Letter 3.

106. Reade, 317 (No. 76).

107. Ibid., 319–20 (No. 104).

108. Ibid., 320 (No. 108).

109. For this project, see Joseph R. Dunlap, *The Book That Never Was* (New York: Oriole Editions, 1971).

110. *William Allingham's Diary,* introduction by Geoffrey Grigson (Carbondale: Southern Illinois University Press, 1967), 140. Rossetti also owned a copy of the *Hypnerotomachia Poliphili.* See Alicia Craig Faxon, *Dante Gabriel Rossetti* (New York: Abbeville Press, 1989), 88.

111. Vallance, 363–64.

112. Letter to G. F. Scotson-Clark [ca. 15 February 1893], *Letters,* 44–45.

113. Reade, 333–34 (No. 261).

114. Ibid., 337 (No. 286).

115. *The Yellow Book III* (October 1894), reproduced in Brophy, 84.

116. Reade, 313 (No. 30).

117. Ibid., 347 (No. 366).

118. Reproduced in Dunlap, 33.

119. The original pose of the young woman, in a discarded sketch, recalls Botticelli's *Birth of Venus.* See Reade, plate 368 (No. 367).

120. Reade, 355 (No. 423).

121. See, for instance, his letter to his sister [26 April 1897], in which he mentions: "I have bought two such delicious dix-huitième engravings from the Goncourt sale, *Toilette du Bal, Retour du Bal* engraved after Troy. Dreadfully depraved things." *Letters,* 309.

122. Reade, 350 (No. 389 and 390).

123. Ibid., 355 (No. 425).

124. Ibid., 364 (No. 496).

125. Letter to Leonard Smithers, 26 December [1897], *Letters,* 413.

126. Lago, 174–75.

127. *Letters,* 379, 225, 383, and 434.

128. The photograph is reproduced in *Under the Hill and Other Essays in Prose and Verse* by Aubrey Beardsley, with a new introduction by Edward Lucie-Smith (London: Paddington Press, 1977), facing 19. Reprint of *Under the Hill* (London and New York: John Lane Publisher. The Bodley Head, 1904).

List of Contributors

ALICIA CRAIG FAXON, coeditor of this volume, is Professor of Art History and Chair of the Department of Art and Music Emerita at Simmons College. She has written on Dante Gabriel Rossetti, William Holman Hunt, the Pre-Raphaelite Brotherhood, Ruskin, Cézanne, Degas, Morisot, Cassatt, Forain, and Munch. Her books include *Dante Gabriel Rossetti, Pilgrims and Pioneers: New England Women in the Arts, A Catalogue Raisonné of the Prints of Forain,* and *Jean-Louis Forain: Artist, Realist, Humanist.* Her articles have appeared in the *Art Bulletin, Master Drawings, The Journal of Pre-Raphaelite Studies, The Print Collector's Newsletter, Art New England, Woman's Art Journal,* and *New Art Examiner.*

SUSAN P. CASTERAS, coeditor of this volume, is Curator of Paintings at the Yale Center for British Art and is on the Faculty of the History of Art Department at Yale University. A specialist in Victorian art, she has lectured extensively in the United States and abroad and has also taught at the Graduate Center of the City University of New York. Among her exhibition catalogues are *Pocket Cathedrals: Pre-Raphaelite Book Illustration, Virtue Rewarded: Morality and Faith in Paintings from the FORBES Magazine Collection, Victorian Childhood,* and *The McCormick Collection of Victorian Painting.* Her books include *English Pre-Raphaelitism and Its Reception in America in the 19th Century* and *Images of Victorian Womanhood in English Art.* Numerous essays, articles, and reviews by her have appeared in various anthologies and in *Victorian Studies, The Journal of Pre-Raphaelite Studies,* and other publications. She is the recipient of several awards, grants, and fellowships; and she is completing, with funding from NEH grants, research for *Parables in Paint: Victorian Religious Painting* and *The Grosvenor Gallery: A Palace of Art in Victorian England.*

ALICE H. R. H. BECKWITH is Associate Professor of the History of Art and Architecture at Providence College. Among her publications are *Victorian Bibliomania: The Illuminated Book in 19th-Century Britain,* essays on John Ruskin and on the architects Guarino Guarini, Germain Boffrand, Edward Pugin, and Edward Lacey Garbett. Her contributions to *British Literary Publishing Houses 1881–1965* included discussions of the Eragny Press, St. Dominic's Press, and the Vale Press. She was the senior scholar and researcher in the Rhode Island Committee for the Humanities Humanist Printer project at the John Hay Library, Brown University, from 1992 to 1993, and she was appointed a John Nicholas Brown Fellow by the John Nicholas Brown Center for the Study of American Civilization in 1993.

LAUREL BRADLEY, Adjunct Assistant Professor at the School of the Art Institute of Chicago in the department of Art History, Theory and Criticism, teaches courses in nineteenth- and twentieth-century art history and culture. In her previous life as a university gallery director, she curated many contemporary art and design exhibitions. Her publications include "From Eden to Empire: John Everett Millais's *Cherry Ripe,*" in *Victorian Studies* (1991) and "Elizabeth Siddal: Drawn into the Pre-Raphaelite Circle," *The Art Institute of Chicago Museum Studies* (vol. 18). She is currently writing a book on Victorian painting.

LIANA DE GIROLAMI CHENEY, Ph.D., is a professor of Art History and chairperson of the Art Department at the University of Massachusetts, Lowell. She was born in Milan, Italy, and educated at the University of Miami, Wellesley College, and Boston University. She has written books on Renaissance and nineteenth-century art: *Religious Architecture of Lowell* (1984), *The Paintings of the Casa Vasari* (1985), and *Botticelli's Neoplatonic Images* (1993); coauthored books on *Whistler Papers* (1986), *Whis-*

tler and His Birthplace (1988), and Piero della Francesca's *Treatise on Painting* (1993); and edited and authored books on *The Symbols of Vanitas in the Arts, Literature and Music* (1992). Her major articles also include studies on Mannerist female painters, Sofonisba Anguissola, Barbara Longhi, and Lavinia Fontana; Mannerist emblems; Dutch symbolism; and Italian Symbolist Giovanni Segantini. Her most recent edited and authored book, *Medievalism and Pre-Raphaelitism* (1993), surveys the inventive manner in which Pre-Raphaelite artists assimilated medieval stylistic and literary concepts. She is completing an edited book on *Essays in Mannerism* as well as a book on Edward Burne-Jones's *Mythological Paintings*.

COLLEEN DENNEY is currently Assistant Professor of Art History at the University of Wyoming. She is co-organizing a traveling exhibition on the Grosvenor Gallery with Susan Casteras and is also working on a book on the Grosvenor Gallery. She has published in several journals, most recently in the *Gazette des Beaux Arts*.

JULIA IONIDES, a great-granddaughter of Constantine Alexander Ionides, is currently researching the family's history. She is an art and architectural historian and has recently completed a masters degree on Thomas Farnolls Pritchard, the eighteenth-century architect. She is also a partner in a specialist recording company that uses sophisticated binaural techniques to produce Acoustic Fingerprint Guides of buildings, especially cathedrals, for visually impaired visitors.

LINDA JULIAN, Associate Professor of English at Furman University (Greenville, South Carolina), wrote her dissertation on the influence of Icelandic sagas on the socialist vision of William Morris. She has presented several papers on Morris, including those at the Philological Association of the Carolinas in March 1994, the Modern Language Association in 1991, and the University of Delaware in 1990. Recently she completed essays on Mary Louisa Molesworth and on George Slythe Street for a forthcoming volume of *Dictionary of Literary Biography*, and she is continuing research on Street for a critical biography.

NORMAN L. KLEEBLATT is Curator of Collections at The Jewish Museum. He has organized a number of interdisciplinary exhibitions such as *The Dreyfus Affair: Art, Truth, and Justice* and *Painting a Place*

in America: Jewish Artists in New York, 1900–1945. He is currently working on an exhibition entitled *Too Jewish?: Art, Identity, and Multi-Culturalism*. His "Merdre! The Caricatural Attack against Emile Zola" appeared recently in *Art Journal*. He is also involved with research on the blurred boundaries between artists and curators and exhibitions and installations as they pertain to European and American art of the past twenty-five years.

HELENE E. ROBERTS, the Curator Emerita of Visual Collections in the Fine Arts Library, Harvard University, is the editor of *Visual Resources: An International Journal of Documentation*. She has published *Iconographic Indexes* on the photographs and slides of Old and New Testament paintings in the Fine Arts Library and bibliographies of English and American art periodicals. In addition, she has written on Victorian art and art criticism and on visual documentation.

SARAH PHELPS SMITH, whose dissertation at the University of Pittsburgh was entitled "Dante Gabriel Rossetti's Flower Imagery and the Meaning of His Paintings," subsequently published an article entitled "Rossetti's *Lady Lilith* and the Language of Flowers" in *Arts Magazine*. She has taught at Swarthmore College and at the University of Delaware and has also worked in the Education Department at the Delaware Art Museum. The mother of eight children, she has, moreover, found time to take two groups to Italy to study art history in Rome and Florence.

BARBARA J. WATTS is Assistant Professor of Art History in the Department of Visual Arts at Florida International University. Her dissertation at the University of Virginia was on Sandro Botticelli's Drawings for Dante's *Inferno*. Her forthcoming articles include "Sandro Botticelli's Drawings for Dante's *Inferno*: Narrative Structure, Topography, and Manuscript Design" in *Artibus et Historiae*; "Sandro Botticelli's Illustrations for *Inferno* VIII and IX: Narrative Revision and the Role of Manuscript Tradition" in *Word and Image*; and "Giorgio Vasari's *Vita di Michelangelo Buonarroti* and the Shade of Donatello" in *Rhetorics of Life-Writing in the Later Renaissance*.

GAIL S. WEINBERG has lectured on Ruskin and the Pre-Raphaelites, on Victorian patrons and collectors, and on exposure to the old masters in nineteenth-century England. Her doctoral thesis at Harvard

University was entitled "Botticelli and the Aesthetes: The Victorian Literary Response to a Renaissance Painter." Among her published articles are "Ruskin, Pater, and the Rediscovery of Botticelli" and "'First of All First Beginnings': Ruskin's Studies of Early Italian Paintings at Christ Church," both published in the *Burlington Magazine,* which will be publishing her article on Dante Gabriel Rossetti and Camille Bonnard's *Costumes Historiques.*

Index